ALSO BY BARBARA EHRLICH WHITE

Renoir: His Life, Art, and Letters

EDITOR
Impressionism in Perspective

IMPRESSIONISTS
SIDE BY SIDE

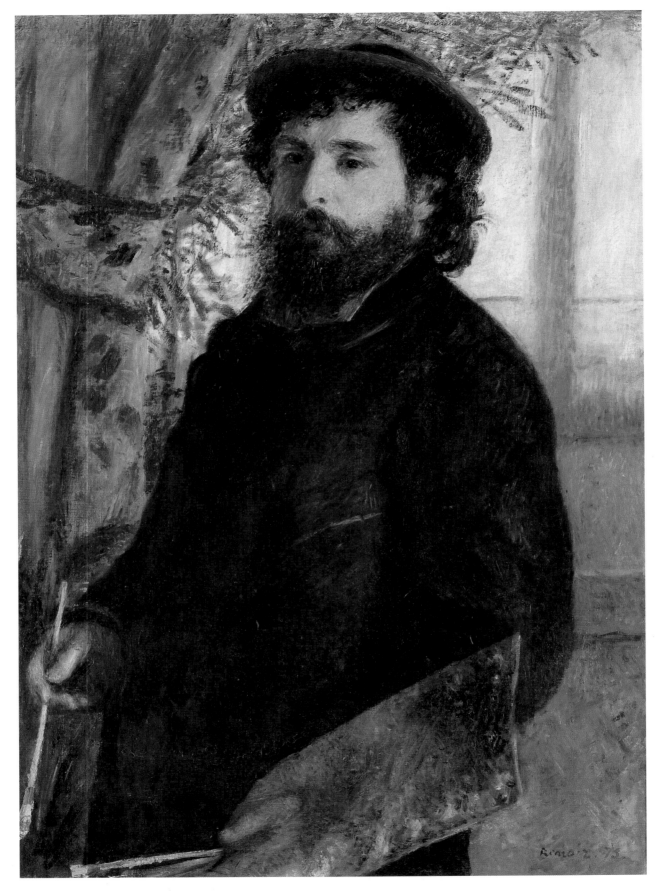

Renoir, *Portrait of Claude Monet*, d. 1875. Oil on canvas, 33½ × 23⅝″
(85.1 × 60 cm). Musée d'Orsay, Paris.

IMPRESSIONISTS SIDE BY SIDE

*Their Friendships, Rivalries,
and Artistic Exchanges*

Barbara Ehrlich White

ALFRED A. KNOPF · NEW YORK · 1996

THIS IS A BORZOI BOOK
PUBLISHED BY ALFRED A. KNOPF, INC.

Library of Congress Cataloging-in-Publication Data

White, Barbara Ehrlich.
Impressionists side by side : their friendships, rivalries, and
artistic exchanges / Barbara Ehrlich White. — 1st ed.
p. cm.
"A Borzoi book"—T.p. verso.
Includes bibliographical references and index.
ISBN 0-679-44317-7
1. Impressionist artists—France—Psychology. 2. Artistic
collaboration—France. 3. Impressionism (Art)—France.
4. Art, Modern—19th century—France. I. Title.
N6847.5.14W49 1995
759.4´09´034—dc20
94-46222
CIP

Manufactured in Italy
First Edition

For Leon S. White, David S. White, Joel S. White,
Katie Bregler Barber, Meyer Schapiro, and Lillian Milgram Schapiro.
And to the memory of Ruth Krimsky Ehrlich
and Linda Krimsley Lechner.

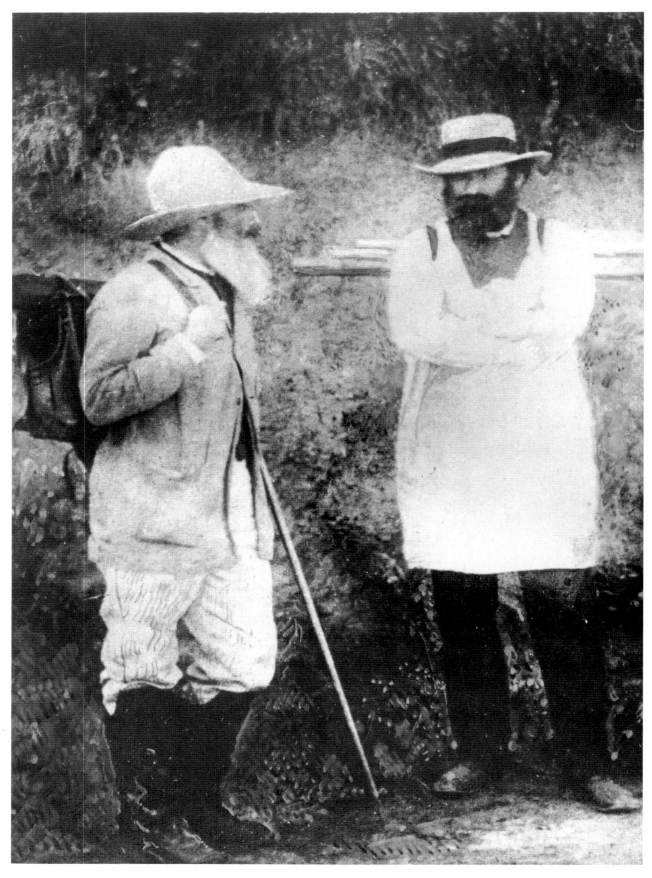

Photograph of Cézanne (right) and Pissarro (left) in the Auvers region
c. 1872. Cézanne is thirty-three years old; Pissarro is forty-two.
Private collection.

Contents

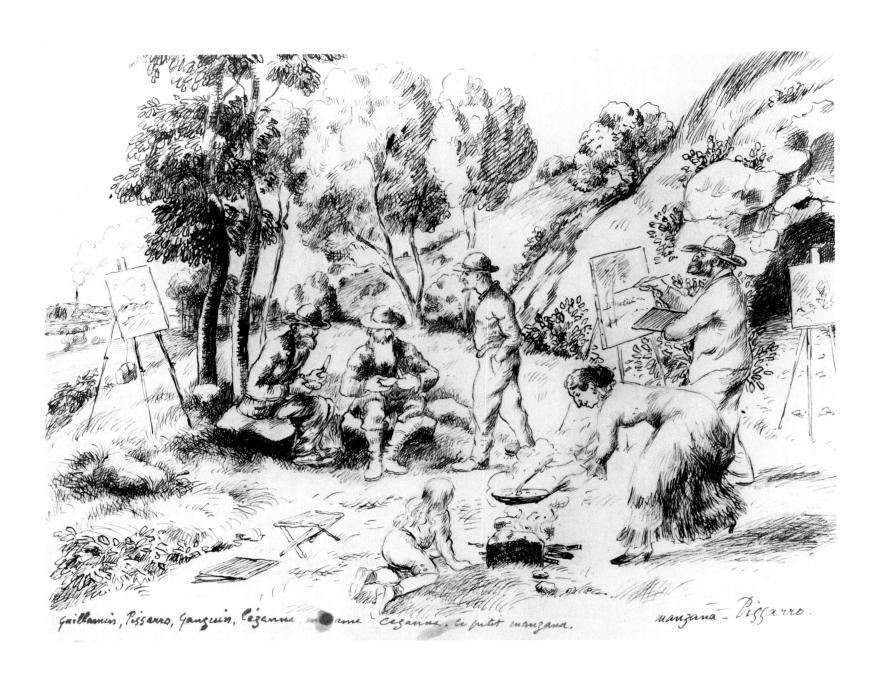

Georges (Manzana) Pissarro, *The Impressionists' Picnic in 1881*, c. 1900.
Pen and ink on paper, 8¼ × 10½″ (21 × 26.5 cm). Inscribed on lower
edge: "Guillaumin, Pissarro, Gauguin, Cézanne [at the easel], Mme.
Cézanne, le petit Manzana." Private collection.

Acknowledgments

T HIS BOOK BUILDS on Meyer Schapiro's humanistic approach to art history: seeing art in the context of real life. To elucidate how and why art evolves as it does, Schapiro studies the people behind the paintings. His passionate love of art history has been, and continues to be, a constant source of inspiration.

Documentation Orsay was of the greatest importance for establishing the visual connections found in this book and for this I am infinitely grateful. Also of great help were many libraries and their research staffs, with special appreciation to the following: Duand-Ruel Archives, Avery Library at Columbia University, The Frick Art Reference Library, The Watson Library, Fogg Library at Harvard University, Wessell Library at Tufts University (and their Interlibrary Loan Staff), and Bibliothèque Orsay.

Of inestimable importance for this volume was the wealth of information found in the Wildenstein Institute catalogs: the five-volume Monet catalog with its rich collection of letters; the two-volume Manet catalog; and the Morisot catalog.

Some of the most knowledgeable people were extraordinarily generous in sharing critical information with me. They went out of their way to help me obtain photographs, and some lent me photographs. Without their assistance, some of the color illustrations found here would appear in black and white and some of the photographs of the artists would not be included. Each is warmly thanked: Joachim Pissarro and Christopher Campbell offered invaluable information about Pissarro and Cézanne; Jayne Warman and Joseph J. Rishel about Cézanne; Claire Durand-Ruel Snollaerts about Pissarro; Paul Tucker, Robert Gordon, and Steven Levine about Monet; Bill Scott, Anne Higonnet, Alain Clairet, Delphine Montalant, and Waring Hopkins about Morisot; Nancy Mowll Mathews and Pamela A. Ivinski about Cassatt; Juliet Wilson Bareau about Manet; and Dominique Lobstein, Jacqueline Henry, and Frances F. L. Beatty with regard to research problems.

My gratitude goes to the many people in libraries, museums, galleries, auction houses, and elsewhere who assisted me in my research throughout the past twelve years, and to those who helped me track down elusive paintings. I am greatly indebted to the many collectors who allowed me to reproduce art from their collections. Each of the following is warmly thanked, as are those who preferred to remain anonymous: Warren Adelson; George Aldor; Henriette Angel; Alex Apsis; William Aquavella; Nicole Arbel; Claude Aubry; Joseph Baillio; Janine Bailly-Herzberg; William Beadleston; Ernst Beyeler; Grazia Bozzoli; Richard R. Brettell; David S. Brooke; Sam Carini; Beverly Carter; Jacqueline Cartwright; Philippe Cézanne; Melanie Clore; Lauri del Commune; Desmond Corcoran; Florence E. Coman; France Daguet; Guy-Patrice Dauberville; François Daulte; Christian De Robert; Marianne Delafond; Anne Distel; Barbara Divver; Walter Feilchenfeldt; Mary Ella Feinleib; Ann Marie Ferraro; Hanne Finsen; Kate Fleet; Rebecca Frazier; Oscar Ghez; Susan Ginsburg; Marilyn Glater; Caroline Durand-Ruel Godefroy; Yves and Catharine Goussault; Martha Graves; Rob Grossman; Charlotte Gutzwiller; Stephen Hahn; Chieko Hasegawa; Ursula Held; John House; A. H. Huussen Jr.; Ay-Whang Hsia; Richard Islop; Colta Ives; Marilyn Jensen; Ellen, Paul, and Samuel Josefowitz; Suzanne Julig; Nora Kabat; Berta Katz; Frédérique Kartouby; Jean Labatut; John Leighton; Cary Lochtenberg; José de Los Llanos; Henri Loyrette; J. Patrice Marandel; Catharine and Philippe Marechaux; Darin Marshall; Anne McCauley; Melissa De Medeiros; Paz S. Mendoza; Claire Messenger; Michael Milkovich; Charles Moffett; Sophie Monneret; Marc de Montebello; Takao Mori; Stephen Nonack; Anne M. P. Norton; Martha Parrish; Claire Peyre; Philippe Piguet; Theodore Reff; Virginia Remmers; Marc Restellini; Jean-Dominique Rey; Christopher Riopelle; Kathryn Ritchie; Anne Roquebert; Marc Rosen; Elaine Rosenberg; James Roundell; Jean-Michel Routhier; Michael Rudell; Kathy Sachs; Samuel Sachs II; Chris Sala; Janet Traeger Salz; Bertha Saunders; Manuel and Robert Schmit; Alison Sherlock; Perrin Stein; Susan Alyson Stein; Mary Anne Stevens; Linda Strauss; Charles Stuckey; Mikio Takai; John Tancock; Patricia P. Tang; E. V. Thaw; Gary Tinterow; Jean-Marie Toulgouat; Jennifer Vanim; Donald S. Vogel; Kevin Vogel; Daniel Wasser; Stacey West; Gabriel and Yvonne Weisberg; Nancy Whyte; Karl Wieck; Daniel Wildenstein; Gretchen Wold; Denise Zayan; and Pascale Zoller.

In the writing process, two people were particularly important: Deborah Edelstein and Mary Susannah Robbins. My writers' group, Florence Harris, Susan Sekula, and Carol Vogel, were unflappable cheerleaders.

I am grateful to Tufts University for having awarded me several grants (including Faculty Research Awards and Debbie Kurson Awards) that helped pay for research assistants. Throughout the past twelve years, many excellent undergraduate and graduate

students enthusiastically worked on this project: Jennifer Fidlon-Bugat and Florence Merle worked with me for more than a year in Boston, New York, and Paris. Others assisted me for shorter periods of time but with equal passion for the relationships between the Impressionists: Bradford Black, Alison Boggs, Marine de Boucaud, Christiane Bourloyannis, Veronique Chagnon-Burke, Lisa Chice, Heidi Gautschi, Kathleen Graf, François Kojey-Strauss, Kristin Kueter, Karen Larsen, Claire Madden, Alessandra Quagliata, Isabelle Rohr, Stephanie Rolland, Ellen Schneider, Virginia Stults, Debra Sussman, Sarbani Thakur, Paul Vallet, Emma Villedrouin, and David S. White.

My agent, Helen Pratt, was consistently supportive, attentive, and helpful throughout this long process.

I would like to thank the many individuals at Alfred A. Knopf, Inc., who assisted me in this project. First and foremost is my editor, Susan D. Ralston, whose enthusiasm for the project allowed this book to come to life. Her expertise, dynamism, and perfectionism contributed greatly to the quality of this volume. The book owes its beautiful appearance to Peter A. Andersen, who designed the volume; Susan Chun, who produced it; and Amanda Gordon, who provided invaluable editorial assistance. I also want to add my personal thanks to Sonny Mehta and to all those at Knopf who were involved in the publication of the book.

Finally, I have appreciated the wisdom, patience, and companionship of my husband, Leon S. White; his meticulous and astute suggestions improved the volume's readability. I am thankful for the support and encouragement of our sons, David S. White and Joel S. White. Throughout the past twelve years, Leon, David, and Joel selflessly cheered on my work. I am grateful to my friend and walking partner, the psychologist Katie Bregler Barber, whose insights about relationships greatly enriched this study. And I have been fortunate in having stellar role models, Meyer and Lillian Schapiro, who, for over thirty years, have encouraged and supported my work.

Tufts University, Medford, Massachusetts, 1996

IMPRESSIONISTS
SIDE BY SIDE

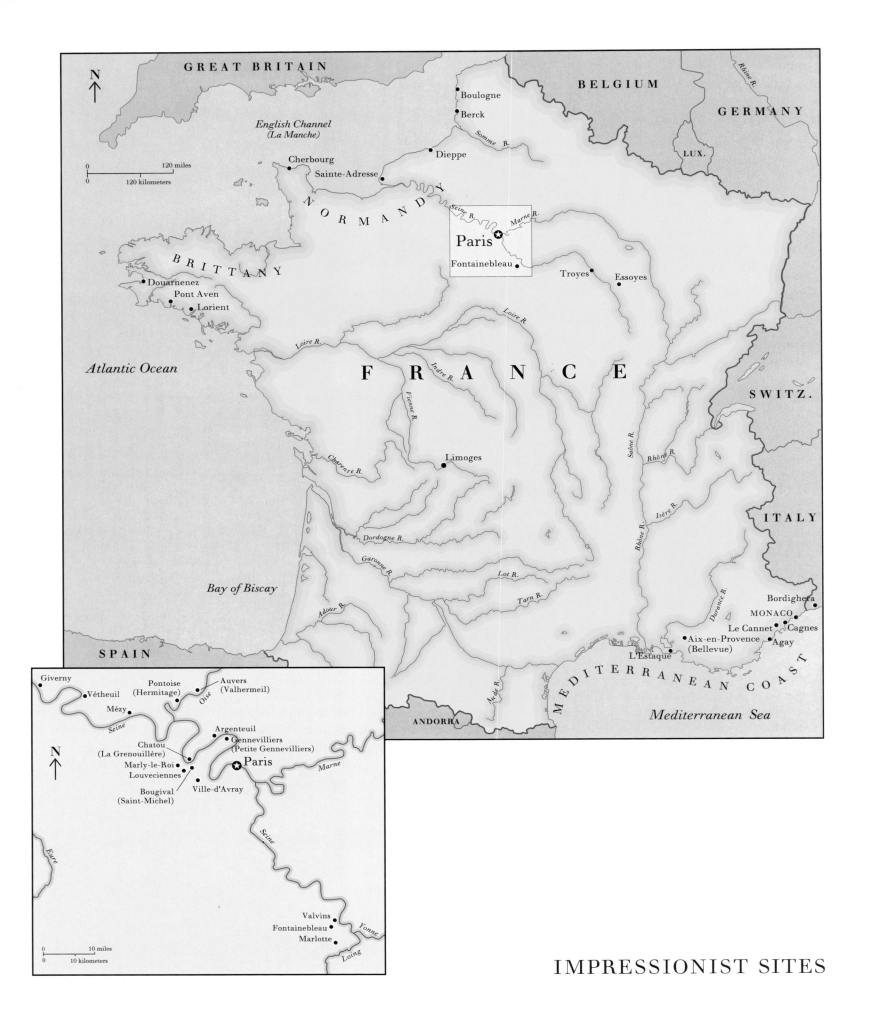

IMPRESSIONIST SITES

Introduction

FRIENDSHIPS, rivalries, and extended working relationships between pairs of painters who were members of the Impressionist movement contributed much to the individual artistic development of the greatest Impressionists—Mary Cassatt, Paul Cézanne, Edgar Degas, Édouard Manet, Claude Monet, Berthe Morisot, Camille Pissarro, and Pierre-Auguste Renoir. Between 1861 and 1919, personal relationships, often intense, existed between the men Degas and Manet, Monet and Renoir, Cézanne and Pissarro; between the men and women Manet and Morisot, Cassatt and Degas, Morisot and Renoir; and between the women Cassatt and Morisot. All of them entailed artistic exchanges: painting or drawing the identical motif either side by side or close in time; portraying each other; collaborating on printing projects, and, in a few instances, copying or correcting each other's work.

The Impressionists,[1] starting in their twenties, thirties, and forties—and continuing, in some cases, until their early fifties—learned from one another over long periods of time and often worked in one another's presence. A study of seven of the most important friendships reveals what has not yet been noted in the literature: the degree to which these relationships were vital to Impressionism. It is not often realized how much these men and women relied on one another for camaraderie, support, inspiration, ideas, and techniques. They not only learned from but competed with each other, and their art changed as a result. Without these friendly rivalries, each artist's work would not have been as rich.

Great differences existed in the seven friendships. The male relationships were overtly competitive. Working together led them to important breakthroughs in style and theme; this resulted in artistic growth for all of the painters and in a great number of works of art.

Beginning in 1861, in the period of pre-Impressionism (if we set the beginning of Impressionism as 1869), Degas and Manet had a relationship whose very existence initiated the pattern of closely allied peers who painted and drew in each other's company and subtly vied with each other to paint modern life in a modern style. Their association was marked by a traditional upper-class male pattern of competition, in which they belittled each other to third parties. Degas made numerous portraits of Manet, and Manet made one depiction of Degas's back in a racing scene.

Five years later Monet and Renoir established a working friendship that resulted in many paintings made in tandem, as well as in Renoir's varied portraits of Monet. Compared with other members of the group, Monet and Renoir were from lower classes on the social scale and had the warmest relationship of any of the men.

The Cézanne-Pissarro working relationship, which started in 1872, resulted in many paintings executed side by side as well as reciprocal portraits. In addition, Cézanne copied Pissarro's works. Both Cézanne and Monet were, on occasion, belligerent to their friends Pissarro and Renoir, although most of the time the relationships were harmonious.

Monet, Renoir, Cézanne, Pissarro, and Manet had a number of less significant relationships involving artistic exchange among themselves as well as with other Impressionists, including Frédéric Bazille, Gustave Caillebotte, and Alfred Sisley. These relationships produced fewer side-by-side paintings and fewer portraits of each other. (See Appendix: Other Impressionist Pairs Who Painted the Same Motif Side by Side or Made Portraits of Each Other.)

The relationships between women and men were quite different from those between men. The friendships were closer and more intense, and the competition more veiled. Without Degas and Manet, neither Cassatt nor Morisot could have evolved into the artist each became, nor could their art have garnered the attention it received. Cassatt built her style on the manner of Degas. Morisot benefited from the emotional support of Manet and later from Renoir's help and his return to traditionalism. She copied one of Renoir's works. In these relationships, in terms of artistic exchange, the men's art benefited less than the women's, but in business and emotional areas they, too, profited.

The work of these pairs is less extensive than that of the pairs of men. Both Morisot and Cassatt were pioneers. They were two of the strongest and most privileged women of the late nineteenth century, yet they vacillated between being colleagues and venerating their mentors' work to the detriment of their own egos. The men, who believed that their talents were superior to the women's, assumed the roles of adviser and mentor. Indeed, Degas and Manet corrected a painting each by Cassatt and Morisot that the women sent to be exhibited. It is unthinkable that Cassatt or Morisot could have altered a painting by Degas or Manet, certainly not one on its way to an exhibition. Society and their own

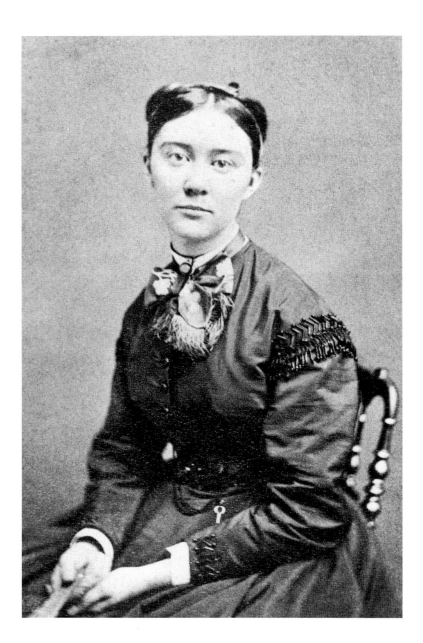

OPPOSITE: Cassatt, *Self Portrait* around the age of thirty-six, c. 1880. Watercolor on paper, 13 × 9⅝″ (33 × 24.4 cm). National Portrait Gallery, Washington.

LEFT: Photograph of Cassatt taken in Paris around the age of twenty-three, c. 1867. Private collection.

psyches taught them that their art was inferior to that of their male counterparts. Typical of late-nineteenth-century women, original as they were, their lives were circumscribed and their attitudes constricted, and this limited their art.

Most of the works produced during these friendships were portraits by the men of the women. This would lead one to believe that the men saw the women's beauty or character as foremost. Furthermore, the women were willing to pose, whereas the men may not have been. Cassatt made a portrait of Degas that is lost, but Morisot never did portraits of Manet or Renoir. The men and women never seem to have worked side by side with the exception of a pair of paintings by Morisot and Renoir.

Cassatt and Morisot had the least close relationship, with the least artistic exchange. These two upper-class women had very different lives. Cassatt was American and Morisot French. Cassatt was single and childless, Morisot was both wife and mother. They

did no portraits of each other. In 1890, inspired by a print show they attended together, they did drawings side by side of a half-nude woman arranging her hair in front of a mirror that led each to create a major work.

All the friendships considered here were between people of the same or closely related classes, with the exception of that between Morisot and Renoir. There, the difference in class was balanced out by Renoir's sense that he was superior simply by being a man and Morisot's belief that she was inferior simply by being a woman.

The personalities of these eight Impressionists were colorful. They were

iconoclasts: a haughty dandy like Manet; an easygoing street urchin like Renoir; a soft-hearted revolutionary like Pissarro; a self-doubting dreamer like Cézanne; an exquisite young

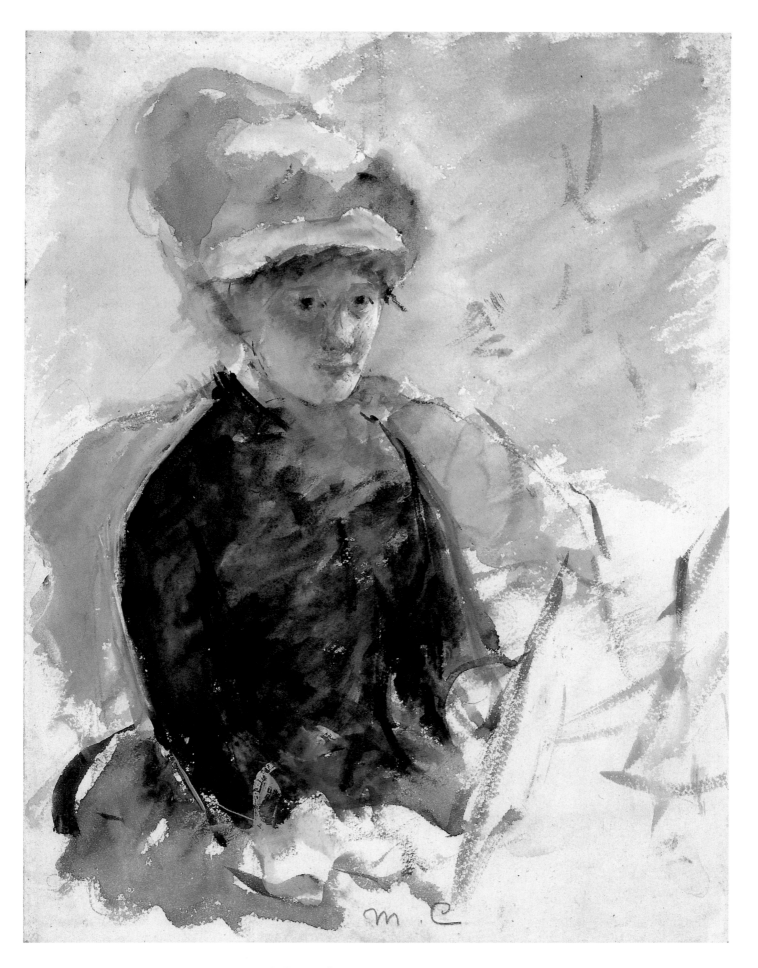

woman of highly proper background like Berthe Morisot; and a rich bourgeois of impeccable breeding but occasionally arrogant and nasty disposition like Degas. Among them was only one rude, outspoken, defiant, and domineering egotist, Claude Monet[2]

and one wealthy American feminist, Cassatt. They engaged in relationships that were varied and dynamic. In each pair was an element of rivalry, one of the most powerful fuels of creativity. A study of these relationships reveals that friendly competition is beneficial for creativity, innovation, and productivity; rivalries stimulate individual achievement.

The artists wrote to and about one another, and talked about one another. They collected one another's art. Their relationships fostered change and, working together, they strengthened the distinctions between their techniques. Comparing the works they made side by side gives us a new understanding of both their commonality and the uniqueness of each artist's style. These periods of artistic exchange were among the most fruitful in their careers.

IMPRESSIONISM is both the ultimate development of an earlier nineteenth-century naturalism and the beginning of abstrac-

tion, which has developed throughout the twentieth century. It is both a collective movement and the work of numerous unique individuals. The styles and themes of the eight greatest Impressionists (at that time they were also called Independents) had more similarities than those of any earlier great painters. Indeed, many hostile journalists asserted that their styles were indistinguishable. The most powerful critic, Albert Wolff, exclaimed: "Renoir or Claude Monet, Sisley, Caillebotte, or Pissarro, it's all the same thing; what is particularly strange about these Independents is that they are just as prone to routine as are the painters who do not belong to their brotherhood. Who has seen one picture by an Independent has seen the works of all of them."[3]

Despite Wolff's assertion, the Impressionists strove for individuality. Each artist sought a unique style, and that style was constantly changing. As Pissarro explained, each painter "kept the only thing that counts, the unique sensation!"[4] And the search for "progress" was a constant theme in the artists' letters. As Pissarro stated, "It is proper not to want to stand still."[5] The Impressionists were not a close-knit, homogeneous group with a clearly formulated theory but a movement composed of talented people with varied aims and practices. Each had different ideas, approaches, attitudes, and contributions.

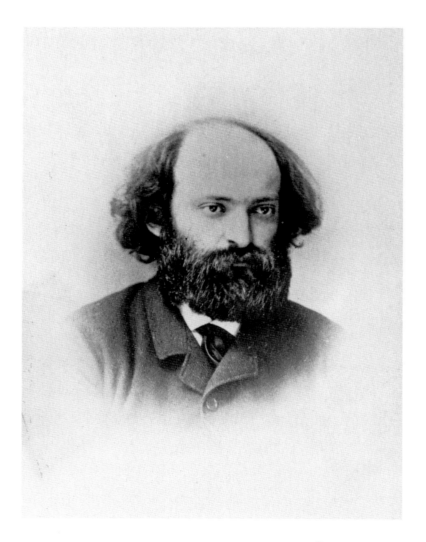

OPPOSITE: Cézanne, *Self Portrait* around the age of thirty-four to thirty-seven, c. 1873–1876. Oil on canvas, 25¾ × 20⅞″ (65.4 × 53 cm). Musée d'Orsay, Paris.

LEFT: Photograph of Cézanne around the age of thirty-six, c. 1875. Private collection.

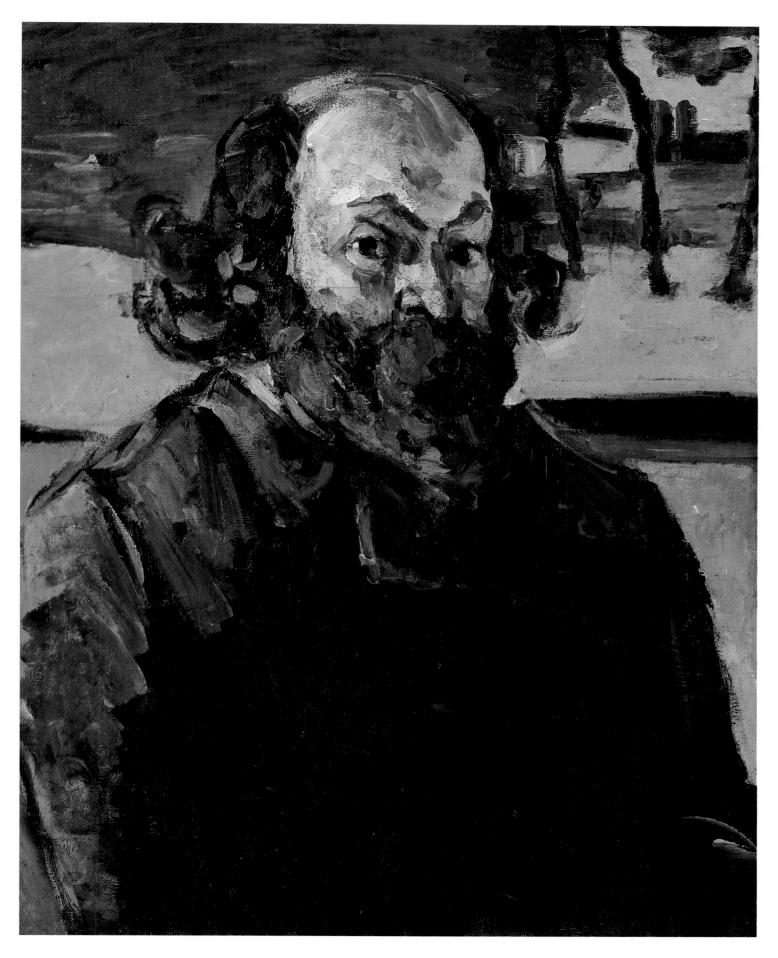

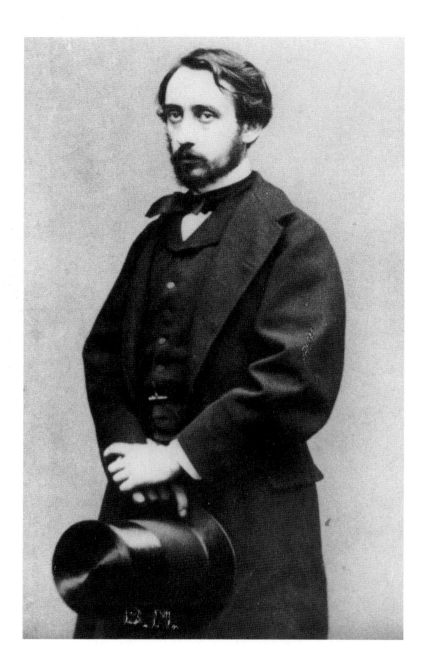

OPPOSITE: Degas, *Self Portrait* around the age of twenty-nine, c. 1863. Oil on canvas, 36⅜ × 26⅛″ (92.4 × 66.4 cm). Fundação Calouste Gulbenkian, Lisbon.

LEFT: Photograph of Degas around the age of twenty-four to twenty-six, c. 1858–1860. Photograph printed from a glass negative in the Bibliothèque Nationale, Paris.

The artists preferred different subjects. Cassatt, Degas, Manet, Morisot, and Renoir chose urban and suburban themes of the middle and upper classes at leisure and play. Monet favored cityscapes and landscapes; Pissarro preferred rural landscapes, often with peasants; and Cézanne chose solitary nature. Gender, more than class, affected the choice of subject matter: the men painted places accessible to them—the streets and cafés, backstage at the theaters, and the brothels—while Cassatt and Morisot painted their own world—women and children including domestic environments and elegant spectators at the theater.

They had different strengths. Degas presented the most unusual viewpoints and perspectives on urban life; Manet, the most direct and abstract view; Renoir, the most idealized relationships between people; Monet, the most profound feeling for nature; Pissarro, the most sympathetic treatment of rural life; Cézanne, the most complex sense of structure; Cassatt, the most intimate rela-

tionship between mother and child; and Morisot, the most ephemeral view of domestic life.

Yet they did share similar goals: to experiment with a new way of painting that was far removed from academic conventions; to depict the visible in spontaneous, subjective terms; to capture their own perceptions of human nature and landscapes; to record a split-second reality in a style that conveyed immediacy; and to render their subject in an imaginative and joyful manner.

The Impressionists were innovative in their procedures, themes, and styles. They usually completed their work in front of their motif. Painting in pairs was part of the sociable aspect of the movement. To paint outdoors the artists had special portable easels and traveling paint boxes with tubes of bright pigments. They carried prepared canvases and used white or pastel grounds to enhance the luminosity of their images and the intensity of colors. Their paints were ground in slow-drying poppy oil to retain

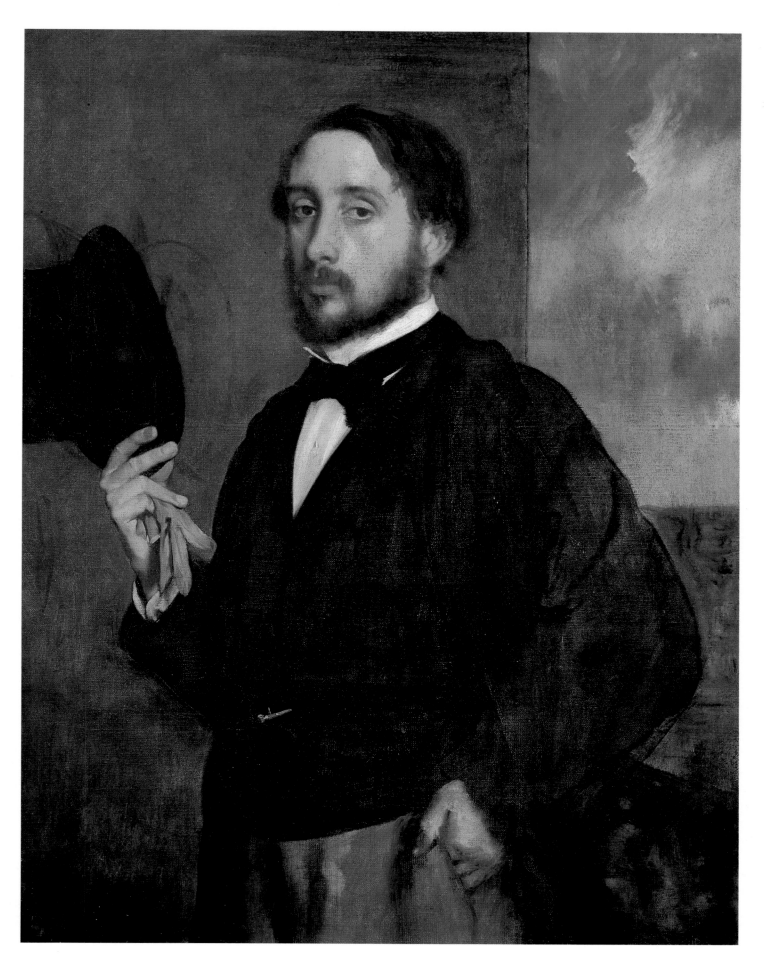

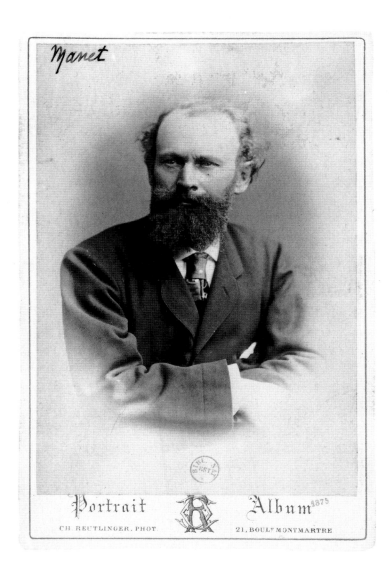

the colorful brush marks on the surface and to give a raised, textured effect.

In 1861 Degas and the following year Manet began painting the pleasures of modern life, and others followed. Eight years later Monet and Renoir, working together at La Grenouillère, introduced the style we now characterize as Impressionist, with its bright, light, visible brushwork, and sketchlike quality. Impressionism celebrates a casual moment in daily life, seeking to record the artist's instantaneous impression of the world, or, as Monet expressed it, "to render my impressions in front of the most fleeting effects."[6] To a greater or lesser extent, all the Impressionists shared Monet's goal: "to manage to convey what I am seeking: 'instantaneity,' above all, the envelopment, the same light spread over everywhere. . . . to convey what I experience."[7]

The themes and styles of the Impressionists were not welcome at the annual government-sponsored Paris Salons, the prime showcase for painting. The Salons featured works by so-called academic artists, often professors at the academy, the École des Beaux-Arts, who painted moralizing subjects from history and mythology, with dark, limited palettes, somber shadows, subtle tonal modeling, meticulous detail, and smooth, finished surfaces (see illus. of William Bouguereau's painting, p. 59).

The Impressionists came together in an effort to reach the critics and the buying public through alternative channels. They were the first artists to institute a group exhibition outside the established system. These juryless exhibitions run by the participants dovetailed with the idea of artistic freedom, which was central to their concerns. Pissarro explained:

> A group of artists have gotten together in order to show their work because the juries systematically prevented them from showing paintings to amateurs and the public. As a matter of principle, we *did not want a school;* we like Delacroix, Courbet, Daumier, and all those who have guts; we like nature, open air, the different impressions that we feel, which are our complete preoccupation. We renounce all artificial theories.[8]

In 1867 a dozen young artists, including six of the future Impressionists, considered mounting a group show outside the official Salon. This alternative exhibition, the first of eight, did not

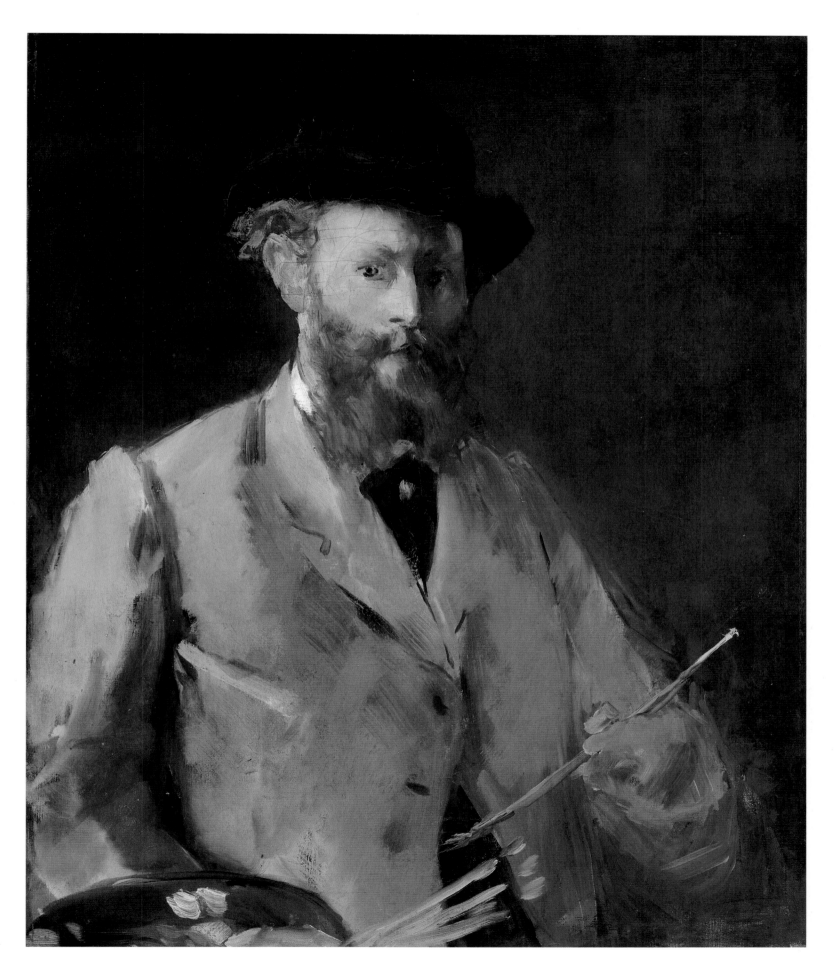

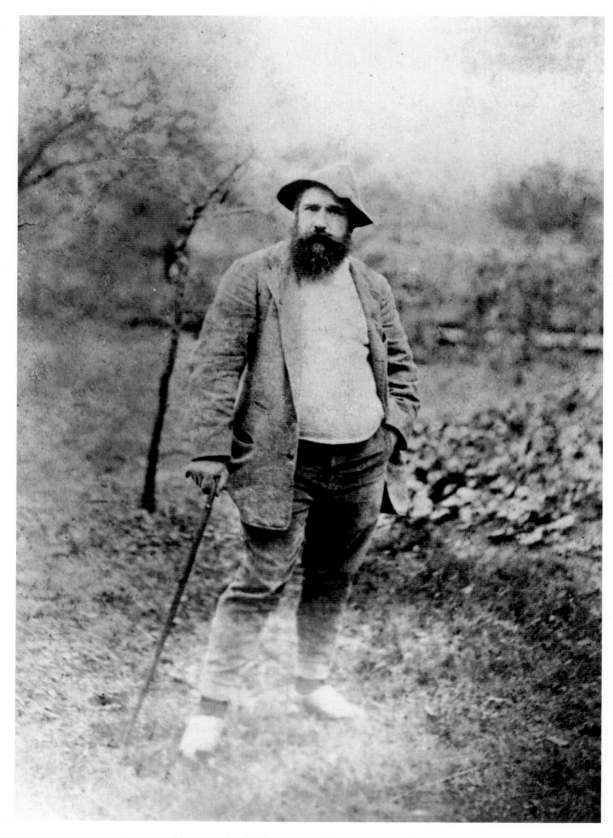

ABOVE: Photograph of Monet near Giverny around the age of forty-nine to fifty, c. 1889–90. Archives Durand-Ruel, Paris.

OPPOSITE: Monet, *Self Portrait* at the age of forty-six, 1886. Oil on canvas, 22 × 18½″ (55.9 × 47 cm). Private collection.

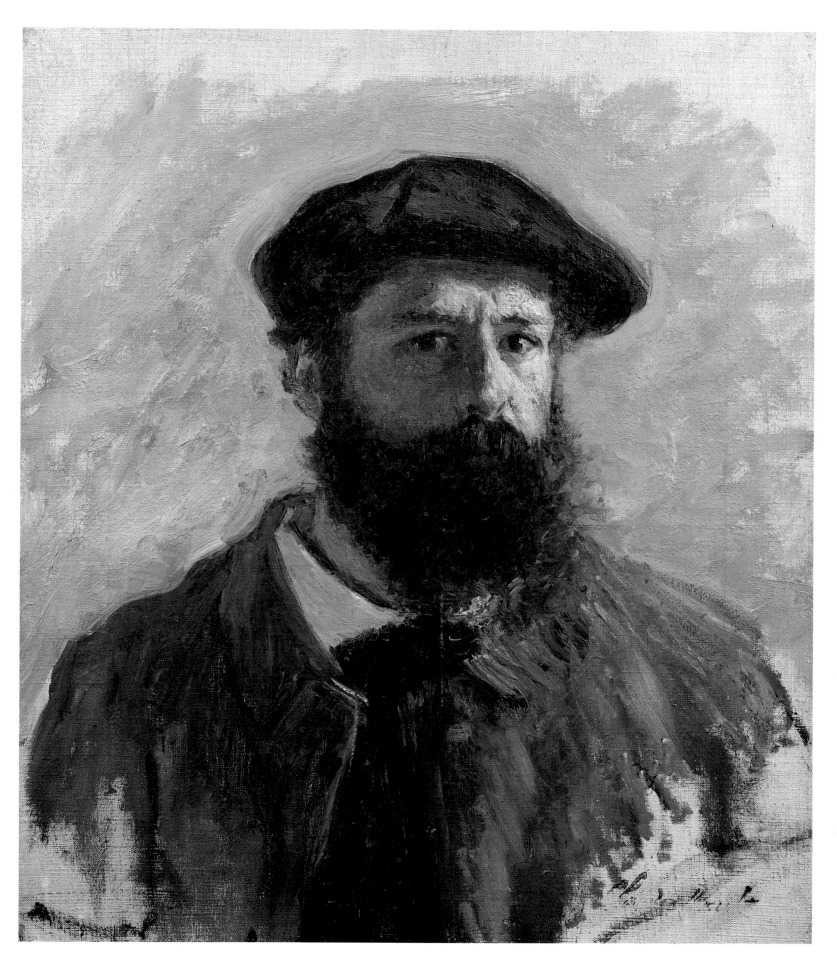

Portrait Album

CH. REUTLINGER, PHOT. 21, BOUL? MONTMARTRE

materialize until seven years later.[9] As Renoir asserted: "In 1874 Pissarro, Monet, Degas, and myself founded the Salon of Impressionists."[10] Despite Renoir's statement, none of the exhibitions was called an Impressionist show; rather they were titled "Exhibition of the Anonymous Society of Painters, Sculptors, and Engravers," or "Exhibition of Independent Artists," or simply "Exhibition of Painting."

The term *Impressionists* was coined by journalists writing during the first group show of 1874.[11] One elaborated:

> The common concept that united them as a group and gives them a collective strength in the midst of our disaggregate epoch is the determination not to search for a smooth execution but to be satisfied with a certain general aspect. Once the impression is captured, they declare their role is over. . . . If one wants to characterize them with a simple word that explains their efforts, one would have to create the new term

of *Impressionists*. They are impressionists in the sense that they render not a landscape but the sensation produced by a landscape.[12]

Over the objection of some of the artists, the term was accepted. When Renoir's friend Georges Rivière put out a journal to accompany the 1877 exhibition, he named it *The Impressionist Journal of Art* and called the show an "Impressionist Exhibition." Nonetheless, among the exhibitors in these juryless shows, those who painted in an Impressionist style were in the minority.

The first show included thirty-one artists; a total of fifty-five artists of diverse styles exhibited in all eight shows, through 1886. Only Pissarro participated every time, the others less often: Degas and Morisot, seven times; Monet, five; Renoir and Cassatt, four; Cézanne, twice; Manet, never. These shows were unpopular with the critics and public, and many Impressionists gradually returned to the official Salons. Disagreements and health problems

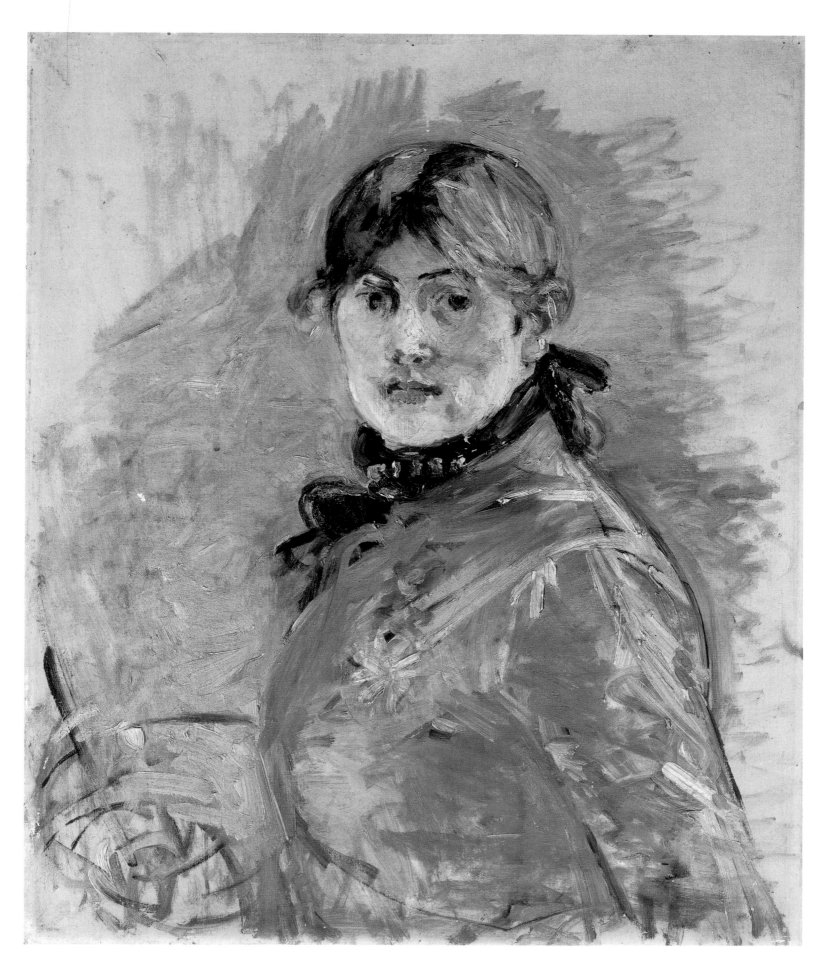

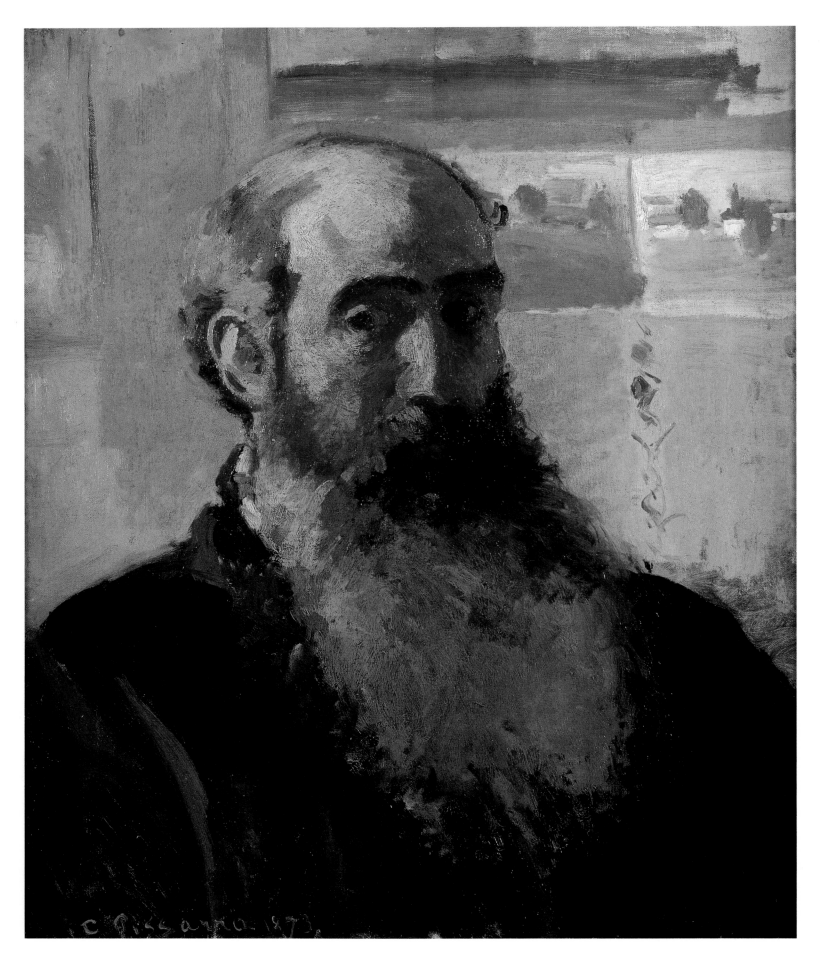

also caused defections. Besides exhibiting together, all of them except Cézanne shared the same dealer, Paul Durand-Ruel.

During these decades the Impressionists encountered the ridicule of the public, the disdain of the collectors, and the insults of many art critics. Those who were self-supporting suffered continuing financial hardship. After the 1877 exhibition, Cézanne wrote to Émile Zola: "It seems that profound depression reigns . . . in the Impressionist camp. The golden stream isn't exactly flowing into their pockets, and their studies are at a standstill. We are living in troubled times, and I don't know when poor painting will recover a bit of its former luster."[13] When Pissarro was nearly fifty, he wrote, "Art is a business of hungry bellies, empty purses, and miserable wretches."[14] A decade later he implored, "What I need is money, and now."[15]

The hallmarks of Impressionism include feelings of freedom, spontaneity, and often optimism. These are achieved through a sketchy style that gives the effect of an immediate and direct execution. Tiny, brightly colored strokes suggest form, color, and atmosphere in a penmanship unique to each artist. The palette is light and bright to approximate the effect of natural light. The colors and forms of objects are modified by the surrounding light, by reflections from contingent objects, and by colored shadows. The Impressionists sought to make all hues clearer and brighter. Monet and Renoir, and perhaps Pissarro, began painting in this style in 1869.[16] The others soon followed. The intrinsic brightness of sheer color structured the links between light and dark within their paintings and gave a new luminosity to their work.

The degrees of structure or randomness in the arrangements of Impressionist paintings vary. Often the artist worked from a high vantage point—a technique learned from both photography and Japanese prints—which emphasizes two-dimensional qualities. Free ordering and scattering are suggested by the flicker of small colored brushstrokes across the canvas. Distant parts of the surface are related by strokes of similar hue, intensity, value, weight, size, and direction. To enhance the idea of instantaneous and fragmentary vision, the frame often crops parts of the image; sometimes there is no focal point.

The Impressionist painters had in common their innovative

OPPOSITE: Pissarro, *Self Portrait* at the age of forty-three, d. 1873. Oil on canvas, 21⅝ × 18⅛″ (54.9 × 46 cm). Musée d'Orsay, Paris.

RIGHT: Photograph of Pissarro around the age of fifty, c. 1880. Collection Sirot-Angel, Paris.

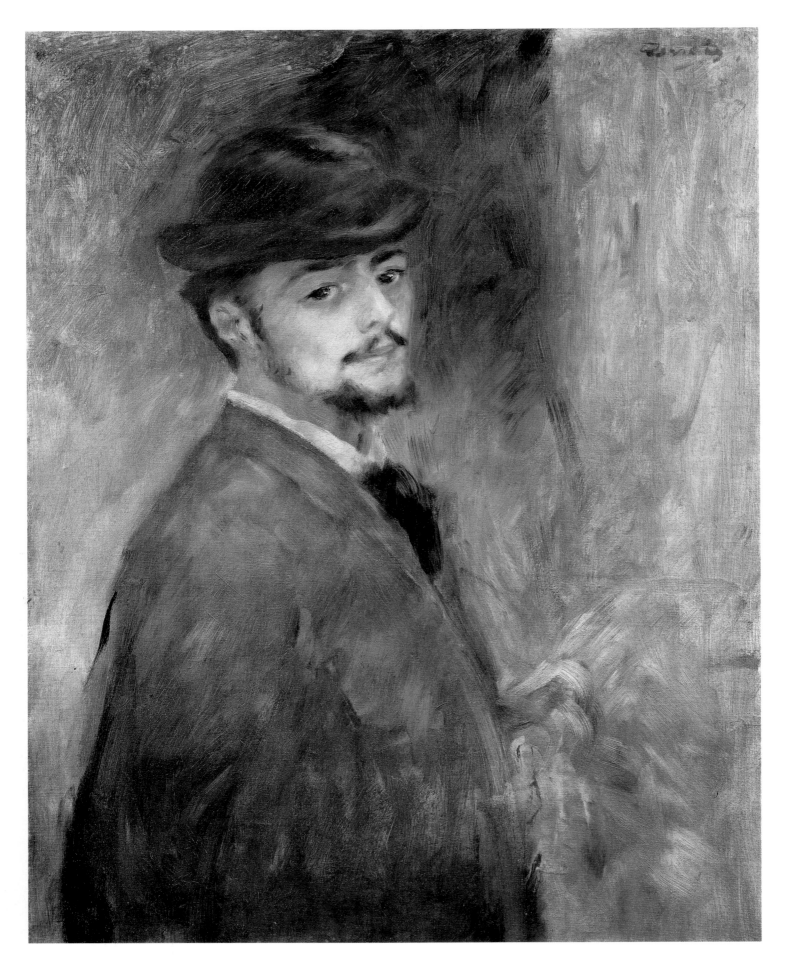

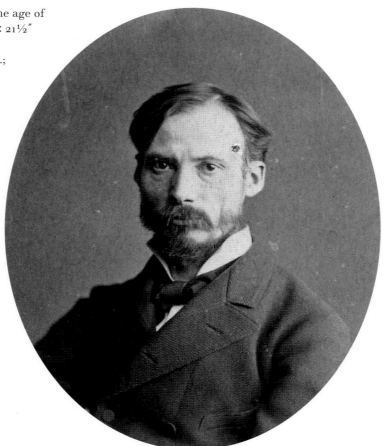

OPPOSITE: Renoir, *Self Portrait* at the age of thirty-five, 1876. Oil on canvas, 27⅞ × 21½″ (70.8 × 54.6 cm). Fogg Art Museum, Harvard University, Cambridge, Mass.; Bequest-Collection of Maurice Wertheim, Class of 1906.

RIGHT: Photograph of Renoir, at the age of thirty-four, 1875. Musée d'Orsay, Paris.

ways of handling stroke, light, color, and composition. Their treatment of form varied in its degree of focus. Consequently, Impressionist figure paintings are more diverse, and landscapes tend to be more similar.

The eight artists in this book treated form (the portrayal of figures and objects) in three ways. Throughout the painting of Cassatt and Degas and in Manet's earlier work, through 1869, one sees a distinctness and clarity of form and a more studied effect. We will refer to them as Realist Impressionists. Beginning in 1869 Monet, Renoir, and perhaps Pissarro, and beginning soon thereafter Morisot and Manet, all of whom we shall call Impressionists, often (but not always) blurred the precision of their form. In many images they captured the dissolving effect of light on an object or person; in these images the forms are rendered with no line, detail, weight, volume, or relief. The colored strokes both create and dissolve form. Seen up close, the image is unclear; from a distance the colored strokes suggest the theme. Although the aim is to give the effect of a free, spontaneous creation, the technique entails a sensitive, painstaking weighing of tiny parts. Cézanne, a Classical Impressionist, continued a traditional conception. "I wanted to make Impressionism something solid and durable like the art in the Museums," he said.[17] He approached nature as would an architect or sculptor.

From the mid-1880s on, only Monet and, later, Pissarro were committed to an Impressionist treatment of form and composition. As Meyer Schapiro explains:

Actually, in the 1880s there were several aspects of Impressionism which could be the starting points of new tendencies and goals of reaction. For classicist painters the weakness of Impressionism lay in its unclarity, its destruction of definite linear forms; it is in this sense that Renoir [and to a lesser extent Morisot] turned for a time from Impressionism to Ingres. But for other artists at the same moment Impressionism was too casual and unmethodical; these, the neo-Impressionists [including Pissarro], preserved the Impressionist colorism, carrying it even further in an unclassical sense, but also in a more constructive and calculated way. . . . There were finally artists [like Cézanne] for whom Impressionism was too unorganized, and their reaction underscored a schematic arrangement. Common to most of these movements after Impressionism was the absolutizing of the artist's state of mind or sensibility as prior to and above objects. If the Impressionists reduced things to the artist's sensations, their successors reduced them further to projections or constructions of their feelings and moods, or to "essences" grasped in a tense intuition.[18]

It was not until the early 1890s, by which time the artists were middle-aged, that their intentions were better understood and Impressionism was accepted. Then the critics wrote favorably and the public bought their paintings at good prices. Finally they could count on a steady income from the sale of their works. Yet by then

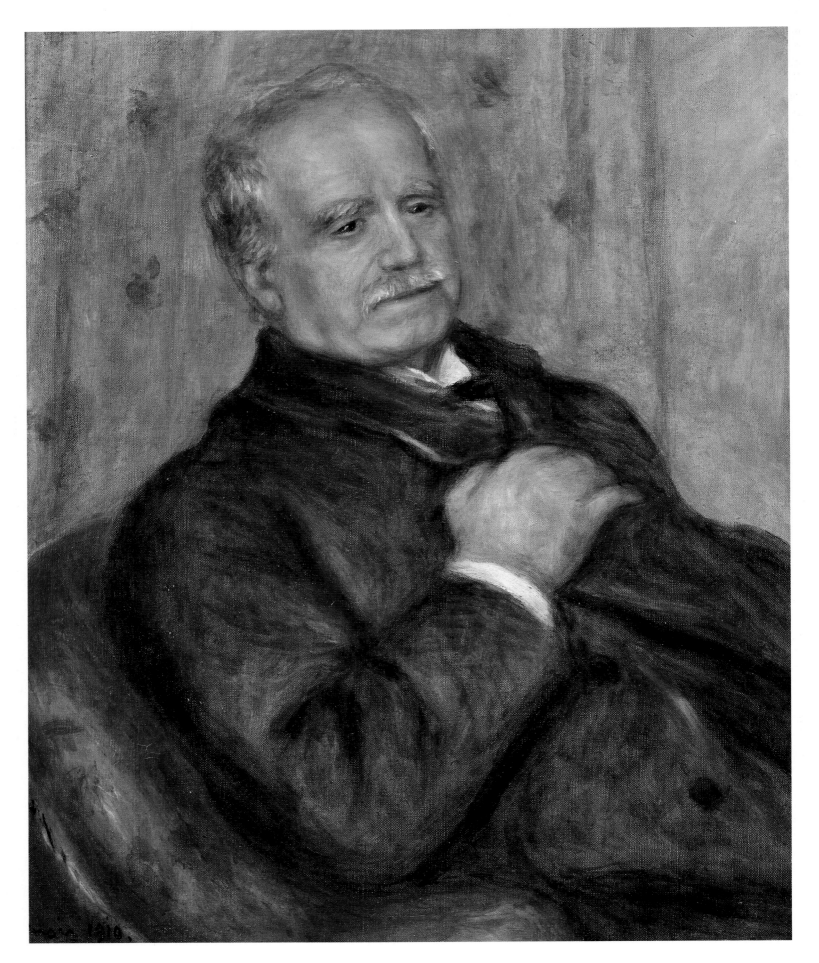

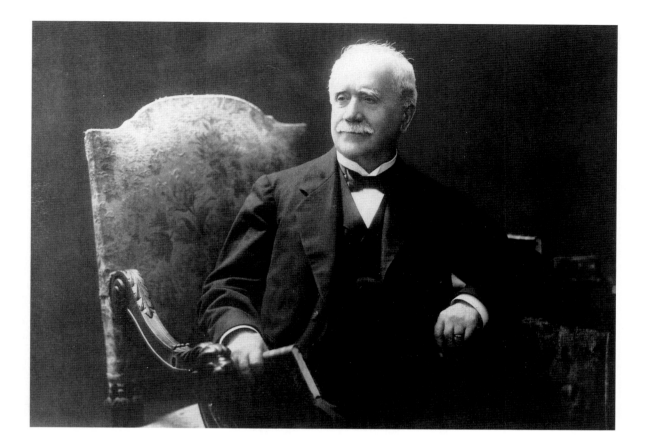

their styles had changed. Some aspects of Impressionism, however, remained in their paintings: a feeling of freedom and randomness, a rainbow palette that is light and bright, and strokes that are mobile and visible.

THE DYNAMIC stories that follow reveal the Impressionists in a new way—in relation to one another. Their partnerships are explored through quotations from diaries, letters, and interviews. In each chapter the focus is on the character of the friendship, the individuals' influence on each other, and the artistic works that resulted from their relationship.

In those pretelephone times, people wrote regularly to each other. The Impressionists' letters and diaries are intimate documents: they reveal who each artist was, what he or she thought about his or her own work, and what they thought about each other: "more vain than intelligent" (Degas on Manet); "had an intellectual charm, a warmth, something indefinable" (Morisot on Manet); "bad-tempered" and "dreadful!" (Cassatt on Degas); and "humble and colossal" (Cézanne on Pissarro). And they provide comments on each other's work: "I will not admit a woman can draw like that!" (Degas about Cassatt); "immense talent" (Morisot about Renoir); "far stronger [than Ingres]" (Morisot about Manet); "[a] playing card without feeling" (Degas about Manet); and "irreproachable perfection" (Pissarro about Cézanne).

The artists' personalities are clearly revealed by what they say and how they say it; Degas, sarcastic and belittling; Manet, supercilious and urbane; Monet, aggressive and blunt; Renoir, flattering and gentle; Cézanne, guarded and moody; Pissarro, magnanimous and paternal; Morisot, self-doubting and charming; and Cassatt, independent and assertive.

From the letters and diaries, a new, more intimate, and more personal story of the Impressionists emerges that captures the unique flavor of each individual, of their collective experience, and of their collaborative relationships.

Nadar, photograph of Manet around the age of thirty-one, c. 1863. Collection Sirot-Angel, Paris.

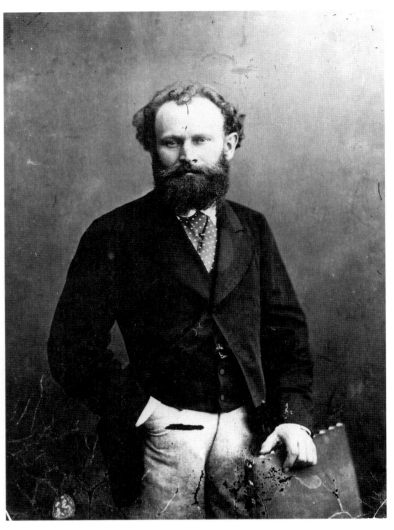

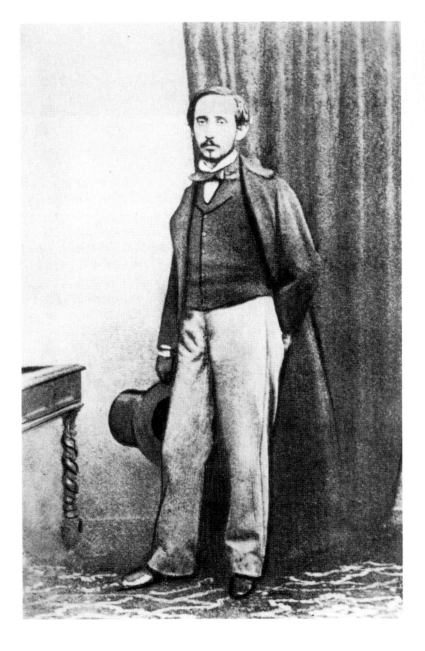

Photograph of Edgar Degas around the age of twenty-six to thirty-one, c. 1860–1865. Photograph printed from a glass negative in the Bibliothèque Nationale, Paris.

Degas & Manet

Degas and Manet were rivals with a stormy relationship. They disliked each other yet were fascinated with each other's art. Theirs was an uneasy friendship. Each irritated the other. But the turbulence between them was based on real professional esteem and a desire to learn from each other's work. They were equally talented, innovative, and productive, and their competition pushed them to greater heights of creativity. They vied as to who better portrayed contemporary life in a modern style and inspired each other in their painting. The similarity of many of their themes motivated them to differentiate their styles.

Their relationship began in 1861 and continued intermittently until Manet's death, twenty-two years later. After one breach Morisot's mother wrote in a letter to her daughter: "The Manets and M. Degas were playing host to one another. It seemed to me that they had patched things up."[1] From 1861 through 1872, when they were closest, Degas made three etchings, one painting, and numerous drawn studies of Manet; Manet included Degas's back in a painting; and they often painted the same motif.

When they first met, Manet was twenty-nine years old and Degas twenty-seven. Both had attended art school in Paris, studied art abroad, and copied extensively in the museums. They were both upper-class, well-educated, well-traveled Parisians, and their art reflected their elevated social status. Manet was a social charmer, with a charisma that attracted many of the leading artists and writers of his time. As Zola described him: "Dressed with great care, of medium size, small rather than large, with light hair and a somewhat pink complexion, a quick intelligent eye, a mobile mouth which was at moments a little mocking; the whole face irregular and expressive, with I don't know what expression of sensitivity and energy. For the rest, in his gestures and tone of voice, a man of the greatest modesty and kindness."[2]

The intellectual Degas was a temperamental man who intimidated people with barbed witticisms. He loved being alone. He felt "that if one wants to be a serious artist and create an original little niche for oneself, or at least ensure that one preserves the highest degree of innocence of character, one must constantly immerse oneself in solitude."[3] To one observer he seemed "an original fellow, sickly, neurotic, and afflicted with eye trouble to the point of being afraid of going blind, but for those very reasons he is an excessively sensitive person who reacts strongly to the true character of things."[4]

The two artists' attitudes toward each other and toward colleagues are illustrated by cutting remarks they made. Degas once called Manet "more vain than intelligent."[5] Morisot, in a letter, described to her sister an incident in which, at a soiree, Degas "came and sat beside me, pretending that he was going to court me, but his courting was confined to a long commentary on Solomon's proverb, 'Woman is the desolation of the righteous.' "[6] And in a subsequent letter she reported that Manet had said, "I certainly do not find [Degas's] personality attractive; he has wit, but nothing more. . . . He lacks spontaneity, he isn't capable of loving a woman, much less of telling her that he does or of doing anything about it."[7]

In spite of Degas's disposition, Manet suggested in 1868 that they travel together to London:[8] "I think we should explore the terrain over there since it could provide an outlet for our products. . . . [and] we would be able to see the picture exhibition [at the Royal Academy] which is still open."[9] We do not know why Degas refused the invitation. Manet went to London anyway. A month later, from Boulogne, he wrote sarcastically to Henri Fantin-Latour, a member of a café group that included Manet and Degas:

> It is quite obvious, my dear Fantin, that you Parisians have all the distractions you need, but I have no one here to chat with and envy your being able to discuss with the great aesthetician Degas the inadvisability of making art attainable to the poor classes and allowing pictures to be sold for two pence. . . . Tell Degas to write to me. According to what [Louis Edmond] Duranty tells me, he is becoming the painter of "high life." That's his business and I'm all the more sorry for his sake that he didn't come to London. The sight of well-groomed horses in movement would certainly have inspired him to paint several pictures.[10]

No letters from Degas to Manet exist, yet Degas occasionally mentioned him in his correspondence. On a trip to New Orleans in 1872, he wrote: "Manet would see lovely things here, even more than I do."[11]

When they met in 1861, Degas was not yet an established artist,

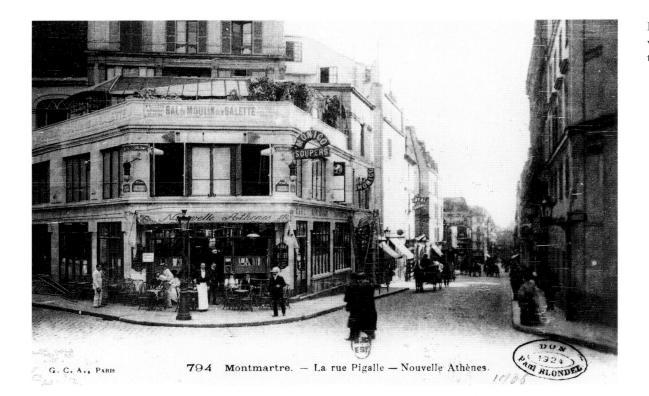

G. C. A., PARIS 794 Montmartre. — La rue Pigalle — Nouvelle Athènes.

but Manet had that year attained great success at the Salon and had befriended the influential critics Charles Baudelaire and Edmond Duranty. It was not long thereafter that Manet invited Degas to join him in the cafés, where he was to be found "every day from 5:30 to 7 P.M."[12] Manet, a leader of the avant-garde art world, held court in the cafés and presided over the discussion of new trends in art and literature as well as strategies of showing work to the critics and public. In the early 1860s, his favorite place was the Café de Bade, in the north center of Paris, near the Opéra at 32, Boulevard des Italiens; from around 1866 through 1873, he and his friends moved farther north to the Café Guerbois, 11, Grand Rue des Batignolles (now 9, Avenue de Clichy); later they moved nearby to the Café de la Nouvelle-Athènes on Rue Blanche near Place Pigalle.

Gathered around Manet at various times were the artists Félix Bracquemond, Cézanne, Degas, Giuseppe De Nittis, Marcellin Desboutin, Henri Fantin-Latour, Armand Guillaumin, Antoine Guillemet, Monet, Pissarro, Renoir, Alfred Sisley, James Abbott McNeill Whistler, and the photographer Nadar [Gaspard Tournachon]; the musicians Jean Cabaner and Edmond Maître, and sympathetic writers and critics such as Paul Alexis, Zacharie Astruc, Théodore de Banville, Philippe Burty, Duranty, Théodore Duret, Stéphane Mallarmé, Catulles Mendès, George Moore, Antonin Proust, Rivière, Armand Silvestre, and Émile Zola. At the café, Moore reported, "[Manet] sits next to Degas."[13] He also noted how their personalities differed: "Manet loud, declamatory, and eager for medals and decorations; Degas sharp, deep, more profound, scornfully sarcastic."[14]

Degas and Manet also socialized at the homes of each other's parents, and later they regularly spent evenings at the homes of the parents of Morisot and of other members of the *haute-bourgeoisie*. These may not always have been festive gatherings, as a letter from Morisot's mother indicates:

> I found the Manet salon in just the same state as before [the Franco-Prussian War]; it is nauseating. If people were not interested in hearing individual accounts of public misfortunes, I think little would have been said. The heat was stifling, everybody was cooped up in the one drawing room, the drinks were warm. But [the Spanish guitarist and tenor Lorenzo] Pagans sang, Madame Édouard [Manet] played [the piano], and Monsieur Degas was there. This is not to say that he flitted about; he looked very sleepy.[15]

On another occasion she reported that Degas and Manet, who had joined the National Guard in the Franco-Prussian War, "almost came to blows arguing over the methods of defense and the use of the National Guard, although each of them was ready to die to save the country."[16] In two letters Manet mentioned being in contact with Degas during military service. To his wife: "Yesterday we were with Degas and Eugène [Manet] at a public meeting at the Folies-Bergère, where we heard [the Minister of War] General Cluseret speak."[17] And to his pupil Eva Gonzalès, "Degas and I are in the artillery, as volunteer gunners."[18]

Besides being connected through the cafés, soirees, and military service, Degas and Manet were also linked through early exhibitions. They first exhibited together in 1865 at the Paris Salon, where Degas displayed his last historical painting and Manet his last religious subject; thereafter they both abandoned such traditional themes for contemporary ones. They continued to exhibit together at the Paris Salons through 1870. Around 1872 Durand-Ruel became both artists' dealer. When the Impressionist group exhibitions began in 1874, Manet chose not to join, although after

1869 his style had become more Impressionist. He continued to display his paintings at the Salons, where he hoped to gain fame and fortune. Degas wrote to a fellow artist: "It looks like Manet is stubbornly keeping aloof, he may well regret it."[19] Degas stopped exhibiting at the Salon and chose to exhibit with the Impressionists, although he did not approve of their spontaneous, light-splattered techniques and continued his Realist Impressionism. He disdained Manet's wish to be successful via the Salon and his yearning for the Legion of Honor. (When Manet finally received it, at age fifty, his brother wrote: "He is delighted about his decoration.")[20]

As commentators on each other's work, Manet was the more generous and Degas the more snide. In 1879 Manet proclaimed: "The fact is, Degas should have decorated the foyer of the Opera. Post-*Semiramis* [a painting of c. 1860–1862] Degas, that is. He would have created a series of absolute masterpieces."[21] In 1871 Degas begrudgingly praised an unidentified work: "I have seen something new of Manet's, of medium size, well finished, done lovingly, in a word, a change. What talent the fellow has!"[22] However, in 1882 he responded negatively when he saw Manet's *Bar at the Folies Bergère:* "Sunday great varnishing day [previewing the Salon of 1882].... Manet [is] stupid and shrewd, [producing a] playing card without feeling, [a] Spanish trompe-l'oeil painter!"[23]

The most important result of their artistic exchange was that it made themes of modern life an acceptable subject for painting. Monet, Renoir, and subsequent Impressionists benefited from this new world of images. In 1846, in *The Heroism of Modern Life,* Baudelaire had written: "The spectacle of elegant life and the thousands of ephemeral existences floating through the labyrinths of a big city ... show that we have but to open our eyes to see our heroism.... Paris life is rich in poetic and marvelous subjects, the marvelous envelops us and nurtures us like the atmosphere, but we don't see it."[24]

Thirteen years later he wrote: "For the born *flâneur,* for the passionate observer, it is an endless source of pleasure to enroll in the multitude, in the ebb and flow, the moving, the transient and boundless.... to see the world, be in the center of the world, and yet remain hidden from the world.... he who loves life makes the world his family ... the lover of universal life enters into the crowd as into a vast reservoir of electricity."[25] Both artists were familiar with Baudelaire's writings. Indeed, on one occasion Degas borrowed two volumes of Baudelaire from Manet.[26] Manet had exclaimed, "One must be of one's time, draw what one sees."[27] Degas wrote in his notebooks: "Make *expressive* heads ... as a study of modern feeling.... If laughter typifies an individual, make her laugh.... How many delicate nuances to put in!"[28]

Degas and Manet often painted the same motif, in apparent competition as to who would initiate the theme and who would best capture "modernity." In some instances the dates of both works are uncertain, so who initiated the theme is unclear. Yet we know that Degas was already painting horse races in 1861, three years before Manet; he painted café scenes in 1876, three years before Manet; he painted pictures within pictures in the *Collector of Prints* (1866) and in his *Portrait of James Tissot* (1867–68), before Manet's portrait of Zola (1868); he was also the first to paint Ellen

Andrée, four years before Manet. On the other hand, Manet was the first to paint casual portraits of friends in their familiar surroundings in *Concert in the Tuileries Gardens* (1862; see p. 39) and in *Portrait of Astruc* (1866), which preceded Degas's portrait of Tissot; *Manet Listening to His Wife Playing the Piano* (c. 1868; see p. 35); and *Orchestra of the Opera* (c. 1870).

From 1862 onward both artists painted instantaneous views of people at leisure and play in new styles. They revered and copied traditional art, but they were innovative. They also looked at Japanese prints and at photography, and both did etchings. As Realist Impressionists, both painted relatively clear forms in the 1860s. Degas continued thus, but, beginning in the 1870s, Manet's forms became more Impressionist as he followed the younger artists—Monet, Morisot, Pissarro, and Renoir—in their search to render the dissolving effects of atmosphere and light.

While their themes were often similar, their styles were quite different. Manet's figures are usually more static, whereas Degas often depicted motion. Degas sought unusual perspectives, looking down from above, up from under, or in from the side. Manet's viewpoint is more traditional, as if we are an audience looking at an imaginary stage. The two artists had very different working methods; Manet's reflects his sociability and Degas's his love of solitude. As the painter Jacques-Émile Blanche explained:

> Manet liked to be looked at as he bent over his easel.... He would have painted quite readily in the Place de la Concorde, with a crowd around him, just as among his friends in his studio, although at times he was impatient and scraped or rubbed out his work. But he would quickly get over that, and smile at the girl posing for him or joke lightly with a newspaper writer. Degas, on the contrary, double-bolted his door, hid his work, unfinished or in course of execution, in closets, intending to take it up again later, in order to change the harmony or to accentuate the form. His work was always in a state of becoming. Worry gripped him, for he was at one and the same time proud and modest.[29]

Both men were guided by the art of the museums, but both painted modern life. Their procedures were as different as their results. They often argued about whether it was preferable to paint before the model or from memory aided by drawings. Degas insisted that an artist should "never draw or paint *immediately,*"[30] and he always made notes and composed in the studio away from the motif. Degas's approach was described in a letter that Pissarro wrote to his son Lucien: "Reproduce, in your own place, from memory, the drawing you make in class.... The observations you make from memory will have far greater and more original power than those made directly from nature. The drawing will have art—it will be your own—this is a good way of escaping slavish imitation."[31] Degas affirmed: "No art is less spontaneous than my own."[32] For him, according to an entry in Morisot's diary, "the study of nature is meaningless, painting being an art of conventions." He stressed the importance of art of the past and affirmed "that it was by far the best thing to learn drawing from Holbein."[33]

It is no surprise, then, that Manet, who claimed, "I can do noth-

Manet, *A Café Interior* (Café Guerbois?), d. 1869.
Pen and India ink on pale tan paper, 11⅝ × 15½″ (29.5 × 39.5 cm).
Fogg Art Museum, Harvard University, Cambridge, Mass.;
Bequest of Meta and Paul J. Sachs.

ing without Nature [before my eyes],"[34] never painted side by side with Degas. Manet asserted, "I do not know how to invent. . . . If I am worth something today, it is due to exact interpretation and faithful analysis."[35] Yet while Degas brought the memory of both the museums and nature to the studio, Manet insisted on bringing his memory of great art to nature so that he could interpret and analyze, not copy. To a young painter he advised: "Cultivate your memory; for nature will never give you more than information—[memory] is a lifeline that saves you from falling into banality. At all times, you must be the master, and do what pleases you."[36]

Degas dismissed the distinction Manet made between their methods as pretense; as Morisot recorded, Degas thought "that Édouard himself, though he made a boast of slavishly copying nature, was in fact the most mannered painter in the world, never

making a brushstroke without first thinking of the masters—for example, he never showed the fingernails, because Frans Hals left them out."[37]

The results are paradoxical. Manet worked with the image in view, yet his paintings are more abstract. Degas worked in his studio from notes, yet his paintings are more realistic. Contemporary critics noted this difference. Of Manet's approach, Zola affirmed: "A picture for you is simply an excuse for an exercise in analysis. . . . You have succeeded admirably in doing a painter's work, a great painter's work: you have forcefully rendered in your own particular idiom the truths of light and shade, and the realities of objects and persons."[38] Of Degas, Edmond de Goncourt noted: "He has fallen in love with modern subjects. . . . Of all the men I have seen engaged in depicting modern life, he is the one who has most successfully rendered the inner nature of that life."[39]

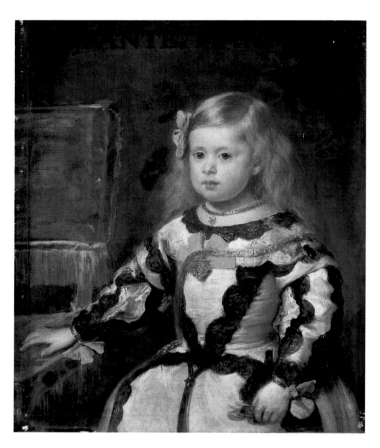

Diego Velázquez (Workshop), *The Infanta Maria Marguerita*, 1654. Oil on canvas, 27½ × 22¾″ (69.9 × 57.8 cm). Musée du Louvre, Paris.

Degas, *The Infanta Marguerita after Velázquez at the Louvre*, c. 1861. Etching and drypoint, first of two states, 5¼ × 4¼″ (13.3 × 10.8 cm). Bibliothèque Nationale, Paris.

Degas and Manet would become prolific etchers, Degas beginning in 1856 and Manet in 1859. Some of their early etchings were copies of past art.⁴⁰ Around 1861 they both made copies of *The Infanta Maria Marguerita*, a painting then attributed to Diego Velázquez and now believed to be by his workshop. Degas was at the Louvre, copying the Velázquez directly onto a copper plate in preparation for making a print, when Manet, who had previously made an etching after a reproduction of the same painting, stopped to introduce himself. The occasion of their first meeting gives an ironic twist to the future debate between Manet, who said he worked from the model, and Degas, who insisted on working from memory. In this instance, Degas evidently wanted his copy to be as close to the original as possible. He may have initially worked from a photograph of the painting in his studio, where he could have lightly etched the entire composition and added dark accents in drypoint. Then he may have returned to the Louvre to complete the extensive drypoint additions to imitate the tonalities of the painting.⁴¹

Manet, *The Infanta Marguerita after Velázquez at the Louvre*, c. 1861.
Etching, first of one state, 12½ × 6¼″ (31.9 × 15.9 cm). Bibliothèque
Nationale, Paris.

Degas's copy is much closer to the original than is Manet's bold, flat, simplified version—which is more than three times as large as Degas's. The latter was etched in the same direction as the painting and consequently appears in reverse; Manet, however, reversed his copy so that the etching would appear in the same direction as the painting. Both artists used a pen-and-ink type of etched line, although Degas's lines are smoother and more consistent throughout, and Manet's are rougher and create more contrasting areas.

In 1865 Manet took a trip to Spain, specifically to "go to *Maître* Velázquez for advice."[42] "The painter of painters," he later wrote, "... didn't surprise me, but he enchanted me."[43] At some point Degas acquired a copy of Manet's etching, which remained in his studio along with sixty-eight other Manet etchings, lithographs, and wood engravings.

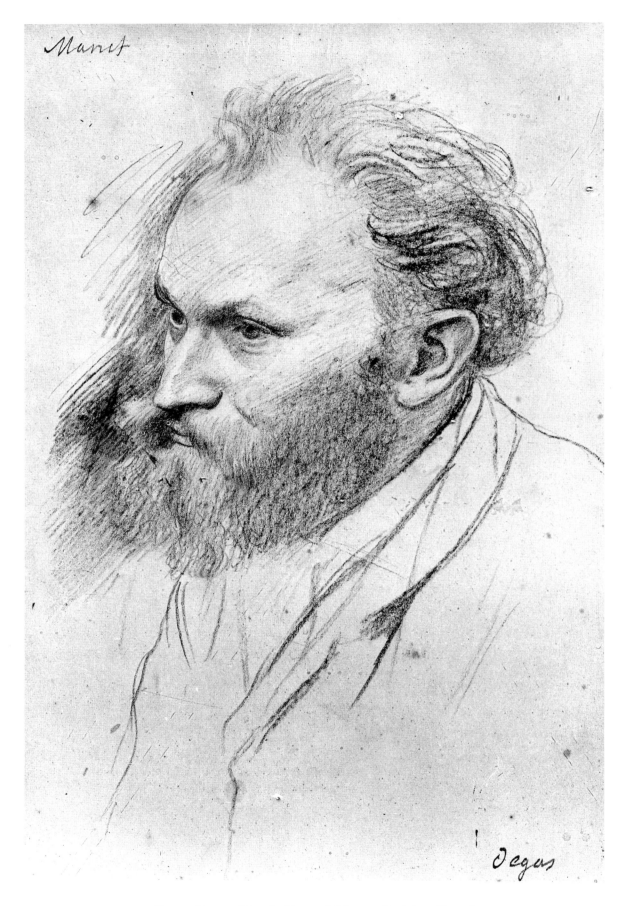

Degas, *Manet*, 1864–65. Pen and lithographic ink, 13⅞ × 9″
(35.2 × 22.9 cm). Private collection.

In 1862 Manet had made casual portraits of his artist friends in *Concert in the Tuileries Gardens* (see p. 39). These may have inspired Degas to make a number of portraits of his own friends at leisure.[44] Between around 1864 and around 1868, he made numerous drawings of Manet that resulted in three etchings and one painting. During the same period he also used other artists as models in scenes from daily life. He made more images of Manet and of Cassatt than he did of his other artist friends.[45]

Degas's images of Manet correspond to Zola's description: "The hair and beard are light chestnut brown; the eyes, narrow and deep set, have a boyish liveliness and fire; the mouth very characteristic, thin, mobile, a trifle mocking at the corners."[46] It was probably a combination of sketches from life, photographs (especially the Carjat photograph of 1863), and Degas's memory that was the basis for these portraits. The etched bust portrait may have been made to illustrate a book or magazine.[47] However, no known publication at that time included it.

LEFT: Étienne Carjat, photograph of Manet at age thirty-one, 1863. Private collection.

RIGHT: Degas, *Manet, Bust Portrait*, 1864–65. Etching, drypoint, and aquatint, in red-brown on wove paper, last of four states, 9⅞ × 6⅝″ (25 × 17 cm). National Gallery of Art, Washington; Rosenwald Collection.

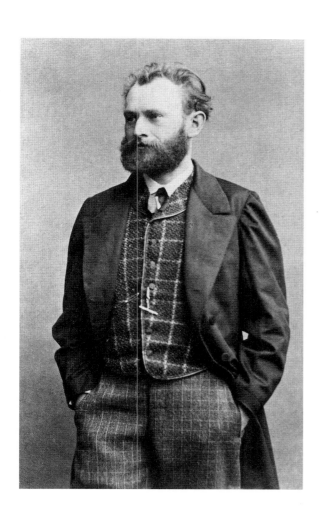

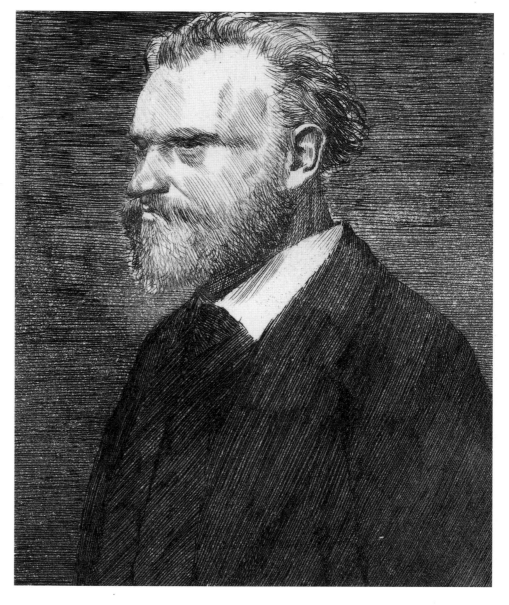

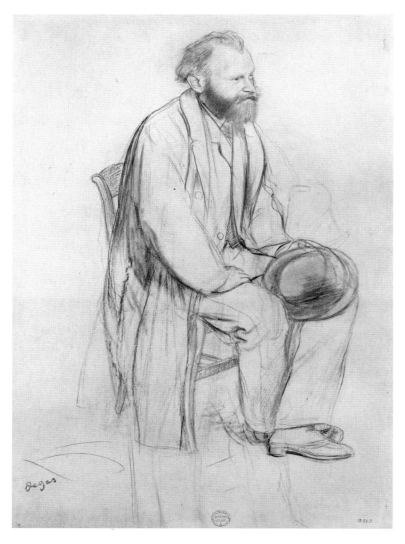

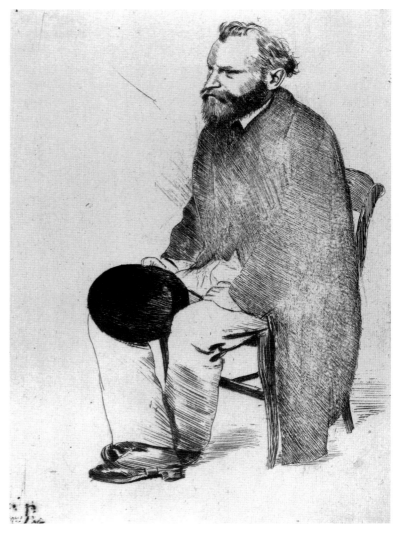

Degas, *Manet Seated*, 1864–65. Black chalk and estompe on off-white wove paper, 13 × 9⅛″ (33 × 23.2 cm). The Metropolitan Museum of Art, New York; Rogers Fund, 1918.

Degas, *Manet Seated, Left Profile*, 1864–65. Etching, second state, 7 × 5″ (17.8 × 12.7 cm). Boston Public Library.

THE TWO full-length etchings and related drawings of Manet reflect Degas's homage to the artist whose paintings of contemporary life were of fundamental importance to his own choice of imagery. At this point Manet was famous and Degas, obscure. The sitter's unconventional and casual postures—with his hand on his thigh and his hat in his hand or hands clasped between his legs, seated forward or sideways on a small chair— reflect his informality and stylishness. Degas wrote in his notebook: "Make portraits of people in familiar and typical positions, above all, give their faces the same choice of expression one gives their bodies."[48] And "There is sometimes a certain ease in awkwardness which, if I am not mistaken, is more pleasing than gracefulness itself."[49]

That Degas captured Manet's essence is evident if we compare these portraits to the verbal picture by the writer Armand Sil-

vestre, who considered Manet a "chef d'école" when he met him at the Café Guerbois:

This revolutionary—the word is not too strong—had the manners of a perfect gentleman. With his often gaudy trousers, his short jackets, his flat-brimmed hat set on the back of his head, always wearing immaculate suede gloves, Manet did not look like a bohemian, and in fact had nothing of the bohemian in him. He was a kind of dandy. Blond, with a sparse, narrow beard, which was forked at the end, he had in the extraordinary vivacity of his eyes—small, pale gray, and very star-studded eyes—in the mocking expression on his lips—his mouth was narrow lipped, his teeth irregular and uneven—a very strong dose of Parisian playfulness. Although very generous, and very good-hearted, he was delib-

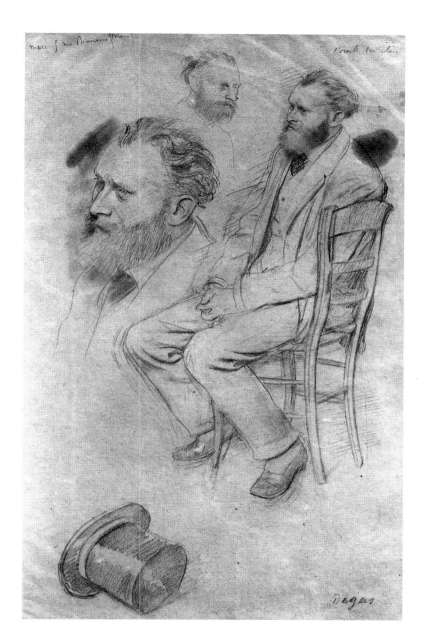

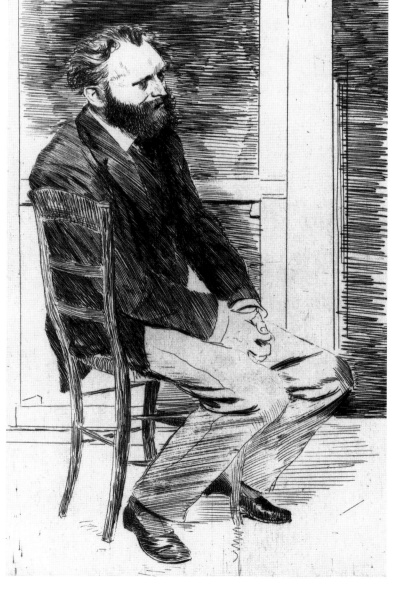

erately ironic in conversation, and often cruel. His words were sharp, cutting, and shredding all at once. Yet what happiness in his expression, what correctness in his idea.[50]

Preparatory drawings for these prints are again in reverse of and larger than the comparable etchings. Evidently the drawings were not intended for transfer onto the copper plate but were notes made from life, in which Degas captured the sitter's costume and pose. Degas particularly esteemed the drawing that shows three views of Manet; it remained in his collection until 1900, when he gave it to Morisot's daughter, Julie Manet, as a wedding gift. This drawing gives a rare glimpse of Degas's working method. He extracted various parts of the drawing and made a synthesis of them. It seems that the overcoat etching preceded the jacket etching: Degas made many more states and impressions of the latter, so evidently he was satisfied with it.[51]

THE LAST PORTRAIT that Degas made of Manet was the cause of a dramatic upheaval between them. Compared with the seated etchings, it shows an even more relaxed Manet. A possibly related wash study shows him with his hand in his pocket, leaning almost vertical and looking alert. In the finished oil he is shown almost horizontal with a fist against his cheek, his elbow resting on his knee, his boot almost on the sofa, and his other hand deep in his pocket. He looks deep in reverie, transported by the music that his wife is playing.

Mme. Manet, née Suzanne Leenhoff, was a distinguished classical pianist who in 1849 came to Paris when she was nineteen and gave piano lessons to Manet, then seventeen, and his younger brothers. Three years later Leenhoff had a son, Léon Édouard Koëlla Leenhoff, whom she claimed was her younger brother. When Léon was baptized at the age of five, Leenhoff registered herself as his godmother and Manet as his godfather. If there ever was a person named Koëlla, his identity has not been established. After Suzanne's death Léon identified her as his mother. Although Manet never recognized Léon as his son, in his will he left everything to his wife and added, "She will leave everything that I have given her to Léon Koëlla, also known as Leenhoff, who has given me the most devoted care, and I believe that my brothers will find these dispositions appropriate."[52] Léon may have been the son of the painter or, as rumor has it, of Manet's father. With the possible exception of Léon, Suzanne and Édouard Manet never had a child together. They lived with one another for several years before they married in 1863, a year after the death of Manet's father. At this time Manet told Baudelaire that Suzanne was "beautiful, very good, and a very great musician."[53]

The conflict between Degas and Manet arose over Degas's rendering of Suzanne, which Manet felt was unattractive. Incensed, he cut off the right third of the canvas, through Suzanne's temple. When Degas visited the Manets and saw his slashed canvas, he grabbed it and took it back to his studio. He added a piece of canvas to the right, saying that he intended to repaint Suzanne, but he never did. In his anger he returned one of Manet's paintings.[54]

Following this incident Manet painted a portrait of his wife that follows the Degas portrait in pose and setting. It too is set in the salon of Manet's mother's Paris apartment, where Édouard and Suzanne had been living for two years. Both canvases display the white walls with parallel lines of gold wainscoting, the white sofa, the round-backed piano chair, and the piano parallel to the wall.

Manet's practice of tampering with other people's canvases was not limited to this exchange with Degas. Two years later he painted on the canvases of both Morisot and Bazille (neither of whom expressed their outrage to him).[55] Degas never made another portrait of Manet. The defaced canvas with its blank addition hung in Degas's drawing room until his death.[56] It was a picture of his uneasy relationship with Manet.

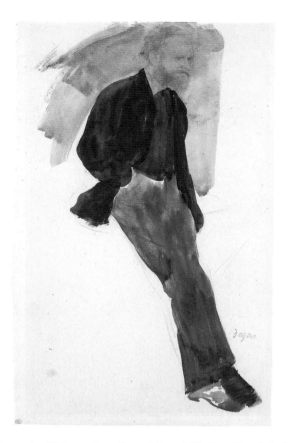

Degas, *Portrait of Manet Standing*, 1864–1868. Pencil and India ink wash, 13⅞ × 9″ (35.2 × 22.9 cm). Musée du Louvre, Département des Arts Graphiques, fonds du Musée d'Orsay, Paris.

Manet, *Mme. Manet at the Piano*, c. 1868. Oil on canvas, 15 × 18¼″ (38.1 × 46.4 cm). Musée d'Orsay, Paris.

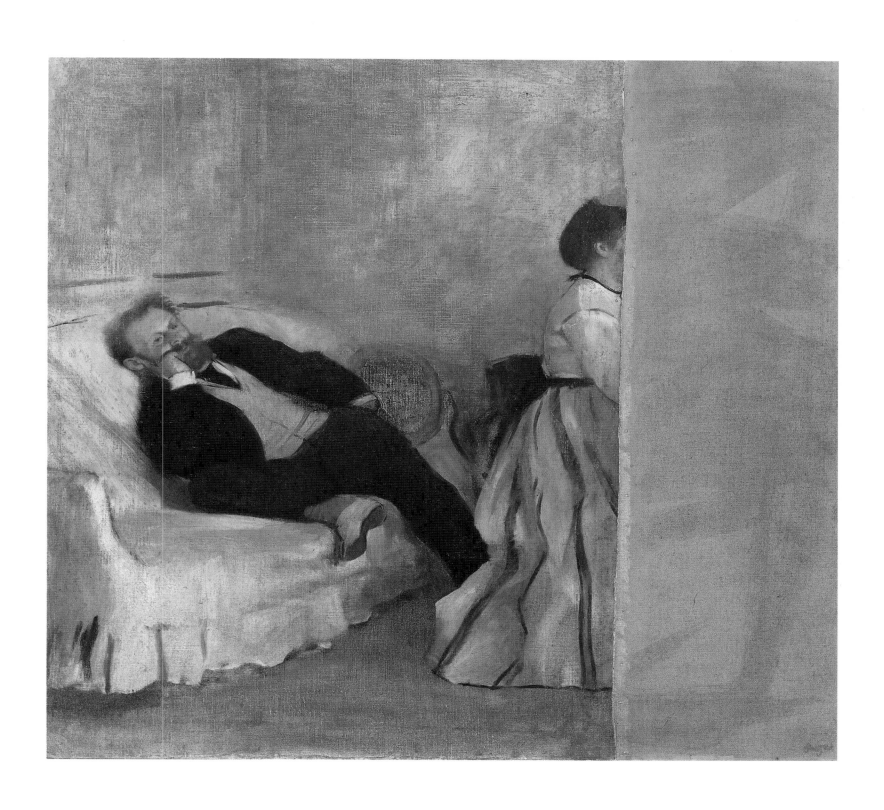

Degas, *Manet Listening to His Wife Playing the Piano*, c. 1868.
Oil on canvas, 25⅝ × 28″ (65.1 × 71.1 cm). Municipal Museum of Art,
Kitakyushu, Japan.

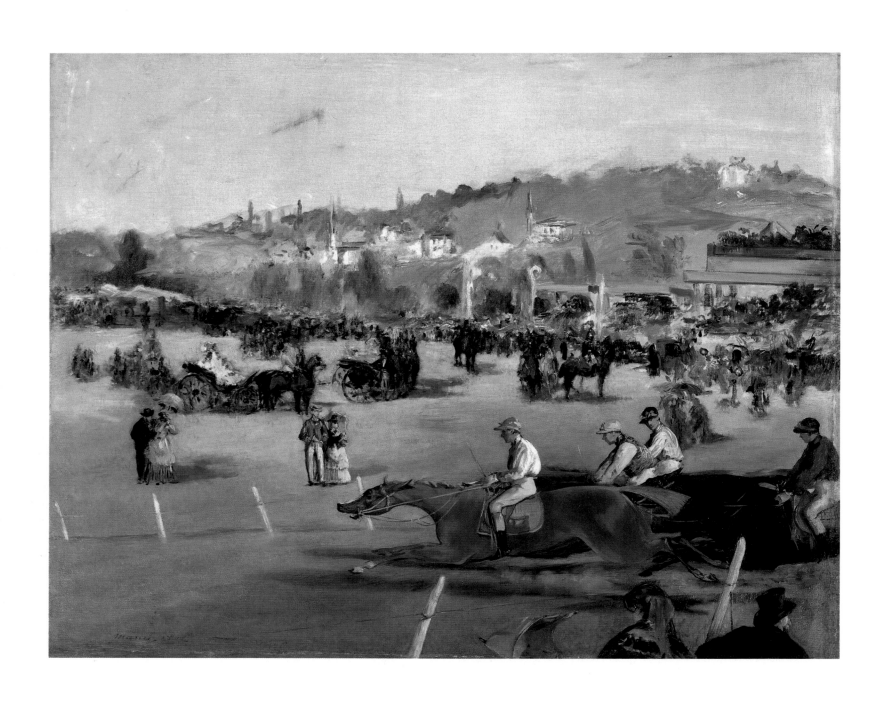

Manet, *Races in the Bois de Boulogne*, d. 1872. Oil on canvas,
28¾ × 36¼″ (73 × 92.1 cm). Collection Mrs. John Hay Whitney,
New York.

Degas, *Portrait of Manet at the Races,*
c. 1866–1868. Graphite pencil on buff
paper, 12⅝ × 9⅝″ (32.1 × 24.4 cm). The
Metropolitan Museum of Art, New York;
Rogers Fund, 1918.

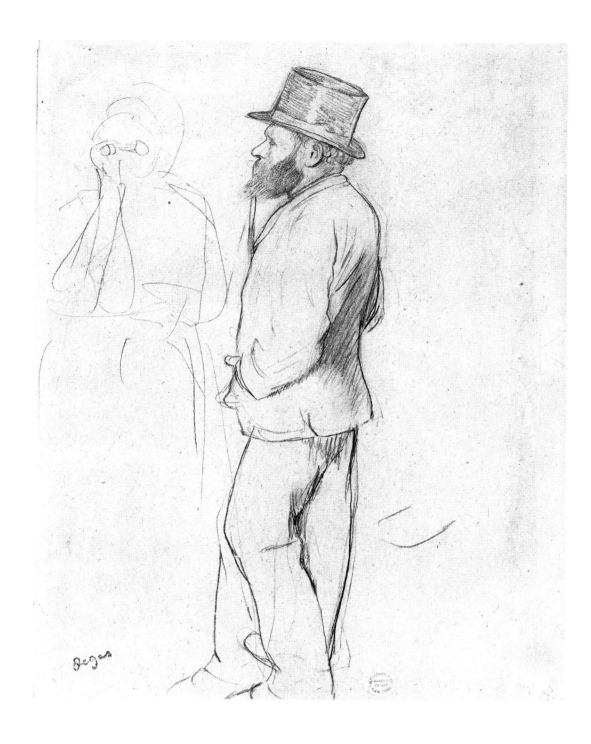

WHILE DEGAS made three etchings, a painting, and draw-
ings of Manet, Manet only once portrayed Degas: the back
of Degas's head and shoulders appear in the lower right corner of
Races in the Bois de Boulogne (1872). It is not known why Manet
did not make a more significant portrait of Degas;[57] however,
Manet demanded of his subjects as many as twenty-five sittings,
to which Degas would have objected.[58] Because Degas worked
from memory and drawings, Manet would not have felt imposed
upon when he was the subject.

Degas and Manet went together to the Longchamps racetrack
at the Bois de Boulogne on at least one occasion. Degas drew a
jaunty Manet accompanied by a faint image of a woman who
peers out at us through binoculars.[59] Manet holds a cane and ap-
pears quite the dandy.

A few years later Manet did his *Races in the Bois de Boulogne,*
which could be his acknowledgment that it was Degas who first
painted horse races in 1861 and 1862, and inspired him to do seven
images of racing from 1864 through 1872.[60] Manet here continued
a tradition of horses in a flying gallop seen in popular English
racing prints and in Théodore Géricault's *Races at Epsom* in the
Louvre.

BOTH MANET AND DEGAS did portraits of Mme. Loubens, a woman in their social set, whose husband was the head of a Parisian boarding school. Mme. Loubens first posed for Manet in 1862, when he painted a group of his friends listening to music in the Tuileries Gardens. She is the woman at the left who wears a veil and holds a fan. In this painting, Manet initiates what would become a popular modern Impressionist theme: his friends enjoying one another's company outdoors in Paris and its suburbs.

Manet included his own portrait at the extreme left. Among the many well-known people depicted are: at the left, Astruc is seen full face, seated in a chair; to the left of a large tree trunk and appearing full face is Fantin-Latour; in front of this same tree trunk is the profile of Baudelaire; to the right of center, with his hands behind his back, is his brother Eugène, who converses with a seated woman.

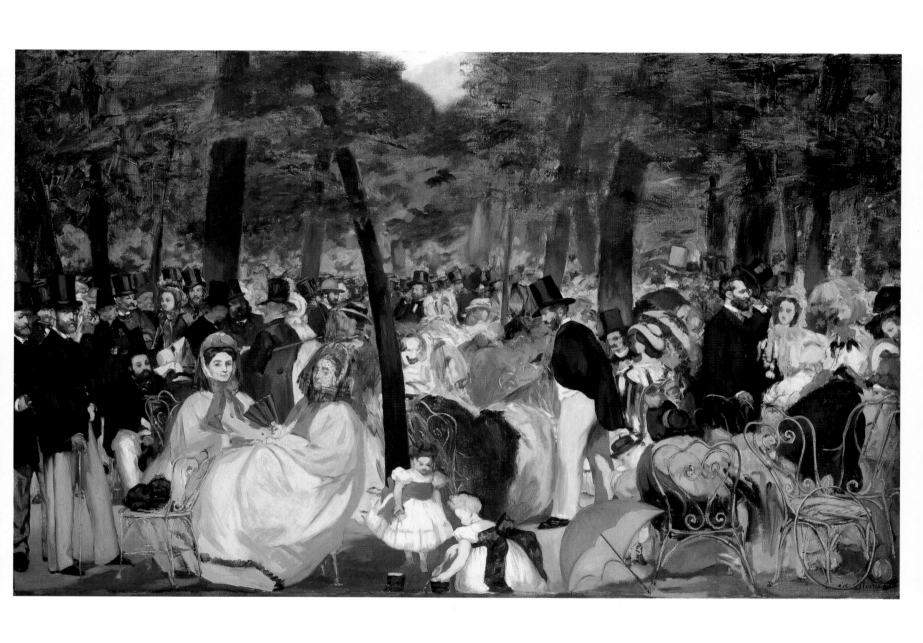

Manet, *Concert in the Tuileries Gardens*, d. 1862. Oil on canvas, 30 ×
46¾″ (76.2 × 118.8 cm). Trustees of the National Gallery, London.

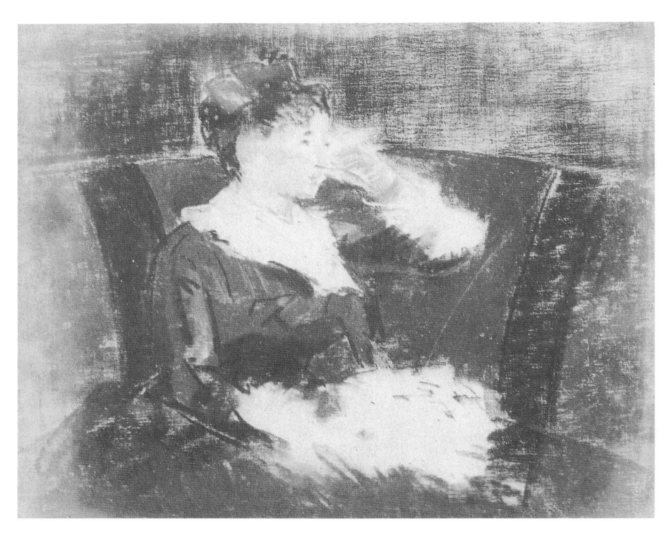

Manet, *Madame Loubens Seated on a Sofa*, 1880. Pastel, 18¼ × 21⅞″ (46.4 × 55.6 cm). Collection unknown. Reproduction in "Album des Photographes, vol. II, page 81," 1883. The Pierpont Morgan Library, New York; Tabárant Collection. MA 3950.

ALMOST two decades later, Manet did two pastels of Mme. Loubens, which remained in his possession.[61] These pastels, done from the model, were completed works rather than studies for an oil painting.

Several years after Manet painted *Concert in the Tuileries Gardens*, Degas painted a double portrait of Mme. Loubens and Mme. Lisle, women to whom he was at least superficially attracted in 1869. We learn this from a series of letters written by the Morisots. Berthe wrote to her sister Edma after meeting Degas at the 1869 Salon: "M. Degas seemed happy, but guess for whom he forsook me—for Mademoiselle Lille [*sic*, Lisle] and Madame Loubens. I must admit that I was a little annoyed when a man whom I consider to be very intelligent deserted me to pay compliments to two silly women."[62] Edma replied, "I pity M. Degas with his latest

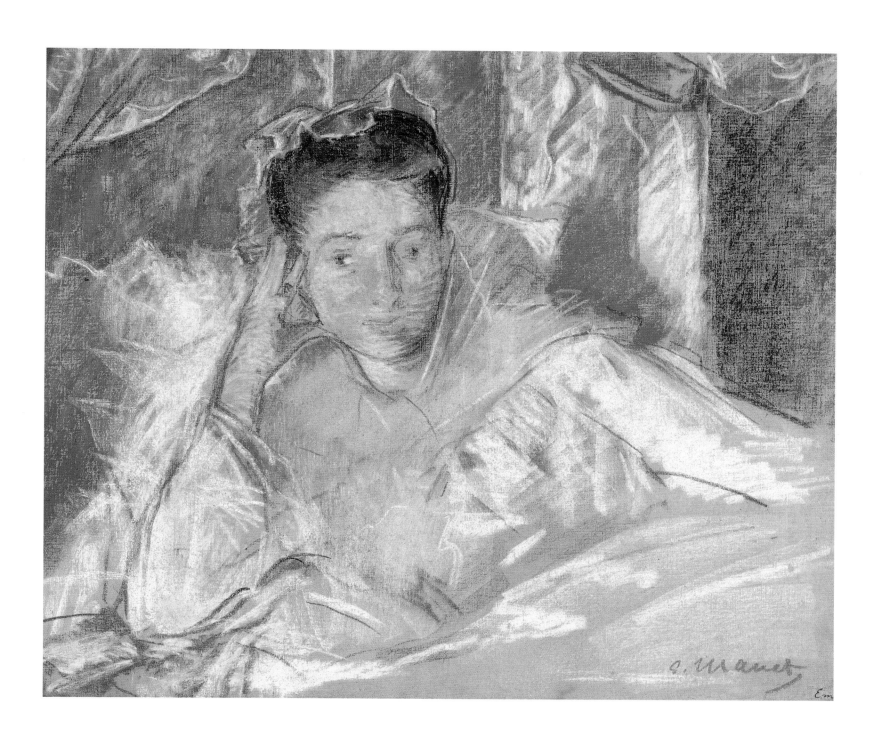

Manet, *Mme. Loubens in Bed*, 1880. Pastel, 18⅛ × 22″ (46 × 55.9 cm).
Private collection.

fancy."[63] Two years later Mme. Morisot wrote to Edma: "La Loubens spent the evening being amiable to M. Degas, and he, who is supposed to despise her, was charming to her. She has become much fatter, which does not make her any prettier in my eyes, though Tiburce [Berthe's brother] says it does."[64]

Degas made pastel studies from life of the heads of both women, which served as notes when he returned to his studio to paint his canvas. These studies (inscribed with each woman's name) and the oil painting were in his studio at the time of his death. Mme. Loubens is the woman on the right who leans forward with her hands clasped at her knee as if she were listening to something Degas is saying. Mme. Lisle appears to be more preoccupied with her own thoughts, yet she also looks at the artist.

Degas echoes Manet's arrangement in his double portrait: he places Mme. Loubens to the right, with her companion to the left. This may well have been his reference to Manet's renowned *Concert in the Tuileries Gardens*.

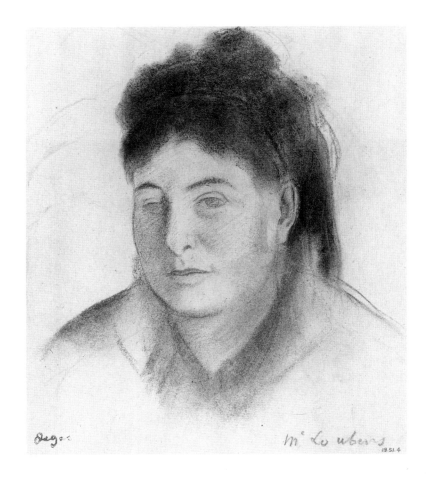

RIGHT: Degas, *Madame Loubens*, 1869–1872. Charcoal, crayon, and pastel, 9⅛ × 8″ (23.8 × 20.5 cm). The Metropolitan Museum of Art, New York; Rogers Fund, 1918.

BELOW: Degas, *Portrait of Madame Lisle*, 1869–1872. Pastel and red crayon on buff paper, 8⅝ × 10⅛″ (21.9 × 25.7 cm). The Metropolitan Museum of Art, New York; Rogers Fund, 1918.

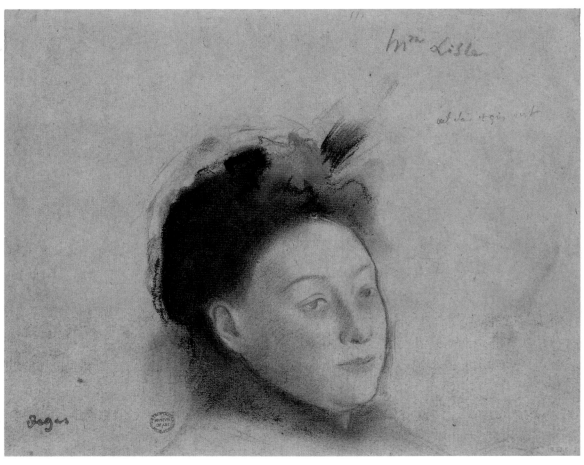

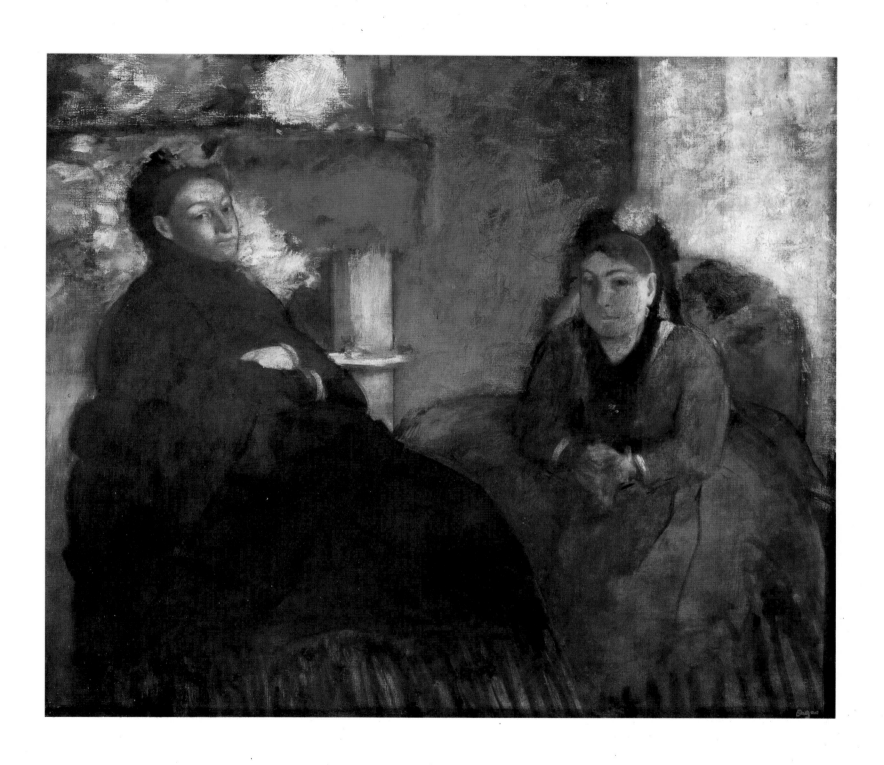

Degas, *Madame Lisle and Madame Loubens*, 1869–1872. Oil on canvas,
33½ × 38⅛″ (85.1 × 97 cm). The Art Institute of Chicago; Gift of
Annie Laurie Ryerson in memory of Joseph Turner Ryerson, 1953.

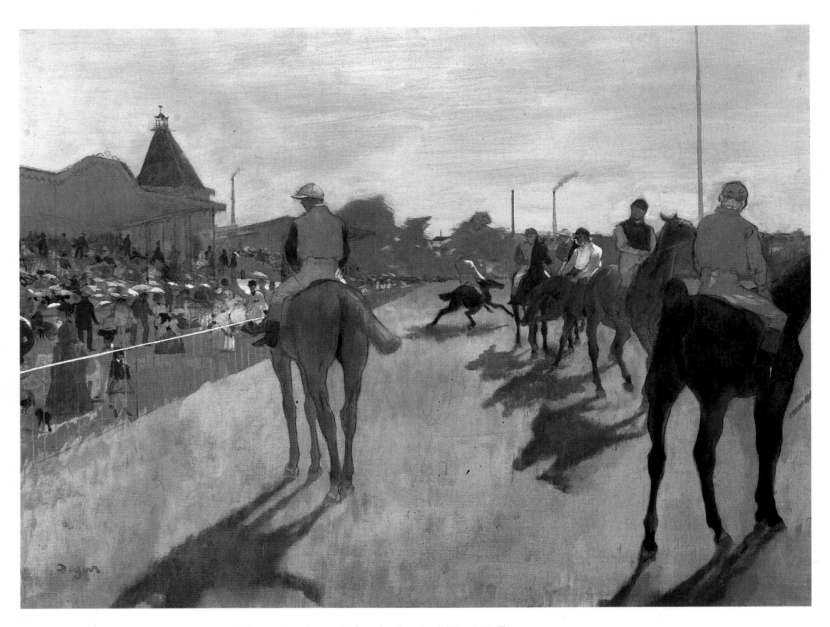

Degas, *Racehorses before the Stands*, 1866–1868. Essence on paper,
mounted on canvas, 18⅛ × 24″ (46 × 61 cm). Musée d'Orsay, Paris.

I N T H E M I D and late 1860s, Degas and Manet painted race-
horses in motion.[65] Their depictions are very different. In
Racehorses before the Stands, Degas showed the horses with their
jockeys pacing before the race. There are several striking innova-
tions. First, the unusual rear view of the horses reflects what
Degas stated in his notebooks: "Study a figure or an object, no
matter what, from every viewpoint."[66] Second, the overlapping of
elements creates an ornamental effect that he mentioned in his
writings: "Ornament is the space between [the] two things and

that's where it is."[67] A sense of movement is provided by the dis-
tant horse. Finally, Degas was concerned with the relation be-
tween light and shadow.

Although Manet is purported to have said, "Degas was painting
Semiramis [*Semiramis Building Babylon*, c. 1860–1862] while I
was painting modern Paris,"[68] Degas preceded Manet in his mod-
ern theme of the racetrack by three years. Degas had made two
paintings of racehorses: *At the Racetrack* of 1861 (which focuses
on the spectators)[69] and *The Gentlemen's Race: Before the Start* of

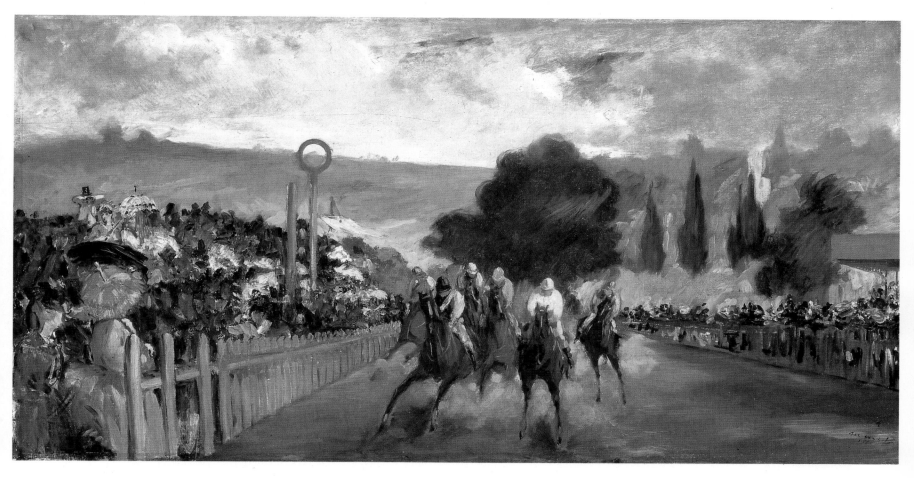

Manet, *The Race Track at Longchamps* (in the Bois de Boulogne),
d. 1866. Oil on canvas, 17¼ × 33¼″ (43.9 × 84.5 cm). Art Institute of
Chicago; Mr. and Mrs. Potter Palmer Collection, 1922.

1862 (which focuses on the jockeys).[70] In 1864 Manet made his first racecourse painting—a large canvas (approximately 30 × 80″), *View of a Race in the Bois de Boulogne*—which he cut up after it was exhibited in 1865. A watercolor of this composition survives.[71] In 1866 he did a variant in *The Race Track at Longchamps*. Here Manet gave a more realistic portrayal of movement than he did later in the commissioned *Races in the Bois de Boulogne* (see page 36). In *The Race Track at Longchamps*, Manet was the first to show a foreshortened front view in which the

horses gallop directly toward us, spewing up dust. He concentrated on the dramatic action of the horses, who have just crossed the finish line (demarcated by the vertical pole with the circle on top) and on the elegant spectators at the left. Another innovation predates later developments in photography: Manet telescoped his horses, making us feel very close to the action. His portrayal of movement here is different from but as innovative as that in Degas's *Racehorses before the Stands*. Each artist successfully captured modernity, though in a different manner.

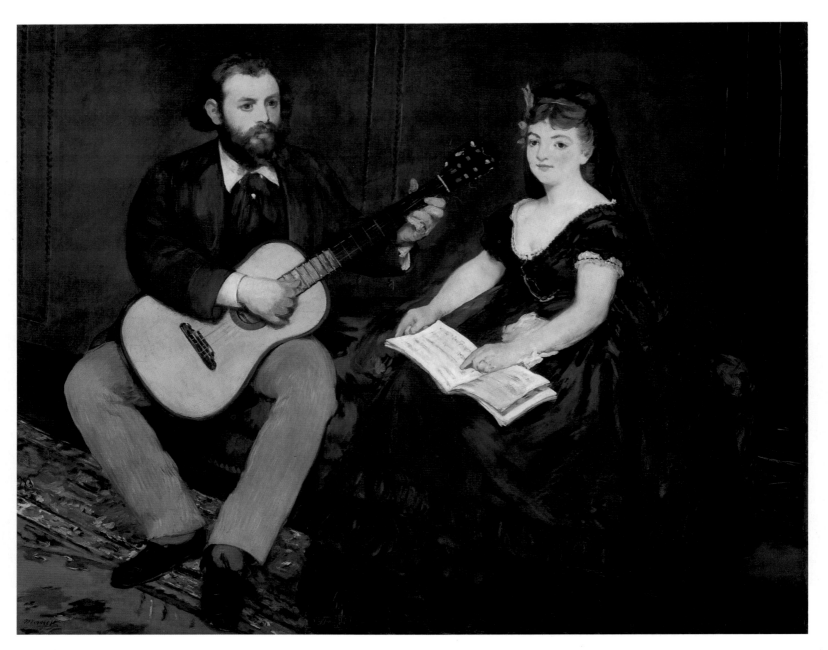

Manet, *Music Lesson*, 1870. Oil on canvas, 55⅛ × 68⅛″ (141.1 × 173.1 cm). Museum of Fine Arts, Boston; Anonymous Centennial Gift in memory of Charles Deering.

Dᴇɢᴀs ᴀɴᴅ Mᴀɴᴇᴛ both executed horizontal paintings of a male musician with a female singer at about the same time. Manet's large painting was exhibited at the Salon of 1870, and Degas saw it there. Presumably his much smaller image was made after that, and it seems to be a deliberate variation on the theme.

Both scenes take place at the homes of the respective artists' parents. Manet portrayed a typical evening performance, while Degas depicted a day rehearsal. Both canvases seem to be portraits, although neither went to the sitters; both remained in the artists' studios until their deaths. Manet's guitarist is his friend Astruc, a critic, poet, and sculptor, who is accompanied by an unknown

singer. The identities of Degas's violinist and singer are not known. They remind one of his earlier portraits of musicians, such as those of the flutist Joseph-Henri Altès in 1868, the cellist Pillet in 1868–69, the pianist Mme. Camus in 1869, the guitarist Pagans in 1869, and the pianist Mlle. Marie Dihaus in 1869–1872.

With their stiff bodies and rigid faces, Manet's couple seem like store mannequins posed close to a glass window. The artist concentrated on shapes, colors, and arrangements of elements more than on the interactions between the two people. Degas, by contrast, sought to portray his two as individuals through posture, gesture, and expression. His more realistic figures have mass and density and seem to exist in a real space, which we enter as we in-

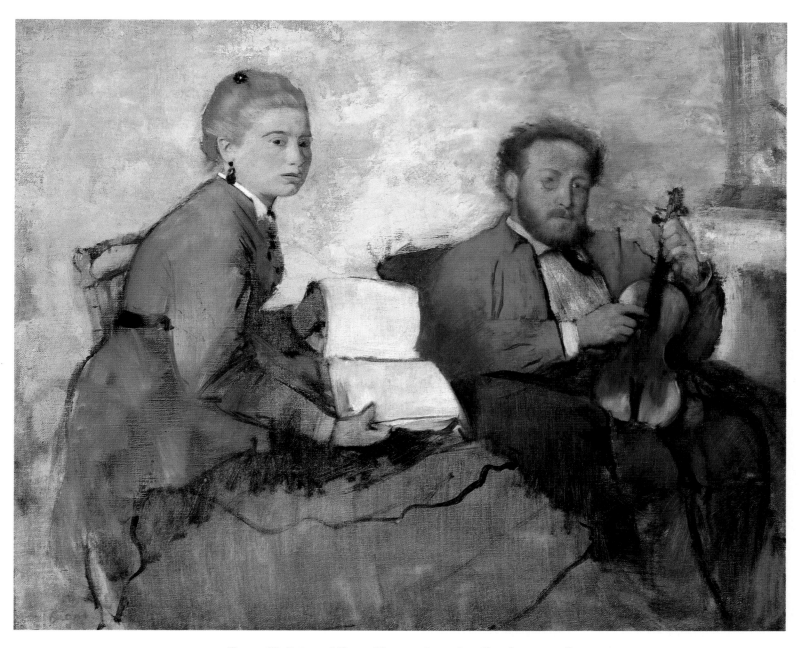

Degas, *Violinist and Young Woman*, 1870–1872. Pastel crayon, oil
crayon, and oil on canvas, 18¼ × 21⅝″ (46 × 54.9 cm). Detroit Institute
of Arts; Bequest of Robert H. Tannahill.

terrupt their session. The woman appears to have been caught in motion as she turns away from the man to look at us. Degas wrote about his personal fascination with motion: "It is the movement of people and things that distracts and even consoles if there is still consolation to be had for one so unhappy. If the leaves of the trees did not move, how sad the trees would be and we too! There is a tree in the garden of the neighboring house that moves at each breath of wind. . . . I say to myself that this tree is delightful."[72]

Manet's figures resemble each other. The artist contrasted the light areas—skin, music, and instrument—with the dark ones—costumes, hair, and setting. Degas's sitters are opposites. The woman is blond, thin, perched on the edge of her chair, and in mo-

tion, while the man is dark, heavy, tuning his violin, and at rest. Manet depicted a scene indoors at night; in Degas's scene, sunlight floods the room. The Manet is a completed work; the Degas appears unfinished. In sum, the Degas is more varied and complex, the Manet more generalized and simplified. Degas was more Impressionist in conveying a feeling of reality, whereas Manet was more traditional and yet more abstract, foreshadowing twentieth-century art in his concentration on the light, form, color, and composition.

MANET BEGAN using a mutual friend Desboutin as a model in 1875, and about a year later Degas followed suit. (Desboutin was an engraver, etcher, painter, and writer.)[73] First Manet did a watercolor of him raising a pipe to his lips, which may have been a preparatory study for the oil in which the standing Desboutin fills a long pipe. The blue smoke that wafts in front of Desboutin in the watercolor seems influenced by Renoir's profile *Portrait of Monet* of 1872, which Manet would have seen when he visited Monet's home (see p. 78). Manet intended that his oil, called *The Artist,* be shown at the Salon of 1876. When it was rejected, he exhibited it, along with another rejected work, in his own studio for two weeks before the Salon. Many people came to see these paintings, and some critics reacted favorably. Mallarmé called attention to the importance of light for Manet:

> The search after truth peculiar to modern artists ... must lead them to adopt air almost exclusively as their medium, or at all events to habituate themselves to work in it freely and without restraint; there should at least be in the revival of such a medium, if nothing more, an incentive to a new method of painting.... Now Manet and his school use simple color, fresh or lightly laid on, and their results seem to have been obtained at the first stroke, that the ever-present light blends with and vivifies all things. As to the details of the picture, nothing should be absolutely fixed, in order that we may feel that the bright gleam which lights the picture, or the diaphanous shadow which veils it, are only seen in passing, and just when the spectator beholds the represented subject, which being composed of a harmony of reflected and ever-changing lights, cannot be supposed always to look the same, but palpitates with movement, light, and life.[74]

Manet, *Portrait of Gilbert-Marcellin Desboutin*, c. 1875. Watercolor over graphite on white paper, 9 × 5½″ (22.9 × 14 cm). Fogg Art Museum, Harvard University, Cambridge, Mass.; Bequest of Grenville L. Winthrop.

OPPOSITE: Manet, *The Artist, Desboutin*, d. 1875. Oil on canvas, 75¼ × 51⅝″ (191.1 × 131.1 cm). Collection Museu de Arte de São Paulo, Brazil; Assis Chateaubriand.

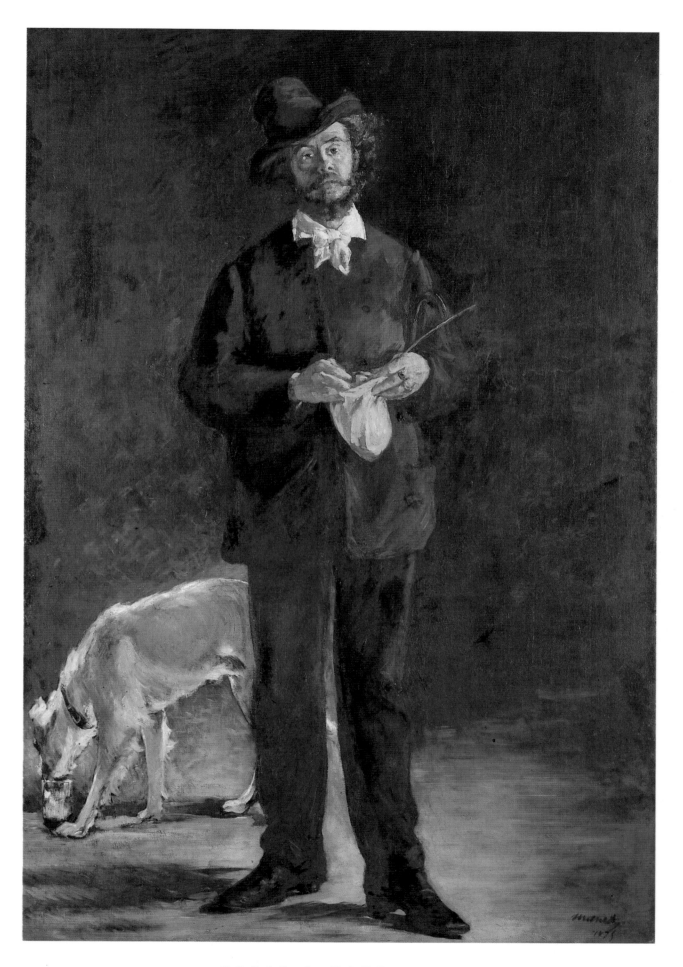

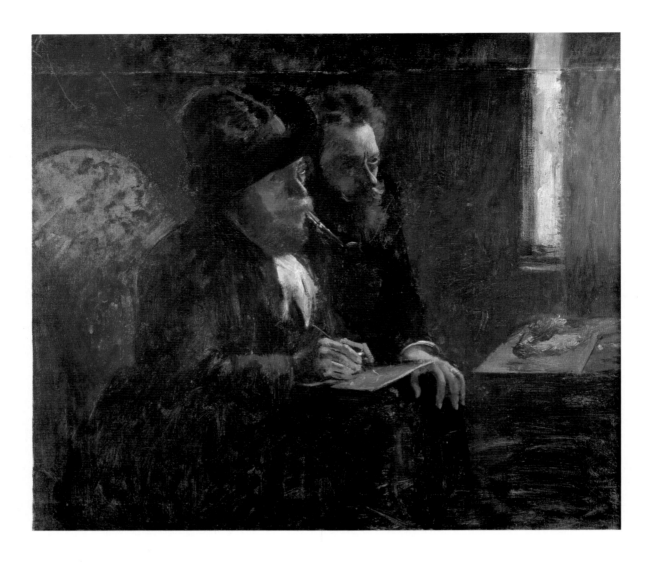

THE YEAR AFTER Manet completed these pictures, Degas depicted Desboutin (with pipe in his mouth, and, as in Manet's painting, wearing the same hat, same dark jacket, and same white shirt tied at his neck) in a double portrait, a single portrait, and a scene from daily life. The double portrait shows Desboutin and another artist, Viscount Ludovic-Napoléon Lepic, with their printmaking and monotype tools. In 1876 Degas was enamored of engraving. As Desboutin wrote that year:

> Degas . . . is no longer a friend, no longer a man, no longer an artist! He's a zinc or copper plate blackened with printer's ink, and plate and man are flattened together by his printing press, whose mechanism has swallowed him completely! The man's crazes are out of this world. He is now in the metallurgic phase of reproducing his drawings with a roller and is running all over Paris, in the heat wave—trying to find the legion of specialists who will realize his obsession. He is a real poem! He talks only of metallurgists, lead casters, lithographers, planishers [metal polishers]![75]

The portrait in the lithograph *Marcellin Desboutin* (also called *Man with a Pipe*) is similar to that in the double portrait and in *L'Absinthe*. In all three, the similarly attired Desboutin looks toward his left. In the lithograph smoke rises from his pipe. Degas wrote ideas for projects in his notebook: "On smoke, smoke of smokers, pipes, cigarettes, cigars, smoke of locomotives, of high chimneys, factories, steamboats, etc.; squeezing of smoke under the bridges; steam."[76]

One of Degas's notes reads, "Hélène [the real name of actress-model Ellen Andrée] and Desboutin in a café," which is the painting *L'Absinthe*. It shows the couple at the Nouvelle-Athènes. Years later Andrée recalled that she posed for "a café scene for Degas. I am sitting in front of an absinthe, Desboutin sitting in front of an innocent brew, the world upside down, eh! and we look like a couple of idiots."[77] Forty-five years later, when a journalist observed that Andrée figured in several masterpieces, including this work, she retorted: "so-called masterpieces!"[78]

The work was exhibited at the third Impressionist show in 1877. It drew the attention of the critic Rivière, who wrote:

> How can I talk intelligently about this essentially Parisian artist [Degas] whose work reveals as much literary and philosophical talent as it displays artistry of line and knowledge of color? . . . His works are always brilliant, refined, and sincere. . . . His prodigious knowledge shines everywhere. With

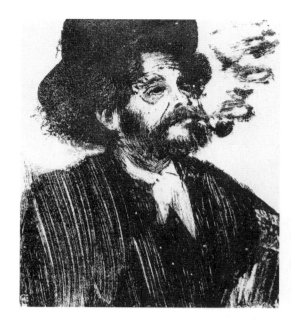

Degas, *Marcellin Desboutin* (Detail from lithograph with three images: *Marcellin Desboutin, Grooming,* and *The Café-Concert*), 1876–77. Lithographic transfer from monotype, second state, 10½ × 9⅔″ (26.7 × 24.6 cm). Mead Art Museum, Amherst College, Amherst, Mass.; Gift of Edward C. Crossett, Class of 1905.

OPPOSITE: Degas, *Desboutin et Viscount Lepic,* c. 1876. Oil on canvas, 28⅜ × 31⅞″ (72.1 × 81 cm). Musée d'Orsay, Paris, on loan to the Musée Masséna, Nice.

Degas, *At the Café* (or *L'Absinthe*), 1875–76. Oil on canvas, 36¼ × 26¾″ (92.1 × 67.9 cm). Musée d'Orsay, Paris.

his ingenuity, so attractive and so exceptional, he groups his figures in the most unexpected and amusing fashion, yet they are always true to life, even normal. . . . He is an observer, he never exaggerates. Effect is always obtained by natural means, without flourish. This makes him the most reliable historian of the scenes he traces for us.[79]

L'Absinthe is one of Degas's most innovative works, and it realizes many of the aims expressed in his notebooks:

After having done portraits seen from above, I will do them seen from below—sitting very close to a woman and looking at her from a low viewpoint, I will see her head in the chan-

delier, surrounded by crystals, etc.; do simple things like draw a profile which would not move, [the painter] himself moving, going up or down, the same for a full face. . . . Studio projects: Set up tiers [a series of benches] all around the room so as to get used to drawing things from above and below. . . . On the evening. Infinite subjects. In the cafés, different values of the glass-shades reflected in the mirrors.[80]

Fifteen years after doing his portrait, Degas was still friends with Desboutin. To another friend he wrote: "Desboutin, still young at seventy years old, reigns with his pipes at the entrance of a café, you will see him again with pleasure."[81]

Both Degas and Manet made several portraits of the actress Ellen Andrée.[82] She was a witty, lively, independent woman who first became a model and later did pantomimes at the Folies-Bergère. She was also a comedienne. Degas knew her from the late 1860s. Between 1875 and 1879, in her twenties, she modeled for him in *L'Absinthe* as well as in small prints—a monotype (see p. 54) and a drypoint.[83] In the drypoint she posed as a museum visitor with a guidebook in her hand. Around 1880 she modeled in profile for Manet's oil bust portrait (see p. 55).[84] In old age she recalled, in an interview, Degas's frugal lunches eaten on a newspaper in his studio, and his sarcastic remarks.[85]

Nadar, photograph of Ellen Andrée, c. 1878–1880. Bibliothèque Nationale, Paris.

OPPOSITE: Degas, *Ellen Andrée*, 1879. Drypoint, third state, 8⅝ × 6¼″ (21.9 × 15.8 cm). Museum of Fine Arts, Boston; Katherine E. Poullard Fund in memory of Francis Bullard and proceeds from the sale of duplicate prints.

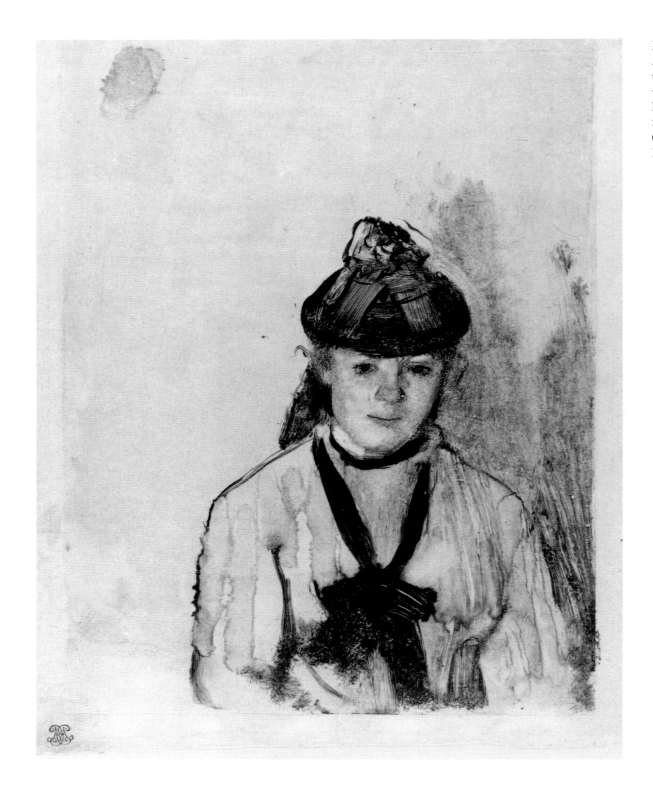

MANET DIED in 1883 at the age of fifty-three.[86] He and Degas made no portraits of each other during the last ten years of Manet's life, but they remained friends.

At the end Degas wrote: "Manet is done for. That [homeopathic] doctor Hureau de Villeneuve is said to have poisoned him with too much diseased rye seed. Some papers, they say, have already taken care to announce his approaching end to him. His family will I hope have read them before he did. He is not in the least aware of his dangerous condition and he has a gangrenous foot."[87]

After Manet's death Degas admitted of his art, "He was greater than we thought."[88] Manet's brother, Eugène, and sister-in-law Berthe Morisot gave Degas a Manet painting, *Departure of the Folkestone Boat* (1869).[89] With deep feeling Degas wrote to Eugène: "My dear Manet: You wanted to give me great pleasure and you have succeeded in doing so. May I also tell you that I deeply feel the many delicate meanings conveyed in your gift. . . . I shall soon come to see you and thank you."[90]

Degas's large collection of Manet's work, much of which was

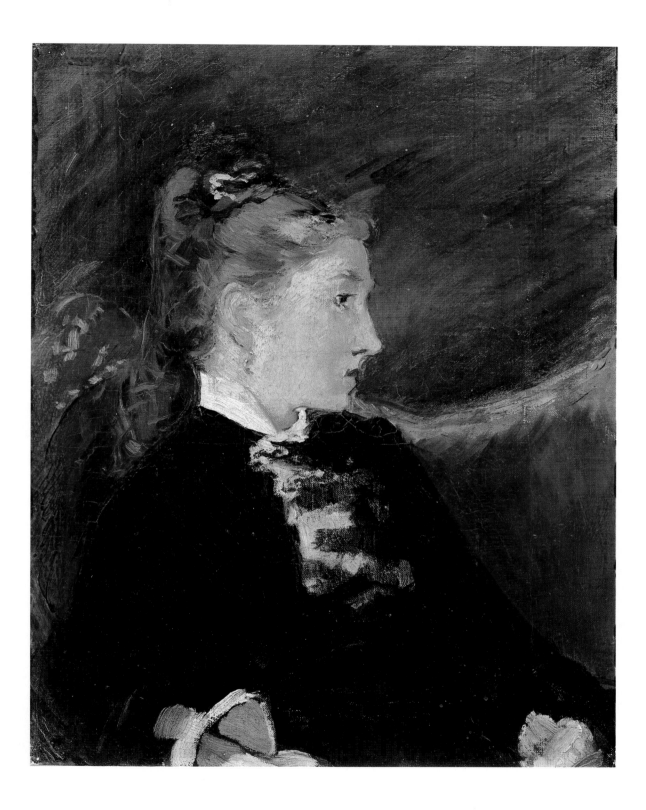

Manet, *Ellen Andrée*, c. 1880.
Oil on canvas, 12 × 9⅞″ (30.5 ×
25.1 cm). Galerie Schmit, Paris.

purchased after Manet's death, shows that his love for the work transcended his ambivalent feelings about the man. At the sale of the contents of Manet's studio in 1884, Degas asked his dealer, Paul Durand-Ruel, to bid on three works: two ink drawings—*Leaving the Bath* (1860–61) and *Portrait of H. Vignaux* (c. 1874)—and a lithograph, *The Barricade* (c. 1871).[91] At a sale four years later, he bought two paintings, *The Ham* (1880) and *A Pear* (1880). In 1894 he bought two of the three known parts of Manet's large *Execution of the Emperor Maximilian* (1867), hop-

ing to reunite them. Two years later he bought *Gypsy with Cigarette* (1861) and subsequently the oil portraits *Berthe Morisot with a Veil* (1872; see p. 172), *Berthe Morisot in Mourning Hat* (1874; see p. 178), *M. Brun* (1880), and *Mme. Suzanne Manet with a Cat* (1880). In addition, as already noted, Degas owned sixty-nine of Manet's prints.[92]

Photograph of Renoir at the age of twenty, 1861. Location unknown.

Carjat, photograph of Monet at the age of twenty-four or twenty-five, 1864–65. Private collection.

Monet & Renoir

THE LANDSCAPIST MONET and the figure painter Renoir came together for companionship and collaboration. They pooled their expertise to develop a new style that combined Monet's extraordinary feeling for nature with Renoir's unique gifts as a colorist. Impressionism itself was born from their work together. The pure Impressionist style first appears in several pairs of landscapes that the two painted in 1869 at La Grenouillère, a fashionable spot on the Seine about twenty minutes by train from Paris. The paintings are of the same motif, and the two men painted side by side in quite similar styles. They continued to paint in tandem and, in total, produced fourteen paintings of identical landscapes or still lifes. Furthermore, Renoir made eleven portraits of Monet. These works are testimony to their amicable partnership.

Friends for fifty-seven years, they were closest from their midtwenties through their midthirties, from 1866 through 1875, when they painted in each other's company. In 1900, when he was fifty-nine, Renoir wrote to Monet, "I value your friendship. As to the others, I don't give a damn about them."[1] After the death of Monet's eldest child, Jean, the elderly artist expressed his deep feeling for Renoir: "My dear Renoir: Thank you for your words— in them I see your friendship. It doesn't date from yesterday. . . . Your old friend Claude Monet."[2] They wrote to each other using the familiar pronoun *tu* but addressed other Impressionists as *vous*.

They met in Professor Charles Gleyre's class at the École des Beaux-Arts late in the fall of 1862, when they were both in their early twenties. Monet later remarked of Renoir and Sisley that he had found his classmates "companions to my liking, original individuals . . . of whom I was never thereafter to lose sight."[3]

Their backgrounds made them the two poorest among the Impressionists. Monet's family, however, seems to have been wealthier and of a higher social class than Renoir's, and this may partly account for Renoir's deferential attitude. Monet's father, a wholesale grocer, refused him financial assistance because he disapproved of his son's artistic career and of his mistress and their son. Renoir's father, a tailor, approved of his career but had no funds to give him. Duret, patron, friend, and art critic, wrote that they were "men who as friends had endured misfortune."[4] They had financial difficulties from the 1860s through the 1880s, but the most difficult years were from 1866 through 1875, during which time they supported each other emotionally and painted together.

Nearly opposites in personality, each drew from the other what he himself lacked. Monet was a "rude, outspoken, defiant and domineering egoist"[5] who gladly fought the group's battles, while Renoir was "an easygoing street urchin"[6] who drew supporters to the group. According to one of Renoir's friends, Monet was "really the soul of the little clique. It was he who rekindled the courage that sometimes weakened in his friends in hard times. With his fighter's temperament, he bravely faced the attacks, like a magnificent bull that the banderillas excite but don't frighten. Renoir often said that at the time when everyone was belligerent toward the poor intransigents, Monet served them the best with his drive, his tenacity, and his unshakable confidence in their final success."[7]

Renoir, by contrast, was an empathetic and gregarious man who was most at ease when surrounded by friends, artists, and models. His friendliness and charm made him feel at home with the Monets and the families of other friends. He did not have a family of his own until he was forty-four. Of the two, Monet was often the leader and Renoir the follower. Renoir was vulnerable in this friendship and sensitive to perceived slights, as a letter to Caillebotte indicates: "Please write to Monet that he shouldn't concern himself with this business. . . . I will write to Monet after you have written to make him understand that his comment bothers the hell out of me. It won't help me in any way to be made fun of. In friendship, Renoir (Please be so kind as to write to Monet)."[8]

In old age Renoir admitted: "I have always submitted myself to my destiny; I never had the temperament of a fighter, and I would many times have given up, if my old Monet, who himself did have the temperament of a fighter, had not helped me up with a pat on the shoulder."[9]

The distinctions in their personalities determined the way they managed their careers. Monet was a liberal free spirit with a disregard for authority; Renoir was conservative and traditional. Monet opposed using the art of the museums as a source, preferring nature as his inspiration. He was also opposed to government-sponsored art exhibits and to such public awards as the Legion of Honor. Renoir, by contrast, esteemed the great art of the museums and drew freely from the masterpieces of the past. He valiantly tried to get his art accepted at the state-sponsored yearly Salons from 1863 through 1883 and only desisted for two years (1876–77) because of Degas's rule that one could not exhibit both at the

Salon and with the Impressionists. He sought official recognition and was delighted when he received all three ranks of the Legion of Honor.

While both artists worked side by side with other Impressionists, they did more paintings together and over a longer period than they did with others.[10] They made a total of twenty-nine works in each other's presence, eleven by Monet and eighteen by Renoir. Among these Renoir made Monet's portrait eleven times, seven times individually and four times with others. Of his other Impressionist friends, he made three portraits each of Cézanne, Morisot, and Sisley, two of Caillebotte and Pissarro, and one of Bazille. Monet rarely painted portraits (except those of family members) and made none of Renoir; both artists, however, painted numerous images of Monet's wife, Camille [Doncieux]. Furthermore, on at least three occasions they painted the identical scene within a year or so of each other. Although they stopped painting together after 1875, they continued to be friends until Renoir's death in 1919.

DURING the flourishing of Impressionism, from about 1869 through 1877, Monet and Renoir shared center stage as the key practitioners of the style. In 1870 the critic Arsène Houssaye wrote, "The two true masters of this school that, instead of saying art for art's sake says nature for nature's sake, are Monet . . . and Renoir, two true masters."[11] Duret regarded "Monet as the impressionist group's most typical landscape painter and Renoir as its most typical figure painter."[12]

Most of the paintings that Monet and Renoir did side by side are landscapes. Possibly Renoir was trying to learn from Monet in an area where Monet was already the acknowledged specialist. Renoir valued landscape painting primarily as a means of improving his style of figure painting. As he later explained to his dealer: "I am making some progress. . . . This landscape painter's craft is very difficult for me, but these three months [painting landscapes] will have taken me further than a year in the studio. Afterward I'll come back and be able to take advantage at home of my experiments. . . . I will then have the time to do a lot of figure paintings for you."[13] Monet admired Renoir's innovations in color and light and hoped to benefit from working with him.

The distinction between Monet the landscape painter and Renoir the figure painter was their bond and the reason they did not feel directly competitive. From 1866 through 1875 Monet painted 278 landscapes, 35 figure paintings, and 12 still lifes, and Renoir painted 48 landscapes, 146 figure paintings, and 9 still lifes. Consistent with the way they wished to be known, at the first Impressionist show of 1874 Monet exhibited four landscapes and one figure, and Renoir exhibited four figures and one landscape. During the time they worked together, Monet painted his largest number of figures (including sixteen of his wife, Camille) and Renoir painted his largest number of landscapes—a testament to the richness of their collaboration. After 1875 they took such different directions that they could no longer fruitfully work together.

Before they did their first paintings side by side in 1869, Monet and Renoir had both painted in a partial Impressionist manner.

Their themes were of their daily lives in and around Paris. They sought to capture the effects of nature by filling their shadows with reflected light and the cool blue-violet hues from the sky, which they contrasted with the warmer yellow tones of the sunlight. Yet their palettes were dark, with a limited number of hues, and their surfaces look more or less "finished," without the myriad visible brushstrokes that became a part of Impressionism.

It was not until 1869 that they made the first fully Impressionist paintings. They created a style with pervasive light tones, added new bright colors, and loosened their brushstrokes so that the entire image looks "unfinished"—like a sketch—even though it was a finished work intended for exhibition and sale. This lack of clarity produced an effect of the hustle-bustle of daily life, as if they had captured a moment in time. Furthermore, the blurred style engages the viewer to focus the image.

Painters had traditionally sketched outside and then modified their paintings in the studio. In 1863 Monet was the first to complete a landscape outdoors, as he wrote, "entirely executed from nature."[14] Renoir soon adopted this procedure. During Easter of the following year, Bazille, Monet, Renoir, and Sisley went to Fontainebleau forest to work outdoors. In 1865 and 1866 Monet did the first large figure paintings outdoors; Renoir soon followed. Renoir used his 1869 landscapes as a springboard for his large-scale Impressionist figure style, beginning in 1870 with *The Promenade* (see p. 84), the surface of which consists of a multitude of visible brushstrokes.

Before their working together Monet had primarily painted landscapes, and his work was more consistent in style than Renoir's, although it varied from realistic to more Impressionist images.[15] Renoir painted a wider range of themes in more varied styles. Some of his early figure paintings are photographic, some call to mind Gustave Courbet, others Eugène Delacroix.[16]

Monet, who once proudly declared, "I am and I always want to be an Impressionist,"[17] from 1869 until his death in 1926 painted consistently in an Impressionist style. The dissolution of form, central to the style, especially suited his landscape motifs.

Renoir was a pure Impressionist for only nine years, from 1869 through 1877. He completed his most innovative figure paintings during this time. Since he wanted to make sensual figures, he had inherent difficulties with Impressionism because the brushstrokes create so open a form that the figure has no clear edges, detail, weight, volume, or relief. After 1877 his figure style became more realistic, then classical, then linear, then sculptural, but his landscape backgrounds remained Impressionist.

The paintings that Monet and Renoir did side by side were often signed and dated. A comparison shows consistent differences between the two. In every case Monet's canvas is larger than Renoir's, one more than twice as big and one more than four times bigger. Size alone suggests that Monet considered his landscapes destined for sale or exhibition, whereas Renoir considered his small experiments a means of learning from Monet a style that he could transpose to his large figure paintings. Over time the influences between the artists became reciprocal.

Monet's choice of nature as his primary subject was partially a result of his self-sufficient character—he was comfortable

alone—and his selection of forms makes the viewer feel the power of the natural world. His primary aim was to capture what he called "the envelope" of air. As he wrote to his biographer: "The further I go, the more I see that I have to work a lot in order to manage to convey what I am seeking: 'instantaneity,' above all, the envelopment, the same light spread over everywhere. . . . I am more and more maddened by the need to convey what I experience . . . it seems to me that I will be making more progress."[18]

The sociable Renoir, by contrast, included figures in his landscapes or created a space in which figures interacted. His canvases are crowded with suggestions of a story. A happy optimist, he painted relationships between people—between the artist/spectator and the model, or between two figures in a scene. His art is sensual, his people beautiful, happy, and healthy. As Octave Mirbeau wrote in 1913: "His whole life and his work are a lesson in happiness. . . . Perhaps Renoir is the only great painter who has never painted a sad picture."[19] Whether miniature or large, a Renoir canvas portrays active, joyful, and flirtatious figures who

appear to dissolve before our eyes and are at the same time fullbodied, sensual beings. During the time he worked with Monet, Renoir was at his most innovative, bold, and original in achieving this style.

In keeping with his self-confidence and forcefulness, Monet had a bold brushstroke. Consistent with his warmth and friendliness, Renoir's was caressing and delicate. Monet created more distance between subject and viewer, while Renoir placed the subject closer to the viewer, who feels intimately related to it.

The pages that follow illuminate the differences a close friend saw in the two painters a century ago: "M. Monet . . . seems to be the absolute antithesis of M. Renoir. The power, the animation, in a word, the life that the painter of the *Dance at Moulin de la Galette* infuses into people, M. Monet puts into things; he has found them a soul. In his paintings water splashes, locomotives move, the sails of the boats swell with the wind; land, houses, everything in this great artist's work has an intense and personal life that no one before had discovered or even suspected."[20]

Bouguereau, *Nymphs and Satyr*, d. 1873. 102⅜ × 70⅞″ (260 × 180 cm). Sterling and Francine Clark Art Institute, Williamstown, Mass. An example of art popular at the French Salons during the 1870s.

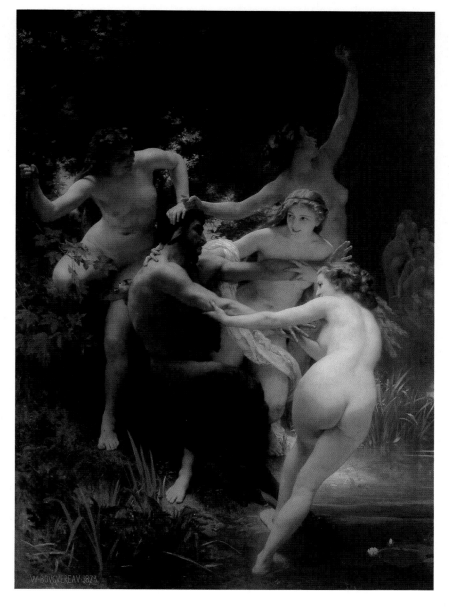

In the fall of 1869, Monet and Renoir painted seven canvases side by side: two still lifes, two pairs of landscapes, and one additional landscape by Monet, lost during World War II and known only through a black-and-white photograph. Two years earlier they had painted in the same city but had not recorded the same motif. Monet wrote then, "Renoir and I are still working on our views of Paris."[21] At this point the impoverished pair were accepting the generosity of their wealthy artist friend Bazille and were living at his Paris studio at 20, Rue Visconti. In the fall of 1867, Bazille wrote to his parents: "I am putting up a friend of mine, a former student of Gleyre's, who for the time being has no studio. Renoir, that is his name, is very hardworking."[22] A short while later Bazille again wrote to his parents: "[Monet] is going to sleep at my place until the end of the month. Along with Renoir that makes two needy painters to whom I am giving shelter. It looks like a real infirmary. I am delighted about this. I have enough space and they are both very cheerful."[23]

In reality it was a particularly difficult year for Monet. On August 8, 1867, his mistress, Camille, gave birth to a son, Jean, in Paris. His family refused to help him, and, because his paintings were not selling, he had no money.

The artists' financial situations continued precariously throughout the next two years. In the fall of 1869, they reached a state of crisis. A later interview and several letters make their struggles vivid. In 1900 Monet wrote, "As for the painful days of great misery with Renoir, it was not at Vetheuil that we lived through them so poorly, but me at St. Michel and Renoir at Louveciennes, two pretty places above Bougival."[24]

On August 9, 1869, Monet described his dire straits to Bazille: "Renoir . . . brought us bread from his parents' house so that we wouldn't croak. For eight days no bread, no wine, no fire to cook, no light. It's atrocious."[25] In a letter to Bazille, Renoir wrote: "I'm in Ville-d'Avray. . . . If you have some money, you'd better send it to me right away, just so that you won't eat it up. You don't have to

worry about me [spending the money], since I have neither wife nor child and am not about to have one or the other."²⁶ In a September letter to Bazille, Renoir gave a fuller picture of their situation and interaction: "I am living with my parents, and I am almost always visiting at Monet's house, where the baby is getting pretty old. We all don't eat every day. Yet I am happy nonetheless because as far as painting is concerned, Monet is good company. I'm doing almost nothing because I don't have many colors. Things may go better later this month."²⁷

Perhaps the still lifes are evidence of things going better. The flowers and fruits in these arrangements—chrysanthemums, asters, zinnias, sunflowers, apples, grapes, and pears—ripen and bloom in the fall, the time the two artists were together. Neither considered still lifes a primary subject, but they both painted them periodically, as a means of experimenting in inclement weather. The Monet here is more than twice as large as the Renoir. Both men exhibited these still lifes, Monet in 1879 and Renoir in 1874.²⁸

The two images have the same vase and some of the same flowers and fruit. Monet included a basket with more pears, apples, and four bunches of grapes. Renoir added additional yellow sunflowers. The wide range of rich, light color and the visible brushstrokes make these paintings among the first Impressionist works.

As is often characteristic of Renoir, the main focus (here the flowers) is closer to us in his than in Monet's painting. More of Renoir's flowers are cut by the frame above and to the left and right showing innovative cropping, which gives the impression that the flowers reach out of the picture toward us. They are more inviting than Monet's rather distant flowers.

Monet's composition, with its random and asymmetrical ordering, is innovative in a different manner. He looked down on the scene (as he might at a landscape) and put more space around objects. Renoir's canvas is symmetrical and balanced. He viewed the scene from lower down, and his rendering is more crowded.

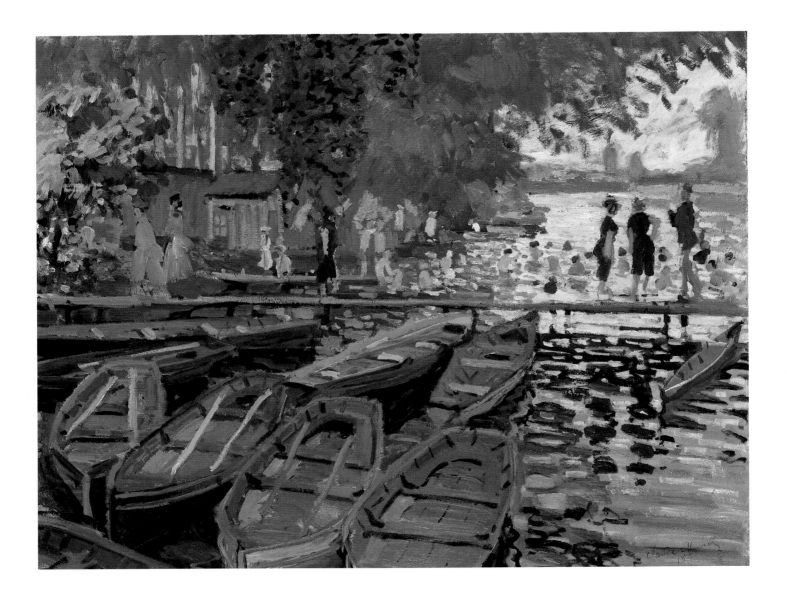

DESPITE THE MISERY and lack of supplies, the artists persevered and made plans. On September 25, Monet wrote to Bazille: "It's harder than you think.... I have probably not reached the end of my troubles. Winter is at hand, a season not very pleasant for the unfortunate. And after that comes the Salon. Alas! I won't be in it once again, since I won't have done anything. I do have a dream, a painting of the bathing spot at La Grenouillère, for which I've made a few bad rough sketches, but it's no more than a dream. Renoir, who has just spent two months here, also wants to do this painting."[29] Monet's three Grenouillère canvases are not the "few bad rough sketches." For him, "the canvas that does not go beyond the *pochade* (sketch) state never [left] his studio."[30]

These paintings are the first that fully express the thematic and formal ingredients of Impressionism. Baudelaire had said that modern life should be portrayed in a modern style, and it was this modern style that Monet and Renoir were seeking. The works were created with the site in view, not in the studio; they emphasize what the eye sees and not what the brain knows. What the artists painted was both real and fantasy, both nature and art, introducing a wide range of bright colors. Spontaneity is deliberately created in paintings that are carefully executed. The small, visible brushstrokes capture the sparkling surface of the water, creating a sense of a split second. Myriad strokes covering the surface suggest the brilliance of natural light.

The two pairs of Grenouillère landscapes were done in October 1869, and Monet did his final one sometime thereafter. The five works were created in the following order: first, Monet's London canvas, paired with Renoir's from Winterthur, then Monet's New York painting (see p. 64), paired with Renoir's from Stockholm (see p. 65), and then the lost Berlin Monet (see p. 64).[31] Evidence for this sequence comes from the images themselves.

The first pair show a footbridge from the Island of Croissy at the left, with the bathing cabins. In Renoir's version the bridge leads to a small island with a tree in the middle that was called the Flower Pot or the Camembert (because of its resemblance to the round cheese). On this island more than a dozen people stand and sit close together.

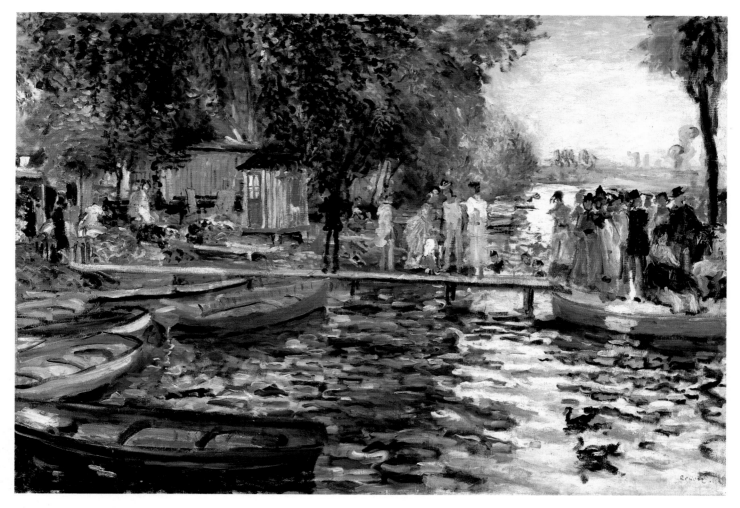

Renoir, *Bathing at La Grenouillère*, 1869. Oil on canvas, 25⅝ × 36¼″
(65.1 × 92.1 cm). Oscar Reinhart Collection, Winterthur, Switzerland.

OPPOSITE: Monet, *Bathing at La Grenouillère* (or *The Frog Pond*),
d. 1869. Oil on canvas, 28¾ × 36¼″ (73 × 92.1 cm). Trustees of the
National Gallery, London.

The slightly larger second pair build on Renoir's earlier view. The Camembert becomes the central focus of both the Monet and Renoir versions. A footbridge leads to an open-air moored barge for dining and dancing that bears the inscription *"Location de canots"* (boat rentals). Both artists' versions show a towel draped over that inscription, a further sign that the paintings were made at the same time.

Another indication that these pictures follow the earlier pair is the fact that Renoir has drawn larger people on the raft and has individualized them in costume and activity. Here Renoir experimented in miniature with the style he would develop the following year in *The Promenade* (see p. 84), a painting with large figures.

Monet's final work, for which there is no comparable Renoir, retains the numerous rowboats in the foreground (as in his London version) and the Camembert and barge at the right (as in his New York version). He also added numerous elements from Renoir's Stockholm version: the sailboat at the upper left; the rowboat that touches the island; the hanging willow foliage that blocks part of the Camembert; the larger and more defined figures with their fashionable costumes and parasols; and the asymmetry of the placement of the island. In Monet's final work, destined for the Salon, he clearly felt free to borrow elements from Renoir's later version.

With the still lifes and landscapes of 1869, Monet and Renoir began a process of painting in each other's company that would continue intermittently during the next six years. Although Renoir had not painted this way before, Monet had painted with Bazille in 1864. In a December 1868 letter to Bazille, he had expressed reservations about painting with friends or perhaps with Bazille: "Don't you think that one is better off alone with nature? . . . What I will do here will at least have the merit of not resembling anybody's work, because it will be simply the expression of what I've felt myself."[32] But Monet must have felt he was learning from Renoir and from his other friends, for he subsequently embraced the practice of painting side by side.

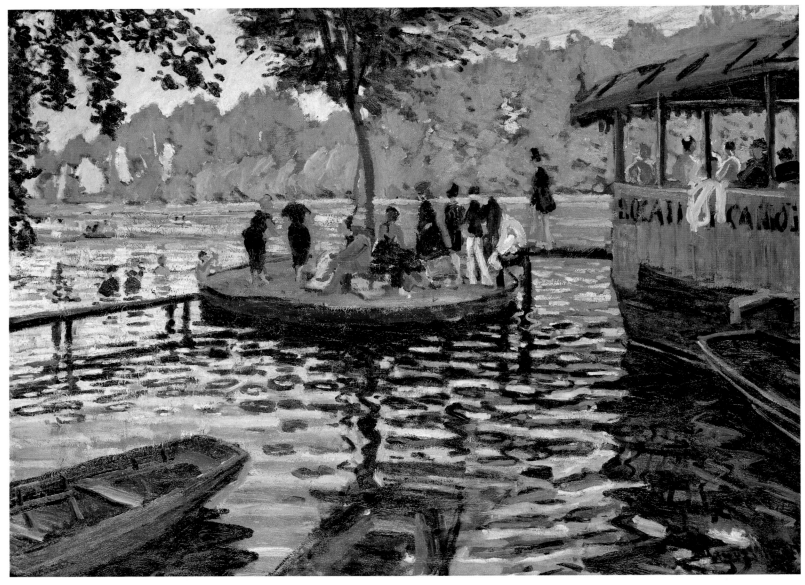

Monet, *La Grenouillère,* 1869. Oil on canvas, 29⅜ × 39¼″ (74.6 × 99.7 cm). The Metropolitan Museum of Art, New York.

OPPOSITE: Renoir, *La Grenouillère,* 1869. Oil on canvas, 26 × 31⅞″ (66 × 81 cm). National Museum, Stockholm.

LEFT: Monet, *La Grenouillère,* 1869. Oil on canvas, approximately 26 × 46½″ (66 × 118.1 cm). Formerly in Arnold Collection, Berlin, and lost or destroyed during World War II.

THE WORKS in the second pair of Grenouillère paintings differ significantly from each other, perhaps because the artists' basic intents were dissimilar. Monet painted a landscape with insignificant figures, while Renoir invented a story about people enjoying themselves outdoors. Monet's figures are isolated from one another and are not individualized; they are clad in black, with touches of two blues, white, and two strokes of orange. They are all set far away from us. If the artist removed the people, his scene would be practically the same.

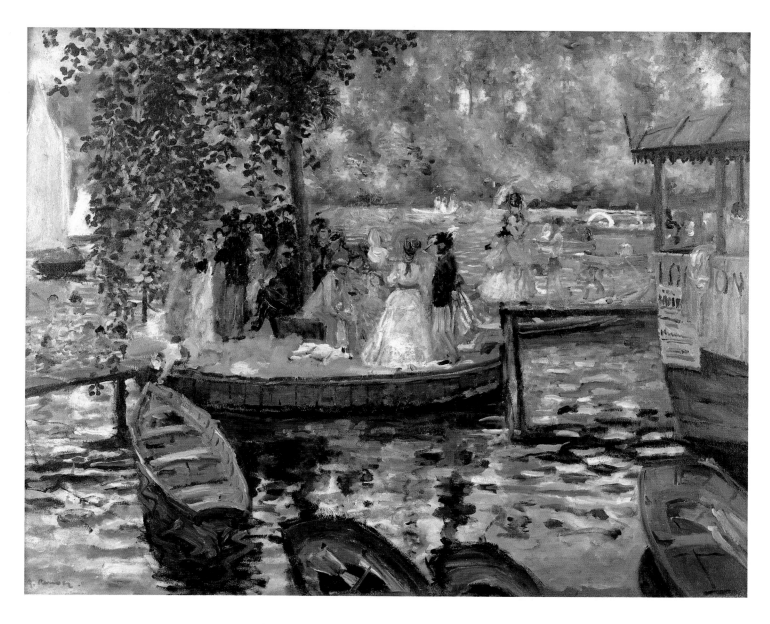

Renoir's primary focus is the fifteen brightly dressed, overlapping figures who mingle in front of and behind the tree. These larger and more substantial people are distinguished by their fashionable costumes, lively gestures, and varied postures.

Monet painted his picture standing to the right of Renoir, closer to the water, and with a lower perspective; the horizon line is at the figures' necks. Renoir was higher up on the bank, so the horizon line is above their heads.

Monet's composition is more structured, formal, and symmetrical. He created a deeper space. The island is farther away and higher in the picture. His is a peaceful and airy scene. Renoir's composition is less formal and more random. His Camembert is closer to us; the hanging branches of the tree on the island and the background trees seem to come toward the viewer. By bringing all parts of the image closer to us, Renoir seems to have integrated the different areas of color on the picture surface. This device, which the Impressionists would develop further, was a harbinger of abstraction.

The paintings at La Grenouillère mark a transition from duller landscape tonalities to hues that are clearer and more varied. Renoir was a more innovative colorist and used lighter, brighter qualities and more varied hues than did Monet. He employed a wide range of purer colors—greens, blues, yellows, and pinks—and he used less gray and fewer dark hues. He broke down the color of an area into varied colored strokes that fuse into a more consistent tone in the eye of the viewer. Monet's view, with its blacks, browns, and grays, and contrasts of light and dark, appears more realistic, whereas Renoir's is more fanciful and imaginative.

By the use of visible strokes, both sought to create the sparkle of sunlight on the water and the foliage. Monet changed the color from area to area and achieved a vigorous effect. Renoir changed the color from stroke to stroke and created a softer effect. Monet painted large, stiff, flat, broad strokes that are energetic and forceful. Renoir, using smaller, softer paintbrushes, made smaller strokes that are rounded and feathery. In these works Monet and Renoir evolved a new style of myriad brushstrokes and bright, light color that was soon to be adopted by Pissarro, Morisot, Manet, and Cézanne.

THE FRANCO-PRUSSIAN WAR interrupted the painters' work together. Renoir was drafted in late October 1870, and he was away from Paris for about eight months. To avoid conscription Monet went to London in January 1871 and did not return until the fall. In London he met Paul Durand-Ruel, who exhibited his work in a gallery he had opened on New Bond Street. Durand-Ruel purchased a painting by Monet and soon became his dealer. This and some other sales enabled Claude and Camille to settle in Argenteuil—twelve miles outside Paris and a fifteen-minute trip on the railroad—in December 1871, after the war's end. They remained there through January 1878. In January 1872 Monet introduced Renoir to Durand-Ruel.

Although Renoir made several portraits of Monet and of Camille in 1872, it was not until 1873 that the artists' side-by-side work resumed. Their paintings of the duck pond are more similar in style than any others made in tandem. The Monet and Dallas Museum Renoir are almost identical. They differ primarily in that the Renoir includes a boat with two men poling. Compared with the Monet, the Renoir has even brighter colors and more delicate strokes. The slightly smaller private-collection Renoir is even more sketchy than the other canvases. In all three canvases the vibrancy of the sun-filled landscape is conveyed through the oranges, blues, and yellows that sparkle throughout the surfaces. It is nearly impossible to distinguish between the hands of Monet and Renoir in these canvases.[33] Forty years later neither artist was able to say who had painted one of the works (which turned out to be the Dallas Museum Renoir).[34]

During 1873 Renoir spent much time at Monet's home in Argenteuil. A letter from Monet to Pissarro in September indicates just how constant a visitor he was: "Renoir is not here, you will be able to use the bed."[35] At this time the three men were working on the constitution of "The Cooperative Society of Artists-Painters-Sculptors etc. in Paris, Incorporated," which became known as the Impressionist group.[36] And they were planning the first Impressionist show, held in 1874.

ABOVE: Renoir, *The Duck Pond, Argenteuil*, 1873. Oil on canvas, 19¾ × 24″ (50.2 × 61 cm). Dallas Museum of Art; The Wendy and Emery Reves Collection.

RIGHT: Renoir, *Duck Pond, Argenteuil*, 1873. Oil on canvas, 18⅝ × 22″ (47.3 × 56.2 cm). Private collection.

OPPOSITE: Monet, *Duck Pond, Argenteuil*, 1873. Oil on canvas, 21¼ × 25⅝″ (54 × 65.1 cm). Archives Wildenstein.

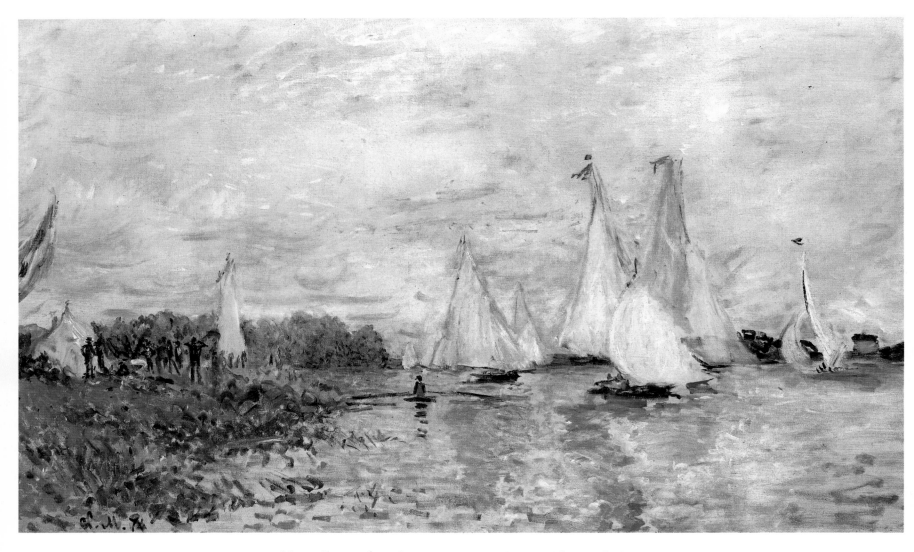

Monet, *Regatta from Gennevilliers in the Argenteuil Region*, d. 1874.
Oil on canvas, 23½ × 38¾″ (59.7 × 98.4 cm). Private collection.

THE NEXT YEAR Monet and Renoir did two pairs of side-by-side water views, one of a regatta[37] and one of individual sailboats. Argenteuil was the center of yachting in the Paris area. Although regattas were staged there twice a month from April to November, it was an unusual subject for Monet, and the choice may have been Renoir's.

The difference in size between these two is the most pronounced of any pair. The Monet is almost four times bigger than the Renoir.

In both paintings the intense light blurs the contours and dissolves the forms. Though Monet introduces some colored lines to define the contours of his sails, Renoir's sails are less defined and

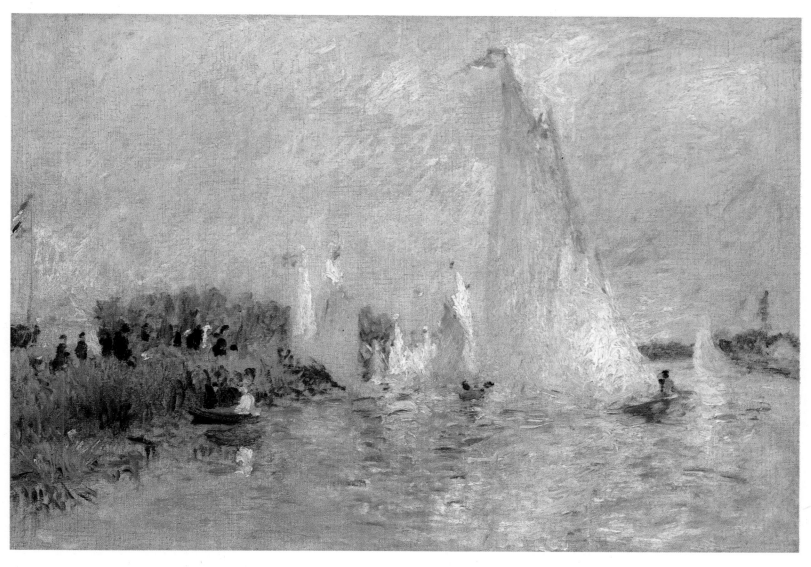

Renoir, *Regatta from Gennevilliers near Argenteuil,* 1874. Oil on canvas,
12¾ × 18″ (32.4 × 45.7 cm). National Gallery of Art, Washington;
Ailsa Mellon Bruce Collection.

decompose into the surrounding atmosphere. In both canvases creamy yellows and brilliant whites suffused with spectral colors suggest sailboats reflected in the choppy blue water. Darker dabs indicate the spectators in the tall grass and the figures on the boats. Because the Renoir is a relatively small sketch, its style is freer, with more dynamic strokes fracturing the surface.

As in earlier works here Renoir experimented boldly in Impressionist vaporousness by blurring the forms. In landscapes the following year, Monet's reflections became more granular and pulverized, closer to what Renoir had done in his *Regatta.* It may be that Monet adopted the technique Renoir had developed in his small sketch.

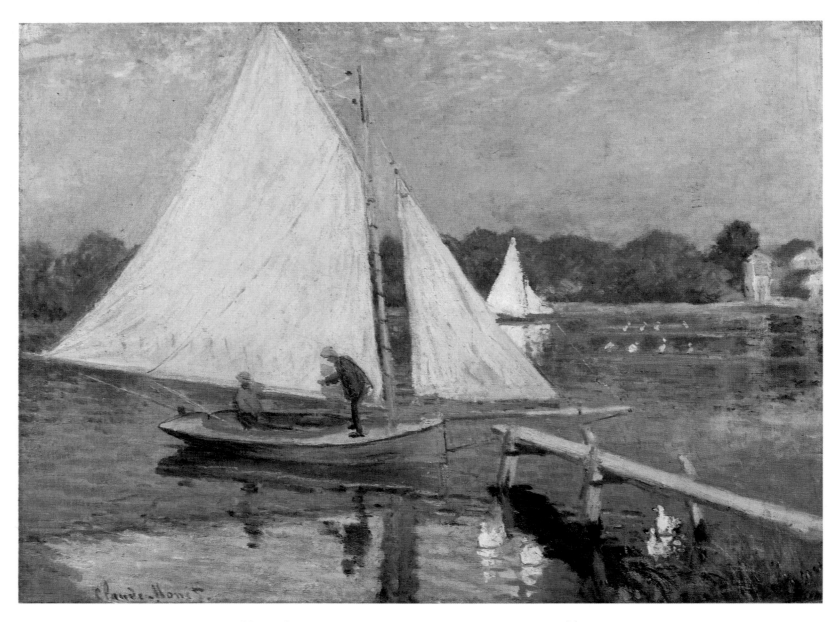

Monet, *Sailboats at Argenteuil*, 1874. Oil on canvas, 24 × 32½″ (61 × 82.6 cm). Private collection.

THAT SAME YEAR the artists set up their easels to paint pleasure boating on the Petit-Gennevilliers side of the Seine, looking toward the toll house of Argenteuil (visible in the distant right). Monet's larger canvas has a lower horizon with more sky and less water. Renoir's Seine has more elaborate reflections with haphazard broken edges; in the Monet the serene reflections have well-defined geometric shapes.

This side-by-side pair shows a Monet that is calm and spacious, while the Renoir is more active and crowded.[38] For example, Monet showed two sailboats, Renoir five. Monet's dock is straight,

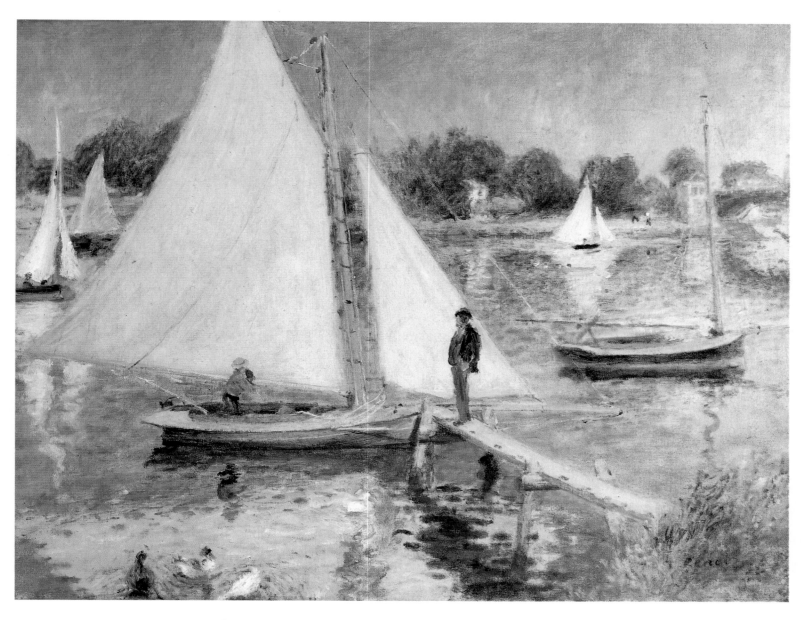

Renoir, *Sailboats at Argenteuil*, 1874. Oil on canvas, 20 × 26″ (50.8 × 66 cm). Portland Art Museum, Oregon; Bequest of Winslow B. Ayer.

while Renoir's sags and emerges from the foliage, giving a sense of movement that also occurs in the silhouette of distant trees. Monet's composition pairs elements: the sailboats, sculls, and ducks. Renoir's has more variety and activity, and appears to be freer. Monet's arrangement is more clean-cut and daring in its organization and forms a bold surface pattern. Comparing the two canvases, we see that Renoir's is innovative in his use of more varied intense colors.

These canvases mark the end of the period when Monet and Renoir worked in tandem on the same landscape motif. They did, however, continue to work in each other's company on portraits.

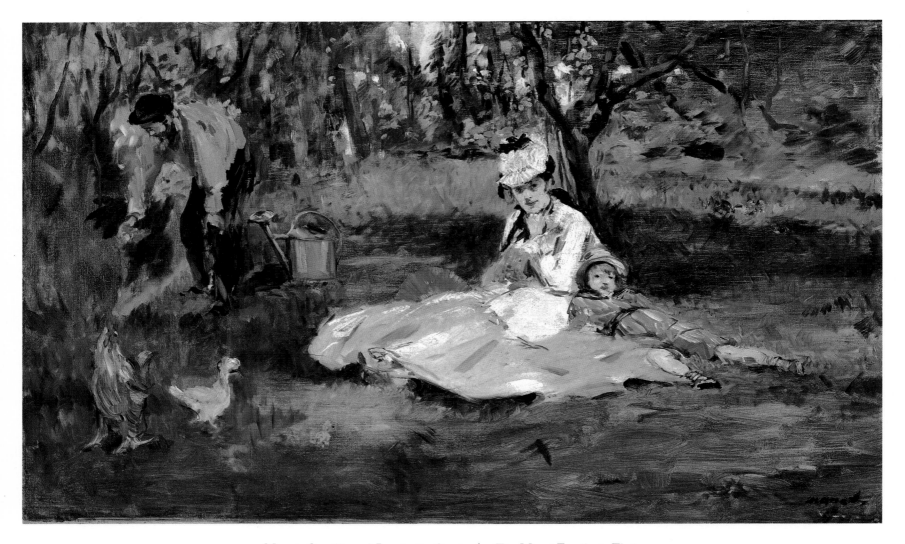

Manet, *Camille and Jean in the Garden* (or *The Monet Family in Their
Garden at Argenteuil*), 1874. Oil on canvas, 24 × 39¼″ (61 × 99.7 cm).
The Metropolitan Museum of Art, New York; Bequest of
Joan Whitney Payson.

IN THE SUMMER of 1874, Monet and Renoir also worked side by side with Manet, who was spending several weeks at his family's property at Gennevilliers, across the Seine near Argenteuil. While Monet painted Manet at work (see p. 74), Renoir and Manet painted Camille and seven-year-old Jean. From Paris, Zola reported in a letter: "I do not see anybody, am without any news. Manet, who is painting a study in Argenteuil, at Monet's, cannot be reached. And since I don't often set foot in the Café Guerbois, that's all the information I have."[39]

Renoir, *Portrait of Camille and Jean in the Garden at Argenteuil*, 1874.
Oil on canvas, 19⅝ × 26¾″ (49.2 × 67.9 cm). National Gallery of Art,
Washington; Alisa Mellon Bruce Collection.

Monet, *Manet Painting in the Garden in Argenteuil*, 1874. Oil on canvas, size unknown. This painting was stolen from a New York collection in 1935.

MANET AND RENOIR gave their paintings to Monet. Manet's larger canvas includes Monet tending his garden. Renoir was seated to Manet's right and was closer to the figures, but the poses of Camille and Jean in both works are the same.

Late in his life Monet told a friend a story that was published while the artist was still alive, so it undoubtedly recounts his recollection accurately: Manet began painting the scene with Camille and Jean. While he was working Renoir arrived and asked Monet if he could borrow a palette, brush, and canvas so that he could paint side by side with Manet. "Manet watched him out of the corner of his eye and went over to look at his canvas from time to time. He would grimace, slip over to me, point at Renoir, and whisper in my ear, 'That boy has no talent. You're his friend, tell

him to give up painting!'... Isn't that funny, coming from Manet?"[40] This ironic teasing was Manet's sarcastic way of expressing his admiration for Renoir. At this time he owned Renoir's 1867 portrait of Bazille, and in 1870 he had urged Fantin-Latour to place Renoir near to him in *A Studio in the Batignolles Quarter*.[41] There Renoir's head is framed in gold, suggesting that he is Manet's heir. Monet is at the extreme right.

In the early 1870s, influenced by Monet, Morisot, Pissarro, and Renoir, Manet was lightening his colors, experimenting with a more sketchy technique, and striving for a feeling of instantaneousness. Nonetheless, Renoir's painting of Camille and Jean has a more impromptu and sketchy appearance; Manet's seems more composed and defined.

Fantin-Latour, *A Studio in the Batignolles Quarter* (Manet's studio in
Paris [left to right: Otto Scholderer, Manet, Renoir, Astruc, Zola,
Maître, Bazille, Monet]), d. 1870. Oil on canvas, 80⅜ × 107⅝″
(204.2 × 273.4 cm). Musée d'Orsay, Paris.

R ENOIR MADE nine portraits of Monet between 1866 and 1875 (many of which were destined for exhibition, sale, or as gifts to Monet). In the first he appears in a large group scene with life-size figures, *The Inn of Mother Anthony, Marlotte* of 1866. Here Renoir was following both Manet's casual portraits of friends (as in *Concert in the Tuileries Gardens* of 1862; see p. 39) and Degas's casual portraits of Manet (see pp. 30 ff). Although some critics challenge the identification of Monet, the slightly later photograph suggests that it is indeed he who stands to the left in the composition, filling his tobacco pouch and looking at Sisley, who sits in the lower right foreground. Opposite Sisley, at the table, is the painter Jules Le Coeur.

Sisley has one hand in his pocket and with the other gesticulates as if to make a point in a discussion. Under his right hand appears the newspaper *L'Événement.* Monet had two canvases accepted at the Salon of 1866,[42] and Zola had praised him in a review, "The Realists in the Salon," which appeared in *L'Événement*

on May 11, 1866. It seems plausible that Renoir here portrayed Monet, Sisley, and Le Coeur as they discussed the review.

At this time Renoir and his friends often worked in the town of Marlotte, near Fontainebleau forest. Mother Anthony's Inn was their favorite dining place. Renoir had even painted a caricature on the wall depicting the recently deceased Henri Murger, author of *Scenes of Bohemian Life*, an appropriate portrait for an inn frequented by bohemian artists. At the distant right we see the back of the head of the proprietress, who leaves the room. Her daughter Nana clears the dishes.

While the theme is Impressionist, a typical subject from Renoir's own life, the style is realistic and follows Courbet's dictum that "painting is an essentially *concrete* art and can only consist of the representation of *real and existing* things."[43] Consistent with Courbet's style, the colors are dark, with a predominance of black, gray, brown, and white. However, Renoir tempered his realism with idealism and beautified the scene.

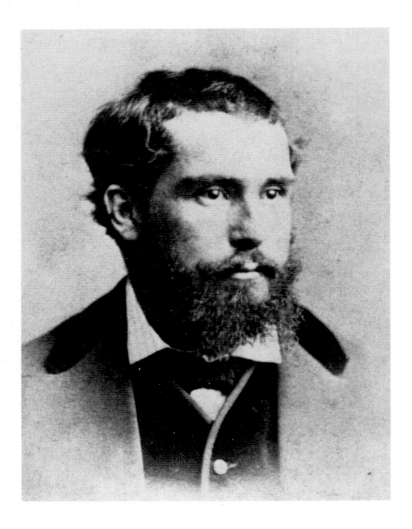

Greiner, photograph of Monet at the age of thirty-one, 1871. From Wildenstein, *Monet*, vol. 1, p. 49.

OPPOSITE: Renoir, *The Inn of Mother Anthony, Marlotte*, d. 1866. Oil on canvas, 76½ × 51″ (194.3 × 129.5 cm). National Museum, Stockholm.

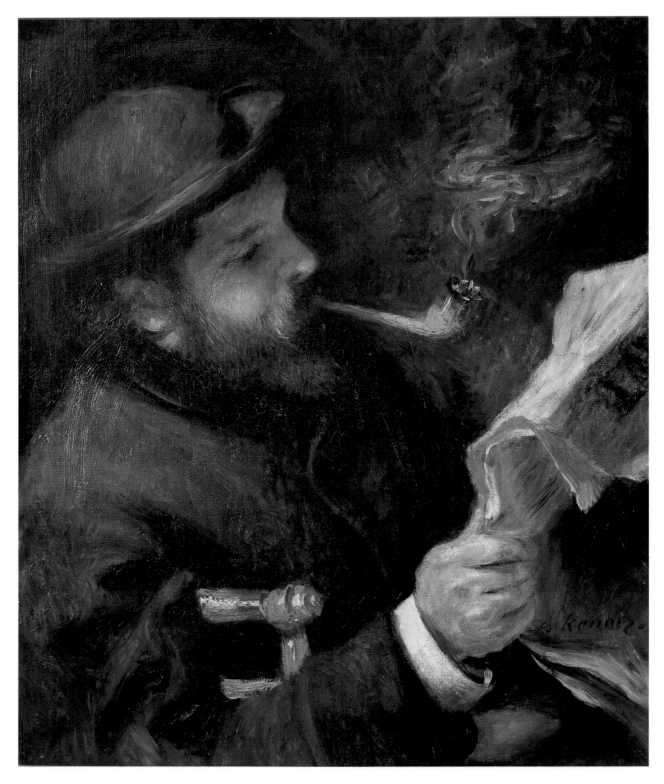

Renoir, *Portrait of Monet*, 1872. Oil on canvas, 24 × 19⅝″
(61 × 49.9 cm). Musée Marmottan, Paris.

IN 1872 Renoir did two bust portraits of Monet. As in the scene at Mother Anthony's, Monet is seen relaxing, not working. The front-view portrait was for sale (and was bought by Jean Dollfus, an early collector of Impressionist painting). The profile view, along with a companion *Bust of Camille* (see p. 91), was a gift for the Monets. All three canvases are close in size.

These portraits are among Renoir's most intimate, informal, and vibrant. Although he is preoccupied with his reading, Monet was

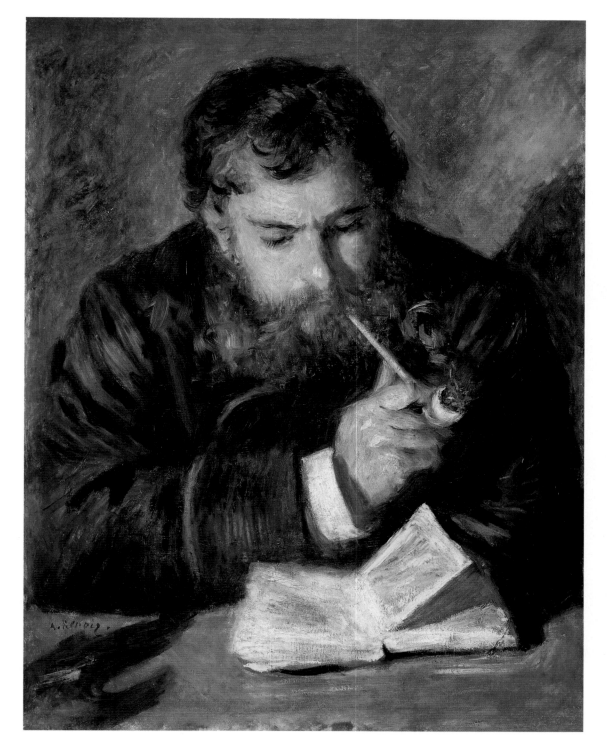

ABOVE: Benque, photograph of Monet at the age of thirty, 1875. Bibliothèque Nationale, Paris.

LEFT: Renoir, *Portrait of Monet*, 1872. Oil on canvas, 23¾ × 19″ (60.3 × 48.3 cm). National Gallery of Art, Washington; Collection Mr. and Mrs. Paul Mellon, Upperville, Va.

so comfortable with Renoir that it is as if he is alone. His relaxed posture and evident enjoyment of his pipe and reading material fill the canvas with a sense of well-being. The blue pipe smoke and fluttering pages bring the canvas to life and suggest a fleeting moment, as if Monet will quickly turn, remove his pipe, and remark on what he has read. The visible brushstrokes pervade the entire surface, reminding the viewer of Renoir's presence. In both portraits the edges of the forms also unify the image: the rounded

edges of Monet's thumb, eyebrows, and hair and of the jacket trim contrast with the straight edges of the page, cuffs, and pipe.

By 1872 Renoir used color more vibrant than any other Impressionist would dare employ.[44] Although on first glance the colors in this painting appear to be limited to blues and flesh tones, closer inspection reveals a range of small, intense, rich tones—red, pink, orange, yellow, mustard, and a variety of blues—that create a warm atmosphere.

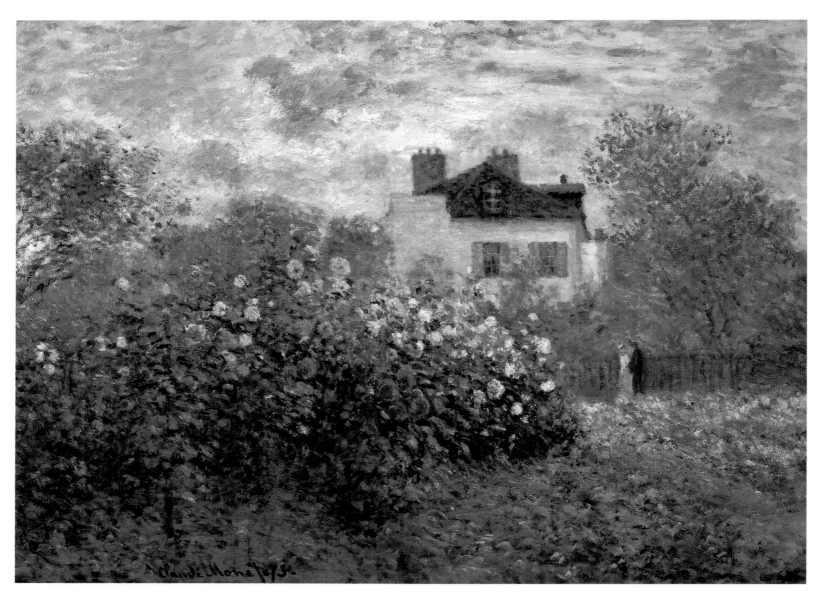

Monet, *Les Dahlias, The Artist's Garden in Argenteuil*, d. 1873. Oil on
canvas, 23½ × 31½″ (59.7 × 80 cm). Collection of Janice Levin and
partial gift to the National Gallery of Art, Washington, D.C.

In 1873 Renoir painted Monet as he worked outdoors. His
painting depicts Monet at work in his garden in Argenteuil
with dahlias in full bloom.[45] The companion work shows Monet's
interest in the rich color and movement of the flowers, the "enve-
lope" of air, and the clouds. Typical of Monet's canvases in com-
parison with Renoir's, the Monet landscape has more sky, more
space, and more interest in nature (as in the flowers). Monet's is a
wilder arrangement than Renoir's more geometric composition.

Renoir emphasized the man and his painting. Monet wears the
same blue-brimmed hat that he wore in the profile bust the pre-
vious year. He has set up his portable easel, his traveling paint box
is on the ground, and his palette and rag are in his left hand. In
keeping with Renoir's more narrative approach, his painting is
more crowded and shows more houses.

Renoir, *Monet Painting in His Garden at Argenteuil*, 1873. Oil on
canvas, 19¾ × 24″ (50.2 × 61 cm). Wadsworth Atheneum, Hartford,
Conn.; Bequest of Anne Parrish Titzell, 1957.

Monet, *Camille at Work*, d. 1875. Oil on canvas, 25⅝ × 21⅝″ (65.1 × 55 cm). The Barnes Foundation, Merion Station, Pa.

Two years after portraying Monet painting outdoors, Renoir depicted him as he painted indoors. Again, this is a side-by-side portrait combination. Just as the dahlias seemed to link the two exterior views, the appearance of the same curtains and plants in the three images suggest that Monet was working on these canvases as Renoir was painting him. In one Monet painted Camille at her needlepoint; in the other eight-year-old Jean stands in the hall, and behind him Camille sits at the dining room table. In all, large windows allow light to stream into the rooms. These images offer a glimpse of the rhythm of life in the Monet household.

When the portrait of Jean was exhibited at the third group show of 1877, the reviewers mocked the atmosphere and light in the scene. A critic with the pseudonym Jacques wrote: "[There is] an apartment interior that I barely like at all. Blue plays a dispro-

Monet, *Interior of an Apartment* (or *Jean Monet in Apartment*), d. 1875. Oil on canvas, 32⅛ × 23¾″ (81.6 × 60.3 cm). Musée d'Orsay, Paris.

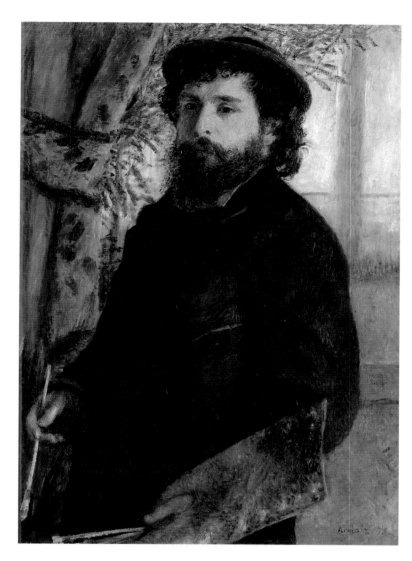

Renoir, *Portrait of Claude Monet*, d. 1875. Oil on canvas, 33½ × 23⅝″ (85.1 × 60 cm). Musée d'Orsay, Paris.

portionate role, and I really had no idea that daylight, however late, would fill dining rooms and the eyes of young boys with such azure."[46] Another reviewer remarked satirically: "A child materializes in a ray of blue light that passes through the glass of a large window."[47] Still another suggested, "This painting could be called *Symphony in Blue,* for that color streams from the window across the floor in surprising abundance."[48]

It is striking how differently Monet and Renoir depicted interior scenes. Monet, who painted more objectively, presented his wife and son sunk into the rooms and concentrated on the brilliant light. Renoir provided a more intimate close-up of a relaxed Monet pausing in his work. The large pastel drawing is probably related to this interior portrait rather than to the smaller exterior portrait. These portraits mark the end of the artists' work together.

Renoir, *Monet*, 1875. Pastel, 17⅜ × 11¾″ (44.1 × 29.8 cm). Musée Marmottan, Paris.

LEFT: Renoir, *The Promenade* (Camille and Claude), d. 1870. Oil on canvas, 31 × 25″ (78.7 × 63.5 cm). J. Paul Getty Museum, Malibu.

BELOW: Renoir, detail from *La Grenouillère*, 1869. Oil on canvas. National Museum, Stockholm.

OPPOSITE ABOVE: Renoir, *Fishing: Camille and Claude*, 1874. Oil on canvas, 21 × 25″ (53.3 × 63.5 cm). Private collection.

OPPOSITE BELOW: Renoir, *Confidences* (Camille and Claude), 1875. Oil on canvas, 32 × 23¾″ (81.3 × 60.3 cm). Portland Museum of Art, Portland, Maine; The Joan Whitney Collection at the Portland Museum of Art.

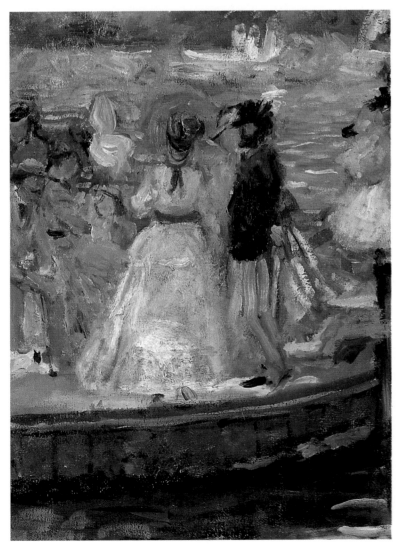

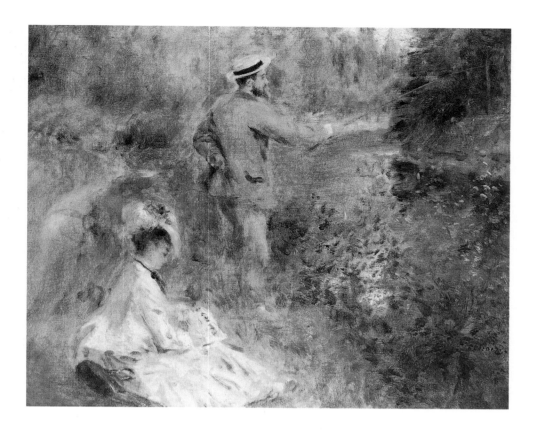

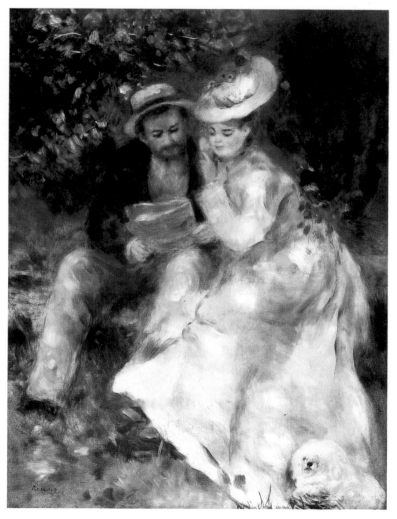

Renoir painted Monet with his wife in 1870, 1874, and 1875. They all spent a great deal of time together in 1869 and 1870, and it is likely that the couple in *The Promenade* is Camille and Claude. The woman certainly resembles Renoir's other depictions of Camille.49

A comparison of the detail from *La Grenouillère* with *The Promenade* suggests the evolution of Renoir's first Impressionist figure painting. There is a transition from diminutive figures successfully integrated into the landscape to large-scale figures, which also merge with nature.

In *The Promenade* Renoir applied the techniques of Impressionism to create an innovative figure painting in which visible brushstrokes of bright colors blur details. Contemporary figure paintings that were popular at the Salon had a smooth finish, dark color, and a somber effect. (See the Bouguereau painting illustrated on p. 59.) Renoir, in contrast, presented amorous figures, often in motion, in a diffused and delicate style. He painted the sexes in their traditional roles: Camille appears demure, sensitive, and shy, while Claude is assertive, bold, and active.

In 1874 and 1875 Renoir again used his friends as models for *Fishing* and *Confidences*. In both images they are placed near foliage so that the brilliant light filters through the branches and leaves, spotting them with random patches.

Of all the Impressionists, only Renoir painted scenes of courtship. He imbued the intimacy of this relationship with sensitivity and joy. He also idealized the figures in a manner that modernizes Antoine Watteau's Rococo loving couples.

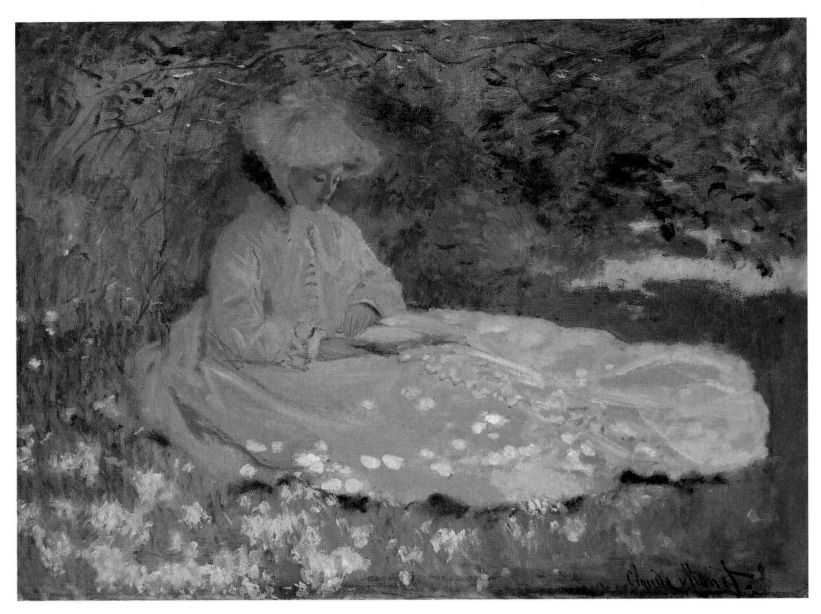

Monet, *Camille Reading*, 1872. Oil on canvas, 19⅔ × 25½″ (50 × 64.8 cm). Walters Art Gallery, Baltimore.

MONET AND RENOIR often painted the same motif not in tandem but close in time. From 1870 through 1875 Camille was their frequent model, posing for fifteen paintings by Renoir and sixteen by Monet, the greatest number done of a common subject.

In all Renoir's paintings of Camille, she appears so beautiful that one wonders if he was in love with her. Actually, Renoir painted all women as if he was enamored of them. During the years when he was working with Monet, he was a bachelor who had romantic relationships with various models, all of whom he painted lovingly. Regardless of their actual appearances, Renoir never painted an ugly or even a plain woman, man, or child. Later in his life his model Gabrielle expressed this when she described a portrait of a little girl that he was working on: "She is not pretty but the boss has made something beautiful out of her."[50] This rev-

erence for the ideal of beauty places Renoir alone among the Impressionists in the idealizing tradition of the museums.

In *A Girl Gathering Flowers* (Camille), Renoir continued the style begun in *The Promenade* (Camille and Claude) (see p. 84), blending the vaporous figure with the landscape.[51] Monet painted *Camille Reading* in 1872 in a similar style. Here, his wife, dressed in pink, is bathed in a pink, blue, and yellow light.[52] In these images the artists portray Camille as a fashionably dressed middle-class woman who has time to enjoy leisure. In both the light successfully integrates the figure and the natural surroundings.

OPPOSITE: Renoir, *A Girl Gathering Flowers* (Camille), c. 1872. Oil on canvas, 25¾ × 21⅜″ (65.4 × 54.3 cm). Sterling and Francine Clark Art Institute, Williamstown, Mass.

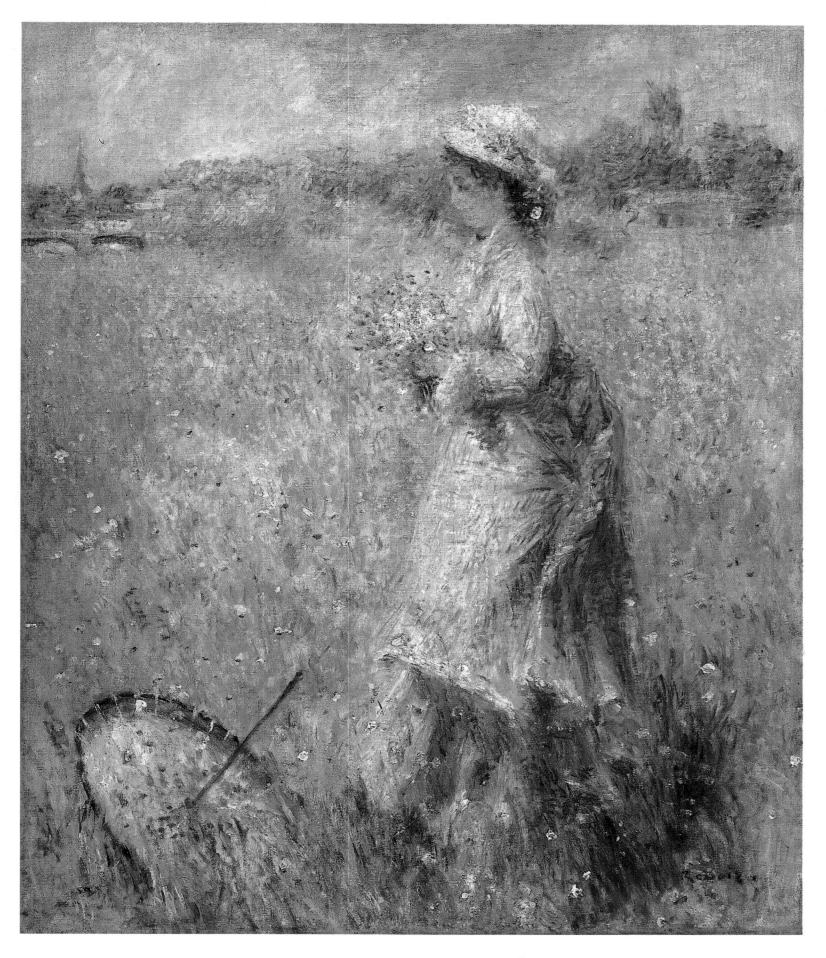

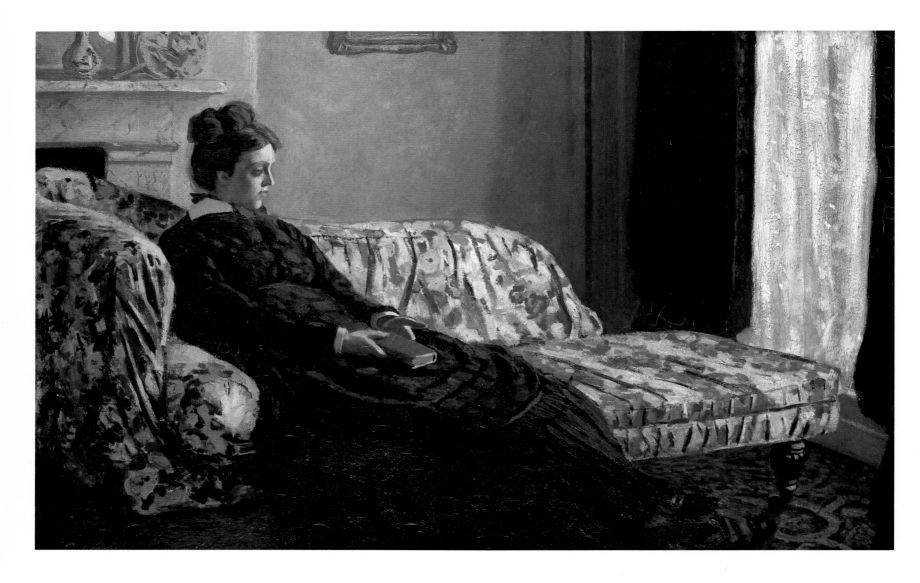

AROUND 1871 Monet painted his wife indoors, at a moment when she paused during reading. In this non-Impressionist portrait Camille comes closest to resembling a contemporary photograph of her as plain and thoughtful.[53]

While Monet's realistic portrait presents his wife as serious and aloof, Renoir transformed her into a beautiful, relaxed, and radiantly happy woman. Here again Monet painted objectively and Renoir subjectively, projecting his own perceptions and feelings onto his model. Monet's figure withdraws from us; Renoir's advances toward us. This in part contributes to the sense we have that Renoir painted an affectionate relationship between the artist/viewer and the model.

Renoir was boldly innovative in the horizontal portrait of Camille. This is the earliest dissolving portrait. The focus varies from the clearer face to the almost imperceptible hands and feet. Camille appears as a body with diffused form—no modeling, no substance, no weight—yet her penetrating glance rivets us. This painting was a gift from Renoir to the Monet family, and it hung for many years in Claude's bedroom in Giverny.

The *Head of Camille*, a preparatory study for this work, was also a gift to the Monets.

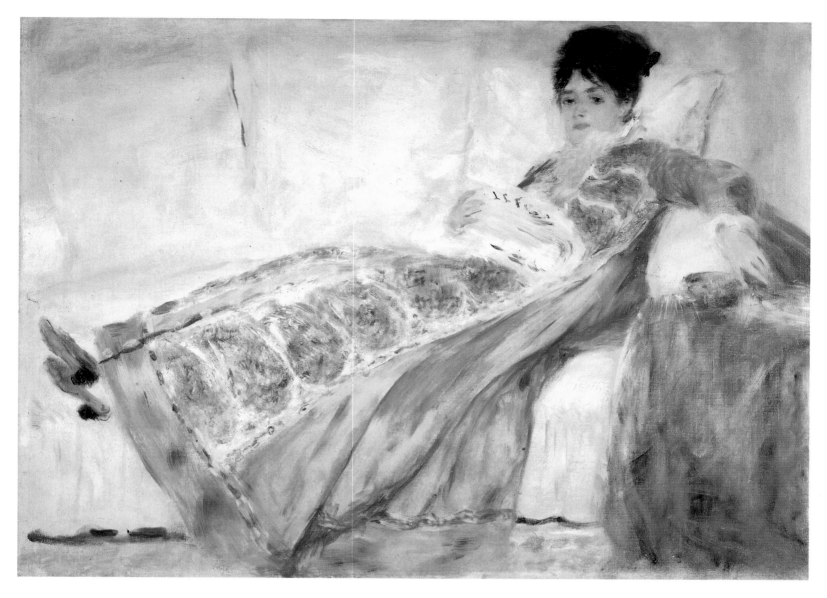

ABOVE: Renoir, *Camille Reading Le Figaro*, 1872. Oil on canvas, 21 ×
28″ (53.3 × 71.1 cm). Fundação Calouste Gulbenkian, Lisbon.

RIGHT: Renoir, *Head of Camille*, 1872. Oil on canvas, 14⅜ × 12⅞″
(36.5 × 32.7 cm). Adelson Galleries, New York..

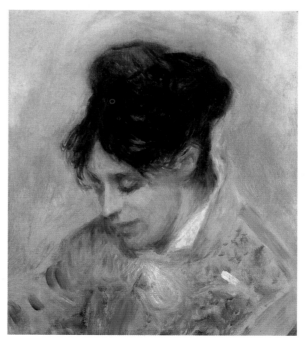

OPPOSITE ABOVE: Monet, *Repose (Madame Monet on a Sofa)*,
c. 1871. Oil on canvas, 18⅞ × 29½″ (48 × 75 cm). Musée d'Orsay,
Paris.

OPPOSITE BELOW: Greiner, photograph of Camille Monet-
Doncieux, 1871. Private collection.

IN THE VERTICAL portrait of Camille,[54] Renoir revealed the influence of Japanese art on his work. The vogue for Japanese objects began in the early 1860s and reached its height in Paris following the Universal Exposition of 1867. (Monet and his wife collected Oriental fans, artifacts, and prints; prominent in the upper left of his portrait (see p. 88) are a Chinese vase and a Japanese fan that belonged to them.) The critic Burty, friend of both artists, coined the term *Japonisme* in 1872 to refer to this craze. (Two years later Renoir wrote to him: "I will come to see you Monday morning. . . . It will still be an opportunity to say hello and to chat a bit about Japonisme.")[55] Camille's upright posture parallels the picture plane and calls to mind Japanese prints of women in which the bodies are flattened close to the picture plane.[56] Another compositional technique common to Japanese prints, evident in the way the fans are cut by the frame, is found in both Monet's and Renoir's portraits of Camille with a book. The *Bust of Camille* is a companion painting to the profile view of Monet reading (see p. 78). Both were gifts to the Monets.

All Renoir's relaxed portrayals of Camille suggest that he felt comfortable with his friends and that they inspired him to be free and experimental. The portraits are intimate studies in which the visible strokes create a lively, snapshot effect. Renoir treated his figures as models in active scenes; these are not meant to be revealing character studies. Consequently, he blurred the distinction between making a portrait of someone and using that person as a model.

Renoir, *Bust of Camille*, 1872. Oil on canvas, 24 × 19⅝″ (61 × 49.8 cm). Musée Marmottan, Paris.

OPPOSITE: Renoir, *Madame Claude Monet Reading*, 1872. Oil on canvas, 24⅛ × 19⅝″ (61.3 × 49.8 cm). Sterling and Francine Clark Art Institute, Williamstown, Mass.

Monet, *Camille Monet, Son, and Nurse in the Garden*, d. 1873. Oil on
canvas, 23⅞ × 31⅞″ (60.6 × 81 cm). Private collection.

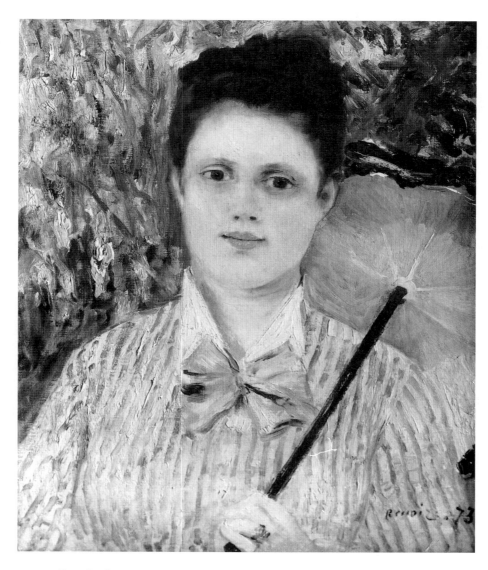

Renoir, *Camille with Umbrella*, d. 1873. Oil on canvas, 18 × 15″ (45.7 × 38.1 cm). Private collection.

In 1873 both Monet and Renoir did paintings of Camille outdoors (not side by side). Monet's canvas is almost three times larger than Renoir's small bust portrait. Camille wears the same elegant costume in both but holds different umbrellas on opposite shoulders.

The differences between the two paintings are again instructive. Monet's looks like a landscape to which the figures of Camille, Jean, and the nurse have been added, whereas Renoir's is a figure painting to which the landscape has been added. Monet remained true to his interest in nature, Renoir to his in figures.

Here Monet painted Camille in an Impressionist style. He concentrated on the sun-drenched flowers and space outside his home, even though he accorded Camille a prominent place in the painting. The bright light appears to dissolve her. Her features and silhouette are not clearly defined. The details are indistinct, and the body lacks sensuality, texture, and density.

Conversely, in Renoir's painting, light bathes Camille but does not dissolve her form, and a light that emanates from within gives her a radiant and sensual appearance. Renoir's portrait also contrasts linear patterns (ringed hand, striped blouse, umbrella, linear strokes in foliage) and smoother surfaces (lips, skin, hair, and magnetic eyes). Monet's figure is truly Impressionist; Renoir's has an underlying solidity with a focus on the eyes and hand.

Monet, *Camille Monet and a Child in the Artist's Garden in Argenteuil*,
d. 1875. Oil on canvas, 21¾ × 25½″ (55.2 × 64.8 cm). Museum of
Fine Arts, Boston; Anonymous Gift in Memory of
Mr. and Mrs. Edwin S. Webster.

THE PAINTINGS of Camille and a child again show stylistic differences. Monet's figures are part of nature and sink into the space; Renoir's sensuous figures interact with us in a magnetic and seductive manner. The child is unidentified: it cannot be Jean, who was born in 1867, nor the Monets' second child, Michel, who was not born until 1878.

Renoir, appreciative of the Monets' hospitality and of their willingness to model for him, gave them his *Portrait of Monet* (in profile, 1872; see p. 78), *Bust of Camille* (1872; see p. 91), *Camille Reading Le Figaro* (1872) and its preparatory study (see p. 89), *Portrait of Camille and Jean in the Garden at Argenteuil* (1874; see p. 73), and the pastel of Monet (1875; see p. 83). The Monets' collection also included Renoirs from a later period: *The Mosque, Algiers* (1881),[57] *The Casbah, Algiers* (1881), *The Algerian Woman*

Renoir, *Woman* (Camille) *with a Parasol and a Small Child on a Sunlit Hillside*, c. 1874. Oil on canvas, 18½ × 22⅛″ (47 × 56.2 cm). Museum of Fine Arts, Boston; Bequest of John T. Spaulding.

(1882), a drawing of Richard Wagner (1882), a seated nude of 1882, and a canvas with two nudes.[58]

Visitors to his home reported that Monet kept three of these works in his bedroom—*Camille Reading Le Figaro, Portrait of Camille and Jean in the Garden at Argenteuil,* and the seated nude.[59] He told one visitor that he never wanted to part with any

of his Renoirs, although once when he was in need of money, he had to sell one for 300 francs.[60]

Renoir seems to have owned one Monet, the *Sailboat* of 1868, a work he purchased in 1892 from Durand-Ruel and kept in the living room of his home in Cagnes.

Monet, *Le Pont Neuf,* d. 1872. 20⅞ × 28½″ (53.5 × 73.5 cm). Dallas
Museum of Art; The Wendy and Emery Reves Collection.

I N AT LEAST three instances, Monet and Renoir painted the identical landscape motif from the same spot within a year's time, in pairs that were not done side by side. It is, however, likely that one artist knew of the other's work. The first such pair is of the Pont Neuf in Paris, under different weather conditions.[61] Quite atypically, here we have a small sketch by Monet and a large, detailed version by Renoir, which later sold at the first Impressionist auction in 1875.[62] The Renoir looks closer to the contemporary photograph.

Both artists viewed the scene from a mezzanine above a café on the right bank of the Seine, looking south over the bridge as it spans the river at the western tip of the Ile de la Cité. This high vantage point was popular both in contemporary photographs of Paris and in well-known Japanese prints of city scenes. The asymmetrical compositions are characteristic of the Impressionists' search for seemingly random views of the city.

Both paintings include the crowded buildings in front of the Quai de l'Horloge on the Ile de la Cité and look beyond to the

houses of the Quai des Grands Augustins on the Left Bank. On the right the Ile de la Cité terminates with the Place du Vert Galant, where we see the equestrian statue of Henri IV on its plinth and beyond that the Quai Conti. In the center is the Pont Neuf and its continuation into the Rue Dauphine on the Left Bank.

Renoir's painting employs bright primary colors to create the scintillating effect of a sunny day. He contrasted the warm colors from the sunlight with the cool blues of the sky and river, and his all-over visible brushwork adds to the vibrancy of the scene. His wider view includes, at lower right, a public bathing establishment that flies the French flag.

Seven years after Renoir painted this scene, his brother Edmond, a journalist, described how the artist worked:

We established our quarters at the entresol of a little café at a corner of the quai du Louvre, but much nearer the Seine than are the present buildings. For our two coffees, at ten centimes each, we could stay at that café for hours. From

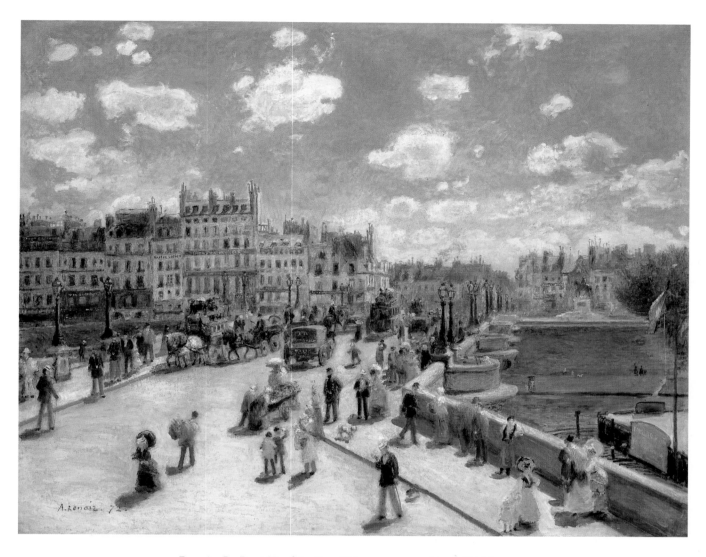

Renoir, *Le Pont Neuf*, d. 1872. Oil on canvas, 29⅝ × 36⅞″ (75.2 × 93.7 cm). National Gallery of Art, Washington; Ailsa Mellon Bruce Collection.

here Auguste overlooked the bridge and took pleasure, after having outlined the ground, the parapets, the houses in the distance, the place Dauphine and the statue of Henri IV, in sketching the passers-by, vehicles, and groups. Meanwhile I scribbled, except when he asked me to go on the bridge and speak with the passers-by to make them stop for a minute.[63]

Renoir's canvas evokes the cheerful mood of a weekend or holiday afternoon. One could easily enlarge these tiny people to make intriguing large-scale figure paintings. Monet chose a slightly different angle and a slightly narrower view. His *Pont Neuf* is a sober image, which conjures up a working day with fewer people. It is raining, and the people do not look at one another as they scurry along, protected by their umbrellas. The separate figures move away from us, whereas Renoir's sociable folk amble toward us. By the use of dour gray tones and hasty brushwork, Monet captured the drizzle, the reflections on the pavement, the gray smoke of the tugboat, and the wind.

Photograph of Le Pont Neuf, c. 1860. Bibliothèque Nationale, Paris.

Monet, *Railroad Bridge in Argenteuil*, 1873. Oil on canvas, 23 × 38″
(58.4 × 96.5 cm). Private collection.

THE VIEWS of the railroad bridge at Argenteuil are another instance of separate renderings of the same motif. Monet's is a large, important painting, which was sold to the singer Jean-Baptiste Faure in 1874 and exhibited at the second Impressionist show in 1876. Renoir's is a little sketch.

This is a different bridge from the one barely visible in both artists' *Sailboats at Argenteuil*. In that pair of images, the artists looked from Petit-Gennevilliers toward Argenteuil. Here they looked from Argenteuil toward Gennevilliers. The artists could see this scene fifty feet from Monet's backyard.

Renoir, *Railroad Bridge in Argenteuil*, 1873. Oil on canvas, 18 × 24¾″
(46 × 63 cm). Private collection.

This pair is a reversal in many ways of what we have come to expect. Monet took a wider view and depicted more details. He showed all four concrete cylinders that support the iron bridge. Renoir left out the Argenteuil end of the bridge and included only three supports. Monet incorporated two figures on the shore contemplating the modern bridge, which had been rebuilt after the old one was destroyed during the Franco-Prussian War. Monet also included two sailboats, whereas Renoir put several small boats in the distance. In Monet's painting, two trains pass in opposite directions; in Renoir's, one train approaches Argenteuil.

Renoir, *Tuileries Gardens*, 1875. Oil on canvas, 9 × 12˝ (22.9 × 30.5 cm). Private collection.

Monet, *Tuileries Gardens* (sketch), d. 1875 but actually painted in 1876. Oil on canvas, 19⅝ × 29˝ (49.8 × 73.7 cm). Musée d'Orsay, Paris.

OPPOSITE: Renoir, *Mme. Chocquet Reading*, c. 1875. Oil on canvas, 25⅝ × 21˝ (65.1 × 53.3 cm). Private collection.

IN *Tuileries Gardens*, as in *Pont Neuf*, the artists did identical views from an elevated location. In 1875 Renoir painted a tiny landscape that he later developed into the background for a portrait. The following year Monet did several renditions from the same spot, the apartment of Victor Chocquet at 198, Rue de Rivoli, in Paris.

Chocquet, one of the early Impressionist patrons, was a customs official and a passionate collector. Over time he acquired thirty-six or thirty-seven Cézannes, fourteen Renoirs, twelve Monets, five Manets, three Morisots, one Pissarro, and one Sisley. He attended the first Impressionist auction on March 24, 1875, and, although he did not purchase any paintings, he wrote to Renoir the follow-

ing evening, asking him to do a portrait of Mme. Chocquet. Less than a year later, Chocquet had acquired at least six pictures by Renoir, which he lent to the second Impressionist exhibition in April 1876. Among those were three portraits of Mme. Chocquet done around 1875, two of which show her in front of their apartment window with a view of the Tuileries Gardens in the background. In one, she stands and blocks the view. In the other, *Mme. Chocquet Reading* (see p. 101), she sits next to the window, permitting a view of the gardens. Renoir's small sketch was undoubtedly a preparatory study for the background in the larger painting.[64]

In 1875 Renoir introduced Cézanne to Chocquet. Almost a year later Cézanne took the collector to Argenteuil to meet Monet. Monet wrote to Chocquet on February 4, 1876: "I made Cézanne promise that he would come with you for lunch tomorrow, Saturday. If it doesn't scare you off to have a very modest lunch, it would be the greatest pleasure for me because I couldn't be more pleased to make your acquaintance."[65] It is possible that Monet had seen Renoir's *Mme. Chocquet Reading* and perhaps also his *Tuileries Gardens* (see p. 100).

Renoir's landscape background seems to have inspired Monet, in 1876, to paint four views from Chocquet's windows, showing the Tuileries Gardens in the foreground, the Louvre to the left, and in the distance the twin spires of the Church of Sainte-Clotilde near the Dome of the Invalides. Monet exhibited three of them at the third Impressionist exhibition in 1877 and soon sold all four. The one pictured here was bought by Caillebotte, but surprisingly none went to Chocquet.

In AN ARTICLE in *Le Voltaire* of 1880, Zola wrote of the Impressionists:

> The real misfortune . . . is that no artist of this group has achieved powerfully and definitely the new formula which, scattered through their works, they all offer. The formula is there, endlessly diffused; but in no place, among any of them, is it to be found applied by a master. They are all forerunners. The man of genius has not arisen. We can see what they intend, and find them right, but we seek in vain the masterpiece that is to lay down the formula. . . . This is why the struggle of the Impressionists has not reached a goal; they remain inferior to what they attempt, they stammer without being able to find words.[66]

In a review in *Le Figaro* of the 1882 show, the powerful critic Wolff also wrote negatively, "Renoir or Claude Monet, Sisley, Caillebotte, or Pissarro, it's the same musical note."[67] Such criticisms drove Monet and Renoir to seek distinctive styles, working alone.

The friendship waned for personal and artistic reasons. By 1879 Camille had died, and Monet's home life became complicated. He combined families with Alice Hoschedé—his two children plus her six—and they moved farther away from Paris, to Vétheuil. Alice's husband, Ernest, died in March 1891, and she and Claude married in July 1892. After 1890 Monet embarked on the series of paintings that includes the grain stacks and records nature's changes, while Renoir concentrated more on classical nudes. In the last decade of the nineteenth century, Renoir's art became more conservative, while Monet's became more innovative.

On the basis of some letters from the early 1880s, it appears that Monet put an end to working with Renoir or with any other artist after 1875. (Renoir continued painting with various artists through 1894.) It seems that Monet returned to the idea he had expressed in 1868, that it was better to paint alone with nature. Eight years after they had last worked in each other's company, the two men traveled together from December 10 to 26, 1883. A letter from Cézanne to Zola relates, "I saw Monet and Renoir, who went off vacationing in Genoa in Italy around the end of December."[68] Their route was along the Mediterranean coast from Genoa to L'Estaque, France. As Renoir wrote to his dealer: "We are enchanted by our trip. . . . We judged that it was preferable to study the countryside carefully so that when we come back we will know where to stop."[69] They did not paint side by side, nor did they paint the same motif.

Renoir apparently enjoyed this reunion and when the voyage was over harbored the hope that they might continue to work together. Monet, however, was adamantly opposed. He wrote to Durand-Ruel from Giverny before embarking on a painting trip on January 12, 1884:

> I am asking you to speak to *no-one* about this trip; not that I want to make it a secret, but because I want to do it alone. As much as it was agreeable to do the trip as a tourist with Renoir, it would be a nuisance for me to do a working trip together. I have always worked better in solitude, and from my own impressions, so keep this secret, until I tell you otherwise. Renoir, knowing that I am about to leave, would no doubt be eager to come with me, which would be just as harmful for each of us. You will probably agree with me.[70]

From Bordighera sixteen days later, Monet again wrote to his dealer: "I wrote to Renoir and I am not making my stay here a secret. I only wanted to come alone, to be free with my impressions; it is always bad for two people to work together."[71]

Four years later Monet again insisted on painting alone. In January 1888, from the Riviera, he wrote to Alice: "This morning I received news from Renoir, whom I have always feared would show up here. He is staying in Aix at Cézanne's house, but he complains of the cold, and he asks if it is warm where I am and if it is nice. Naturally I am not going to ask him to try to come, and I will not tell him that I am going to Agay; I have too much of a need to be alone and in peace."[72] While he did not want to work with them, Monet missed his artist friends and felt lonely. In November 1884 he wrote to Pissarro: "I wrote to Renoir so that we could set up a time to dine all together each month, so that we can get together to talk because it is stupid to isolate oneself. As for me, I am turning into a clam and all I do is worry more about it."[73] The men instituted monthly dinners at the Café Riche.

In later years each artist had praise for the other's works. In 1886 Renoir was invited to participate in an exhibition at Georges Petit's gallery, where Monet had shown the year before. After a glowing review by Mirbeau, Renoir wrote to the critic about an article that discussed himself, Monet, and Auguste Rodin, remarking, "You do me the honor of putting me next to the two greatest artists of the period."[74] In 1912 Monet wrote to Geffroy: "Congratulations on the article on Renoir's portrait. Yes, that one is certainly a beautiful and rare painter."[75]

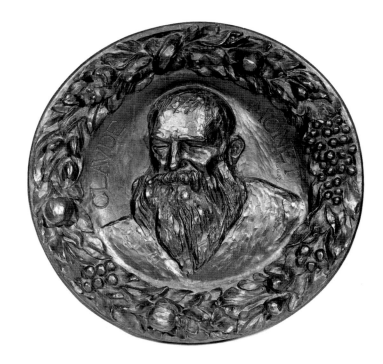

ABOVE: Renoir, *Portrait Medallion of Claude Monet* (sculpted by Renoir's assistant Richard Guino after the 1906 drawing), 1916–17. Bronze, diameter 27⁵⁄₁₆″ (69.5 cm). The Chrysler Museum, Norfolk, Va.; Gift of Walter P. Chrysler, Jr.

LEFT: Renoir, *Drawing of Monet*, 1906. Size unknown. Location unknown.

THE TWO MEN were estranged around 1889, when Monet sold more paintings at higher prices than did Renoir. Their colleagues were distressed by the news. Duret wrote to Caillebotte: "I was pained to read what you had written me about the quarrel between Monet and Renoir. Men who as friends had endured misfortune and who break up as soon as success comes to them unequally!"[76] By mid-1891 the breach was beginning to mend. On July 22, Monet generously wished Pissarro and Renoir the good fortune that he had received.[77] It took a few more years for the artists' prices to reach parity: in 1893 the best Renoirs were priced at 4,000 francs while Monet was asking 15,000 francs for his cathedrals. A few years later, though, Renoir's work started to sell at equivalent prices to and sometimes higher prices than Monet's.[78]

Around 1900 the painters' friendship was tested again because of a difference in attitudes toward traditional honors. On August 16, 1900, Renoir accepted the government's invitation to become a *chevalier* [knight] of the Legion of Honor. Because he hated such official accolades, Monet scorned Renoir's decision, as Renoir knew he would. Renoir did not want to create a rift with his friend and still felt vulnerable—as he always had. Consequently, a month after having accepted the honor, he wrote to Monet: "My dear friend, I let them decorate me. Be assured that I am not telling you this for me to discuss with you whether I am wrong or right, but so that this little piece of ribbon does not become an ob-

stacle to our old friendship. No matter whether I did a foolish thing or not, you can make silly remarks, say the most unpleasant words, it will be all right with me, but no joking please. Your friendship is very important to me. As for the others, I couldn't care less about them. In friendship, Renoir."[79]

Three days later he again wrote to Monet:

Dear friend, I realize today and even before that I wrote you a stupid letter. I was feeling ill, nervous, tense. One should never write in those moments. I wonder a little what difference it makes to you whether I've been decorated or not. You are admirably consistent in your behavior, while I have never been able to know the day before what I would do the next. You must know me better than I do myself, just as I very probably know you better than you do yourself. So, rip up this letter and let's not talk about it anymore and long live love! My warm greetings to Mme. Monet and to all at your place. Yours, Renoir.[80]

Monet wrote to Renoir of his disapproval: "Oh! it is so sad!"[81] He also wrote to his friend and biographer Geffroy:

You doubtless know about Renoir's decoration. I myself am very sad about it, and Renoir feels this so acutely that he wrote to me to excuse himself, poor man. Truly isn't it very

ABOVE: Nadar, photograph of Monet at the age of fifty-nine, 1899. Bibliothèque Nationale, Paris.

BELOW: Photograph of Renoir, around the age of sixty-four, painting at Villa de la Poste, Cagnes, c. 1905.

sad to see a man of his talent, after having struggled so many years and to have so valiantly led this struggle in spite of the administration, then at the age of sixty to accept the decoration? Humans are really pathetic. It would have been so chic to stay virgins from rewards, but who knows. I will perhaps be the only one remaining pure in this regard, unless I become really senile.[82]

Despite his disapproval Monet was concerned about his old friend. A year later he wrote to a friend who was living near Renoir in the Midi: "Do you sometimes see Renoir, and is he really in better health? If accepting the Cross of the Legion of Honor could have done the miracle of *making him feel better*, I would forgive him for his weakness."[83]

The two men remained friends. In September 1908, Monet was one of the first houseguests at the new Renoir home in Cagnes: "Monet is within our walls," exclaimed his host.[84] And when, a decade later, Renoir was promoted to the rank of *officier* of the Legion of Honor, Monet graciously wrote, "My dear Renoir, My congratulations on your nomination to the rank of officer."[85]

In their sixties and seventies, the artists maintained a friendship that was warm but sporadic, because of the physical distance between them. Monet spent his time in Giverny, and Renoir moved among his residences in Paris, Essoyes, and Cagnes. In 1905 the art dealer Ambroise Vollard commissioned Renoir to make a portrait drawing of Monet. Renoir began it, took sick, and then wrote Monet in October 1905 that he was too ill to finish it.

A year later Alice Monet wrote a series of letters to her daughter about Renoir's desire to draw Monet's portrait. From Giverny, "Monet wrote to Renoir to inquire if he has arrived in Paris, for Renoir is to make a sketch of Monet for Vollard. Renoir writes that he will stay there approximately two weeks."[86] The next day, from Giverny, "Tomorrow Monet will pose at Renoir's place."[87] The next day from Paris, "When Monet arrived here, he found a note saying that Renoir was waiting for him to pose for his drawing and that he would keep him for lunch."[88] The work was finally completed, and Alice reported from Paris the next day, "Monet is very satisfied with what Renoir has done. I believe they were very happy to see each other."[89]

A decade later, in 1916–17, Renoir had his sculptural assistant make medallions of some of the great artists of the past and present: Corot, Delacroix, Ingres, Cézanne, Monet, and Rodin. The bust of Monet is a reversal of the 1906 drawing.[90]

Throughout the years of World War I, numerous letters from Monet express his concern about Renoir's health and about Renoir's two sons, who were wounded in battle. To his dealer Monet wrote: "As for Renoir, he is still amazing. They say he is very sick, and then suddenly one hears of him working hard and valiantly nonetheless. He is simply admirable."[91]

Renoir died on December 3, 1919, at age seventy-eight. Monet wrote four letters describing how devastated he felt. All are similar to his letter to Geffroy: "And then the death of Renoir is for me a painful blow. With him leaves a part of my life, the struggles and the enthusiasms of youth. It is very hard. And here I am, the survivor of this group."[92]

Cézanne & Pissarro

THE CLOSE ten-year association between Cézanne and Pissarro began in 1872 and was motivated by what they could learn from each other. During that time they made twenty side-by-side paintings in their very distinct styles. They were not looking to forge a common style; rather, each was trying to enhance his uniqueness by capturing his sensations in front of nature. (In French, *sa sensation* encompasses one's own physical and sensorial experience.) They painted together because they respected and admired each other's art and felt comfortable being influenced by each other. In eight portraits they depicted each other as artists as well as friends. In addition, Cézanne made three copies of Pissarro's work.

In 1895 Pissarro recalled his first meeting with Cézanne: "Didn't I judge rightly in 1861," he wrote to his son Lucien, "when [Francisco] Oller[1] and I went to see the curious *provençal* at the Académie Suisse where Cézanne's figure drawings were ridiculed by all the impotent artists."[2] In 1861 Cézanne was twenty-two years old and Pissarro, the eldest among the Impressionists, thirty-one. Through Pissarro, Cézanne met many of the future Impressionists, including Monet and Renoir.

Cézanne and Pissarro shared certain life situations. Both were born far from Paris, Cézanne in Aix and Pissarro in St. Thomas in the West Indies. Pissarro was a Jew, which made him something of an alien among the Impressionists. In 1885 he expressed to Monet his dismay at Renoir's brother's accusation that he was a "first-class schemer, untalented, a greedy Jew, plotting underneath to replace . . . [Monet] and Renoir. . . . Is it because I am an intruder [by being Jewish] in the group? It would really be unfortunate to realize this so late!"[3] Pissarro's outsider status may have appealed to Cézanne, whose very personality made him an outsider also.

Both artists faced parental opposition; their fathers wanted them to follow in their footsteps and seek careers as businessmen. Despite self-doubts each decided to pursue his dream of being an artist. Although Cézanne never overcame his aversion to his bourgeois family, he did appreciate the allowance he received from age twenty-three onward; it meant he never suffered the financial hardships endured by Pissarro, who had little money, a wife, and six children.

As youthful bohemians, they both dressed and acted like workmen, and they both postponed getting married until after they had children. Cézanne formed a stable union with Hortense Fiquet in 1869; she gave birth to their son, Paul, in 1872; they married in 1886. In 1858 Pissarro began a liaison with his mother's maid, Julie Vellay; their first child was born in 1863 and a second in 1865; they married in 1871 and soon had four more children. In their youth, as nonconformists, both Cézanne and Pissarro objected to France's conservative politics. Cézanne disdained all authority in matters of art and personal life, but he was basically apolitical. As early as 1870 Pissarro was an anarchist (according to his son Lucien) and a revolutionary in 1882 (according to Renoir).[4] After their time together Pissarro became more outspokenly anarchist and socialist while Cézanne grew more politically conservative.

CÉZANNE'S PERSONALITY was complex. In his youth he was a "hopeless dreamer. Withdrawn and shy, [he] was at the same time romantic and boisterous, exuberant and unstable, overconfident and moody, hesitant and stubborn, proud and melancholy, sensitive and insecure, suspicious and irascible."[5] An anxious person, Cézanne realized that his temperament was an obstacle and longed, as he wrote to one of his patrons, "to possess the intellectual balance so notable in you . . . that enables you to attain the goals you set. . . . And since I was struck by that serenity, I'm mentioning it to you. Fate did not provide me with similar fare, it's my only regret where earthly matters are concerned."[6] Work helped to allay his distress. As he wrote to Zola: "Work . . . is, in my opinion and in spite of all the alternatives, the sole refuge where one can experience true inner contentment."[7] Cézanne liked solitude and became increasingly reclusive as he aged. He wrote, "The fear of appearing inferior . . . is doubtless the excuse for keeping to one's self."[8]

Cézanne was like a boiling caldron with the cover on. His intensity was legendary; yet he had a softer side. As Cassatt noted: "[Cézanne] is like the man from the Midi whom [Alphonse] Daudet describes: 'When I first saw him [probably in the late

Photograph of Cézanne (right) and Pissarro (left) in the Auvers region, c. 1872. Cézanne is thirty-three years old; Pissarro is forty-two. Private collection.

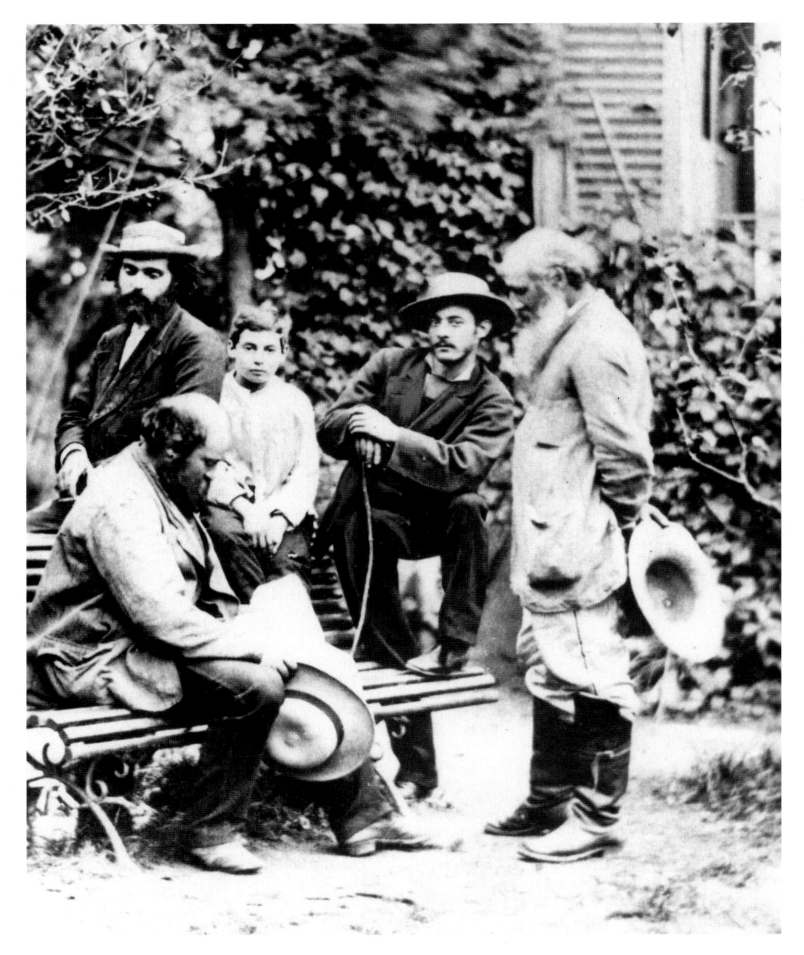

1870s] he looked like a cut-throat weaver [bird with a red chest], with large red eye-balls standing out from his head in a most ferocious manner, a rather fierce-looking pointed beard, quite gray, and an excited way of talking that positively made the dishes rattle.' I found later that I had misjudged his appearance for, far from being fierce or a cut-throat, he had the gentlest nature possible, *like a child*, as he would say."[9]

When he reached middle age, Cézanne was prone to erratic behavior as a result of untreated diabetes. On several occasions he turned against old friends, including Pissarro. With knowledge of his medical problems, in 1896 Pissarro excused him:

> It seems he [Cézanne] is furious with all of us: "Pissarro is an old fool, Monet a cunning fellow, they have nothing in them. . . . I am the only one with temperament, I am the only one who can make a red! . . ." [Doctor] Aguiar has been present at scenes of this kind; speaking as a doctor, he assured Oller that Cézanne was sick, that the incident couldn't be taken seriously since he was not responsible. Is it not sad and a pity that a man endowed with such a beautiful temperament should have so little balance?[10]

A few years later, when Pissarro was still alive, Cézanne wrote to a critic: "I despise all living painters, save for Monet and Renoir."[11] While Pissarro may not have learned of that insult, he was aware of others.

Although Cézanne was certainly cognizant of Pissarro's role in persuading Cézanne's dealer, Ambroise Vollard, to mount his first retrospective in 1895, the following year Cézanne denigrated his mentor. The benevolent Pissarro could ignore his behavior, as he explained to his son: "Cézanne, who is now doing Geffroy's portrait, is running me down to him. Now that's nice! . . . Let us work hard and try to make dazzling grays! It will be better than running down the others in turn."[12] Since the 1870s Pissarro had taken it upon himself to defend and promote Cézanne's work to collectors. To Duret he wrote in 1873, "If you are looking for something out of the ordinary, I think Cézanne's the man for you; he has some very strange studies, his vision is unique."[13] Pissarro also made the critics aware of Cézanne's importance. He questioned Joris-Karl Huysmans in 1883, "Why is it that you do not say a word about Cézanne, whom all of us recognize as one of the most astounding and curious temperaments of our time and who has had a very great influence on modern art?"[14] Furthermore, as one of the organizers of the Impressionist shows, Pissarro invited Cézanne to the first exhibition in 1874 and urged him again to exhibit in 1877. In a letter to Lucien in 1896, Pissarro reflected: "For thirty years [I] defended him with so much energy and conviction!"[15]

As evidence of his admiration, Pissarro had a collection of more than forty Cézannes: twenty-four oils (twelve landscapes, four portraits, three mythologies, two nudes, two still lifes, and one genre), nine watercolors, and nine pencil drawings. Many were done between 1872 and 1882, the decade the artists worked together. Some had special importance for Pissarro: *Orchard in Pontoise, Quai de Pothuis* (see p. 130), was done side by side with Pissarro; the background of *Still Life with Soup Tureen* (see p. 144), copies a Pissarro landscape. Pissarro's collection also included the drawings *Pissarro, Seen from the Back* (see p. 143) and *Pissarro in Pontoise Going Out to Paint with a Walking Stick and Knapsack* (see p. 141).[16]

The generosity Pissarro extended to Cézanne was typical of this mild-mannered patriarch who was happy to share his knowledge and equally eager to learn from those he taught.[17] He was the most ethical, moral, and magnanimous of the Impressionists, and one could not, a contemporary recalled, "set eyes on him without being impressed by the simple majesty of his countenance, in which there was never a hint of hardness or disdain."[18] Another recalled, "The first thing that struck one in Pissarro was his air of kindness, of delicacy and at the same time of serenity that joyous work brings forth."[19] Yet another mused: "Whether it was because he was infallible, infinitely kind and just—or was it merely his prominent, beaky nose and long white beard?—in any case, everyone who knew him in the nineties thought of him as something like God the Father."[20] Zola linked Pissarro's moral qualities with his art: "One need only glance upon such works [by Pissarro] to understand that there is a man within them—an upright and vigorous personality incapable of falsehood—who fashions art into a pure and eternal truth."[21]

CÉZANNE THOUGHT of Pissarro as his teacher, friend, and second father. Nonetheless, after he had worked with Pissarro for two years, Cézanne felt that his art had surpassed his master's. He wrote to his mother: "I know that he [Pissarro] thinks well of me, given my own good opinion of myself. I'm beginning to feel stronger than all those around me, and you know that I have reasons for the good opinion I have of myself."[22] Another indication that Cézanne esteemed Pissarro's art less than Pissarro valued his is the fact that, later in his life, he had no works by Pissarro in his art collection, although he was wealthier than Pissarro.

Nonetheless, on many occasions in his later years, Cézanne proclaimed the talent of his teacher and admitted his debt: He listed himself in exhibition catalogs of the early 1900s as "Paul Cézanne, pupil of Pissarro."[23] He wrote of "the humble and colossal Pissarro."[24] "As for old Pissarro," he said, "he was a father to me; someone to turn to for advice, somebody like the good Lord Himself."[25] "In our times," he wrote, "there are no more real painters. Monet supplied vision. Renoir created the woman of Paris. Pissarro drew near to nature. What follows does not count."[26] On another occasion he referred to Monet and Pissarro as "the two great masters, the only two."[27] That he credited Pissarro with having fundamental importance for Impressionism was evident when he said: "We may all descend from Pissarro."[28]

In earlier years Cézanne and Pissarro had tried similar methods of exhibiting their work. Although Cézanne submitted works to

fifteen Salons between 1863 and 1886, he was accepted only once, in 1882. Pissarro was accepted at seven Salons from 1859 to 1870. Cézanne exhibited in two Impressionist shows, whereas Pissarro participated in all eight. The first known letter from Cézanne to Pissarro discusses the Salon of 1865: "Dear Mr. Pissarro . . . I should like to know whether . . . you have prepared your canvases for the Salon. . . . On Saturday, we will go to the shed on the Champs-Elysées to bring our canvases, which will make the Institute blush with fury and despair. I hope you will have done some nice landscapes; with a cordial handshake. Paul Cézanne."[29] While Cézanne's work was rejected, two of Pissarro's landscapes were accepted.

By this time Pissarro was moving in an avant-garde direction. Cézanne later recalled: "In '65 he was already reducing black, bitumen, raw sienna, and the ochres. That's a fact. 'Never paint with anything but the three primary colors and their derivatives,' he used to say to me."[30]

In 1866 Pissarro and Cézanne attended Zola's Thursday night dinners, and both men spent late afternoons discussing art at the Café Guerbois. Once again Cézanne was rejected and Pissarro accepted by the Salon. Zola wrote:

> M. Pissarro is an unknown artist about whom nobody will probably talk. I consider it my duty to shake his hand warmly before I leave. Thank you, sir. Your winter landscape refreshed me for a good half hour during my trip through the great desert of the Salon. . . . You should realize that you please no one, and that one finds your painting too bare, too black. Then, why the devil do you have the arrogant clumsiness to paint solidly and to study nature frankly? . . . An austere and serious kind of painting, an extreme concern for truth and accuracy, a rugged and strong will. You are a great blunderer, sir—you are an artist that I like.[31]

While Zola championed Pissarro and Manet, he was not an ardent supporter of his childhood friend Cézanne. He owned a dozen Cézanne paintings done between 1864 and 1871, but noth-

ing from subsequent years.[32] As early as 1861 he had expressed doubts about Cézanne's personality: "Paul may have the genius of a great painter, but he will never have the genius to become one."[33] Zola would not help Cézanne. In 1870 he put off the collector and critic Duret, who wanted to know Cézanne's address: "He is in a period of experimentation. . . . Wait until he has found himself."[34] But in 1896 Zola had an awakening and wrote: "Yes, thirty years have gone by and I have lost some interest in painting. I grew up almost in the same cradle as my friend, my brother, Paul Cézanne; we are suddenly, only now, discovering the brilliant parts of this great aborted painter."[35]

WHILE BOTH Cézanne and Pissarro had originally trained by studying and copying art in the museums, they felt that they should rely on their sensations in front of nature. As Cézanne wrote: "In my opinion, one does not replace the past, one only adds a further link to it. . . . to occupy a suitable rank in the history of art."[36] At another time he wrote: "The Louvre is a fine place to study, but it must be only a means. The real and great study to undertake is the diversity of nature's scenes."[37] Two years later he added: "That is the great point, getting away from any and all schools. Pissarro wasn't mistaken, therefore, although he went a bit far, when he said that one should burn all artistic necropolises. . . . The first person is the artist himself."[38]

Cézanne's early work is largely romantic and has some affinities with Delacroix's. At the same time, like Pissarro, he was drawn to Courbet's realism. With the goal of capturing natural effects, he wrote to Zola in 1866: "My dear Émile. . . . You know, any picture done indoors, in the studio, never equals things done outdoors. In pictures of outdoor scenes, the contrast of figures to scenery is astonishing, and the landscape is magnificent. I see superb things and I must resolve to paint only out of doors. . . . If you see Pissarro, greet him warmly for me."[39]

A few days later Cézanne wrote to Pissarro about outdoor effects: "You're completely right in what you say about gray, it alone prevails in nature, but it's frightfully difficult to capture."[40] Although Cézanne occasionally painted out-of-doors in the 1860s, it was not until he apprenticed himself to Pissarro in 1872 that he regularly executed landscapes entirely outside the studio.

Cézanne, *The Thaw in L'Estaque* (or *The Red Roofs*), 1870–71. Oil on canvas, 28½ × 36¼″ (72.5 × 92 cm). Private collection.

From 1872 through 1882 Cézanne worked with Pissarro. It turned out to be a reciprocal exchange, and a turning point in Cézanne's career. He chose to study with Pissarro because he felt a closer affinity to Pissarro's art, with its rural themes, intensity, and structure, than to that of any other Impressionist painter. Furthermore, Cézanne felt most comfortable with Pissarro, whose moderate, even temper calmed his emotionalism. From Pissarro he learned to seek his own sensations before nature as well as to use Impressionist light, bright color, and expressive strokes. And Pissarro in turn learned from Cézanne's treatment of composition and form and was encouraged by his strong individualism.

The majority of Cézanne's paintings of the period 1859–1871

were done in a romantic expressionist style; many are imaginative scenes of violence (murders, rapes, autopsies). When he made landscapes, such as *The Thaw in L'Estaque*, they, too, were dramatic and intense. The passionate mood was enhanced by his impulsive execution of powerful, thick strokes applied with his palette knife or large brush. The modeling of form was achieved through strong contrasts of light and dark, and the palette had few, mostly dark, colors.

Pissarro's paintings of the late 1860s, such as *Jallais Hill, Pontoise* of 1867 (see p. 114), influenced Cézanne to paint in a naturalistic style. He doubtless shared Zola's assessment of this work: Pissarro "is a naturalist who closely pursues nature. But, his paint-

Cézanne, *Jallais Hill, Pontoise*, 1879–1882. Oil on canvas, 23⅝ × 28¾″
(60 × 73 cm). Private collection.

ings have an accent of their own, an austere accent and a truly heroic grandeur.... They are supremely personal and supremely true."[41] It was Pissarro's Impressionist works of the early 1870s, such as *A Corner of the Hermitage* (a small village adjacent to Pontoise; see p. 115), that influenced Cézanne's stroke, color, and value. In a letter to Pissarro in 1874, Cézanne acknowledged, "You were replacing a model [gradations of light and dark] with studies in tonalities [varied hues]."[42]

Pissarro's tranquil, objective paintings appealed to Cézanne because their calm offset his anxieties. In this area Pissarro's influence on his work can also be seen. Beginning in 1872 Cézanne was able somewhat to control his passionate nature. It is from this du-

ality between his fervor and nature's serenity—learned in part from Pissarro—that his unique style emerged.

In 1870 Pissarro was living in Louveciennes in order to paint near Monet and Renoir. Perhaps, like them, he was exploring the initial stages of Impressionism. We cannot know, however, because all his paintings of 1869 were destroyed during the Franco-Prussian War, when Prussians and their horses lived for four months in his house. But as he later wrote to Lucien: "I remember that, although I was full of ardor, I didn't conceive, even at forty, the deeper side of the movement we followed instinctively. It was in the air!"[43] Pissarro's works of the early 1870s are paintings executed outdoors. The fragmented and loose brushstroke captured

Pissarro, *Jallais Hill, Pontoise*, d. 1867. Oil on canvas, 35 × 45⅔" (89 × 116 cm). The Metropolitan Museum of Art, New York; Bequest of William Church Osborn, 1951.

shimmering reflections and light shadows. The palette became richer and lighter, with more pure colors. While Monet and Renoir were painting modern suburban landscapes, Pissarro preferred rustic scenes with peasants.

Beginning in 1872 Cézanne learned from Pissarro's new Impressionist manner, in which small touches of color approximate the artist's delicate sensations before nature. Cézanne minimized the use of black, earth colors, and other neutral pigments and brightened his palette while increasing the variety of hues. He used pale colors instead of earth colors and varied shades of grays instead of contrasting light and dark values to enhance the luminosity.

Under Pissarro's tutelage Cézanne felt that he made steady progress toward his ideal: the expression of his sensations. "I am proceeding very slowly," he later explained, "nature appears to me very complex; and continual progress must be made. One must see the model clearly and feel it right; and then express oneself with distinction and force."[44] At the end of his life he summarized his

Pissarro, *A Corner of the Hermitage, Pontoise*, d. 1874. Oil on canvas,
24 × 31⅞″ (61 × 81 cm). Oskar Reinhart Collection,
Winterthur, Switzerland.

work in a letter to his son: "Sensations being what my life's essentially been about, I believe I'm unfathomable."[45]

A comparison of Cézanne's *The Thaw in L'Estaque* (see p. 112), with his *Jallais Hill, Pontoise* (see p. 113), painted a decade later, reveals his progress toward a light, colorful, and naturalistic style. Yet Cézanne never was as Impressionistic as Pissarro. Instead, he transformed what he learned to make his paintings monumental, generalized, and classical. His strongest work, from 1880 through 1895, emerged from his years of collaborating with Pissarro.

Cézanne also influenced the elder artist. In the 1870s Pissarro painted in a range of styles: some works were Monet-like, with their informal focus on seasons and moments and their more casual compositions; others were more deliberately arranged through the placement of houses and trees. The ones he made with Cézanne were among the most structured of his canvases. During the decade they worked together, Pissarro's painting became increasingly ordered, both in a return to his style of *Jallais Hill, Pontoise* of 1867 and under the influence of Cézanne.

Pissarro, *The Road to Louveciennes at the Outskirts of the Forest*, d. 1871.
Oil on canvas, 43⅜ × 63″ (110 × 160 cm). Private collection.

CÉZANNE AND PISSARRO worked together in rural Pontoise, twenty miles northwest of Paris, from 1872 through 1882. For the first two years they were neighbors; later Cézanne traveled almost annually among Pontoise, Paris, and Aix. Pissarro had moved to Pontoise in 1866 and, while he occasionally sojourned elsewhere and maintained a Paris address, he continued to live there until 1883. Cézanne first came to study with him late in the summer of 1872, bringing with him Hortense and baby Paul, Jr., who had been born in Paris in early January. They lived in Pontoise at first and a few months later moved to the nearby village of Auvers-sur-Oise.

Soon after he arrived Cézanne copied a painting that Pissarro had done the year before in Louveciennes. Forty years later Lucien recalled: "To say who influenced the other is impossible. All I can say is that Cézanne borrowed one of father's pictures in 1870 [*sic*, 1872] to make a copy, probably to study the way it was painted. Cézanne's copy still exists: it is, I believe, in the collection of Dr. [Paul] Gachet. It is good to say this because one day it might be said that father copied Cézanne."[46] About fifteen years later Lucien remembered the "reasons that had brought Cézanne to make a copy of [Pissarro's work]. My father was then starting to do light painting; he had banished black, the ochres, etc. from his

Cézanne, *Louveciennes*, 1872. Oil on canvas, 28¾ × 36¼″
(73 × 92.1 cm). Private collection.

palette. . . . He explained his ideas about this subject to Cézanne, and the latter, to understand this, asked him to lend him a canvas so that he could, in copying it, judge the possibilities of this new theory. The arcades of Louveciennes were immediately behind the house that we lived in."[47]

Cézanne's copy is considerably smaller but retains the same proportions as Pissarro's canvas. It is also starker, with minimal foliage on the trees. In this copy and in later works made side by side with Pissarro, Cézanne was learning to synthesize his powerful emotions with his objective visual sensations, and his work was becoming more naturalistic.

During their first year together, Pissarro perceptively assessed his colleague's promise: "Our Cézanne gives us hope, and I've seen some pictures. At home I have a painting of both remarkable vigor and force. If, as I hope, he stays some time in Auvers, where he is going to live, he will astonish quite a few artists who were all too quick to condemn him."[48]

IN AN EFFORT to learn the Impressionist method, Cézanne would set up his easel next to Pissarro's and paint identical scenes. We know of ten such pairs: two in 1873, two in 1874, one in 1875, one in 1876, three in 1877, and one in 1882. Often the sizes of the two canvases differ. In their ten years together, Cézanne and Pissarro made twenty-eight works in each other's presence, about the same number as Monet and Renoir. But whereas Monet and Renoir tackled a variety of subjects together, Cézanne and Pissarro made only portraits of each other and landscapes with buildings. Compared with Monet and Renoir, Cézanne and Pissarro actually did more paintings side by side of the same motifs, and they made these over a longer period of time. The styles of Monet and Renoir are similar in their works made together; the styles of Cézanne and Pissarro are always different. Sometimes Cézanne's images look like fall or winter scenes, with leafless trees; in Pissarro's the season appears to be spring or summer. (This was even the case in Cézanne's copy of *Louveciennes*; see p. 117). Cézanne never intended to mimic Pissarro's style. As he later said: "I wanted to make of Impressionism something solid and lasting like the art of the museums."[49] For Cézanne this meant dealing "with nature as cylinders, spheres, cones, all placed in perspective so that each aspect of an object or a plane goes toward a central point. Lines parallel to the horizon give a feeling of expanse. . . . Lines perpendicular to that horizon give depth."[50]

Pissarro, who later considered Cézanne the greatest living artist, was proud of his own role in the younger man's development. "Cézanne . . . was influenced . . . by me at Pontoise, and I by him," he wrote to Lucien. "Curiously enough, in Cézanne's [1895] show at Vollard's there are certain landscapes of Auvers and Pontoise that are similar to mine. Naturally, we were always together! But what cannot be denied is that each of us kept the only thing that counts, the unique 'sensation'!—This could easily be shown."[51] And after the show Pissarro exclaimed: "These paintings have I do not know what quality like the things of Pompeii, so crude and so admirable! . . . There are exquisite things, still lifes of irreproachable perfection, others *much worked on* and yet unfinished, of even greater beauty, landscapes, nudes and heads that are unfinished but yet truly grandiose, and so *painted*, so supple. . . . Why? Sensation is there!"[52]

The basic differences between the art of the two men are evident in their versions of *Street in Pontoise, Winter*. Fundamentally, Cézanne was a Classical Impressionist and Pissarro a pure Impressionist. Cézanne possessed the noble harmony of the old masters, while Pissarro presented a pastoral simplicity. Cézanne made his scenes solid and constructed, as if he were looking through the eyes of a classical landscape painter such as Nicolas Poussin, yet he abstracted the essentials. Pissarro created a more tender and modest nature—as if seen through the eyes of a peasant. Whereas Cézanne painted the immutable in nature, Pissarro captured the transient. Cézanne submitted the landscape to rigorous analysis;

Cézanne, *Street in Pontoise, Winter* (or *Snow Effect, Rue de la Citadelle, Pontoise*), 1873. Oil on canvas, 15¼ × 18½″ (38.7 × 47 cm). Collection Josse Bernheim-Jeune, Paris; stolen by Germans during World War II; present location unknown.

Pissarro painted more intuitively. The world of the antisocial Cézanne is inaccessible and untraversable; by contrast, the extroverted Pissarro invites us into a human environment populated by humble folk. Cézanne approached art as an architect. He seems to have moved around to present multiple viewpoints. Pissarro, however, painted from one stable point. Cézanne's perspective is blunted or slowed down, so that distant objects appear to be closer, more dense, and more solid. As a Classicist, Cézanne changed nature to achieve greater stability and constructive order. He created conflict by contrasts, asymmetries, and discontinuities. As a pure Impressionist, Pissarro strove to reproduce an instantaneous perception of nature.

"It took me forty years," Cézanne said, "to find out that painting is not sculpture."[53] It was this very sculptural quality that led him to emphasize the edges of objects. Pissarro, on the other hand, was more interested in the flicker of light and air around these same forms. Cézanne took nature apart and reconstructed it to create a new cohesive, abstract view; Pissarro focused on the freedom, randomness, and mobility of our world. Cézanne's anxious personality motivated his search for stability in art, whereas the centered Pissarro appreciated nature's transitory qualities.

Cézanne used the expressive power of color to enhance solidity. His more intense, powerful, and weighty colors emphasize the density of things. Cool colors recede; warm ones advance. Pissarro used bright color to integrate objects with the atmosphere. Light,

bright, soft colors accent the sunlight around things. Cézanne painted with constructive strokes that are more troweled and chiseled; Pissarro painted with descriptive, delicate, flickering strokes.[54] A peasant who had watched them working together at Auvers said that Pissarro made little stabs at the canvas ["*piquait*"] and Cézanne laid on the paint like plaster ["*plaquait*"].[55]

Working side by side with a colleague on the identical motif was not new to Pissarro, who had painted with Monet in 1870 and 1871 and with Renoir in 1870.[56] It was new for Cézanne, however, and he seems to have thought it a good practice. During the period that he painted with Pissarro, he also worked with Armand Guillaumin and copied one of his canvases.[57] Later he painted with Renoir.[58]

In their paintings of the Rue de la Citadelle in winter, both Cézanne and Pissarro executed what was a typical subject for Pissarro at this time—a winter scene down a village road. Pissarro's version is more than twice as large as Cézanne's. Pissarro presents a long view with very little of the right wall. Cézanne stood at Pissarro's left, turned more to the right wall, and positioned himself farther down the path, one-third into Pissarro's painting. Cézanne brought the distant, snowcapped building closer to us and widened the perspective, whereas Pissarro created a narrower vista. Cézanne's stark scene has no people, whereas Pissarro's more casual scene has two men conversing and a woman walking toward them.

Pissarro, *Street in Pontoise, Winter* (or *Rue de la Citadelle, Pontoise, in Winter*), d. 1873. Oil on canvas, 21⅛ × 29½″ (53.7 × 74.9 cm). Private collection.

Cézanne, *The Railroad Bridge and Dam, Pontoise*, c. 1873. Oil on
canvas, 23⅔ × 28⅝″ (60 × 73 cm). Private collection.

AROUND 1873 each artist painted a version of *The Railroad Bridge, Pontoise*. Cézanne's canvas is larger than Pissarro's, and his central view creates a more symmetrical composition. Cézanne's village is higher on his canvas, and the foreground bushes block our passage into the space; his painting is less finished, with pervasive, vigorous visible strokes. Pissarro stood to the left of Cézanne, to include more of the path that runs alongside the Oise river. He gave a closer view of the bridge and village. Searching for nature's transitory effects, Pissarro payed closer attention to the water's reflections of the bridge, houses, and trees and to the fluffy clouds moving through the sky. Pissarro's scene is more naturalistic and more delicate.

Pissarro, *The Railroad Bridge, Pontoise*, c. 1873. Oil on canvas, 19⅝ ×
25⅔″ (50 × 65 cm). Private collection.

Cézanne, *House and Tree near the Road of the Hermitage, Pontoise,*
1874. Oil on canvas, 25⅝ × 21¼″ (66 × 53.3 cm). Private collection.

IN 1874 Cézanne and Pissarro again made two pairs of landscapes in each other's company. Cézanne's Hermitage painting is almost twice as large as Pissarro's. In it he presented bare branches, giving an impression of winter; Pissarro's flowering trees suggest summer. Cézanne's tree is a barrier holding us back from the house; Pissarro's soft, protective tree and path lead us toward the distant buildings. Cézanne stood closer to the house and tree, which expand in width and height, filling most of the canvas. Pissarro, by contrast, made the house recede into the distance while he explored details of the resting adult and child at the left foreground, of the blossoming foliage, and of the cloud-filled sky.

Pissarro, *The Road of the Hermitage, Pontoise*, d. 1874. Oil on canvas, 18 × 15″ (45.7 × 38.1 cm). Private collection.

Cézanne, *Auvers, Small Houses*, 1874. Oil on canvas, 15½ × 21″ (39.4 × 53.3 cm). Fogg Art Museum, Harvard University, Cambridge, Mass. Bequest of Annie Swan Coburn.

ANOTHER PAIR of paintings were done in the fall.[59] Once again the Cézanne is considerably larger. *Auvers, Small Houses* and *Harvesting Potatoes* depict the same site, although Cézanne omitted the figures and Pissarro focused on the six peasant women. Pissarro seems to have been responding to a suggestion made by his friend Duret, who had written to him on December 6, 1873:

All that I know is that for the sentiment of power, your landscape . . . is as beautiful as a Millet. I persist in thinking that nature, with its rustic fields and its animals, is what corresponds best to your talent. You do not have the decorative feeling of Sisley, nor the fantastic eye of Monet, but you do have what they don't, an intimate and profound feeling for nature, and a power in your brush that makes a beautiful painting by you something absolutely definitive. If I had any

Pissarro, *Harvesting Potatoes,* d. 1874. Oil on canvas, 13 × 16⅛"
(33 × 41 cm). Sacerdoti collection.

advice to give you, I would tell you not to think of either Monet or Sisley, don't preoccupy yourself with what they are doing; go your own way; in your path of rustic nature, you'll go into a new path, both as far and as high as any master.[60]

In *Harvesting Potatoes* Pissarro began to use composition, form, and stroke to move away from the freedom of Impressionism in a direction suggested by Cézanne's work. He ordered the composition by spacing the peasant women in a diagonal from right to left. As in Cézanne's *Auvers, Small Houses,* the background fields have a series of horizontal planes reaching close to the upper canvas edge, which leaves little sky and causes a powerful feeling of compression. Also present in both paintings are solid structured houses, and in both broad strokes are layered on the surface to suggest forms with solidity and texture.

Cézanne, *Les Mathurins, Pontoise (L'Hermitage)*, 1875–1877. Oil on canvas,
22⅞ × 28″ (58 × 71 cm). Pushkin State Museum of Fine Arts, Moscow.

ᴇARLY IN 1875 Pissarro expressed the closeness he felt to Cézanne: "I would ask my friends, MM. Ludovic Piette, A. Guillaumin, and P. Cézanne, to please be my executors and to please, in remembrance of my good friendship with them, accept from among my studies and paintings a memorial gift from me."[61]

That year Cézanne visited Pissarro in Pontoise, where together they painted the road that passed in front of Les Mathurins, a former convent of the Order of the Holy Trinity in the section of Pontoise known as L'Hermitage. The works exhibit their characteristic differences. Cézanne painted solitary nature, while Pis-

sarro showed people and animals: a man and woman walk behind a cow and are approached by a covered wagon drawn by a white horse. As in the earlier canvases, Cézanne zoomed in on a portion of Pissarro's view. He was closer to the distant buildings and eliminated some of the foreground; he also cut out much of the wall on the left and the houses and hill on the right. Pissarro's broad panorama is enhanced because his canvas is actually wider than Cézanne's. Cézanne emphasized the permanence of architectural construction, while Pissarro stressed ephemeral light bathing the scene.

Pissarro, *The Saint-Antoine Road at the Hermitage, Pontoise*, d. 1875.
Oil on canvas, 20½ × 31⅞″ (52.5 × 81 cm). Oeffentliche Kunstsamm-
lung, Basel, Private collection. (The Saint-Antoine Road—also called
the Ennery Road—was a continuation of the Hermitage Road.)

Pissarro's style became more compressed and more stable as he followed Cézanne's penchant for structuring. However, Cézanne tended to flatten the space and make it geometric, while Pissarro deepened it with linear and aerial perspective. Though more pronounced in Cézanne's canvas, both landscapes have carefully organized vertical and horizontal axes, parallel layers, and predominantly defined solid forms, which reduce the composition to its basic elements. Cézanne vigorously modeled form and space in abstract, blocked-in areas of paint, a technique that Pissarro exhibited in his foreground grass. By stronger handling of the palette knife, Cézanne's color has more force, mass, and compactness. Also his hues are more pure, while Pissarro's incorporate shades of different colors.

At this time both artists experienced a renewed interest in Courbet, which may account for their return to the use of long, flat, flexible palette knives along with brushes.[62] This allowed both of them to achieve a more regular brushstroke and a heavier and more deliberate execution.

Cézanne, *District of Valhermeil near Pontoise*, c. 1876. Oil on canvas,
20⅞ × 33⅔″ (53 × 85.5 cm). Private collection.

IN 1876 Cézanne continued his efforts to create a more struc-
tured Impressionism. From l'Estaque he wrote to Pissarro: "The
sun here is so frightfully strong that it seems to me that objects are
always outlined, not only white or black, but blue, red, brown, vio-
let. I may be wrong, but it seems to me that it is the extreme oppo-
site of modeling."[63] Cézanne knew that many of Pissarro's earlier
canvases gave the effect of having used outlines; this was the result
of first applying an underlying layer of paint where the principal
areas were silhouetted. While Pissarro went on to superimpose
many layers of paint over this initial layer, in the final painting the
effect of an underlying outline is often retained thereby giving the
effect of a contour.[64] Cézanne also wrote to Pissarro that he was
eager to paint a large painting in Pontoise—as large as Pissarro had
painted there a decade earlier: "As soon as possible, I shall come and
spend a month in this area, for I must paint at least [six-foot]-long
canvases, just like the one you sold to Faure."[65]

Two months later he returned to Paris and wrote to his parents:

"I haven't yet managed to see Pissarro nor any of the other people
I know, since I got down to painting the very day after I arrived."[66]
When he did reach Pissarro, they decided to work side by side in
an Auvers district called Valhermeil.[67] Cézanne's painting is a lit-
tle larger than Pissarro's but not six feet long. In contrast to
Cézanne's solitary landscape, Pissarro included a laborer turning
over the earth with a plough pulled by a horse. On the path, one
can see the silhouette of a peasant wearing an apron and head-
scarf. Three strokes (pinkish beige, blue, and brown) suggest a
child next to her. Following ideas expressed in his letter to Pis-
sarro, here Cézanne used colored outlines around objects. Yet his
outlines were never closed, but were open, discontinuous, and
often separate from the forms. In his painting, Pissarro did not re-
inforce the contours; however, on the two closest houses, he indi-
cated the shadows that fell on the roofs by means of colored
strokes. Nonetheless the edges of his forms are clear. Both artists
sought geometric constructive elements in these landscapes.

Pissarro, *The Laborer*, d. 1876. Oil on canvas, 21¼ × 25⅔″ (54 × 65 cm).
Private collection.

Cézanne, *Orchard in Pontoise, Quai de Pothuis*, 1877. Oil on canvas,
20 × 24½″ (50 × 61 cm). Private collection.

CÉZANNE SPENT part of 1877 with Pissarro at Pontoise, where they did three pairs of side-by-side paintings. Cézanne's art was becoming more architectural and sculptural. Pissarro was experimenting with a variety of opposing techniques. Sometimes his work (such as *Vegetable Garden and Trees in Flower, Spring, Pontoise*) was similar to Monet's, with broken touches of paint capturing light and movement. At other times his paintings (such as *Oxen Hill at the Hermitage, Pontoise*; see p. 133) were like Cézanne's, with structured space and heavily textured strokes.

The side-by-side orchard paintings were executed behind Pissarro's home. Cézanne presented seemingly deserted buildings

Pissarro, *Vegetable Garden and Trees in Flower, Spring, Pontoise,*
d. 1877. Oil on canvas, 26⅛ × 32½″ (65.5 × 81 cm). Musée d'Orsay,
Paris; Caillebotte bequest.

separated from us by a prominent wall. Pissarro's focus was on the cozy homes and flowering trees that prevent us from seeing any wall. Cézanne's canvas has little sky, giving a feeling of compression, especially as compared with Pissarro's balmy cloud-filled sky. Cézanne's work is contradictory. It looks unfinished, but the volumes possess density and weight, and the space is defined. Here we see what Pissarro admired when he later remarked that Cézanne's unfinished works are "really extraordinary for their fierceness and character."[68] Pissarro acquired Cézanne's *Orchard in Pontoise, Quai de Pothuis* for his collection. Pissarro included his own version of the scene in the 1879 Impressionist exhibition.

In the third Impressionist exhibition of 1877, Cézanne showed sixteen works and Pissarro twenty-two. The pair of paintings of *Oxen Hill at the Hermitage, Pontoise* were exhibited in the same room.[69] One critic stated: "Pissarro and Cézanne, who have supporters, together form a school apart, and even two schools within one. I recognize again their qualities of draftsmanship and even of composition, but their color is a different matter."[70] In this exhibition Cézanne also showed his version of *Auvers, View of Surroundings* (see p. 134) without Pissarro's counterpart. Both pairs are of similar vertical format. Pissarro's Auvers canvas (see p. 135) is slightly larger than Cézanne's, but his *Oxen Hill* is almost three times larger and is approximately the same size as his large exhibition piece of 1867, *Jallais Hill, Pontoise* (see p. 114).

The works were well-received. In his review Zola departed from his customary reticence about Cézanne and praised him as "most certainly the greatest colorist of the group. There are by him, at the exhibition, some landscapes . . . of the finest character.

The so strong and deeply felt canvases of this painter may make the bourgeois smile. They nevertheless contain the makings of a very great painter. The day when Paul Cézanne shall be in full possession of his means, he will produce some quite superior work."[71]

The complexity and compression of space in Pissarro's *Oxen Hill* are the result of Cézanne's influence. Yet as we have seen, Cézanne was then developing under the influence of Pissarro. Truly this was a reciprocal dialogue between the two artists. Even more than in *The Saint-Antoine Road* of 1875 (see p. 127), Pissarro emphasized the surface planes and created a complicated composition in which the distinction between near and far and between the solid and the intangible blurs into an intricate two-dimensional pattern.

In both canvases, we see blue-and red-roofed buildings through a dense screen of poplar trees and foliage. Primarily with a palette knife, but also with some light brushstrokes, Cézanne applied

Cézanne, *Oxen Hill at the Hermitage, Pontoise*, c. 1877. Oil on canvas, 25⅝ × 21¼" (65 × 54 cm). Museum of Fine Arts, St. Petersburg, Fla.; extended anonymous loan.

patches and spots of bright clear colors. Pissarro used no palette knife, only brushes. In Pissarro's canvas, a path leads us into space; at the left, two small figures stare out at us from within the trees. Cézanne's image contains no people. Cézanne's version shows the same motif from slightly farther away and higher up the hill, so that the houses are lower and less visible, but it has a similar composition and is even more geometric and simplified in its vertical tree trunks that cross the horizontal rooftops and by the diagonal branches. Cézanne's stark trees have a forbidding fierceness. In the Pissarro the geometric structure is softened by the pervasive leaves which welcome us into a safe haven.

Both *Oxen Hill* paintings give the effect of reinforced edges. However, the effects are achieved differently. Cézanne outlined both the trees and the houses with colored lines. His surface is also densely worked. Quite differently, Pissarro used no colored lines. However, in his underpainting Pissarro had initially drawn the silhouettes of the tree trunks and houses with dark outlines. Over this he superimposed many layers of complex strokes that create a virtual relief on the surface so that the raised and highlighted areas of thick layers of paint catch the light and project toward us (like sculpture). The contours are sunken and recede away from us because they are made with the thinnest paint, where the dark underpainted silhouettes show through and shadows from the paint fall. His densely worked surface looks like a raised relief mesh weave. This was a belabored process that Pissarro referred to as "the work of a Benedictine [monk]."[72]

The compositional structure and textured surface of Pissarro's *Oxen Hill* are typical of many of Pissarro's works of the late 1870s and early 1880s, a period of great experimentation for him as for all the Impressionists. Works done in the manner of *Oxen Hill* led Pissarro to search for more control in brushstroke and color leading eventually into his Neo-Impressionism of 1885–1890.

Pissarro, *Oxen Hill at the Hermitage, Pontoise*, d. 1877. Oil on canvas, 44⅞ × 34¼" (114 × 87 cm). Trustees of the National Gallery, London.

Cézanne, *Auvers, View of Surroundings*, c. 1877. Oil on canvas, 23 ×
19⅔″ (60 × 50 cm). Private collection.

I**N** *Auvers, View of Surroundings*, Cézanne created an image
that looks up to the village, which is higher in the canvas than
Pissarro's painting has it, and shows much less sky than his. As is
typical for Cézanne, the foreground foliage acts like a screen as if
to prevent our physical access. Furthermore, the heavy trees ex-
tend to the top of the frame and also bar our entrance. In *Land-
scape of Auvers*, Pissarro created an image where we look down at
the town, which is farther from us than in Cézanne's. The sky is
larger and the trees part to welcome us into the deep airy vista.
Pissarro's surface is built up of small, heavily loaded brushstrokes
with heavy impasto which are the equivalent of Cézanne's con-
structivist brushstrokes. Here Cézanne's great power differs from
Pissarro's greater warmth.

Pissarro, *Landscape of Auvers*, d. 1877. Oil on canvas, 26 × 21¼″ (66 × 54 cm). Private collection.

Cézanne, *Copy of Pissarro's Young Woman Sewing*, 1881. Pencil on page from a sketchbook, 5 × 8⅝″ (12.7 × 21.75 cm). Private collection.

AFTER 1877 Cézanne spent more time working alone around Aix. He saw Pissarro much less frequently, and their artistic exchange lost its importance. He ceased exhibiting with the group and continued to seek acceptance at the Salon.

Pissarro became increasingly interested in painting peasants. *Young Woman Sewing* is a gouache (opaque watercolor) that he painted in 1881 and exhibited at the Impressionist show in April of that year. It resembles Jean-François Millet's images of peasants, but without the idealism and religious overtones. The comparison between Millet and himself annoyed Pissarro. An atheist, he felt that religious beliefs hinder social reform. He wrote to Duret: "They are all throwing Millet at me, but Millet was biblical! As a Hebrew I am hardly so, it's strange!"[73] As Degas aptly stated: "Millet? His *Sower* is sowing for Mankind. Pissarro's peasants are working to earn their daily bread."[74]

Cézanne probably saw *Young Woman Sewing* at the 1881 exhibition where, on a small sketch pad, he could have made his pen-

cil copy of the upper torso of the woman. Whereas Pissarro stressed her humanity, concentration, and industriousness, Cézanne depersonalized her and reduced her upper torso to a geometrical scheme of spheres, cylinders, and rectangles. His primary concern was to abstract her sculptural and architectural qualities.[75]

After the show closed Cézanne, Hortense, and nine-year-old Paul, Jr., settled in Pontoise for six months. "I see Pissarro fairly frequently," he wrote,[76] and he worked side by side with him, as is recorded in a drawing by Pissarro's son Georges (nicknamed Manzana). *The Impressionists' Picnic in 1881* (see p. viii) shows four artists who are identified on the inscription: "Guillaumin, Pissarro, [Paul] Gauguin, Cézanne." We see three easels, each with a landscape in progress. Cézanne works at the central easel; Gauguin strolls; Guillaumin and Pissarro eat the food being prepared by Mme. Cézanne; little Manzana observes.

In 1882 Cézanne again spent time in the Pontoise area during the spring, summer, and fall. It was during this period that he and Pissarro made their last side-by-side works, *View of Valhermeil Houses on the Way to Auvers-sur-Oise* and *Paths and Slopes of Auvers*.[77]

From 1880 through 1895 Cézanne developed his classical style, which, despite compositional complexity, retained an ordered calm. He used robust color to enhance the geometric basis of form and the rigors of composition. Beginning in 1880 he also developed a parallel, constructive stroke to record his variable sensations of nature. He had formerly used such strokes only in fantasy scenes and copies.[78]

Cézanne, *View of Valhermeil Houses on the Way to Auvers-sur-Oise*,
1882. Oil on canvas, 28¾ × 36¼″ (73 × 92 cm). Private collection.

Pissarro, *Path and Slopes of Auvers*, d. 1882. Oil on canvas, 23⅝ × 28¾″
(60 × 73 cm). Location unknown.

Cézanne, *Self Portrait*, c. 1877. Pencil on paper, 7⅓ × 5¾″ (18.5 × 14.5 cm). Private collection.

RIGHT: Pissarro, *Portrait of Cézanne (full-face)*, c. 1874–1877. Pencil on page from sketchbook, 7½ × 4⅜″ (19 × 11.1 cm). Musée du Louvre, Département des Arts Graphiques, Paris.

Cézanne and Pissarro made several portraits of each other in the mid-1870s. Some were in Pissarro's collection; one was owned by Cézanne.[79] Pissarro's are more individual; Cézanne's are more abstract. A group photograph taken in Auvers around 1874 was the source of Cézanne's standing portrait, which shows Pissarro with painting equipment on his back and walking stick in his hand. This lead-pencil drawing has a strongly reinforced silhouette appropriate to a study for sculpture. The figure's face is almost hidden by the big hat and dark shadows.

Pissarro may have used the same photograph to make the drawing of Cézanne's head. The serration at the top edge of the paper suggests that the sheet was ripped from a sketch pad. Cézanne's less finished *Self Portrait* may be a copy of a part of this drawing or a copy based on the photograph. In the two drawings, Cézanne's temperament was conveyed differently. Pissarro showed him as withdrawn and gentle; Cézanne portrayed himself as intense and sinister.

Cézanne, *Portrait of Pissarro in Pontoise Going Out to Paint with a Walking Stick and Knapsack*, c. 1874–1877. Black lead pencil on paper, 7⅝ × 4⅜″ (19.5 × 11.4 cm). Musée du Louvre, Département des Arts Graphiques, Paris; Collection Pissarro.

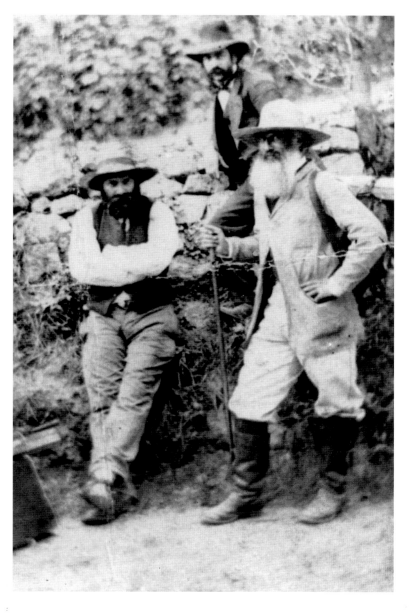

Photograph of Cézanne (left) and Pissarro (right) at Auvers, c. 1874. Private collection.

LIKE THE STANDING portrait of Pissarro, four other depictions of him by Cézanne are abstract and impersonal. Two show the artist from the back and one from the side. The frontal drawing (from a sketchbook) emphasizes his silhouette along with a sketch of Mme. Cézanne and a woman in a regional headdress. Here we see a search for geometry within the form that Cézanne would later develop in such drawings as his copy of *Young Woman Sewing* (see p. 136).

Cézanne, *Portrait (Profile Head) of Pissarro,* c. 1873–74. Pencil on paper, 3⅞ × 3⅛″ (9.8 × 8 cm). Private collection.

LEFT: Cézanne, Sketchbook, folio 2, *Portrait of Pissarro in Front of an Easel and Sketches,* 1874–1878. Pencil on paper, 8⅝ × 5″ (21.7 × 12.6 cm). The Pierpont Morgan Library, New York; The Thaw Collection.

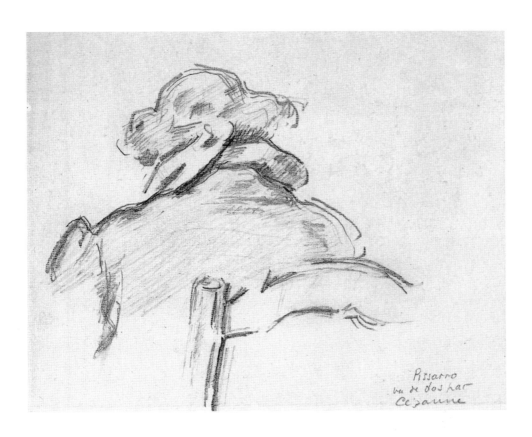

Cézanne, *Pissarro, Seen from the Back*, 1874–1877. Pencil on paper, 4⅞ × 5⅞″ (12.5 × 15 cm). Inscription (not in either artist's handwriting): "Pissarro seen from the back by Cézanne." Private collection.

Cézanne, *A Painter (Pissarro?) at Work*, 1874–75. Oil on canvas, 9½ × 13½″ (24.1 × 34.3 cm). Private collection.

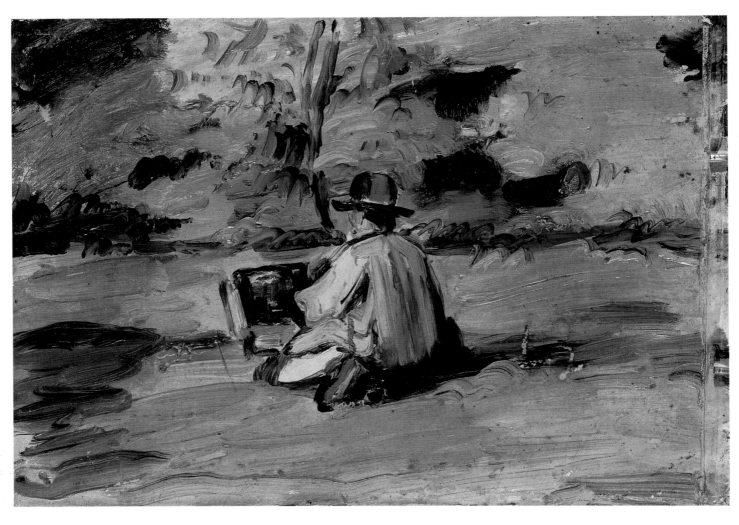

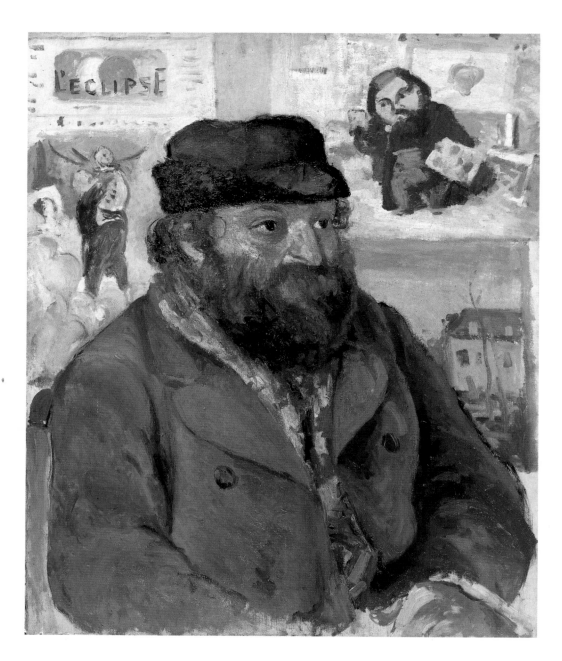

Pissarro, *Portrait of Paul Cézanne*, 1874. Oil on canvas, 28¾ × 23½″ (73 × 59.7 cm). Collection of Laurence Graff.

OPPOSITE LEFT: Photograph of Cézanne around the age of thirty-four on his way to work near Pontoise, c. 1874. Albuminized print from a collodion glass negative. Musée du Louvre, Département des Arts Graphiques, Paris.

OPPOSITE RIGHT: Pissarro, *Portrait of Cézanne*, d. 1874. Etching, 10⅝ × 8¼″ (27 × 21 cm). Bibliothèque Nationale, Paris.

Cézanne, *Still Life with Soup Tureen*, 1875–1877. 25⅝ × 32″ (65 × 81.5 cm). Musée d'Orsay, Paris.

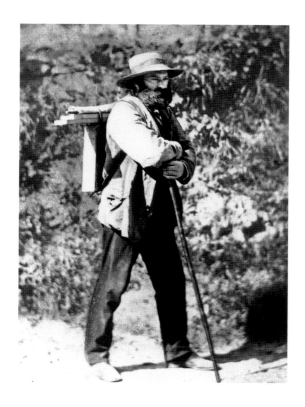

Pissarro's 1874 oil portrait of Cézanne expresses his veneration for the younger artist's genius.[80] This painted homage remained in Pissarro's collection until his death, a treasured memento of his esteemed friend. The portrait exhibits the generosity and support that Pissarro so vigorously extended to Cézanne. He painted his colleague as a serious, forward-looking man sitting in Pissarro's studio and flanked by three modest art objects tacked to the wall. These form allegorical tributes, first from avant-garde artists (as suggested by Pissarro's Impressionist landscape), then from the well-established painters (the caricature of Courbet, who toasts Cézanne),[81] and finally from France itself (the caricature of France toasting Cézanne).[82] A more supportive statement could not have been fashioned.

The massive figure of Cézanne may have been adapted from the photograph of him on his way to work near Pontoise. It confirms Lucien Pissarro's impressions of his father's friend: "His portrait painted by Father resembles him. He wore a cap; his long, black hair was beginning to recede from a high forehead; his beard was long and rather untidy; he had big and large black eyes, which rolled in their orbits at the slightest excitement."[83] Cézanne's bohemian appearance and attire affirm that he was a nonconformist; his immobility suggests that he was staunch in his artistic convictions.

Courbet was the recognized champion and symbol of the independent and progressive tendencies in France. Pissarro saw Cézanne as the heir to Courbet's individualism and wrote to Lucien:

What's the good of looking to the past and never at nature, so beautiful, so luminous, so diverse? Always in the dust of the old masters, whom one should not copy under the pretext of veneration, it seems to me that the better course is to follow their example by seeking with our own senses elements in our own environment. I am talking nonsense, perhaps, in saying this, but I stick to my guns. I have seen some Courbet landscapes recently. They are far superior [to Alphonse Legros] and really his own, Courbet's. . . . And take Cézanne, his expressiveness didn't come from his not being himself.[84]

Sometime after Pissarro painted his portrait, Cézanne returned the tribute by incorporating a copy of Pissarro's landscape of 1873, *Father Galien's House in the Gisor Road, Pontoise*, into the background of *Still Life with Soup Tureen*. This appears to be the same landscape that is in Pissarro's oil of Cézanne. Lucien said that Cézanne painted his still life in Pissarro's house.[85] The artist gave it to Pissarro, who kept it until he died.

Pissarro's etching of Cézanne dates from the same year as the oil portrait. It has no background and thus appears more formal and aloof, but the clothing and the pose, reversed because of the etching process, resemble those in the oil. In the etching Cézanne also wears a large overcoat, and we see his knee and his hand, which resembles the hand in the photograph, a hand faintly indicated in the oil. Although the oil is neither signed nor dated, the etching is signed above and both signed and dated below.

During this period Pissarro, Cézanne, Guillaumin, and Dr. Gachet were experimenting with the etching process on a press purchased by the doctor.[86] About twenty impressions of Pissarro's print of Cézanne were made during Pissarro's lifetime. In 1891 he submitted it as an illustration for an article about Cézanne by the artist and critic Émile Bernard.[87] Four years later it was used as an illustration for the catalog of Vollard's Cézanne retrospective.

THE TWO ARTISTS whom Cézanne and Pissarro most admired were Courbet and Delacroix, and they were influenced by them in numerous ways. Pissarro, as evidenced by his tribute and various passing remarks, acknowledged their valuable effect on Cézanne: "He was influenced like all the rest of us, which detracts nothing from his qualities. People do not realize that Cézanne was first influenced by Delacroix, Courbet, Manet and even Legros, like all of us."[88]

In 1875, when Cézanne's patron Chocquet purchased his first picture by the artist, he said: "How well that will go between a Delacroix and a Courbet!"[89] And in 1880, when Cézanne was forty-one, Zola described him as having "the temperament of a great painter who is still caught up in experiments in technique—[and] remains closer to Courbet and Delacroix."[90]

Cézanne preferred Delacroix to Courbet. His adulation was matched by Chocquet, who owned more than eighty oils, watercolors, and drawings by Delacroix.[91] "Delacroix has been the intermediary between yourself and me," Cézanne wrote to Chocquet in 1886.[92] Cézanne made at least fifteen copies after Delacroix's work. Besides numerous reproductions of Delacroix's works, Cézanne collected prints by and after him that outnumbered those of other artists.[93] Pissarro owned one Delacroix painting as well as his drawings, lithographs, and engravings.

As an expression of his admiration, Cézanne made a watercolor study in around 1876 called *The Apotheosis of Delacroix*. In 1891, after Chocquet died, Cézanne began an oil study that was similar to but slightly larger than the earlier watercolor. Over a decade later he still had not completed the work that was, in his words, to proclaim his "feeling and admiration for Delacroix. I don't know whether my precarious health will ever enable me to realize my dream of creating his apotheosis."[94] He died two years later, leaving the small oil study.

In the sky of the watercolor study, Delacroix is borne aloft by two angels. He is preceded by a third angel who holds his palette and brushes. In the midground is an artist wearing a pointed hat painting at an easel. In front of him a figure looking upward with one arm bent over his or her head sits under an umbrella. In the foreground from right to left is a dog and another artist with a pointed hat on his head, walking stick in his hand, and with paint equipment on his back. Farther to the left are two figures, one kneeling and one standing, who applaud Delacroix. At the extreme left, a canvas rests against a tree.

The oil study is less finished than the watercolor. Here the seated figure has been eliminated. In the foreground, a third artist with pointed cap has been introduced along with a dog who rears up on his hind legs and looks upward. At the lower left, a formal top hat rests under the tree.

It is likely that two of the artists represent Cézanne and Pissarro and that one of the applauding figures depicts Chocquet.[95]

Both Cézanne and Pissarro acknowledged the influence of Delacroix. Cézanne affirmed that for him it was "Delacroix above all."[96] Pissarro had begun to admire Delacroix's engravings when

Cézanne, *Watercolor Study for the Apotheosis of Delacroix*, c. 1876. Pencil, ink, watercolor on white paper, 7⅞ × 8⅝" (20 × 22 cm). Private collection.

he was fifteen years old; when he was twenty-five he was impressed with the Delacroixs he saw at the Universal Exposition.[97] He thought of Delacroix as one of the Impressionists' forefathers: "Our route begins with the great English painter [Joseph Mallord William] Turner, Delacroix, [Camille] Corot, Courbet, [Honoré] Daumier, [Johan-Barthold] Jongkind, Manet, Degas, Monet, Renoir, Cézanne, Guillaumin, Sisley, [Georges] Seurat! There is our path."[98]

THE ARTISTIC EXCHANGE between Cézanne and Pissarro, while it benefited Cézanne more, also contributed to Pissarro's development. Cézanne constantly searched for structure and order. Around 1885 Pissarro adopted the regularized brushstrokes and systematic approach of Seurat's Neo-Impressionism while preserving Impressionism's light and color. He later regretted this, and in 1895 wrote to Lucien: "I am so sick of this sort of thing that all my pictures done in my period of systematic divisionism, and even those I painted while making every effort to free myself from the method, disgust me. I feel the effects of that as late as 1894!"[99] Cézanne's inspiration seems here to have led Pissarro in an uncongenial direction. Eventually he was able to integrate his own expressive style with the lessons he had learned from both Cézanne and Monet, and thus to create the harmonious works of his later years.

At the end of their lives, each wrote an artistic credo embodying the lessons he had learned from the other. Bolstered by Cézanne, Pissarro affirmed his own beliefs in individualism before nature:

> Look for the kind of nature that suits your temperament. . . . Paint the essential character of things, try to convey it by any means whatsoever, without bothering about technique. . . . Precise drawing is dry . . . it destroys all sensations. . . . Use small brushstrokes and try to put down your perceptions immediately. . . . Don't proceed according to rules and principles, but paint what you observe and feel. . . . Don't be timid in front of nature: one must be bold, at the risk of being deceived and making mistakes. One must have only one master—nature; she is the one we must always consult.[100]

In 1906, the year of his death, Cézanne wrote of his quest to capture his sensations, the fundamental lesson Pissarro had taught him:

> Anyhow, I must tell you that as a painter I am becoming more lucid with regard to nature, but for me the realization of my feelings is still very difficult. I can't manage to achieve the intensity my senses feel, I don't have that magnificent richness of color that livens nature. Here, on the river bank, there are so many motifs, the same subject seen from another angle offers a subject of the most compelling interest, and so varied that I believe I could work away for months without changing position but just by leaning a little to the right and then a little to the left.[101]

Cézanne, *Oil Study for the Apotheosis of Delacroix,* 1891–1894. 10⅝ × 13¾″ (27 × 35 cm). Musée d'Orsay, Paris.

Nadar, photograph of Manet around the age of thirty-three,
c. 1865. Bibliothèque Nationale, Paris

Photograph of Morisot around the age of thirty-two, c. 1873.
Private collection.

Manet & Morisot

BERTHE MORISOT and Édouard Manet had an intense and long-lasting friendship. It is possible that their relationship bordered on love, if we judge by his intimate portraits of her and by her letters. The fourteen portrayals of her are more numerous and more tender than his portraits of anyone else.[1] They reveal an affection and sensitivity that go beyond a friend's response to her "extraordinary charm ... exquisite breeding ... and ... exceptional personal elegance."[2] Manet, it seems, was one of the few people who could bridge the "baffling distance" that this "rare and reserved" woman unknowingly created "between herself and all who approached her."[3] Never his student, she was his colleague, and they significantly influenced each other's art.

They met at the Louvre in 1867. Morisot, then twenty-six, and her next older sister Edma were copying a painting from Rubens's Marie de Medici cycle when Fantin-Latour introduced them to Manet, who was then thirty-five. She was single; he was married. Six years later she married Manet's next younger brother, Eugène. Their families were both upper bourgeois and moved in the same circles. There was an immediate mutual attraction. Manet found the "Morisot girls ... charming" and playfully wrote Fantin-Latour: "It's a pity they're not men; but being women, they could still do something in the cause of painting by each marrying an academician and bringing discord into the camp of those old dodderers, though that would be asking for considerable self-sacrifice—meanwhile, give them my respects."[4] Morisot was likewise impressed with Manet, later writing to Edma, "I have never seen such an expressive face as his.... I think he has a decidedly charming temperament, which pleases me immensely."[5] Edma, too, was smitten—and recovered only when she married the next year. At that time she declared to Morisot, "My infatuation for Manet is over."[6] But the fascination and attraction between Morisot and Manet grew into a friendship that lasted until Manet's death sixteen years later.

It is likely that the very year they met she saw fifty of his works at his one-man show in a specially constructed pavilion outside the 1867 World's Fair.[7] By this time Manet was already well-known through the writings of Zola and because of the controversy surrounding his modern and audacious work. He could also have known Morisot's paintings, because they exhibited at the same Salons in 1864, 1865, and 1868.[8] Furthermore, several months before they met, the painter Alfred Stevens gave Manet a portrait he had made of Morisot.[9]

She made no portraits of him; with the exception of her husband, she did not paint men. But she captured both the playfulness and depth of her relationship with him in letters to Edma. After a visit to the Louvre, she wrote: "I had completely lost sight of Manet and his wife, which further increased my embarrassment. I did not think it proper to walk around all alone. When I finally found Manet again, I reproached him for his behavior; he answered that I could count on all his devotion, but nevertheless he would never risk playing the part of a child's nurse."[10] Morisot's jealous attitude toward Manet's wife, whom she referred to as "his fat Suzanne,"[11] and toward his student Eva Gonzalès,[12] suggests the depth of her feelings for him.

Many years later, soon after his death, she wrote: "My old bonds of friendship with Édouard, an entire past of youth and work suddenly [is] ending, [thus] you will understand that I am crushed.... His richly endowed nature compelled everyone's friendship; he also had an intellectual charm, a warmth, something indefinable.... I shall never forget the days of my friendship and intimacy with him, when I sat for him and when the charm of his mind kept me alert during those long hours."[13] Less than a year later she spoke to Edma of her continuing loss: "I'm not having as much fun as you think. I do go to the [Manet exhibition at the] Beaux-Arts, but the days of trysts are over."[14]

Although "trysts" suggests a possible love affair between them, it is unlikely that this proper, upper-class young lady would have engaged in more than flirtation. As was customary for French women at the time, Morisot seems to have been continuously chaperoned. As a woman she was not even welcome at the cafés, so her friendship with Manet advanced through the soirees hosted by her mother on Tuesday evenings, by Manet's mother on Thursday evenings, and by others. Zola and Astruc, the composer Emmanuel Chabrier, and the painters Degas, Stevens, and Puvis de Chavannes were among the visitors at these gatherings.[15] At one of them Manet introduced her to Degas. During and after dinner the conversation often turned to literature, music, and art, affording Morisot a chance to exchange ideas with some of the most talented artists in Paris.

Carjat, photograph of Mme. Edouard Manet (Suzanne Leenhoff)
around the age of forty, c. 1870. Bibliothèque Nationale, Paris.

THE QUALITIES that distinguished Morisot and made her so alluring seem paradoxical: on the one hand, her rebellious desire to pursue painting professionally and to participate actively in the most controversial art movement of her time; on the other, her conformity to a femininity that her society expected of her as daughter, sister, wife, and mother. Her ability to be successful in her various roles can be explained by her strong sense of self, her perseverance, and the support she received from her family, Manet, and her husband.

It may have been at a soiree shortly after they met that Manet asked Morisot to pose for him (accompanied by her mother) in his studio on the Rue Guyot. The invitation was flattering to Morisot, and, even more important, it came at a particularly opportune moment. From the time Edma married in 1869 through 1871, Morisot often felt depressed, stuck, and confused about her work. In a letter to Edma in the spring of 1869, she asserted: "My paint-ing never seemed to me as bad as it has in recent days. I sit on my sofa, and the sight of these daubs nauseates me. I will try to do my mother and Yves [the eldest sister] in the garden; you see I am re-duced to doing the same things over and over again."[16] Nonethe-less, a few months later she painted *The Harbor at Lorient* (see p. 156), an innovative work with many Impressionist qualities— sunlight, imprecise figure, visible strokes—but without the vi-brant color of true Impressionism. That year she did only four paintings. Subsequently her output slowed even more. She pre-served two paintings from 1870 (including *The Mother and Sister of the Artist*, see p. 155) and one from 1871, making them the least productive years of her career.

Posing for Manet's fourteen portraits, some of which entailed numerous sittings, spurred Morisot to move from an artistic part-nership with Edma—with whom she had studied painting since 1857, painted outdoors since 1860, and exhibited at the Salons

since 1864—to independence as an artist. These sessions and the conversations they entailed helped her progress from melancholy, depression, and self-doubt to increasing resolve. They enabled her to steel her will, focus her ambition, and launch into what was then thought to be a "revolutionary" or "catastrophic" path[17]—to pursue a life as a professional painter, a wife, and a mother. By 1874 she had achieved the first two goals and four years later, the third.

MANET PROVIDED the support that made these goals possible. While she posed for him, Morisot had access to the most innovative and controversial artist in Paris. She revered his art, and she, like so many of the young avant-garde artists, was influenced by his depictions of modern life in a modern style. His talent and vitality exhilarated her. The fortitude he showed in the face of continuous rejection and humiliation by the Salon jury and by most critics gave her the courage to pursue her own goals, and even to follow her own ideas about exhibiting with the Impressionists.

Morisot's mother was pressuring her to give up a career for marriage and a family, and expressed a low opinion of her work. As Berthe confided to Edma, "Yesterday my mother told me politely that she has no faith in my talent, and that she believed me incapable of ever doing anything worthwhile."[18] To make matters worse, Edma had abandoned a career in painting to marry a conservative navy commander, Adolphe Pontillon, and was living with him in Normandy. Her unhappy letters must have alerted Morisot to the dangers of following her sister's path. Edma wrote: "I am often with you, my dear Berthe. In my thoughts I follow you about in your studio, and wish that I could escape, were it only for a quarter of an hour, to breathe that air in which we lived for many long years."[19] She envisioned the pleasures of Berthe's life: "To me, your life seems to be quite charming at this moment. . . . to talk with Monsieur Degas while watching him draw, to laugh with Manet, to philosophize with Puvis—each of these experiences seems to me enviable. You would feel the same way if you were far off as I am."[20]

Morisot's replies reveal how conflicted she felt: "Consider that it is sad to be alone; despite anything that may be said or done, a woman has an immense need of affection. To make her withdraw into herself is to attempt the impossible."[21] Yet a month later she asserted, "Men incline to believe that they fill all of one's life, but as for me, I think that no matter how much affection a woman has for her husband, it is not easy for her to break with a life of work."[22] Two years later she admitted, "Work is the sole purpose of my existence, and . . . indefinitely prolonged idleness would be fatal to me from every point of view."[23] These mixed feelings left her confused and depressed and affected her appetite. Photographs from the late 1860s and early 1870s show her alternately plump and gaunt. During one period her mother wrote to Edma: "I do not think that Berthe has eaten half a pound of bread since you left; it disgusts her to swallow anything. I have meat juice made for her every day. Oh, well!"[24]

Throughout this difficult period Manet tried to help Morisot. He cajoled and goaded her and even tried to dislodge her from passivity by setting up a competitive situation between her and Gon-

zalès. As Morisot wrote to Edma, "Manet lectures me, and holds up that eternal Mademoiselle Gonzalès as an example; she has poise, perseverance, she is able to carry an undertaking to a successful issue, whereas I am not capable of anything."[25] This state of affairs piqued Edma, who loyally replied: "The thought of Mademoiselle Gonzalès irritates me, I do not know why. I imagine that Manet greatly overestimates her, and that we, or rather you, have as much talent as she."[26] Morisot's mother reported to Edma: "Manet himself, even while heaping compliments on her, said: 'Mlle B. has not wanted to do anything up to now. She has not really tried; when she wants to, she will succeed.' "[27]

Thanks in part to Manet's encouragement and to her own strong will, Morisot began to work more in 1872, and in an Impressionist style. That year she painted four works—including *View of Paris from the Trocadero* and *On the Balcony* (see pp. 159 and 160)—and in 1873 she painted six. By 1872 she was also romantically involved with Manet's brother Eugène, whose cause matchmaker Édouard promoted. Together the two men helped her turn her life around. In 1874 she produced ten new paintings, married Eugène, and first exhibited with the Impressionists. Her works had been refused by the Salon that year, and Degas invited her (now thirty-three) and Edma (thirty-five), through the etiquette of writing to their mother, to exhibit in the first group exhibitions. Edma refused, but Berthe accepted, despite advice from Manet, Puvis, and others against joining the separatists' show. She submitted nine works. In 1875 she produced eighteen paintings, firmly launching her career.

After they became in-laws, Manet continued to encourage her. For example, in 1880, he sent "my dear Berthe" a "modest New Year's gift" of the "latest style easel, very handy for pastel."[28] The following year he urged her to take "a little trip to Italy" and to "visit Venice and to bring back from there some paintings that would certainly be very personal."[29] She took his suggestion and began a tour, but her daughter, Julie, became ill, and they never reached Venice. At the Impressionist exhibition of 1882, Manet asserted that her pictures were among the best.

Morisot gave Manet at least two of her works: *The Harbor at Lorient* (1869; see p. 156) and *Hide and Seek* (1873). She owned more than seven of his: at least five oils had been gifts from Manet—two oil sketches of her daughter,[30] two portraits of her, and a still life. She and Eugène purchased other Manet oils, including another portrait of her, *Boy with the Cherries* (1858), *Nina de Callias* (1873), *Laundress* (1875), *Portrait of Mlle. Isabelle Lemonnier* (c. 1879), and *Young Woman in a Garden* (1880).

The differences between being a male artist and being a female artist in France in the late nineteenth century created an imbalance in their relationship. Morisot was one of Manet's links to the avant-garde and valuable to him as his style changed, but she looked up to him as a superior talent, in part because he was a man. (As she wrote when she gave birth to Julie in 1878: "Well, I am just like everybody else! I regret that Bibi is not a boy. . . . Each and every one of us, men and women, are in love with the male sex.")[31] They had similar aims: to paint with freedom, randomness, and mobility what they saw around them, concentrating on the leisure and pleasure of modern life. But as a man Manet had

access to a wide range of spectacles not accessible to upper-class women.

His world included diverse classes and experiences, and he was free to explore this world without limitation. He socialized with politicians, actors, writers, and artists; saw life backstage at the opera, theater, and ballet; was acquainted with life outside and inside the cafés and café-concerts; and freely wandered the city streets, public gardens, railroads, harbors, beaches, and brothels. Morisot was constantly chaperoned and had limited access to even "proper" places. Her sheltered world included her family and friends at home and at leisure, and the models she employed. Her life experience was clearly restricted because she was a woman.

"The peculiarity of Berthe Morisot . . . ," Paul Valéry wrote, "was to live her painting and to paint her life, as if the interchange between seeing and rendering, between the light and her creative will, was for her a natural and necessary function, linked to her vital needs." As a result, "her sketches and paintings keep closely in step with her development as a girl, wife, and mother; her sketches and her paintings closely follow her situation." They are "like the diary of a woman who uses color and line as her means of expression."[32]

That difference, between capturing public life and producing a "diary" in paint, is evident in other ways as well. Although they each died in their early fifties and each produced approximately 425 oils, most of Manet's are large works made with an eye to important public and private collections, whereas Morisot's are primarily small works destined for her family. She was not an amateur; she had the same dealer (Durand-Ruel) as did Manet, and she exhibited with Degas and the Impressionists. Yet her narrow world prevented her from developing her talents as Manet did. Hence her work is less rich than his. Nonetheless her friend Mallarmé wrote after her death: "While current praise would see in her a typically feminine talent—she was indeed also a master. Her work, now completed, is worthy, in the estimation of some of the great revolutionary artists who considered her a comrade-in-arms, to rank beside that produced by any one of them, and is intimately, exquisitely linked with the history of painting during an epoch of this century."[33]

Morisot wished "to capture something transient"[34] and valued most spontaneity, individuality, and originality. She distinguished herself as the Impressionist with the most unfinished surfaces and with a stroke that is the most feathery, delicate, and suggestive. She often used watercolors in her search for lighter hues and a freer execution.

As the critic Geffroy wrote in 1881, "No one represents Impressionism with more refined talent or with more authority than Morisot."[35]

OPPOSITE: Morisot, *Portrait of Mme. Edma Pontillon* (sister of the artist), 1871. Pastel on paper, 31⅞ × 25⅝" (81 × 65 cm). Musée de Louvre, Département des Arts Graphiques, fonds du Musée d'Orsay, Paris.

THE ONE documented instance of friction between Manet and Morisot erupted when she asked his advice and received much more than she wanted. In March 1870 she was completing a double portrait of her mother dressed in black and her pregnant sister Edma in a customary white dress. The mirror behind Edma's head reflects a window with open curtains that captures the light streaming into the room. The play of light on the sitters and on the still life displays Morisot's technical virtuosity.

At this point Morisot had modeled for Manet in four portraits. When she asked his opinion about her double portrait, she expected a verbal response. Instead, stunned and outraged, she watched helplessly as he "fixed" her canvas, making it more "finished." After this experience she never again let him touch her paintings.

Manet's overbearing interference had nothing to do with the fact that Morisot was a woman. He had taken similar liberties in 1868 when he cut Degas's double portrait of him and his wife (see p. 35) and in 1870 when he took the brush from Bazille, who was working on *The Studio*, and painted in Bazille's own portrait.

Morisot first mentioned the problem she was having with *The Mother and Sister of the Artist* in a letter to Edma in September 1869: "The Manets came to see us Tuesday evening, and we all went into the studio. To my great surprise and satisfaction, I received the highest praise.... Then he talked to me about finishing my work, and I must confess that I do not see what I can do."[36] In early March 1870 she wrote, "Manet exhorted me so strongly to do a little retouching on my painting of you, that when you come here I shall ask you to let me draw the hands again and add some touches at the bottom of the dress, and that is all."[37] Shortly thereafter Morisot described what happened next:

Tired, unnerved, I went to Manet's studio on Saturday. He asked me how I was getting on, and seeing that I felt dubious, he said to me enthusiastically: "Tomorrow, after I have sent off my pictures, I shall come to see yours, and you may put yourself in my hands. I shall tell you what needs to be done." The next day, which was yesterday, he came at about one o'clock; he found it very good, except for the lower part of the dress. He took the brushes and put in a few accents that looked very well; mother was in ecstasies. That is where my misfortunes began. Once started, nothing could stop him; from the skirt he went to the bust, from the bust to the head, from the head to the background. He cracked a thousand jokes, laughed like a madman, handed me the palette, took it back; finally by five o'clock in the afternoon we had made the prettiest caricature that was ever seen. The carter was waiting to take it away [to the Salon jury]; he made me put it in the handcart, willy-nilly. And now I am left confounded. My only hope is that I shall be rejected. My mother thinks this episode funny, but I find it agonizing.

I put in with it the painting I did of you at Lorient [*The Harbor at Lorient*; see p. 156]. I hope they take only that.... Another silly trick of that madman Manet![38]

Manet's strokes are seen in the somewhat heavier touch around the eyes and mouth of Mme. Morisot, in her long, minimally defined fingers, and in the broadly painted expanse of her black dress with its thick impasto.

Morisot's mother continued the story in a letter to Edma:

Berthe must have told you about all the mishaps. Except for your sake she certainly would not have set pen to paper. Yesterday she looked like a person about to faint; she grieves and worries me; her despair and discontent were so great that they could be ascribed only to a morbid condition; moreover she tells me every minute that she is going to fall ill. She overworked herself to such a point on the last day that she really could not see any more, and it seems that I made matters worse by telling her that the improvements Manet had made on my head seemed to me atrocious. When I saw her in this state, and when she kept telling me that she would rather be at the bottom of the river than learn that her picture had been accepted, I thought I was doing the right thing to ask for its return. I have got it back, but now we are in a new predicament: won't Manet be offended? He spent all Sunday afternoon making this pretty mess, and took charge himself of consigning it to the carter. It is impossible to tell him that the entry did not get there in time, since the little sketch of Lorient went with it. It would be puerile to tell this to anyone except you; but you know how the smallest thing here takes on the proportions of a tragedy because of our nervous and febrile dispositions, and God knows I have endured the consequences. It is these constant ups and downs that make it impossible to compose oneself.[39]

The double portrait was returned to the Salon, where it was exhibited along with the Lorient canvas. Other letters from Morisot to Edma prompted the following reply, "You write that you [your two paintings] 'do not make as absurd an impression [at the Salon] as you feared.' "[40]

A sarcastic letter from Berthe to Edma concludes the episode:

I am still engrossed in [the problem of] this wretched painting. I certainly did show my two pictures; it is my principle never to try to rectify a blunder, and that is the main reason why I did not profit from my mother's intervention. Now I am thankful: having got over my first emotion, I find that one always derives benefit from exhibiting one's work, however mediocre it may be. On the other hand I am not receiving a great many compliments, as you think, but everyone is sufficiently kind enough not to make me feel any regrets.[41]

This experience intensified Morisot's desire for her art not to look like Manet's. She expressed her concern openly in 1871: "I am doing Yves [the eldest of the three sisters] with Bichette [her daughter Paule]. I am having great difficulty with them. The work is losing all its freshness. Moreover, as a composition it resembles a Manet. I realize this and am annoyed."[42]

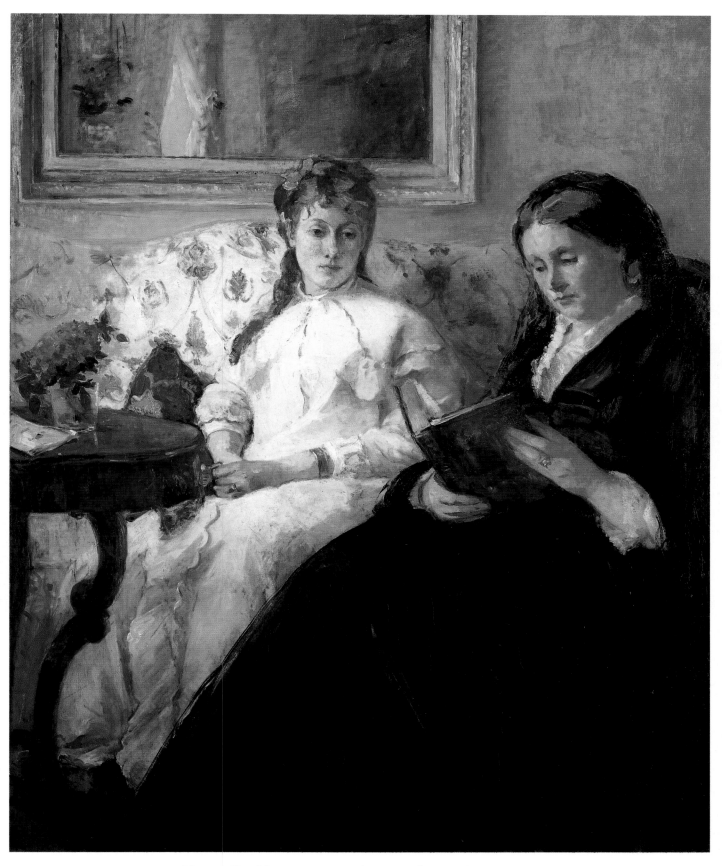

Morisot, *The Mother and Sister of the Artist* (Mme. Edmé-Tiburce
Morisot and Mme. Edma Morisot Pontillon), 1869–70. Oil on canvas,
39½ × 32¼″ (101 × 82 cm). National Gallery of Art, Washington;
Chester Dale Collection.

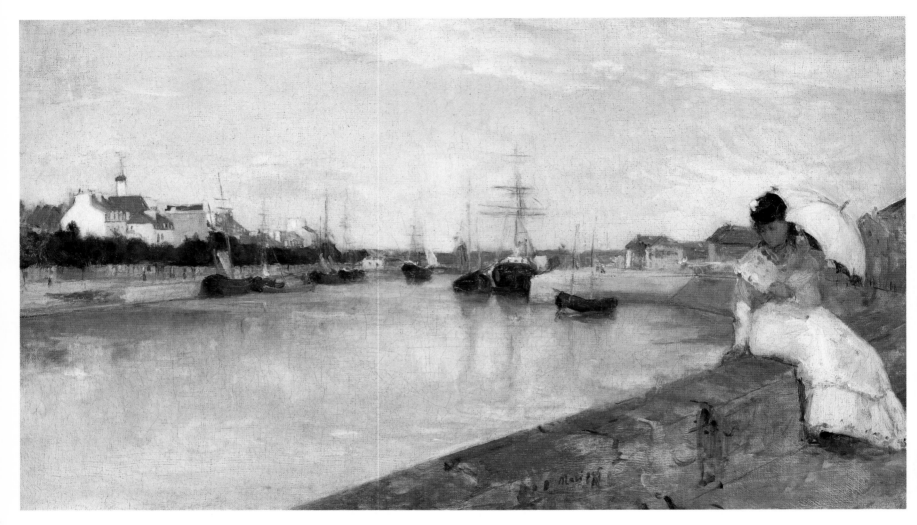

Morisot, *The Harbor at Lorient*, 1869. Oil on canvas, 17⅛ × 28¾″ (43.5 × 73 cm). National Gallery of Art, Washington; Ailsa Mellon Bruce Collection, 1970.

AT A TIME when Morisot was concerned about the originality of her vision, Manet's paintings were becoming less "finished," like hers, and his strokes became more and more visible and even seemed to dissolve the form. We can attribute this to the influence of Morisot as well as of Monet and Renoir, who were then experimenting with the new Impressionist style. While Manet did not approve of the lack of finish on the double portrait, he did admire the sketchiness of a small landscape with a figure, which she had made the year before.

In May 1869 Morisot wrote to Edma about an artistic problem "we have so often attempted—a figure in the outdoor light. . . . [with] much light and sun in it."[43] That summer she painted *The*

Harbor at Lorient, which shows Edma shielded by an umbrella, seated on a parapet. This work is partially Impressionist; only lacking is the rainbow palette that Monet and Renoir would employ in their work at La Grenouillère in October. She painted it entirely *en plein air* [outdoors], with the subject in view. Her composition appears random, and the figure is placed to the right and seen from above, a viewpoint perhaps inspired by photography or Japanese prints. The execution lacks finish, and Edma's face is merely suggested. Visible strokes create imprecise forms and also suggest the process of painting. This process captures what Baudelaire considered "the transitory, fleeting beauty of our present life."[44] Edma's white dress with pink reflections from the parasol

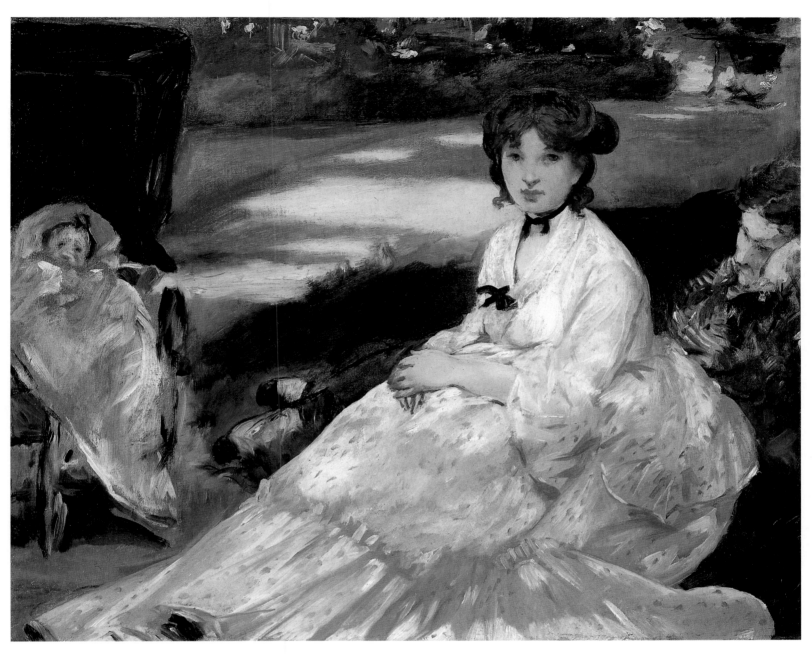

Manet, *In the Garden*, 1870. Oil on canvas, 17½ × 21¼″ (44.5 × 54 cm).
The Shelburne Museum, Shelburne, Vt.

lining is rendered in quick broad strokes, which show the active play of light and shade. The atmosphere is suggested through the broad expanse of sky and the reflections of clouds on the water.

Manet was so enamored of this and other works that Morisot did at Lorient that he called them "masterpieces."[45] She gave him *The Harbor at Lorient* at once, much to the dismay of her mother, who lamented, "thus nothing will remain of it at home. This souvenir of Lorient would have been nice to have."[46] Inspired by it, Manet made several outdoor scenes that show his change toward Impressionism in 1870.

In May 1870, less than a year later, he painted *In the Garden*, his first work executed entirely outdoors. Berthe's friend Valentine Carré first posed for this painting; later Edma replaced her, posing with her new baby and her brother Tiburce. The arrangement of the three figures seems spontaneous, and this is the first Manet painting to capture vibrant natural light and shadow. It is also the first time he used a vigorous, sketchy style, which gives a transitory effect. Lighter and brighter colors and less finish replace his former dark, opaque colors and smooth surfaces. A sense of immediacy and randomness replaces his former static effect.

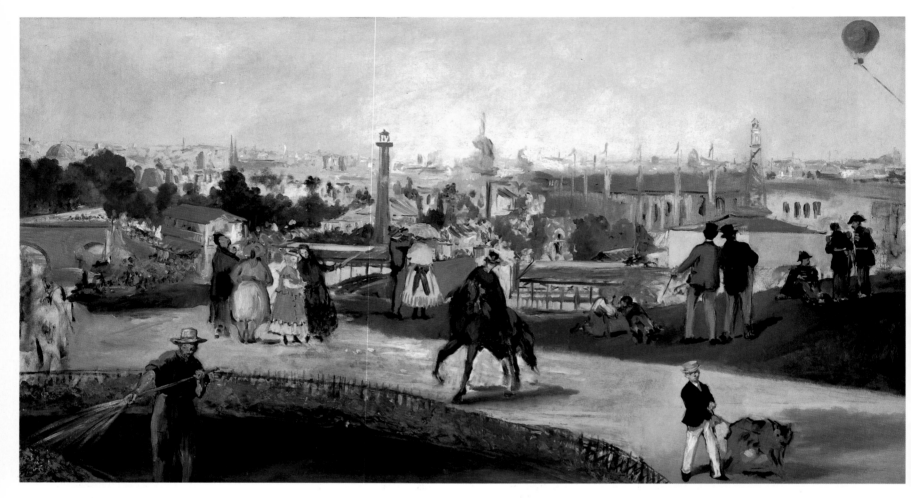

Manet, *Universal Exposition of 1867*, 1867. Oil on canvas, 42½ × 77⅜″
(108 × 196.5 cm). Nasjonal Galleriet, Oslo.

Two pairs of works by Manet and Morisot in the late 1860s
and early 1870s further reveal their influence on each other.
In the first pair Morisot was influenced by Manet's choice of a spe-
cific panorama as subject. In the second pair he borrowed the pos-
ture of one of her figures.

In the first pair the artists portrayed Paris from a similar van-
tage point on the Trocadero hill, two blocks from Morisot's home.
Manet's scene is from halfway down the hill, near the edge of the
circular lawn shown in Morisot's picture; her view is painted from
the top of the hill. Both cityscapes include the same distant back-
ground: from left to right, the twin spires of the churches of
Sainte-Clotilde and Notre-Dame and the domes of Saint-Louis-
des-Invalides and the Panthéon. Manet's version also includes a
middle ground with structures from the World's Fair of 1867. At
the extreme left are pillars of the Pont de l'Alma, near which his
private exhibition was installed.

Manet's large painting shows a public scene. In the foreground
he depicted more than a dozen figures gathered to admire the

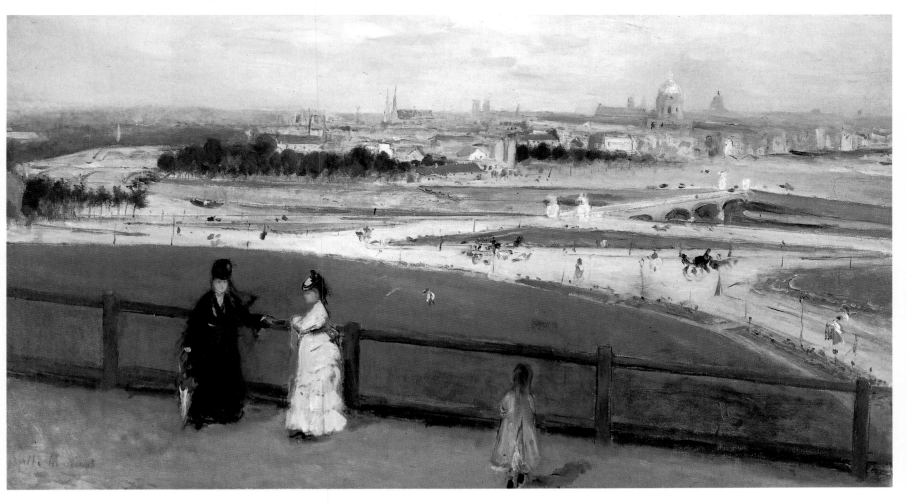

Morisot, *View of Paris from the Trocadero*, c. 1871–72. Oil on canvas,
18 × 32″ (46 × 81.5 cm). Santa Barbara Museum of Art; Gift of
Mrs. Hugh N. Kirkland.

splendor of Paris and its exhibition grounds: a female rider, a workman, two working-class women, a couple, bourgeois sightseers, two street urchins, two middle-aged dandies, three imperial guardsmen, and Suzanne Manet's son, Léon, walking his dog. In the upper right Nadar's balloon floats above the fair.[47]

This 1867 painting could well have inspired Morisot's rendition of the same view around five years later. Her smaller canvas depicts Paris not on a specific occasion but during a calm moment after the Franco-Prussian War. Instead of a public gathering, she presented an intimate view of her family. In the foreground are her two sisters, Edma Pontillon and Yves Gobillard, and Yves's three-year-old daughter, Paule.[48] Executed in an Impressionist style, her sketchy canvas has more pervasive light and varied color than does Manet's more defined painting which is darker and less colorful.

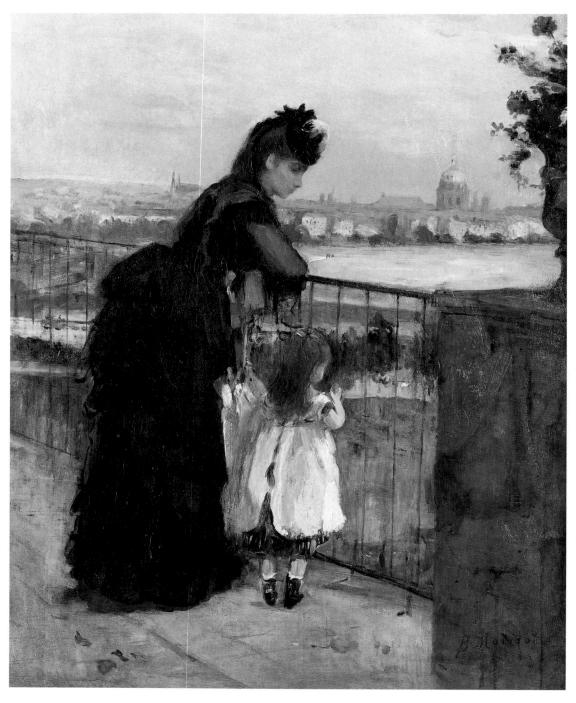

Morisot, *On the Balcony*, c. 1871–72. Oil on canvas, 23⅝ × 19⅝" (60 × 50 cm). Private collection.

Around the same time that she was painting the horizontal *View of Paris from the Trocadero* (see p. 159), Morisot created *On the Balcony*, a vertical canvas with a similar background and figures. On the balcony behind her house appear two of the same family members, Yves and Paule. Morisot portrayed the intimacy of a protective mother looking down at her little girl, who admires the splendid view. The centrally placed figures' bodies are linked through the mother's posture and gesture. The effect is dignified and lyrical.

In *Gare Saint-Lazare*, begun in the fall of 1872 and completed the following year, Manet borrowed Morisot's motif; however, the paintings otherwise are very different. The adult is his model Victorine Meurent, and the young girl, the daughter of a friend, appears to be about ten years old. In his background is the Gare St. Lazare, with its smoke, buildings, and activity. Manet's much larger work was shown at the Salon of 1874 and then sold to the actor Faure.

Although the charming *On the Balcony* entices us, the bold

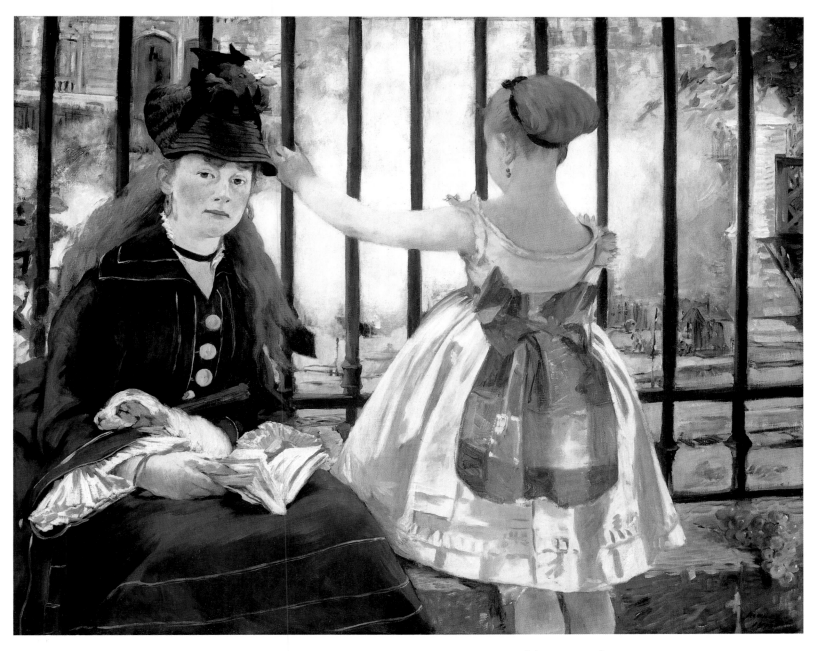

Manet, *Gare Saint-Lazare*, d. 1873. Oil on canvas, 36¾ × 45″ (93 × 114 cm).
National Gallery of Art, Washington; Gift of Horace Havemeyer in
memory of his mother, Louisine W. Havemeyer.

Gare Saint-Lazare intrigues us and is held together by contrasts. The standing child is seen from the rear; the seated adult is seen from the front. The two figures are in a shallow space close to us, yet they are psychologically distant from us and from each other. The girl's arm expands out to the railing; the woman's hands are held close to her body. The girl, dressed in white with a blue sash, has a dark ribbon holding up her hair. The woman, dressed in blue with white buttons, has a dark ribbon around her neck and loosely flowing hair. The composition is asymmetrical, with the major

focus at the left. This gives some spontaneity, which balances the woman's frozen stare.

In Morisot's small painting light dissolves the form; in Manet's large work it surrounds the form. Morisot captured a tender, intimate, lyrical moment; Manet rendered a detached, enigmatic, confrontive scene.

Manet's fourteen portraits of Morisot—eleven oils, two prints, and one watercolor dating from 1868 through 1874—trace his perception of her personal growth from the age of twenty-seven to thirty-three. There are two large works, one destined for the Salon of 1869 and one for the Salon of 1871, although the latter's admission was postponed until the Salon of 1873. The others, all significantly smaller, were experimental works, most of which remained in Manet's studio. He gave two of them to Morisot, and she bought a third after his death.

In the earlier portraits (1868 through 1871) she looks anxious, brooding, and depressed. Manet evidently captured her mood correctly; she expressed it herself in two letters to Edma late in 1869: "I feel myself no longer capable of anything. . . . The opinions of this one and that one worry me, and make me disgusted with things before they are in place."[49] She later added: "I feel myself overcome by an insurmountable laziness. I am reproached by everybody and I do not have the strength to react. . . . I have reached the point of wondering how I have ever in my life been able to do anything. . . . I am sad, and what is worse, everyone is deserting me; I feel alone, disillusioned, and old into the bargain."[50]

In the portraits dating from 1872 through 1874 she appears hap-

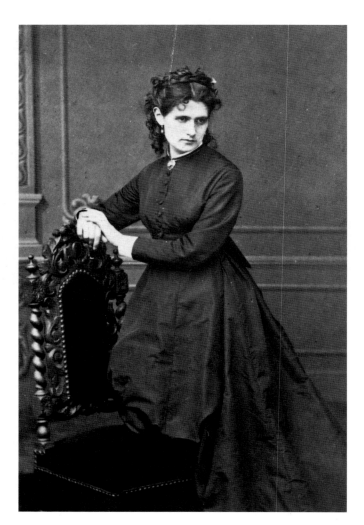

Photograph of Morisot around the age of twenty-seven or twenty-eight, c. 1868–69. Private collection.

pier, calmer, and stronger. By this time she felt confident that she could be both a professional artist and a wife and, perhaps, a mother, and she had begun to view Eugène Manet as a likely prospect for marriage. In addition, her self-esteem must have been enhanced by the fact that, as her mother reported, "To believe these great men, she has become an artist!"[51]

The Balcony of 1868–69, the first and largest work for which Morisot modeled, calls to mind a famous early nineteenth-century Spanish work—Goya's *Majas on a Balcony*, which also shows two women and two men. Morisot posed with the landscape painter Antonin Guillemet, the violinist Fanny Claus, and Suzanne Manet's son, Léon. Here Morisot appears troubled and tense. It is striking how much of a psychological portrait Manet has made of Morisot's face, gestures, and posture, compared with those of the others, who appear stiff and contrived, like mannequins. He had great difficulty painting Guillemet and Claus. Mme. Morisot reported: "Antonin says that he made him pose fifteen times to no effect and that Mademoiselle Claus is atrocious. But both of them, tired of posing on their feet, say to him: 'It's perfect—there is nothing more to be done over.' "[52] He evidently had trouble at times attaining his goal of painting directly (and presumably quickly) from the model.

Manet exhibited *The Balcony*, along with another work, at the 1869 Salon. Morisot sent none of her own works to this exhibition. She was enthralled by Manet's paintings, which she felt "as always produce the impression of a wild or even a somewhat unripe fruit."[53] And she was intrigued by the response to *The Balcony*: "I am more strange than ugly. It seems that the epithet of *femme fatale* has been circulating among the curious."[54]

The painting was not a success at the Salon, as Morisot's mother reported:

Manet was laughing heartily. This made him feel better, poor boy, because his lack of success saddens him. He tells you with the most natural air that he meets people who avoid him in order not to have to talk about his painting, and as a result he no longer has the courage to ask anyone to pose for him. He has made indirect overtures to the Gonzalès. . . . However, he told me that he had been asked the price of *The Balcony*; it must be someone who wants to make fun of him or perhaps to satisfy his curiosity. He said naively that Berthe was bringing him luck. He seems to me very nice because he is interested in Berthe; he also spoke of Tiburce in a tone that shows he likes us.[55]

Morisot too was concerned about his experience at the Salon. "Poor Manet," she wrote, "he is sad; his exhibition, as usual, does not appeal to the public, which is for him always a source of wonder. Nevertheless he said that I had brought him luck and he had an offer for *The Balcony*. I wish for his sake that this were true, but I have grave fears that his hopes will once again be disappointed."[56]

Evidently they were, for the painting did not sell. Manet kept *The Balcony* in his studio next to his famous *Olympia*. At the sale of his works after his death, Caillebotte bought *The Balcony* for 3,000 francs; he later bequeathed it to the Louvre.

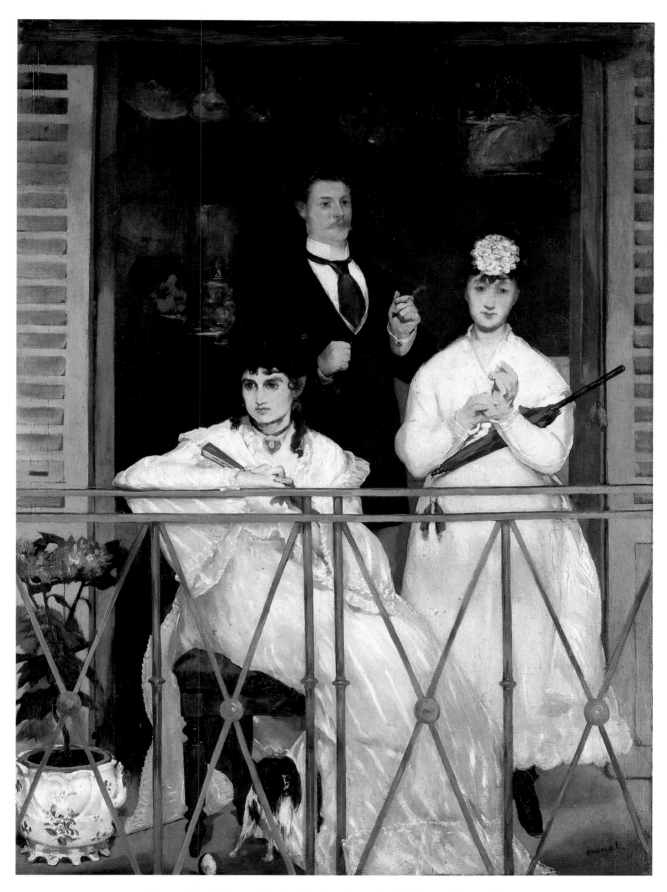

Manet, *The Balcony* (Berthe Morisot, Antonin Guillemet, Fanny Claus,
and Léon Leenhoff), 1868–69. Oil on canvas, 66⅞ × 49¼″ (170 ×
125 cm). Musée d'Orsay, Paris; Caillebotte Bequest.

In *Morisot in Profile* and *Morisot with a Muff*, as in *The Balcony* (see p. 163), the elegant, fashionable Morisot appears edgy, brooding, and solemn. In the painting with the muff, only her head is finished. Her clothing is sketched impressionistically but not colorfully.[57]

It is telling that in all Manet's depictions of Morisot, not one shows her working. Quite differently, he showed his pupil Gonzalès in the act of creating a work of art (see p 166). Maybe the facts that Morisot was not his student and that he and his family were socially involved with Morisot and hers explain why he chose not to portray her painting.

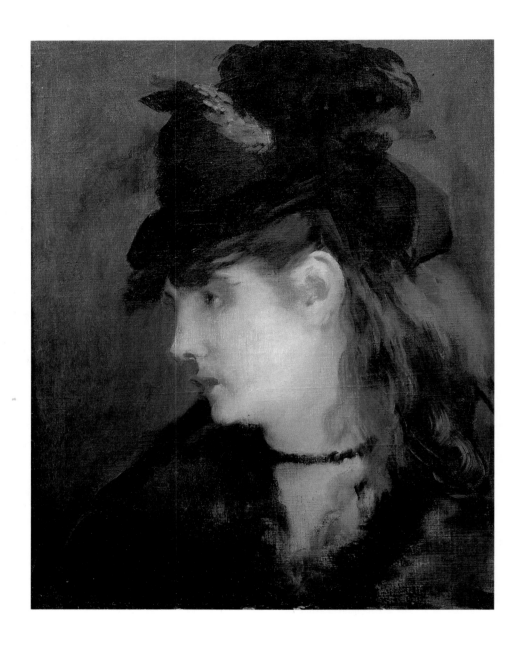

Manet, *Berthe Morisot in Profile*, 1868–69. Oil on canvas, 16 × 12½″ (40.5 × 32 cm). Private collection.

OPPOSITE: Manet, *Portrait of Berthe Morisot with a Muff*, c. 1869. Oil on canvas, 29 × 23⅝″ (73.6 × 60 cm). Cleveland Museum of Art; Bequest of Leonard C. Hanna, Jr.

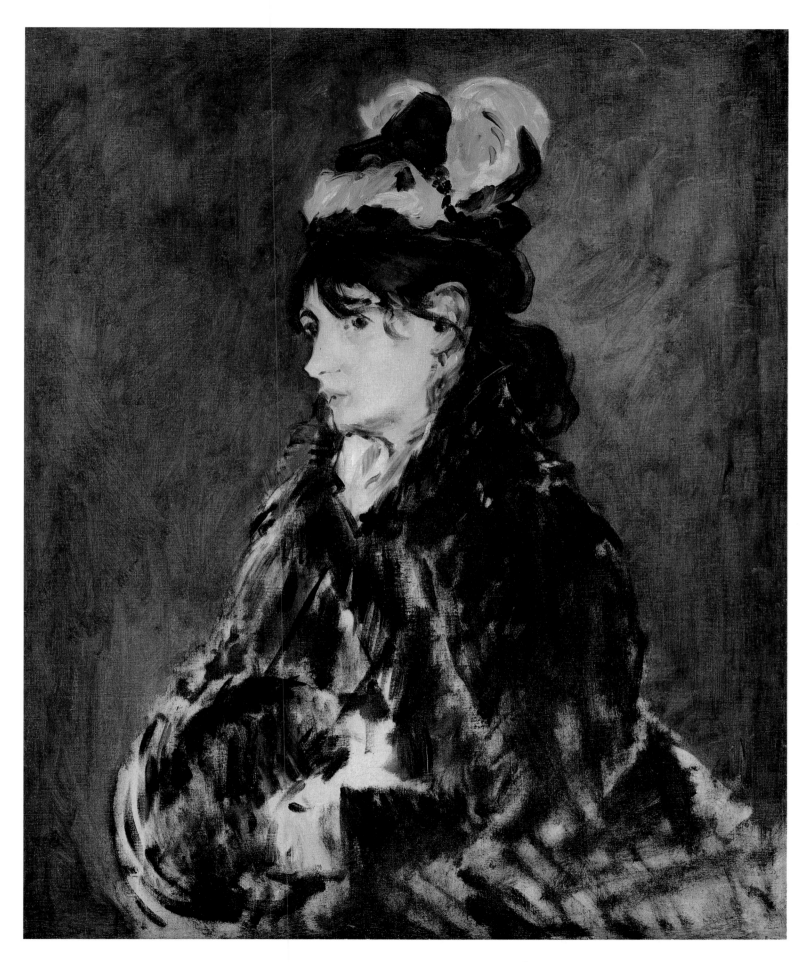

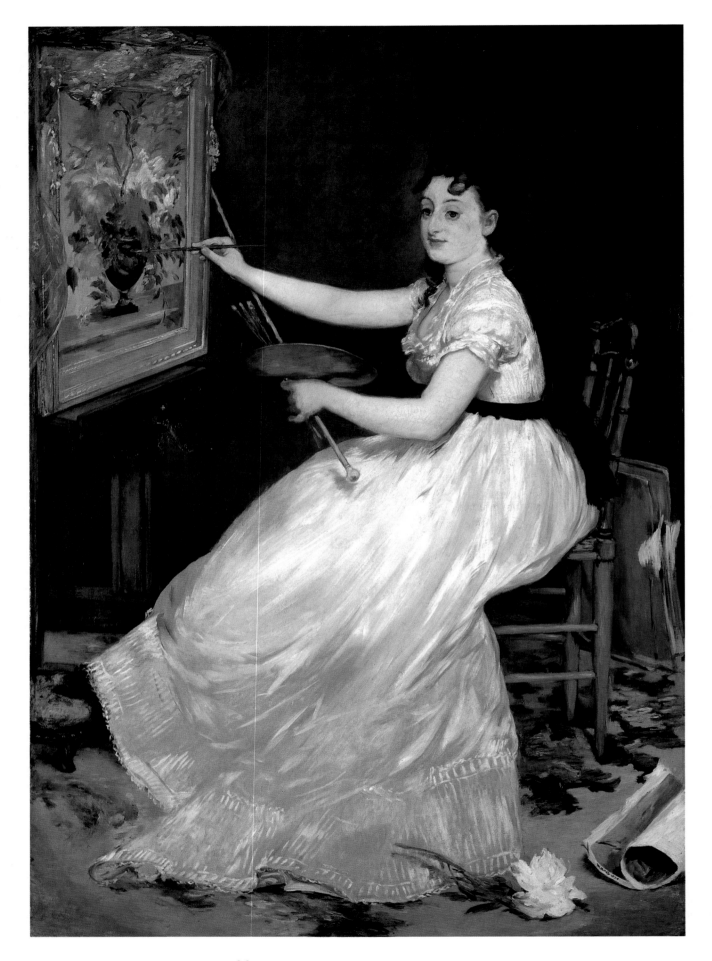

THE LARGE *Portrait of Eva Gonzalès,* which Manet sent to the Salon of 1870, was painted after *The Balcony* (see p. 163) and before *Repose* (see p. 169). His attentiveness to Gonzalès stirred Morisot's jealousy, and her mother contributed to these feelings. "I found [Manet] in greater ecstasies than ever in front of his model Gonzalès," Mme. Morisot wrote to Berthe. She continued: "He did not move from his stool. He asked how you were, and I answered that I was going to report to you how unfeeling he is. He has forgotten about you for the time being. Mademoiselle G. has all the virtues, all the charms, she is an accomplished woman."[58]

It is not clear whether Manet wanted to make Morisot jealous of Gonzalès as an end in itself or as a means of encouraging her to become more productive. In any case, the twenty-nine-year-old Morisot voiced her antipathy toward Manet's twenty-year-old student and apparently delighted in the difficulties he had in painting Gonzalès's face: "In the meantime," Morisot wrote to Edma, "he has begun her portrait over again for the twenty-fifth time. She poses every day, and every night the head is washed out with soft soap. This will scarcely encourage anyone to pose for him!"[59] A little later she reported: "We spent Thursday evening at Manet's. He was bubbling over with good spirits, spinning a hundred nonsensical yarns, one funnier than another. As of now, all his admiration is concentrated on Mademoiselle Gonzalès, but her portrait does not progress; he says that he is at the fortieth sitting and that the head is again effaced. He is the first to laugh about it."[60]

When Morisot saw the completed canvas in Manet's studio, she proclaimed, "Manet has never done anything as good as his portrait of Mademoiselle Gonzalès."[61] She modified her opinion, however, when she saw it, along with *Music Lesson* (see p. 46), at the Salon: "I cannot say that Manet has spoiled his paintings. Indeed I saw them in his studio the day before the exhibition, and they enchanted me, but I do not know how to account for the washed-out effect of the portrait of Mademoiselle Gonzalès.... The delicacies of tone, the subtleties that charmed me in the studio, disappear in this full daylight. The head remains weak and is not pretty at all."[62]

Manet, *Portrait of Eva Gonzalès,* d. 1870. Oil on canvas, 75⅛ × 52⅓″ (191 × 133 cm). Trustees of the National Gallery, London.

WHEREAS Gonzalès's face is lacking in animation and seems devoid of inner life, in *Repose* Manet captured Morisot's expressive face and intense feelings. As in *The Balcony* (see p. 163) she looks dejected, melancholy, and off balance. She seems to express what she later wrote to her brother, that she was living "in chimeras that did not give . . . [her] much happiness."[63] The critics noticed. One wrote: "A forlorn, miserable creature, and miserably dressed . . . from woebegone face to tiny foot, she is wilted, wretched, and ill-humored as can be."[64] Yet another critic saw an "intense spirit of modernity. . . . [and an] exquisite feeling for *la vie moderne*."[65]

As in *The Balcony* she wears white and has a black velvet ribbon around her neck. Yet now her posture is more informal. Manet suggested her modern taste by including in the portrait the Japanese woodcut triptych behind her head: Utagawa Kuniyoshi's *The Dragon King Pursuing the Ama with the Sacred Jewel* of 1853.

For *Repose*, Morisot had begun posing after the 1870 May Salon and continued through early 1871. Manet intended to send the work to the 1871 Salon. In March he asked Morisot's mother for permission: "I received a letter from Paris that there will probably be an exhibit opening May 20th. Would you allow me to send the study that I made of Mlle. B.? This painting is not at all in the character of a portrait, and in the catalogue I would call it— *study*."[66] He called it "study" perhaps partly because Mme. Morisot might object to people knowing that her daughter posed, somewhat seductively, on a couch, and partly because his style was sketchy. This lack of finish, for which he had criticized Morisot during the spring of 1870, was a method of painting he subsequently adopted more and more. In style *Repose* is more sketchy than any earlier portrait he had done. Perhaps here, as in *In the Garden* (see p. 157), he was inspired by Morisot's *The Harbor at Lorient* (see p. 156), then in his collection. We can assume that Mme. Morisot agreed to his request; however, because of the Commune (the revolutionary government that ruled Paris after France's defeat, from March 18 to May 17, 1871), no Salon took place in 1871. We do not know why Manet did not submit *Repose* to the Salon of 1872; instead he sent other work to that Salon and waited to send *Repose* to the Salon of 1873.

Manet gave Morisot an inscribed photograph of this work with the words "To Mlle. Berthe Morisot, respectfully E. Manet."[67] In 1894 she tried to buy the painting at the Duret sale (he had acquired it in 1880), but the person bidding for her made an error, and she failed to obtain it.

During the Franco-Prussian War (July 19, 1870–February 1, 1871), Morisot and Manet remained close friends. Morisot and her parents stayed in Paris until the advent of the Commune. During the war Mme. Morisot wrote: "We see no one; at rare intervals we see Manet."[68] Manet wrote: "Paris is a sorry sight—A lot of people are leaving. . . . Mme and Mlle Morisot are staying, I believe."[69] "Yesterday evening Eugène and I paid the Morisots a short visit."[70] "I've seen the Morisot ladies who are probably going to make up their minds to leave Passy which is likely to be bombarded."[71] "We went with Eugène to see the Morisot ladies— they're ill and are having difficulty coping with the hardships of the siege."[72]

When the Morisots finally left Paris, Berthe went to stay with Edma and her family in Cherbourg. When the Commune ended Mme. Morisot returned to Paris, but Berthe remained in Normandy through the summer. There she received a letter from Manet: "Dear Mademoiselle, we came back to Paris several days ago. . . . I met Tiburce a few days ago, and I have been unable to go to see your mother as I had planned. . . . Eugène went to see you at Saint-Germain, but you were out that day. I was pleased to hear that your house in Passy has been spared. . . . I hope, Mademoiselle, that you will not stay a long time in Cherbourg. Everybody is returning to Paris; besides, it's impossible to live anywhere else."[73]

Despite the separation the flirtation did not wane. As her mother reported after attending a Manet soiree: "Édouard kept asking me whether you are coming back, or abandoning all your adorers because you have found others."[74]

Late in 1871, after Morisot's return to Paris, she thought of posing for Édouard and wrote to her sister Edma: "I did not go to Manet's last Thursday. . . . On the preceding Thursday he was very nice to me. Once more he thinks me not too unattractive, and wants to take me back [after the war hiatus] as his model. Out of sheer boredom, I shall end by proposing this very thing myself."[75] However, it appears that she did not begin to pose until the new year.

OPPOSITE: Manet, *Repose (Berthe Morisot)*, 1870–71. Oil on canvas, 59⅛ × 44⅞" (150.2 × 114 cm). Museum of Art, Rhode Island School of Design, Providence; Bequest of Edith Stuyvesant Vanderbilt Gerry.

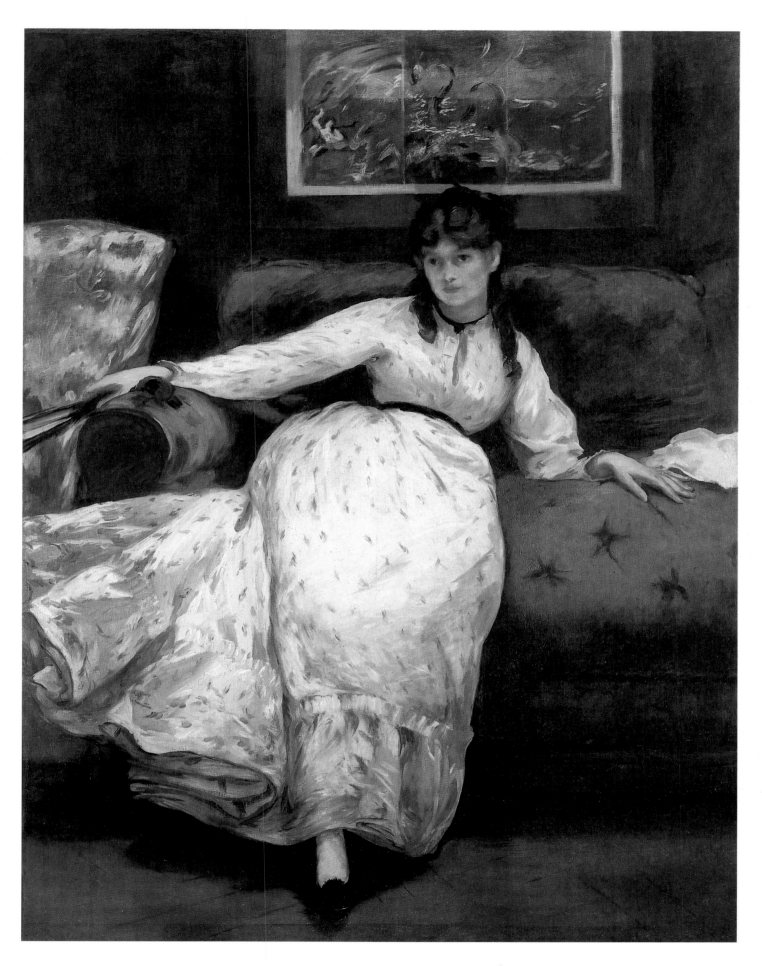

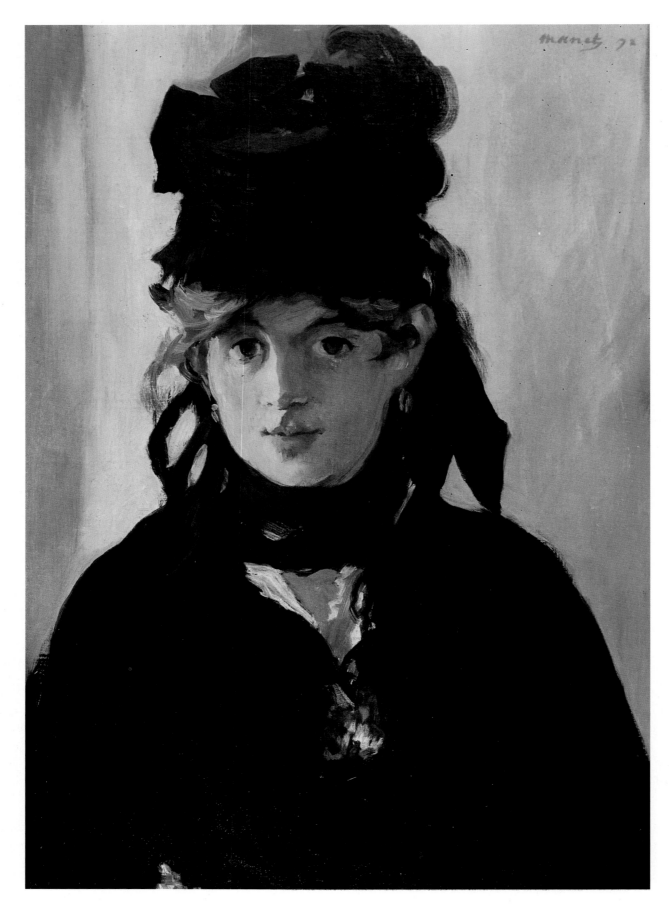

Manet, *Berthe Morisot with Bouquet of Violets*, d. 1872. Oil on canvas,
21¾ × 15″ (55.2 × 38.1 cm). Private collection.

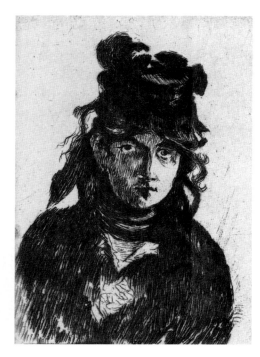

Manet, *Berthe Morisot in Outline* (after the painting), 1872–1874. Lithograph, first of two states, 8⅝ × 6½″ (22 × 16.5 cm). Baltimore Museum of Art.

Manet, *Berthe Morisot in Black* (after the painting), 1872–1874. Lithograph, second of two states, 8⅛ × 5⅝″ (20.5 × 14.3 cm). Cleveland Museum of Art; Dudley P. Allen Fund.

Manet, *Berthe Morisot* (after the painting), 1872. Etching, second state, 4⅝ × 3⅛″ (11.8 × 7.9 cm). Bibliothèque Nationale, Paris.

THE SEVEN small oils, and the lithograph, etching, and watercolor of Morisot that Manet executed from 1872 through 1874 reveal her transformed emotional state. Her depression had lifted. She was working again. The foremost avant-garde dealer, Durand-Ruel, was interested in her artwork. Part of her new happiness was her relationship with Eugène Manet, who was one year younger than Édouard and resembled him in temperament, appearance, and interests. Morisot's friendship with Eugène began in 1868, soon after she met his brother, and she saw him regularly at the family soirees. However, it wasn't until 1871 that the relationship between the thirty-year-old Berthe and the thirty-eight-year-old Eugène began to be "serious."

By 1871 Manet was pushing the couple toward marriage. He encouraged them to take a trip together to Bordeaux, because, as Mme. Morisot reported, "he had wanted to arrange it so as to compromise the two of you in order that you become his sister-in-law."[76] Although the Bordeaux plan was not carried forth, Manet continued to plead his brother's case.

The sitting for *Berthe Morisot with Bouquet of Violets* gave him his opportunity. As Julie later recalled: "Maman told me she had sat for it during the day before one of the Thursday dinners that used to be held at Bonne-Maman's [her grandmother, Mme. Marie-Cornélie Morisot]. That day Uncle Édouard told Maman that she ought to marry Papa and he talked to her about it for a very long time."[77]

This bust-length portrait is slightly smaller than life-size. Morisot is centered, involved, and attentive, yet her wistful look makes us wonder if some of her thoughts are distant. Of this work her daughter wrote: "It is hanging in my bedroom and I look at it from my bed; it's marvelous and magnificently executed, one would hardly believe that he did it in one or at the most two sittings."[78] Its power, as Valéry noted, derives from Manet's ability to relate "the physical likeness . . . with the unique harmony fitting to a singular personality, thus boldly transfixing the distinct and abstract charm of Berthe Morisot."[79] The painting was sold to Manet's friend Duret. When his collection was auctioned in 1894, Morisot bought it.

After completing the painting Manet made a lithograph in two states and an etching in three states. The prints are all smaller than the oil and appear flatter. The lithographs, which give a bolder and more immediate effect, could have been transferred to the stone by tracing a photograph of the painting, because the image is not reversed and the contours are similar. In the first state of the lithograph, which concentrates on the contour line, Morisot's elaborate hat and ribbons contrast with her calm face. The second state of the lithograph reproduces the darks and lights of the painting. Yet the face is not modeled, and the blacks of the costume are not as varied as in the oil. Consequently, the print looks more two-dimensional. The even smaller etching shows a reversed image which tilts to the right. It is darker throughout and gives Morisot a more serious and intense expression than the other versions.[80] This print calls to mind Mallarmé's description of "the lady [who] . . . painted . . . with fury and nonchalance."[81]

Manet, *Berthe Morisot with a Veil*, 1872. Oil on canvas, 24¼ × 18¾″
(61.5 × 47.5 cm). Musée du Petit Palais, Geneva.

Manet, *The Bunch of Violets*, 1872. Oil on canvas, 8¾ × 10¾″ (22 × 27 cm). Inscribed at right on white sheet: "A Mlle Berthe [Mo]risot [?]/E. Manet." Private collection.

THE OTHER PORTRAITS of Morisot that Manet completed between 1872 and 1874 are also small, sketchy paintings, Impressionist in style, which seem to have been made quickly. Despite the fact that Morisot's costume is usually black, the space is filled with light, which seems to dissolve the precision of the form. The visible brushstrokes intentionally create an immediacy and vibrancy that are close in style to the work of Monet, Morisot, Pissarro, and Renoir.

The same year that he painted *Berthe Morisot with Bouquet of Violets* (see p. 170), Manet made three other portraits, which show her relaxed and even playful.[82] *Berthe Morisot with a Veil* is a variant of *Berthe Morisot with Bouquet of Violets* in an even more sketchy style that seems to capture an instant as she turns toward the artist.

In two other 1872 paintings, Manet alluded to Goya as he had in *The Balcony* (see p. 163) of 1868–69. Many of Goya's works portray elegant ladies in long black dresses with delicate shoes and fans. In *Berthe Morisot with a Fan* (see p. 174), humorously, Morisot hides her face behind a large unfurled fan, which appears as both a mask and a hat. Here, as in *Berthe Morisot with a Pink Shoe* (see p. 175) and *Repose* (see p. 169), dainty shoes peep out from underneath her dress, symbols of her femininity and flirtatiousness. Around this time Eugène wrote to her: "How I miss . . . the charming walks that we took. . . . I wandered through every street in Paris today, but nowhere did I catch a glimpse of the little shoe with a bow that I know so well."[83]

In appreciation for her modeling in 1872, Manet gave Morisot a tiny still life that is inscribed to her. In it we see a bouquet of violets similar to the corsage in *Berthe Morisot with Bouquet of Violets* and a fan calling to mind fans that she held in *The Balcony*, *Repose*, and *Berthe Morisot with a Fan*.

Manet, *Berthe Morisot with a Fan*, 1872. Oil on canvas, 23⅝ × 17¾″
(60 × 45 cm). Musée d'Orsay, Paris.

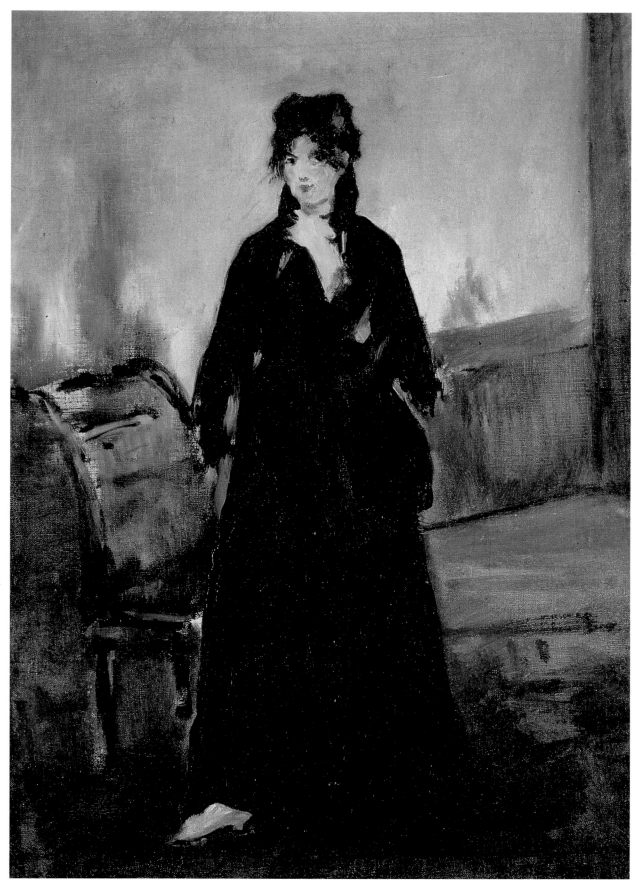

Manet, *Berthe Morisot with a Pink Shoe*, 1872. Oil on canvas, 18¼ ×
12¾" (46.4 × 32.5 cm). Hiroshima Museum of Art, Japan.

Berthe *Morisot Reclining* (1873) shows her even more self-possessed and self-assured. Originally a full-length work in which she lay sideways on a sofa, it was cut down to its present size because either Manet or Morisot did not like the way the painting looked. This is the most seductive among her portraits, humorously suggesting a clothed version of *Olympia*. Like the courtesan she wears a black ribbon around her neck, but Manet captured her unique warmth, so different from Olympia's masklike and calculating expression. Manet gave this portrait to Morisot. She hung it in her apartment, and it appears in the background of one of her own canvases, *Julie* (Manet) *Playing the Violin* (1894). Her daughter, Degas, and Mallarmé admired the painting and chose it as the frontispiece for her posthumous exhibition catalog in 1896.

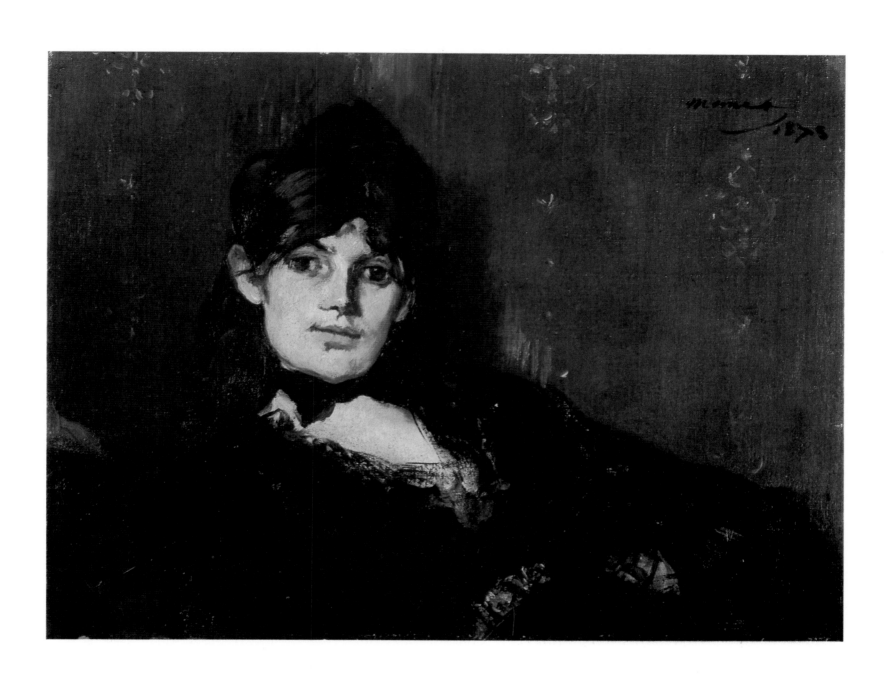

Manet, *Berthe Morisot Reclining*, d. 1873. Oil on canvas, 10⅔ × 13¾″
(27 × 35 cm). Private collection.

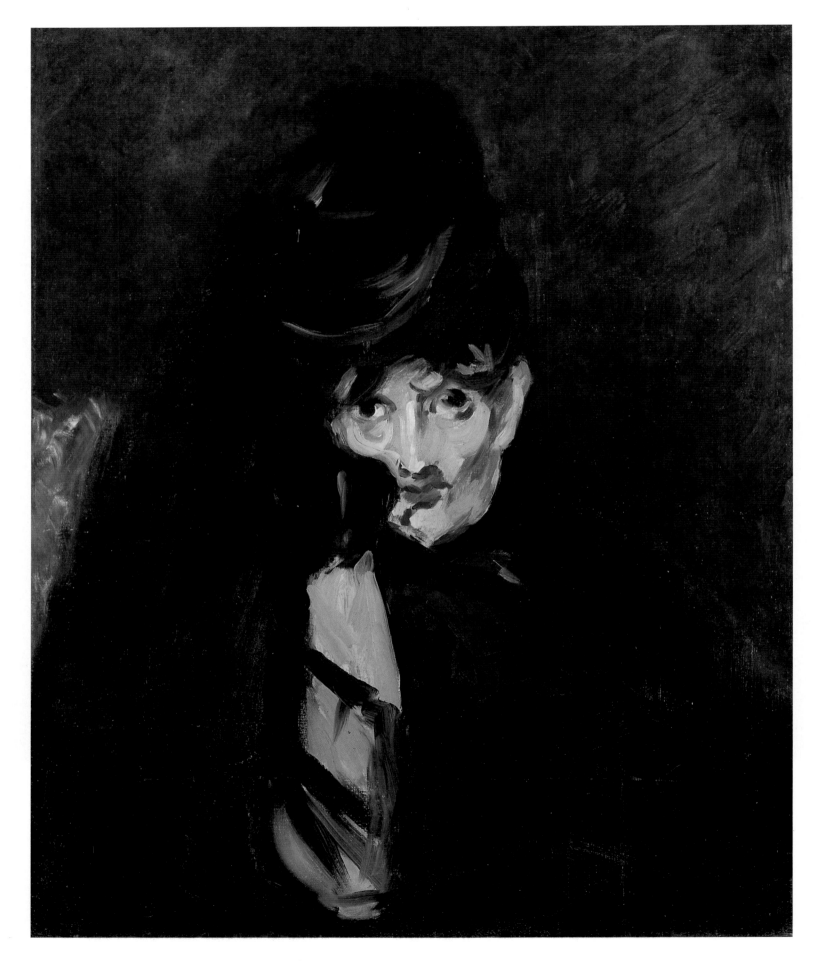

THE YEAR 1874 began with sorrow and ended with joy. On January 24, Morisot's father died after years of heart disease; on December 22, she married Eugène. Manet captured her changing moods in three portraits.

Berthe Morisot in a Mourning Hat is the most expressionistic portrait Manet ever made and conveys her deep sorrow with great intensity. A letter she wrote a year after her father's death expresses what the painting shows: "Today is January 24, a sad day, the anniversary of the death of poor father. How my heart tightens at the thought of these last years that were so agonizing, of his very long suffering, and how I regret that I did not know enough how to ease his last moments!"[84] Her extreme sadness is conveyed by the dramatic contrast between her pallor and the black of her outfit and by the wild intensity of her expression. She is depicted in the traditional pose of mourning, with her head resting on her fist. The sketchy technique emphasizes her anguish and grief. Here, Manet revealed how well he knew Morisot's deepest feelings. This portrait[85] is sadly prophetic of a series of bereavements Morisot would endure: her mother in 1876, Édouard Manet in 1883, and Eugène in 1892. Her own early death came in 1895, at age fifty-four.

Manet, *Berthe Morisot in a Mourning Hat*, 1874. Oil on canvas, 24 × 19⅔" (61 × 50 cm). Private collection.

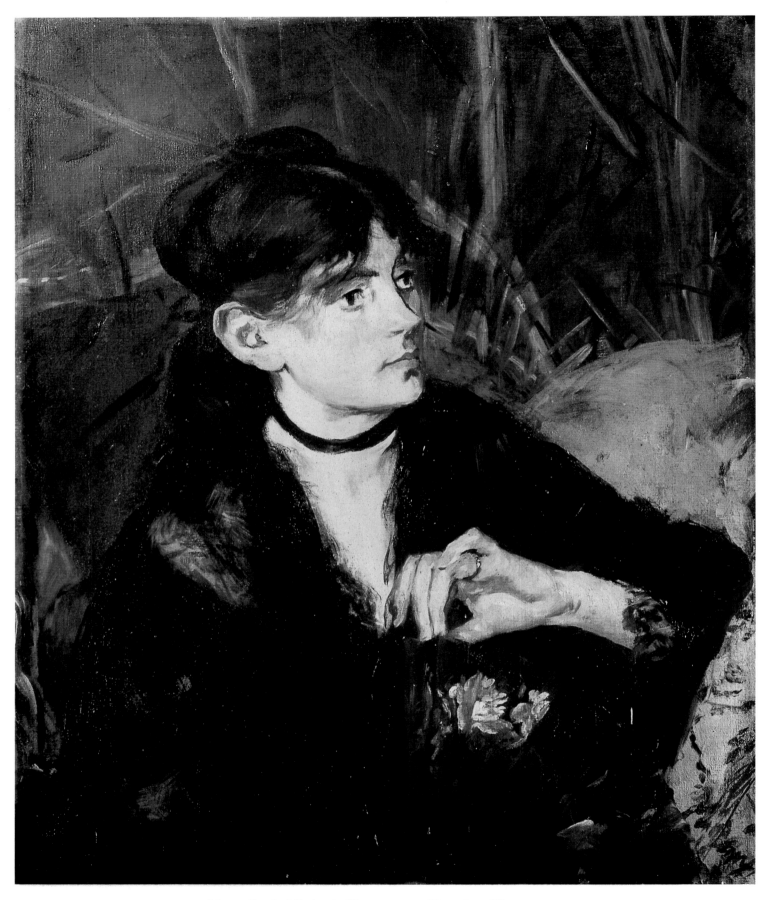

Manet, *Berthe Morisot in Three-quarters View*, 1874. Oil on canvas,
24 × 19⅔″ (61 × 50 cm). Private collection.

Manet, *Portrait of Berthe Morisot*, 1874. Watercolor, 8 × 6½″ (20.3 × 16.5 cm). The Art Institute of Chicago; Gift of the Joseph and Helen Rubenstein Foundation, 1963.

RIGHT: Photograph of Morisot, around the age of thirty-six, her husband, Eugène, around the age of forty-seven, and their daughter, Julie, around the age of two, Bougival, c. 1880. Private collection.

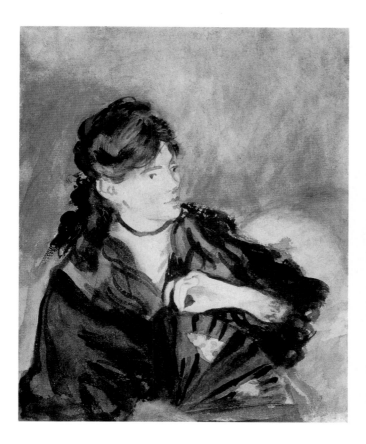

LATER THAT YEAR Manet made the oil painting *Berthe Morisot in Three-quarters View* as a wedding gift. Preceding the oil version he experimented with a small watercolor in which her right hand is suggested below. In the study and the oil, once again she has a black ribbon around her neck and a fan in her hand. Manet emphasized her left hand and prominently displayed the gold band, an engagement or wedding ring, on her finger. Morisot appears graceful, self-confident, and serene. Her happiness is no doubt tied to her relationship with the eminently romantic Eugène: "I doff my hat to the beautiful artist," he wrote. "When shall I be permitted to see you again? Here I am on very short rations after having been spoiled."[86] He vowed to make her "the most adulated, the most cherished woman in the world. . . . I should gladly court you for one thousand five hundred years . . . on condition that I might pay my respects at least once a week."[87]

During that year Eugène further proved his faithful support by defending Morisot's decision to exhibit with the Impressionists despite the opposition of his brother. Throughout the next twelve years, Eugène actively endorsed Morisot's involvement in seven out of the eight Impressionist shows. (She missed only the 1879 exhibit, because of complications following the birth of her daughter, Julie.)

Late in 1874 the thirty-three-year-old Berthe and forty-year-old Eugène were married at her local church in Passy. In the eighteen years before his death in 1892, he lived up to the trust Morisot noted a month after the wedding: "I have found an honest and excellent man, who I believe loves me sincerely."[88]

In Eugène, Morisot found the ideal husband. He appreciated her strength of character, courage to pursue her ambitions, artis-

tic talents, and femininity. Independently wealthy, he could devote his resources and attention to her career. After their marriage he spent much of his time acting as her agent and promoter. As an amateur artist who did pastels and watercolors, he often accompanied her on painting expeditions and on occasion worked at her side. Besides painting he also wrote novels and published one book, *Victims*, in 1889.

After the wedding Manet made no further portraits of Morisot, although he made several sketches of Julie. Until his death nine years later, Manet and Morisot continued to be close as friends, in-laws, and colleagues. Although she loved her husband deeply, she continued to be infatuated with Manet, as a person and as an artist. These feelings were poignantly expressed in a letter after his death to her friend Sophie Cannet: "I know, my dear friend, that you have understood how painful the spectacle of that terrible agony was for me. Édouard and I were friends for many, many years, and he is associated with all the memories of my youth; moreover, he was such an attractive personality, his mind was so young and alert, that it seemed that more than others he was beyond the power of death."[89]

A few months later, at the time of Manet's retrospective exhibition, she wrote to Edma: "The exhibition is a great success. The connoisseurs are surprised by the vigor of his work when it is thus shown in its entirety. There is a sureness of execution, a technical mastery that imposes itself even upon ignorants and that overwhelms us all. . . . On the morning of the opening, Stevens, Chavannes and [Ernest] Duez [90] were saying: 'Since Père Ingres we have not seen anything as strong,' but we, the truly faithful, we say: 'It is far stronger.' "[91]

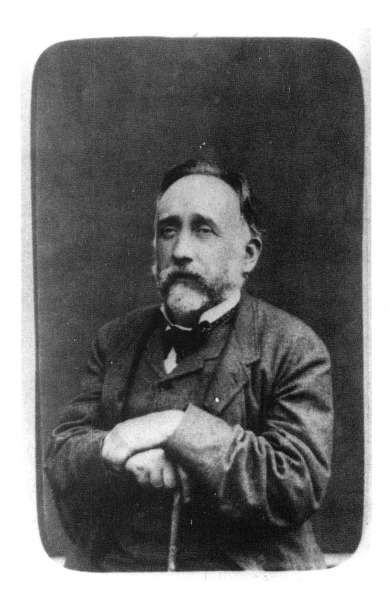

Barnes [Dieppe], photograph of Degas around the age of fifty-three, c. 1885. Bibliothèque Nationale, Paris.

Baroni e Gardelli [Parma], carte de visite photograph of Cassatt at the age of twenty-eight, 1872. Albumen print in the Archives of the Pennsylvania Academy of the Fine Arts, Philadelphia.

Cassatt & Degas

Upon Edgar Degas's death, Mary Cassatt, then seventy-three, wrote from Paris: "I am sad; he was my oldest friend here, and the last great artist of the 19th Century—I see no one here to replace him."[1] Cassatt and Degas were proud, independent, and opinionated people who were collaborators, colleagues, friends, and rivals. Their turbulent forty-year friendship was best described by Cassatt's closest friend, Louisine Elder Havemeyer:

> After they met . . . long years of friendship ensued, of mutual criticism, and I must frankly add, of spicy estrangements, for Degas was addicted to the habit of throwing verbal vitriol, as the French call it, upon his friends and Miss Cassatt would not have been the daughter of the Cassatts if she had not been equal to parrying his thrusts. She could do without him, while he needed . . . her generous admiration. I have been amused during the long years I have known them at the little luncheons or dinners planned by friends in order to effect a pleasant reconciliation. . . . Degas's admiration for Miss Cassatt was unbounded, but there was always a little dart in his remarks. "I will not admit a woman can draw like that!" he exclaimed, as he stood before one of her pictures.[2]

Cassatt met Degas's malicious remarks with fortitude and magnanimity. She once said, "Sometimes it made him furious that he could not find a chink in my armor."[3] But she could get along without him because, as she said, "I am independent! I can live alone and I love to work." She understood the rhythm of the relationship: "There would be months when we just could not see each other, and then something I painted would bring us together again and he would go to Durand-Ruel's and say something nice about me, or come to see me himself."[4]

When they met in 1877, she was thirty-three and he forty-three. By this time both were set in their single lives, and neither was looking for a mate. Both were well-educated and well-traveled members of the upper class. From the time she was six, Cassatt's family spent much time in Paris. At age twenty-two she returned without her family to study art and remained there for most of her life. As an American living abroad, Cassatt was less sheltered, chaperoned, and constrained than was Morisot. She was also more independent and self-confident, although, as an *haute-bourgeoise*

woman in Paris, she was not welcome at the cafés, backstage at the theater, or at other male haunts.

Cassatt was a match for the bullying Degas. Her clashes with him were a manner of relating that was well-known to her because of her power struggles with her father, who once wrote, "She is dreadfully headstrong in some things, and experience is lost upon her."[5] When she was a young art student, her father virtually forbade her to move to Europe to pursue an art career, telling her, "I would almost prefer to see you dead,"[6] but she went anyway. At the age of twenty-eight she traveled alone to Spain and spent a few months there, even though she knew nobody and had only a rudimentary knowledge of Spanish.[7] Cassatt lived in Europe without her parents until 1877 (the year that she and Degas met), when her father, at the age of seventy-one, with his wife and elder daughter, Lydia, relocated in Paris to join her. That Cassatt was able to stand up to her father enabled her to stand up to Degas when some others could not. After years of friendship with him, the painter Gustave Moreau could no longer endure Degas's attacks and said: "See here, Degas, I must lead my life! Let us no longer meet!"[8]

Cassatt's mother was supportive of her daughter's career, especially after Lydia died in 1882.[9] As she wrote to her son: "Mary is at work again, intent on fame & money she says. . . . After all a woman who is not married is lucky if she has a decided love for work of any kind & the more absorbing it is the better."[10] Yet in other areas Cassatt's and her mother's opinions clashed. This was especially the case about the buying of works of art, one of Cassatt's passions. "Mother does not give me much encouragement," she wrote, "as 'au fond' I think she believes picture buying to be great extravagance."[11] Cassatt's ability to stand up to both parents helped her become a self-sufficient woman. Furthermore, living through conflicts with them enabled her to sustain the antagonistic and mercurial relationship with Degas and even to derive pleasure from it.

The American Cassatt interested Degas in part because his mother, who died when he was fourteen, had been a Creole from New Orleans. Shortly after meeting, Cassatt and Degas began to socialize with each other's families, and members of them figured in each other's paintings.[12] Their friendship was primarily a business relationship between a celebrated older painter who became

mentor to one lesser known. Although Cassatt was already an accomplished painter when they met, and never took lessons from Degas, their association enabled her to develop her talents to the utmost. She patterned her style after his; also, she learned a great amount about printmaking from collaborating with him. For the sake of learning from his genius, she put up with Degas's ill-humor, graciously forgiving much. For Degas's part, he relied on Cassatt for financial support, because his family had lost their fortune in 1874; she found American patrons for his work.

The year 1877 was pivotal in Cassatt's life. She saw Degas's art and met him; decided to cease exhibiting at the Salons and to join the avant-garde exhibitions; and helped a friend buy one of Degas's works. "The first sight of Degas's pictures," Cassatt exclaimed, "was the turning point in my artistic life."[13] Forty years later she recalled "seeing for the first time Degas's pastels in the window of a picture dealer on the Boulevard Haussmann. I used to go and flatten my nose against that window and absorb all I could of his art. It changed my life. I saw art then as I wanted to see it."[14] Knowledge of Degas's work brought about dramatic changes in her subject matter, style, and techniques. She revered his pictures and told her best friend, Louisine, they were "magnificent!"[15] Throughout her life, while she retained her own sense of self-worth and individualism, she gracefully admitted his superiority as an artist and never failed to acknowledge her enormous debt to his work.

Sometime after she had seen Degas's pastels and after the spring 1877 Impressionist show, their mutual friend Léon Auguste Tourney brought Degas to her studio so that they could meet and Degas could personally invite her to join the Impressionists in the next show.[16] Degas had first seen her work at the 1874 Salon, when (as Cassatt told her biographer) Tourney led him "to the portrait of a young woman that Miss Mary Cassatt had sent and that she had painted in Rome.[17] Degas stopped and said: 'It's true. Here is someone who feels as I do.' "[18] Her work shared his forthright realism and combined the influences of the old masters and the moderns.

By 1877 a stylistic schism between the Realist Impressionists and the pure Impressionists led Degas to look for new recruits to shore up his faction. The friends whom he invited painted in a variety of styles, but all were strongly grounded in Realism. Cassatt's exhibiting history made her an ideal candidate. She had a work rejected at the Salon of 1875. The following year she resubmitted the work but had darkened the background. It was accepted. "In 1877," Cassatt explained, "I again sent work to the Salon. They rejected me. It was at that moment that Degas urged me no longer to send to the Salon and to exhibit with his friends in the Impressionist group. I accepted with joy. At last I could work with absolute independence without considering the opinion of a jury! I had already recognized who were my true masters. I admired Manet, Courbet, and Degas. I hated conventional art. I was beginning to live."[19]

At the last minute the 1878 exhibit was canceled; Cassatt first exhibited with the group in the next show in 1879. Subsequently, she joined them in 1880, 1881, and 1886. Degas boycotted the exhibit of 1882, and Cassatt withdrew to support his position.

Of her first participation in the group she later wrote:

I, however, who belong to the founders of the Independent Exhibition must stick to my principles, our principles, which were, no jury, no medals, no awards. Our first exhibition was held in 1879 and was a protest against official exhibitions and not a grouping of artists with the same art tendencies. We have been since dubbed 'Impressionists' a name which might apply to Monet but can have no meaning when attached to Degas's name. Liberty is the first good in this world and to escape the tyranny of a jury is worth fighting for, surely no profession is so enslaved as ours.[20]

At that first exhibit the critics reacted favorably to her works. Her father reported: "In addition to my letters I have also sent you a number of newspapers, art journals &c containing notices of Mame [Cassatt's nickname],—Her success has been more and more emphasized since I wrote and she even begins to tire of it— She is now known to the Art world as well as to the general public in such a way as not to be forgotten again so long as she continues to paint!!"[21] By 1879, two years after meeting Degas, her style had changed and her fame had grown. Degas had brought her into the avant-garde, and their association elevated her status in the art world. Subsequently, many critics linked the two artists, because her work was most similar to his.

WHILE CASSATT looked to Degas for help with her art, he needed her financial support. Because of his family's financial reverses, Degas had to sell his works for his livelihood. Nonetheless, Pissarro declared, "Degas doesn't care [about the 1886 exhibit], he doesn't have to sell, he will always have Miss Cassatt."[22] Shortly after meeting Degas, Cassatt took the nineteen-year-old Louisine to buy a Degas pastel over monotype (a technique he had begun to use in the summer of 1876).[23] Louisine bought *The Ballet Rehearsal* of 1876–77 for 500 francs[24] and became Degas's first American patron.[25] The following year she lent it to a New York exhibition, and it became the first Impressionist work shown in America.[26] Havemeyer later wrote, "I did not know until long afterward how opportune the sale of the picture was for Degas, and then Miss Cassatt told me Degas had written her a note of thanks when he received the money, saying he was sadly in need of it."[27]

Havemeyer said that Cassatt was the "godmother" of her collection, which numbered over 120 works by Degas.[28] Cassatt also served as the go-between for sales to other rich Americans—the Wittemores, Stillmans, Macombers, Palmers, Searses, and oth-

Cassatt, *Portrait of Louisine Elder Havemeyer*, 1896. Pastel, 29 × 24″ (73.7 × 61 cm). The Shelburne Museum, Shelburne, Vt.

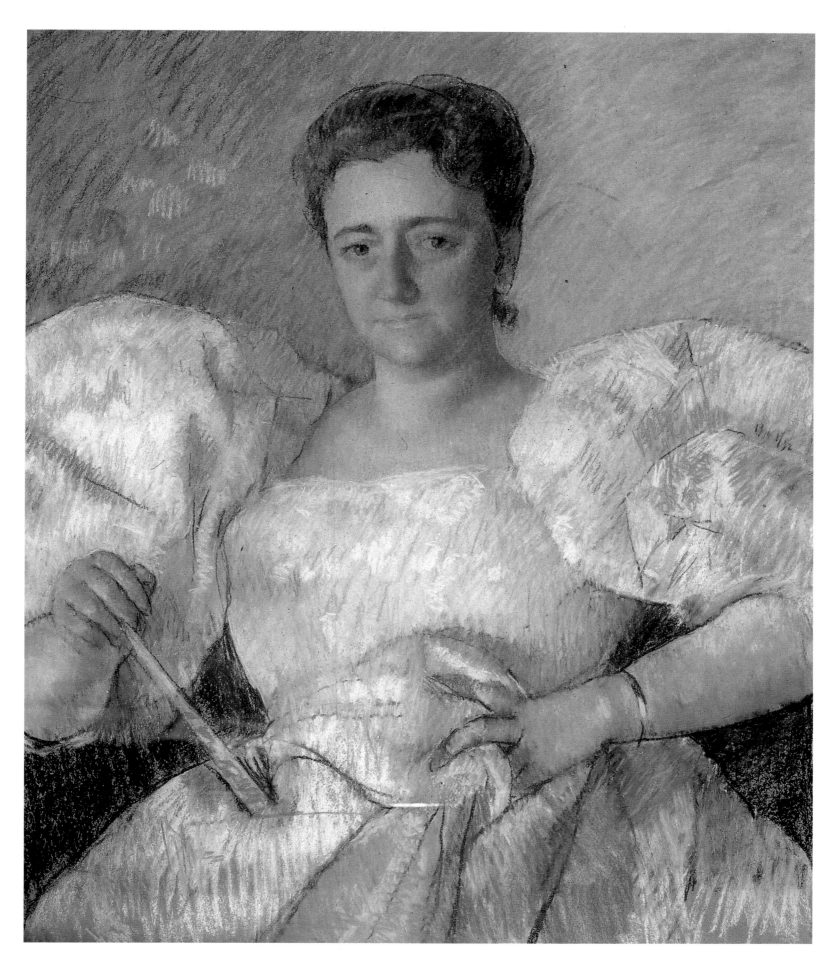

ers—to whom she advocated buying art both as an investment and as a way of helping artists who had money problems. "I am so glad you saw the Degas [paintings] . . . ," she wrote to a friend, "you can now understand why the French artists put him so high so far above all the rest."[29]

Being Degas's "agent" was a difficult endeavor, as Cassatt explained to a collector: "I will try to get you some proofs of Degas, but I cannot promise that I will be successful; he is not an easy man to deal with."[30] An infuriating example of his behavior was recorded by Havemeyer:

A transaction . . . cost Degas Miss Cassatt's friendship for a long time, and strangely enough this time about a matter of price, for even Degas's ideas of a bargain were more picturesque than businesslike. . . . On this memorable visit, Degas sold us a small oil painting called, "The Designer of Prints" [1866] and the price was one thousand dollars. He asked to keep it for a time as he wished to add a few touches. He kept it nearly two years, and then told Miss Cassatt he would not give it up for less than three thousand dollars, as his pictures during those two years had advanced in price. In vain Miss Cassatt argued that he had sold the picture for one thousand dollars to Mr. Havemeyer and that he could not change the price. It was of no use! Degas was quite stubborn about it, and the idea was so fixed in his mind that he was entitled to the increase in value that at last Mr. Havemeyer yielded.[31]

Degas's behavior was not only embarrassing to Cassatt but especially outrageous in light of the fact that the Havemeyers were among his most faithful collectors.

The Cassatt family also collected Degas's work. Cassatt helped her father[32] and her brother Alexander[33] with selections, and, late in life, she herself owned his oil portrait of her (c. 1880–1884; see p. 205), an oil of a ballet class (1878), and a pastel of a nude in a tub (1885).[34] Degas owned many examples of Cassatt's art: her oil of a girl arranging her hair (1886; see p. 206), three pastel drawings, and ninety prints.[35]

Although their relationship was mainly stormy, on rare occasions Degas acted kindly to Cassatt. The documented instances are so few that they can be listed. He was worried to learn that "Mlle Cassatt is settling in a ground floor studio which does not seem too healthy to me."[36] Another time he expressed concern when she fell from her horse and broke her leg.[37] Degas had a fondness for pets, so he helped her buy a dog,[38] and he wrote a sonnet "dedicated to Miss Cassatt about her cherished parrot."[39]

MORE OFTEN, as Havemeyer wrote, Degas's "caustic wit . . . frequently burned deep and hurt hard."[40] Cassatt dreaded his cruel sarcasms, which became worse as he aged, although she may have been "quite his equal in repartee."[41] She often wrote disparagingly about him, calling him "sharp-tongued" and "bad-tempered,"[42] "dreadful!"[43] and "a pessimist . . . [who] 'dissolves' one so that you feel after being with him: 'Oh, why try, since nothing can be done about it?' "[44] Fifteen years after they met, when working for an important exhibition, she wrote to a friend: "To tell the truth I needed all my sang-froid [cool] & Degas takes a pleasure in throwing me off the track; for years I have never shown him anything without its being finished."[45] The following day she wrote to another friend: "I have been half a dozen times on the point of asking Degas to come and see my work, but if he happens to be in the mood he would demolish me so completely that I could never pick myself up in time to finish for the exposition. Still he is the only man I know whose judgment would be a help to me."[46]

Cassatt, of course, was not his only target. Degas had a mean streak and often lashed out at close friends in spiteful and deflating ways. Other artists were universally disparaging of his personality: Morisot wrote of his "bad temper,"[47] and Caillebotte blamed him for "introducing disunity into our midst" and continued, "Unfortunately for him, he has a bad character. . . . This man has gone sour."[48]

Degas could be cruel to strangers as well. One story sums up his personality. As Cassatt related: "A young painter seeing Degas in a color shop begged the proprietor to introduce him to the great Degas! 'Better not,' cautioned the proprietor, but as the young fellow insisted he presented him to Degas. Of course the youth was delighted, but after a few moments' conversation Degas turned to a picture which stood upon an easel and said 'Jeune homme, c'est vous qui avez fait ça?' (Young man, did you do that?) 'Mais oui, monsieur,' replied the young fellow, delighted that Degas had noticed his canvas. 'Je vous plains' (I pity you) and he turned upon his heel and left the shop."[49]

Degas was cruel to women and men alike, a misanthrope not a misogynist. In fact, he helped several of his female colleagues in their artistic pursuits: Cassatt, Mme. Fantin-Latour (Victoria Dubourg), Morisot, and Suzanne Valadon. Renoir's close friend Georges Rivière compared the attitudes of Degas and Renoir:

Degas enjoyed the company of women! He, who often depicted them with real cruelty, derived great pleasure from being with them, enjoyed their conversation and produced pleasing phrases for them. This attitude presented a curious contrast to that of Renoir. The latter, though 'he painted women seductively, endowing with charm even those who did not possess it, generally experienced little pleasure from the things they valued. He was interested in women, with few exceptions, only if they were likely to become his models.[50]

Degas's hostility and bitterness may have been a result of deep-seated insecurity combined with an acute awareness of his talent. In a letter to a friend when he was fifty-six, he explained:

I have been unusually . . . [difficult] with myself; you must be fully aware of this seeing that you were constrained to reproach me with it and to be surprised that I had so little confidence in myself. I was or I seemed to be hard with everyone through a sort of passion for brutality, which came from my uncertainty and my bad humor. I felt myself so badly made, so badly equipped, so weak, whereas it seemed to me, that my calculations on art were so right. I brooded against the whole

world and against myself. I ask your pardon sincerely if, beneath the pretext of this damned art, I have wounded your very intelligent and fine mind, perhaps even your heart.[51]

In another letter Degas wrote: "I have seen some very beautiful things through my anger, and what consoles me a little, is that through my anger I do not stop looking."[52]

Despite Degas's personality he and Cassatt were able to forge their bond because each was completely devoted to his or her own art. Cassatt was in her studio from dawn to dusk (although she cared for her sister Lydia, her father, and her mother during their illnesses), and Degas, by her account, lived "the life of a hermit in its simplicity and frugality."[53] It is unlikely that these two loners, who are not known to have been romantically involved with anyone, had an affair with each other. Because they destroyed each other's letters, all evidence has disappeared. Nonetheless, Cassatt specifically denied it when, in her later years, a relative asked her directly. She replied indignantly, "What, with that common little man; what a repulsive idea!"[54] It was the art that brought them together. What sustained the friendship, in the face of Degas's outbursts, was Cassatt's devotion to Degas's art, his adulation of her work, and Degas's need for Cassatt's help in selling his paintings.

Degas, *The Pedicure,*
d. 1873. Oil on canvas,
24 × 14⅛″ (61 × 46
cm). Musée d'Orsay,
Paris.

DEGAS'S INFLUENCE on Cassatt is most apparent in the works she executed in the first few years after they met. During this time she began to paint themes of daily life and of the theater. His infinite variations on the theme of ballerinas inspired her mother-and-child variations, which she began in 1880. Like Degas, she painted with objectivity and intimacy in a style that can be called Realist Impressionism because the form is not dissolved by the light. Guided by his work, her manner became freer, with lighter and more colorful tones, looser brushstrokes, and bolder compositions. Degas helped her to sharpen her drawing skills by encouraging her printmaking from 1879 onward. He taught her innovative techniques of engraving and pastels, and introduced her to Japanese prints, which influenced her compositions and the strong outlining that characterizes them. Adopting

Degas's procedure, she carried around a sketchbook in which to record her pictorial ideas and later worked them out in her studio. She learned from Degas to seek an effect of spontaneity that was in fact the result of a diligent study of gestures and postures.

No matter how indebted her art is to his, however, she transformed what she learned and made her work unique. "I don't copy him in this age of copying," she asserted.[55] There were significant differences between their works. He chose detachment, movements in progress, and bold, unusual compositions; she depicted intimacy, relaxed intervals, and straightforward arrangements. Cassatt's paintings of 1878 and 1879 show most clearly her debt to Degas. It is noticeable in the similarities between his *Pedicure,* which Cassatt called "a remarkably fine work,"[56] and her *Little Girl in a Blue Armchair.* In Degas's painting a young girl relaxes

Cassatt, *Little Girl in a Blue Armchair*, 1878. Oil on canvas, 35½ ×
51⅛″ (90.2 × 130 cm). National Gallery of Art, Washington; Collection
of Mr. and Mrs. Paul Mellon.

on a sofa while having her toenails cut. Cassatt adopted a similarly
relaxed pose for her figure and displayed her brand of Realist Im-
pressionism through the childlike, informal pose and unusual per-
spective, and by cropping and asymmetry. Cassatt's sense of humor
led her to place a Brussels griffon dog where Degas had placed the
chiropodist.

Degas worked on her painting, and she subsequently sent it to
an important exhibition. Unlike Morisot, who was dismayed by a
similar experience with Manet, Cassatt was thrilled. Twenty-five
years later she wrote to the dealer Vollard:

> I wanted to come back to your place yesterday to talk to you
> about the portrait of the little girl in the blue armchair. I did
> it in '78 or '79—it was the portrait of a child of friends of M.

Degas—I had done the child in the armchair, and he found
that to be good and advised me on the background, *he even
worked on the background*—I sent it to the American section
of the Gd. [grand] exposition 79 [really Exposition Uni-
verselle of 1878] but it was refused. Since M. Degas had
thought it good I was furious especially because he had
worked on it—at that time it seemed new, and the jury con-
sisted of three people, of which one was a pharmacist![57]

Degas's contribution is seen in the way the light pours into the
room through the curtained windows and in the large floor area
with its unusual silhouette. He had painted similar effects in sev-
eral of his ballet practice scenes.

AN UNDATED, half-serious letter explains how Degas helped Cassatt obtain a Brussels griffon dog, perhaps the one that appears in *Little Girl in a Blue Armchai* (see p. 189).

To M. Le Comte Lepic supplier of good dogs, at Berck: Dear Monsieur, I have been twice more than satisfied with your deliveries not to turn to you once again. Could you . . . either from your kennels and apartments, or from your friends and acquaintances, find me a small griffon, thoroughbred or not (dog, not a bitch), and send it to me to Paris if an opportunity arises, or by carrier. As regards the price I shall not consider that further than you did. However if you should wish to draw on me for a sum exceeding 50 centimes, I should be grateful if you would warn me some months in advance as is always the custom in these parts. Please accept, Monsieur le Comte, my sincere regards. E. DEGAS

I think it in good taste to warn you that the person who desires this dog is Mlle. Cassatt, that she approached me, known for the quality of my dogs and for my affection for them as for my old friends etc. etc. I also think that it is useless to give you any information about the asker, whom you know as a good painter, at this moment engrossed in the study of the reflections and shadows on skin or dresses, for which she has the greatest affection and understanding. . . . This distinguished person whose friendship I honor, as you would in my place, also asked me to advise you regarding the age of the subject. It is a young *dog* that she needs, quite young, so that he may love her. If you do send the dog, you would give appreciable pleasure to your requester, by sending with this dog some news of your health and of your noble pursuits.[58]

Degas, *Ludovic Lepic Holding His Dog*, c. 1888. Pastel on paper, 19¾ × 12⅝″ (50 × 32 cm). The Cleveland Museum of Art; Gift of The Mildred Andrews Fund.

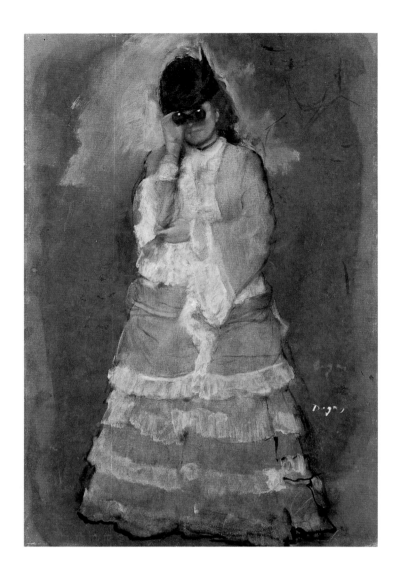

IN THE LATE 1870s Degas was encouraging Cassatt to create a forceful style. He wrote to a friend: "The Cassatts have returned from Marly. . . . What she did in the country looks very well in the studio light. It is much stronger and nobler than what she had last year."[59]

Cassatt's *At the Opera* was inspired by numerous works of Degas's, such as *The Ballet*, which show the spectator's view at the theater. In addition, she seems to have been following his portrayal of an assertive woman peering through binoculars.[60]

The year Cassatt painted *At the Opera* was also the first year she showed her works with the Independents. In one of Degas's notebooks, he listed the twenty-five pictures he was exhibiting as well as Cassatt's eleven. During the show Degas helped with the sale of Cassatt's work so that she would not have to get involved with financial transactions. To a friend he wrote, "Tell [Charles] Haviland [a collector] who was infatuated with a little picture of Mlle. Cassat [*sic*] and who wished to know the price, that it is a simple matter of 300 francs, that he should write to me if that does not suit him and to Mlle. Cassat, 6, Boulevard de Clichy if it does."[61]

Degas, *Woman with Binoculars,* c. 1875–76. Oil on cardboard, 18⅞ × 11⅞ (48 × 32 cm). Staatliche Kunstsammlungen, Dresden.

OPPOSITE: Cassatt, *At the Opera*, 1879. Oil on canvas, 31½ × 25½″ (80 × 64.8 cm). Museum of Fine Arts, Boston; Charles Henry Hayden Fund.

Degas, *The Ballet,* c. 1877–78. Pastel over monotype, 15⅞ × 19⅞″ (40.3 × 50.5 cm). Museum of Art, Rhode Island School of Design, Providence; Gift of Mrs. Murray S. Danforth.

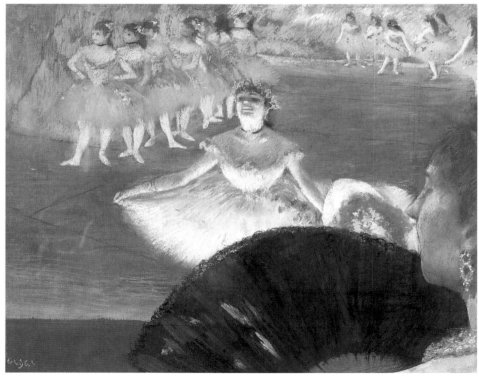

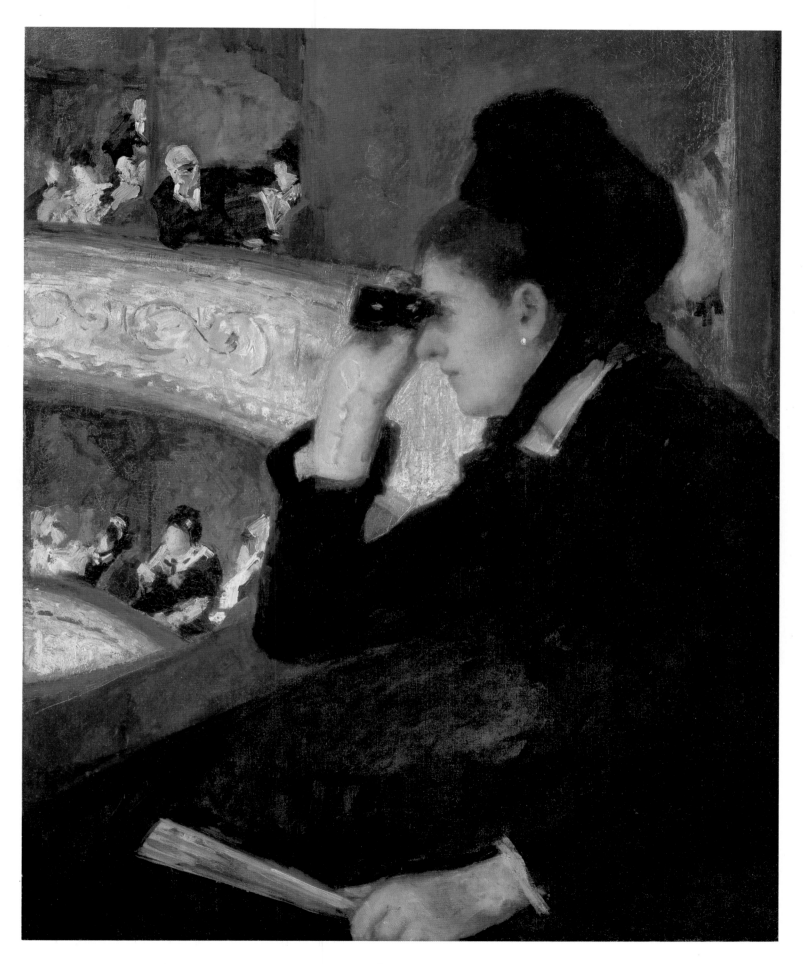

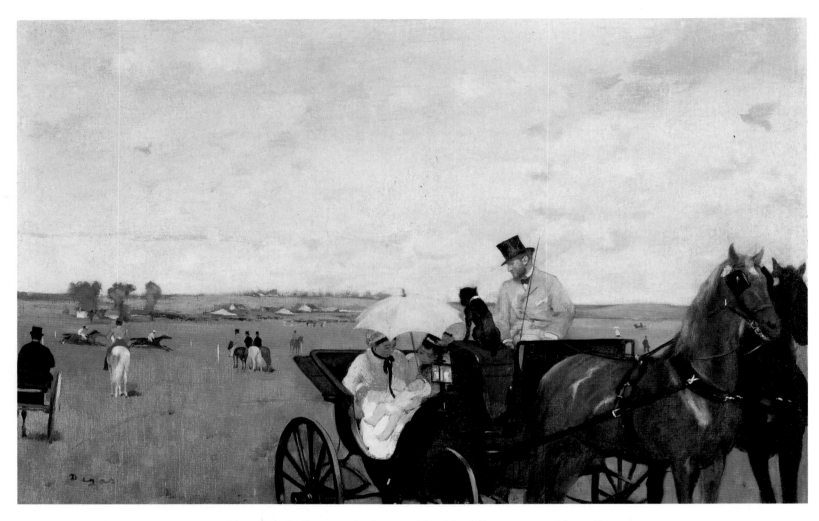

Degas, *At the Races in the Countryside*, 1869. Oil on canvas, 14⅜ × 22″
(36.5 × 55.9 cm). Museum of Fine Arts, Boston; 1931 Purchase Fund.

Another example of Degas's influence can be seen in his *At the Races in the Countryside* of 1869 and Cassatt's *Woman and Child Driving* twelve years later. Cassatt's models were her sister Lydia and Degas's niece, Odile Fèvre. In Degas's painting a wet nurse rests from nursing a baby while the mother, father, and bull-dog observe.[62] The influence from *Races* to *Driving* is most apparent in the general theme and in the composition's asymmetry and cropping. However, differences exist. Degas's painting shows space, air, and movement in the background, whereas Cassatt's close-up seems airless, monumental, and static.

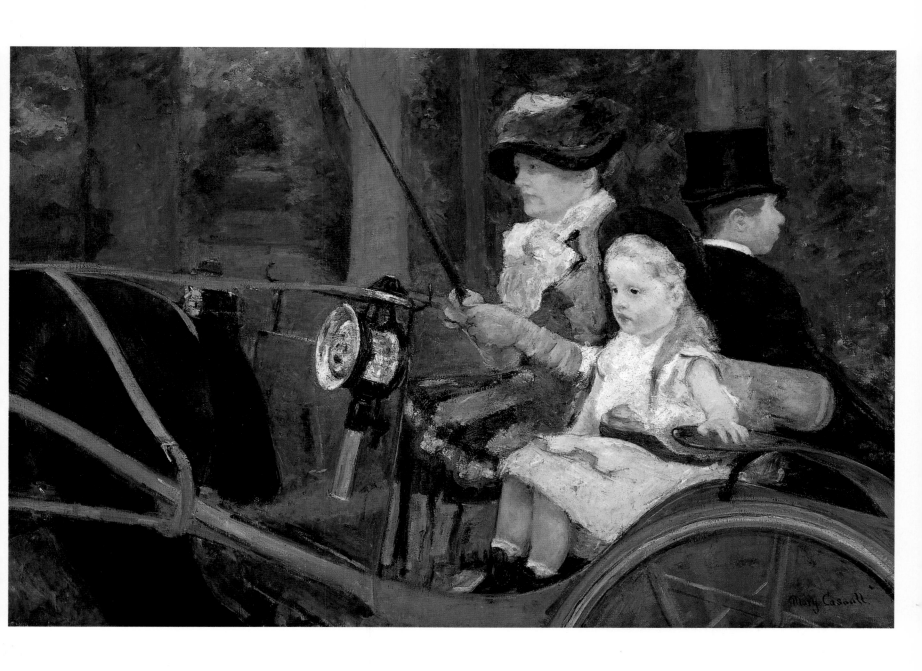

Cassatt, *Woman and Child Driving* (Lydia Cassatt and Degas's niece
Odile Fèvre), 1881. Oil on canvas, 35¼ × 51½″ (89.5 × 130.8 cm).
Philadelphia Museum of Art; W. P. Wilstach Collection.

Degas, *Mary Cassatt at the Louvre: The Paintings Gallery*, 1879–80. Etching, intermediate state between twelfth and thirteenth states, soft- and hard-ground etching, aquatint, drypoint, and electric crayon on wove paper, 14½ × 8⅞″ (37 × 22.5 cm). National Gallery of Art, Washington; Rosenwald Collection, 1946.

DEGAS MADE eight portraits of Cassatt, beginning two years after they met and continuing over the next six years. All are indoor scenes of daily life: three of her back as she contemplates the art in two different rooms of the Louvre, three in which she tries on hats, one in which she holds a dog, and one in which she holds cards. As in the nine portraits Degas made of Manet over a decade earlier, he concentrated on the most telling gesture and posture to capture the essence of his model. Unlike Manet, who in his portraits of Morisot emphasized her femininity and charm, Degas revealed Cassatt's assertiveness and independence—the traits that enabled her to stand up to his ill-humor. She told her friend Louisine Havemeyer that she modeled for him "only once in a while when he finds the movement difficult, and the model cannot seem to get his idea."[63] Her help to a colleague stemmed from a different motivation than that of Morisot when she posed for Manet.

Degas apparently only posed once for Cassatt. In 1913 her chosen biographer, Achille Segard, wrote that he had not seen the portrait and assumed that it had been destroyed or stolen from its storage place. Unfortunately nothing is known of it.[64]

"I posed for the woman at the Louvre leaning on an umbrella," Cassatt wrote.[65] Degas's intent was to make two etchings—one at the Etruscan gallery and one at the paintings gallery. The pastel in the paintings gallery is a related preparatory work (see p. 200); Degas also made a tracing drawing for the etchings (see p. 201). In this series, by depicting Cassatt from the back, Degas was following what his friend Edmond Duranty had suggested in his 1876 study of Impressionism, *The New Painting:* "What we need is the unique character of the modern individual in his clothing, in the midst of his social situation, at home or in the street.... With a back, we want to reveal a temperament, an age, a social position; with hands, we should express a magistrate or a merchant; with a gesture a whole range of feelings or emotions."[66]

In the Louvre series Degas presented Cassatt engaged in an appropriate activity: studying the great art of the past. She is identified by her lanky frame, fashionable attire, and omnipresent hat, as well as by her energy, self-assurance, and assertiveness. "Her pose as she leans upon an umbrella," according to Havemeyer, "is very characteristic of her."[67]

Degas took special care with these two Louvre prints, because they were made for his public debut as a graphic artist and are the only prints he ever made for wide distribution. These portrayals of Cassatt, and other portraits of that year, are at the summit of his long and varied career.[68] Of *The Etruscan Gallery* (see p. 198) Degas made nine different states [changes on the copper plate] and printed more than fifty impressions.[69] Of *The Paintings Gallery* he made twenty states and forty-four impressions.

The Paintings Gallery is the most Japanese of all Degas's works. Here he followed the Japanese woodcuts [hashira-e prints] of a tall, thin, pillar format that were popular in France. In this image Degas brought Mary and Lydia close together so that they share one large silhouette and appear as one large form. The compressed space and flattened shapes are reminiscent of Japanese prints. Many impressions of both of Degas's Louvre etchings were printed on thin Japanese paper.

Degas's two prints and Cassatt's related print *The Visitor* (see p. 199) are part of a collaborative venture that marked the period of their closest interaction. They were working on a journal to provide subscribers with original prints. Others involved in the project included Pissarro, Caillebotte, and the professional printmaker Félix Bracquemond. They hoped the publication would be both popular and profitable. Degas learned advanced printing methods from Bracquemond and relayed this information to Cassatt and Pissarro, who were working on a printing press at Degas's studio.

IN MAY 1879, shortly after the conclusion of the group exhibition, Degas's friend Ludovic Halévy wrote: "Visit to Degas. I met him in the company of *l'indépendante* Miss Cassatt, one of the exhibitors of the rue de la Paix. They are very excited. Each has a profit of 440 francs from their exhibition. They are thinking of launching a journal; I ask to write for it."[70] The collaboration between Degas and Cassatt is evident in a letter from Degas to Pissarro: "I hurried to Mademoiselle Cassatt with your parcel [of prints]. She congratulates you as I do in this matter."[71]

Cassatt had made only three etchings before working with Degas. In 1879 and 1880 she made more than thirty. On October 15, 1879, her father wrote: "Mame is just now very much occupied in 'eaux-fortes' [etchings]."[72] From Degas she learned advanced techniques of soft- and hard-ground etching, drypoint, and aquatint processes, which enabled strong lights and shadows and the play of reflections as well as various types of lines. At around the same time, Degas wrote to Pissarro, who was still in Pontoise: "Mlle Cassatt is trying her hand at engravings, they are charming. Try and come back soon. I am beginning to advertise the journal on various sides."[73]

After Pissarro's return in the fall, Degas wrote to Bracquemond: "We must discuss the journal. Pissarro and I together made various attempts [at printmaking] of which one by Pissarro is a success. At the moment Mlle Cassatt is engrossed in it. Impossible for me, with my living to earn, to devote myself entirely to it as yet. So let us arrange to spend a whole day together, either here or at your house.—Have you a press at your place?"[74]

On January 24, 1880, an article in *Le Gaulois* stated that on February 1, 1880, the first issue of *Le Jour et la Nuit* [Day and Night] would appear. Yet by the time of the spring 1880 exhibition, the journal was still not ready. Cassatt's mother expressed her anger and disappointment, feelings perhaps shared by her daughter: "Degas who is the leader undertook to get up a journal of etchings and got them all to work for it ... and as usual with Degas when the time arrived to appear, he wasn't ready—so that 'Le Jour et la Nuit' ... which might have been a great success has not yet appeared—Degas never is ready for anything—This time he has thrown away an excellent chance for all of them."[75] Although the journal was never published, the prints were seen at the 1880 exhibition. Nonetheless, the collaboration was extremely important for Cassatt, who learned from Degas's instruction as well as from his two Louvre prints.

The journal title, *Le Jour et la Nuit*, was chosen to suggest the changes in daily life. It also alludes to the range of lights and shad-

Degas, *Mary Cassatt at the Louvre: The Etruscan Gallery*, 1879–80.
Seventh state, soft- and hard-ground etching, drypoint, and aquatint,
10½ × 9⅛" (26.7 × 23.2 cm). Museum of Fine Arts, Boston; Katherine
E. Bullard Fund in memory of Francis Bullard and proceeds from the
sale of duplicate prints.

ows achieved by various graphic processes that would parallel changes in the daily cycle. It seems likely that Degas's light-filled *Etruscan Gallery* would have been the opening print in the issue, which would have closed with the lightless *Paintings Gallery*.

Part of the "inside joke" of this issue would have been that Cassatt was model as well as creator. Her print *The Visitor* was a clever takeoff on Degas's *Etruscan Gallery*.[76] In Degas's print the two women are contrasted to reveal their different personalities. Lydia is torn between reading the catalog and looking at the art while Cassatt depends on her own observations. Lydia appears shy, with

a contracted posture, while the independent Cassatt appears bold, with an expanded stance. The statues of the deceased husband and wife lie on top of their tomb, in contrast with the lively spinsters. In this print, by skillfully using new graphic techniques, Degas achieved varieties of interior lighting so that the glass case both reflects light and partially frames the bottom of the luminous window behind it. The frieze arrangement gives ample space for the three-dimensional figures.

Cassatt's print *The Visitor* is, of all her works, the one most indebted to Degas. Like him, she used a preliminary pencil drawing

Cassatt, *The Visitor* (or *Interior Scene*), c. 1879–80. Sixth state, soft-
and hard-ground etching, drypoint, and aquatint, 15⅝ × 12⅛″
(39.7 × 30.8 cm). Sterling and Francine Clark Art Institute,
Williamstown, Mass.

to transfer the lines onto the copper plate and created numerous states. On one trial proof she wrote: "unique series of thirteen states."[77] Besides planning to include this print in the first issue of *Le Jour et la Nuit,* she exhibited it in 1880, and an impression went to Degas's collection.

In *The Visitor* Cassatt emulated Degas's technique by combining aquatint, hard-ground etching, soft-ground etching, and drypoint to achieve gradations of light and dark as well as atmosphere. She achieved tonal complexity through the use of lines, hatchings, and grains. The arresting posture of the strong figure with an extended arm and the relationship between the standing and seated figures are a witty variation on Degas's postures in *The Etruscan Gallery. The Visitor* also resembles Degas's print because of the bright sunlight that streams in through the window and strongly silhouettes the figures. The acute diagonal perspective and linear design are also patterned on Degas's composition. Cassatt said of making these prints, "That is what teaches you to draw!"[78]

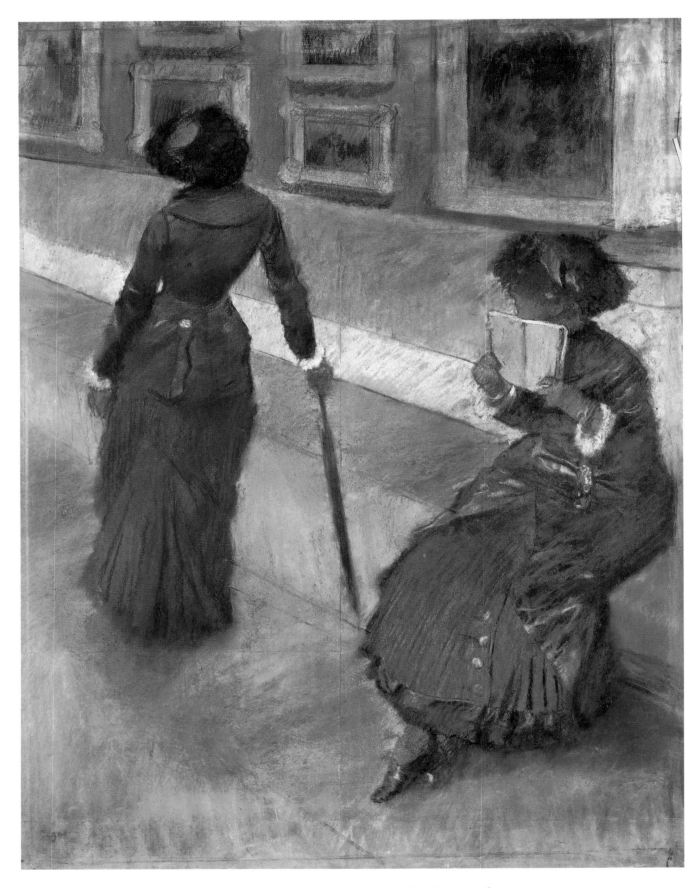

Degas, *Pastel of Miss Cassatt at the Louvre: The Paintings Gallery,*
c. 1879–80. Pastel on seven pieces of paper joined together, 28 × 21¼″
(71 × 54 cm). Private collection.

Degas, *Recto Tracing Drawing for Mary Cassatt at the Louvre,*
1879–80. Graphite on off-white, thin, smooth, wove paper, 12⅝ × 9⅔″
(32.3 × 24.5 cm). Mr. and Mrs. Paul Mellon, Upperville, Va.

Degas, *Verso Tracing Drawing for Mary Cassatt at the Louvre,*
1879–80. Soft-ground adhering to traced lines on off-white, thin,
smooth, wove paper, 12⅝ × 9⅔″ (32.3 × 24.5 cm). Mr. and Mrs. Paul
Mellon, Upperville, Va.

Before beginning concurrent work on the two Louvre
prints, Degas made a large pastel in the paintings gallery in
which he perfected the postures and gestures of Cassatt and Lydia.
From pastel to print he reduced the size of the figures and
changed the relative scale so that Cassatt becomes slightly larger
than Lydia. In the recto tracing drawing, besides the silhouettes
and costume details, Degas drew a grid of ruled lines to aid in the
rearrangement of the figures within the two formats. By means of

one tracing drawing, he manipulated the same postures of the sis-
ters to create two quite different images that he worked out on two
copper plates.

In the pastel both Cassatt and Lydia face to the left. In *The
Etruscan Gallery* (see p. 198) they both face to the right. In *The
Paintings Gallery* (see p. 196), Lydia faces right and Cassatt left.
To achieve Cassatt's different postures in the two prints, Degas
used the tracing of Cassatt on both recto and verso sides.

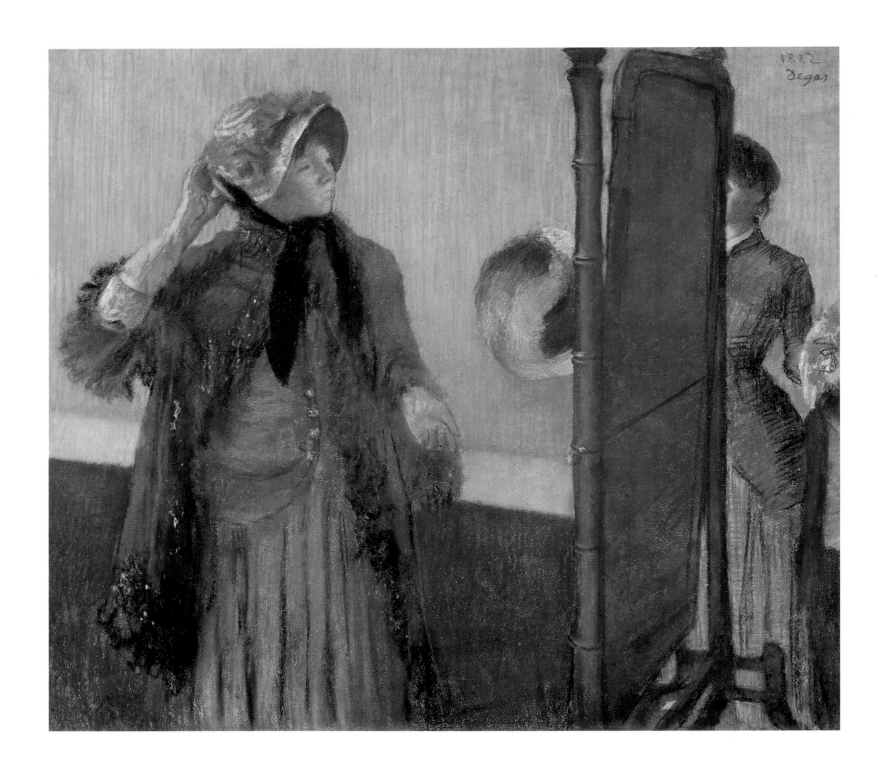

Degas, *At the Milliner's*, d. 1882. Pastel on pale gray wove paper, 30 × 34″ (75.6 × 85.7 cm). The Metropolitan Museum of Art, New York; Bequest of Mrs. H. O. Havemeyer, 1929; The H. O. Havemeyer Collection.

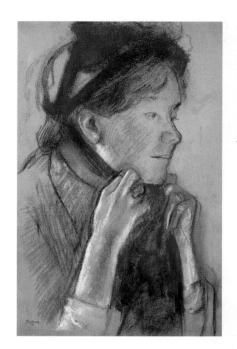

Degas, *Study of Mary Cassatt* (or *Woman Tying the Ribbons of Her Hat*), c. 1882. Pastel, 18⅞ × 12¼″ (48 × 31 cm). Musée d'Orsay, Paris.

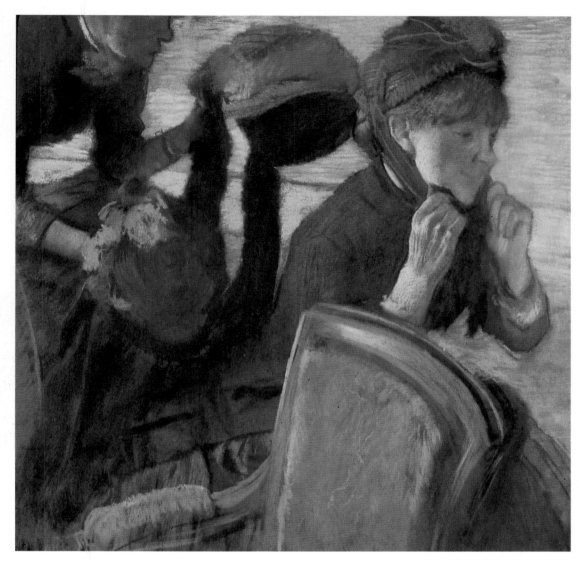

Degas, *At the Milliner's*, c. 1882. Pastel, 26⅜ × 26⅜″ (67 × 67 cm). Collection, The Museum of Modern Art, New York; Gift of Mrs. David M. Levy.

CASSATT POSED for two pastels of a woman trying on hats. The Havemeyers acquired one, as Louisine later explained: "When the 'Milliner' series appeared, Miss Cassatt secured for us the large one—extraordinary in color—of a woman trying on a hat before a long mirror. Miss Cassatt posed for this picture. The movement of the hand that places the hat upon her head . . . is very characteristic of her."[79] She added: "In certain of Degas's pictures one can recognize Miss Cassatt as she helped him out of a difficulty by posing for a turn of the head or a movement of the hand."[80]

The second milliner pastel and preparatory study from life most closely resemble photographs of Cassatt taken at the time. Her face was thin and angular with wide-apart, intense eyes, a slightly upturned nose, a long upper lip, and a pointed chin. If we compare the study with the finished pastel, the study is more vertical and static whereas the completed work is more diagonal and lively. In both milliner pastels, Degas used unusual croppings and overlappings to give a snapshot effect and to subordinate the forms of the salesgirls to that of Cassatt.

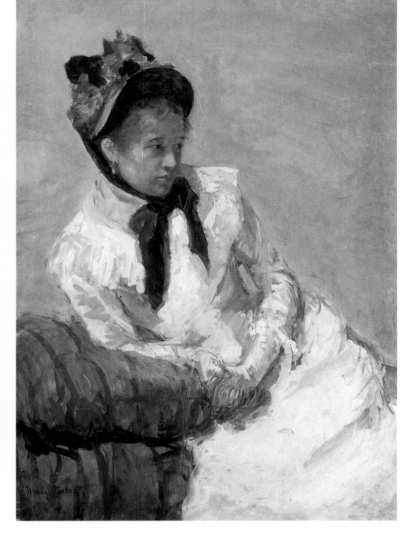

Degas, *Seated Woman with Dog on Knees* (or *Mary Cassatt*),
c. 1878–1880. Pastel, 26⅓ × 20½″ (67 × 52 cm). Private collection.

D EGAS MADE two three-quarter-length portraits of Cassatt seated on a ballroom chair and wearing a hat. His last portrait of her is the oil done around 1880–1884, which soon thereafter he either gave to or traded with her. Cassatt's attitude toward this portrait changed during the twenty-five years that she owned it. It was one of only three of Degas's works in her collection, so initially she may have treasured it. Moreover, because Degas displayed her oil painting *Girl Arranging Her Hair* (see p. 206) in his living room from 1886 until 1913, she perhaps felt obligated to hang his portrait in a prominent position in her own home.

Toward the end of her life, Cassatt hated this work. In late 1912 she wrote to Durand-Ruel:

I particularly want to get rid of the portrait Degas made of me which is hanging in the room beside the drawing room (my studio). . . . I don't want to leave this portrait by Degas to my family as one of me. It has some qualities as a work of art but it is so painful and represents me as such a repugnant person that I would not want anyone to know that I posed for it. It is framed and has glass on it. . . . If you think my por-

trait can be sold I should like it sold abroad and particularly that my name not be attached to it. . . . The portrait is not finished and not signed.[81]

In a later letter she added: "Now I do not want the picture to go to America. I know many collectors of Degas over there, and several have seen the painting at my place."[82]

There are several possible explanations for her negative feelings. Perhaps she felt that the portrait did not present her with the beauty and femininity that she displayed in her gouache self-portrait. There she captured the self-assured, serious, and purposive character that made her such an accomplished person. In Degas's portrait her posture is not proper, refined, or graceful, as an upper-class woman's should be. Yet it is unlikely that failure to flatter or impropriety would have made Cassatt feel repugnance. Her intense negative feelings are probably based on the fact that Degas depicted her in the guise of a fortune-teller, a type who, in late-nineteenth-century Paris, was often a procuress. She sits forward on her chair, elbows on her thighs, and offers Degas tarot cards to divine his fortune. This is an example of his black humor,

Degas, *Portrait of Mary Cassatt*, c. 1880–1884. Oil on canvas, 28⅛ × 23⅛″ (71.4 × 58.7 cm). The National Portrait Gallery, Smithsonian Institution, Washington; Gift of the Morris and Gwendolyn Cafritz Foundation and the Regents; Major Acquisitions Fund, Smithsonian Institution.

OPPOSITE: Cassatt, *Self Portrait*, c. 1878. Gouache on wove paper laid down on a buff-colored wood-pulp paper, 23½ × 17½″ (60 × 45 cm). The Metropolitan Museum of Art, New York; Bequest of Edith H. Proskauer.

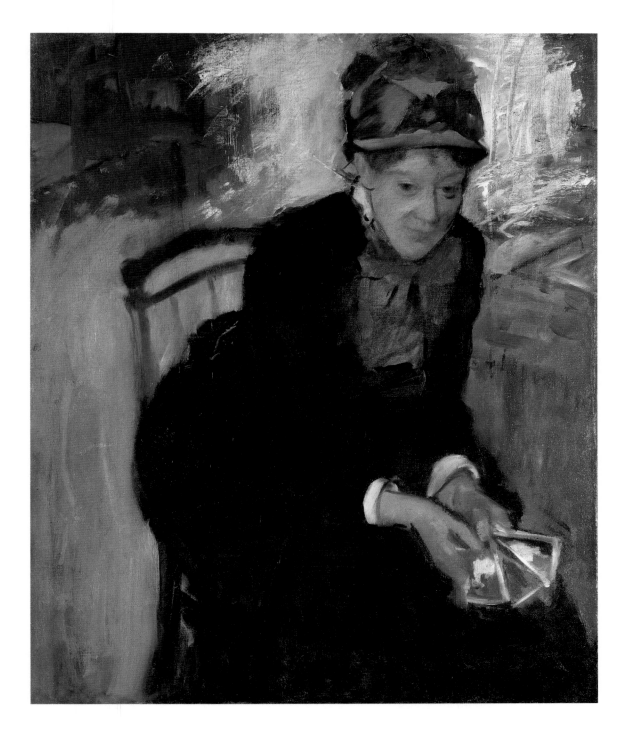

for indeed, in her role as art adviser to rich Americans, she held the cards to his future financial situation. While Degas was flattered by her admiration for his art and indebted to her for the scores of purchases she arranged, he was also resentful of her power over him in this area. The portrait both acknowledges Cassatt's role in his life and deprecates it.[83]

Over time the malicious message troubled her more, and her tolerance for any ambivalent acknowledgment—even from Degas—diminished. By late 1912, when close to age seventy, Cassatt felt justified in getting rid of the work. She knew that Degas would soon move from his apartment, which was to be demolished, and that he would be taking down *Girl Arranging Her Hair*

to store it in his studio. Around this time Cassatt wrote to Havemeyer that the nearly blind Degas was "immensely changed mentally but in excellent physical health."[84] On another occasion she wrote that Degas was "a mere wreck."[85] She did not expect him to visit her, and even if he had, his vision was so poor that he would not have noticed that his painting was not in her studio. In 1913 the portrait was sold to a Danish collector.

The other Degas portrait is an indistinct pastel showing Cassatt holding a griffon, perhaps the one that he had obtained for her around 1878. The influence of Japanese prints is seen in the flat, dark pattern of her form against the light, tipped-up background. Degas kept this portrait in his studio until his death.

Cassatt, *Girl Arranging Her Hair*, 1886. Oil on canvas, 29⅝ × 24⅝″
(75.1 × 62.5 cm). National Gallery of Art, Washington;
Chester Dale Collection.

Degas had always praised the power, force, and strength of Cassatt's treatment of form and composition. In 1883 he lauded one of her paintings (*Lady at the Tea Table* [*Mrs. Riddle*], 1883–1885, Metropolitan Museum of Art, New York) as "distinction itself."[86] Nonetheless, in 1886 he challenged her to show him what "style" really meant. Cassatt's biographer related:

The story is that one day, in front of Degas, Miss Cassatt in assessing a well-known painter of their acquaintance dared to say: "He lacks style." At which Degas began to laugh, shrugging his shoulders as if to say: Look at these meddling women who set themselves as judges! Do they have the slightest idea of what style is?

This angered Miss Cassatt. She hired as a model an extremely ugly woman, a servant of the most vulgar kind. She had her pose in a robe next to her dressing table, with her left hand at the nape of her neck holding her meager braid while she fixed it with her right, in the manner of a woman

Degas, *Dancer Fixing Her Hair before the Mirror*, c. 1877. Oil on canvas, 18⅛ × 12⅝″ (46 × 32 cm). Norton Simon Museum, Pasadena.

Degas, *Girl Fixing Her Hair*, d. 1894. Pastel, 24 × 18⅛″ (61 × 46 cm). Private collection.

preparing for bed. This girl is seen almost entirely in profile. Her mouth hangs open. Her expression is weary and stupid.

When Degas saw the painting [*Girl Arranging Her Hair*, at the last group show of 1886], he wrote to Miss Cassatt: "What drawing! What style!"[87]

At the close of the exhibition, Degas obtained this painting from Cassatt, trading it for a drawing he had just exhibited.[88]

Cassatt's masterpiece shows a greater emphasis on drawing and has more control and stability than her earlier works. She also experimented in it with using ugliness and beauty at the same time, a concept she had learned from Degas. While the model, her clothing, and her expression are not beautiful, the handling of form, composition, color, and light are.

Degas twice treated the theme of a girl fixing her hair: once in

a painting of around 1877, *Dancer Fixing Her Hair before the Mirror*, which may have inspired Cassatt, and again in a pastel of 1894, *Girl Fixing Her Hair*, executed after he acquired her *Girl Arranging Her Hair*. His early oil shows a posture with great three-dimensionality, whereas Cassatt's oil shows a pose that is extended upward in one plane. In his late pastel Degas returned to a three-dimensional pose with the figure moved back to the midground. He concentrated on the intense play of color, pattern, and stroke. The standing girl is reduced in scale and placed asymmetrically behind a chair, creating a more delicate and less forceful figure, not as strong in style as Cassatt's.

The artistic flow between Cassatt and Degas was primarily from his art to hers. However, on occasion, her work challenged him to try to better her. In the case of *Girl Arranging Her Hair* and *Girl Fixing Her Hair*, her work surpassed his.

Cassatt, *Mural of "The Modern Woman"* (Mural for the South Tympanum of the entrance to the Hall of Honor of the Woman's Building of the World's Columbian Exposition, Chicago), 1892. Exhibited in 1893. Oil on canvas, 12 × 58′ (3 m 65.7 cm × 17 m 67.8 cm). Whereabouts unknown (presumed destroyed). Photo courtesy of the Chicago Historical Society.

THE RELATIONSHIP between Cassatt and Degas diminished in intensity in their later years. In 1888 Degas wrote to Mallarmé that he had so neglected Cassatt that he no longer had her address.[89] Two years later, however, Degas wrote to a friend: "Dinner at the Fleury's on Saturday with Mlle Cassatt. Japanese exhibition at the Beaux Arts."[90] Inspired by the prints they saw together, Cassatt made a series of color prints that impressed Degas when he saw them in 1891. Pissarro reported: "Degas . . . was flattering, he was charmed by the noble element in her work, although he made minor qualifications which did not touch its substance."[91]

In the mid-1890s their friendship ruptured over the Dreyfus affair, which divided France's political, social, and intellectual life for over a decade beginning in 1894. Alfred Dreyfus, a Jewish officer, was wrongly convicted of treason. Cassatt was an ardent supporter of Dreyfus's pardon; Degas believed him guilty. This was one of the many issues that polarized the two in their later years.[92]

In the early 1890s Cassatt became more outspoken in her feminism and in her support for American woman suffrage. To further this cause, she made paintings and raised money. In March 1892 she accepted the invitation of Mrs. Potter Palmer (Berthe Honoré Palmer) to execute a large mural on modern woman's achievements for the Woman's Building of the 1893 Chicago World's Columbia Exposition. Cassatt was energized by Mrs. Palmer's project and wrote: "After all speak to me of France. Women do not have to fight for recognition here if they do serious work. I suppose it is Mrs. Potter's French blood which gives her organizing powers and determination that a woman should be *someone* not *something*."[93]

Cassatt painted a now lost mural showing modern woman's freedom to pursue knowledge, art, and fame. When the work was completed, she explained her intentions to Mrs. Palmer: "I should like very much to give you some account of the manner I have tried to carry out my idea of the decoration. . . . Men I have no doubt, are painted in all their vigor on the walls of the other buildings; to us the sweetness of childhood, the charm of womanhood, if I have not conveyed some sense of that charm, in one word if I have not been absolutely feminine, then I have failed. . . . This seems to me very modern."[94]

Like most men of his time, Degas wanted to keep women in a subservient role. He did not think Cassatt should do a decoration celebrating women's achievements. As Cassatt wrote to Pissarro: "I have begun a great decoration for one of the buildings in Chicago (for the Worlds Fair)—You ought to hear Degas on the subject of a woman's undertaking to do such a thing, he has handed me over to destruction."[95] She also wrote to Havemeyer: "The bare idea of such a thing put Degas in a rage and he did not spare every criticism he could think of, I got my spirit up and said I would not give up the idea for anything. Now, one has only to mention Chicago to set him off."[96]

Even though Degas disapproved of her project, he had warm praises for a work on the same theme, *Young Women Picking Fruit.* To the director of the museum that later bought this painting Cas-

Cassatt, *Young Women Picking Fruit*, 1891. Oil
on canvas, 51½ × 35½″ (130.8 × 90.2 cm). The
Carnegie Museum of Art; Patrons Art Fund,
22.8.

satt wrote: "It may interest you to know what Degas said when he
saw the picture you have just bought for your Museum. It was
painted in 1891 in the summer, & Degas came to see me after he
had seen it at Durand-Ruels. He was chary of praises but he spoke
of the drawing of the woman's arm picking the fruit & made a fa-
miliar gesture indicating the line & said no woman has a right to
draw like that."[97]

In 1910 Cassatt and Havemeyer were still involved in the cause
of woman's suffrage, which gained American women the vote in
1920. Cassatt was happy to retaliate behind Degas's back for all his
cruel sarcasms. To raise money they helped organize the "Suffrage
Loan Exhibition of Old Masters and Works by Edgar Degas and
Mary Cassatt," held at the Knoedler Gallery in New York in 1915.
The exhibition was arranged without Degas's knowledge or ap-
proval. Hence she wrote to her Paris dealer, "As for an exhibition
of some of Degas's pastels and paintings to benefit women's suf-
frage, the idea is quite titillating, if Degas knew about it."[98] She
had the last word.[99]

Late in the 1890s, Degas had the highest praise for *Mother and Child*. According to her dealer, "Degas . . . considers it the finest work that Mary Cassatt ever did; he says it contains all her qualities and is particularly characteristic of her talent."[100] Cassatt herself related Degas's response: "When he saw my *Boy Before the Mirror* [*Mother and Child*] he said to Durand-Ruel: 'Where is she? I must see her at once. It is the greatest picture of the century.' When I saw him he went over all the details of the picture with me and expressed great admiration for it, and then, as if regretting what he had said, he relentlessly added: 'It has all your qualities and all your faults—*c'est l'Enfant Jésus et sa bonne anglaise* [It is the little Jesus and his English nurse].' "[101]

Degas died in 1917 at the age of eighty-three. At the end of his life, he was nearly blind. Cassatt told her friend Havemeyer: " 'Mercy! what a state he is in! He scarcely knows you, he neglects his clothes, he takes no interest in anything, it is dreadful. With millions of francs still in his studio, they can do him no good; he is consumed with old age.' "[102]

After Degas's funeral Cassatt wrote to Havemeyer: "Of course you have seen that Degas is no more. We buried him on Saturday, in beautiful sunshine, a little crowd of friends and admirers, all very quiet and peaceful in the midst of this dreadful upheaval [World War I] of which he was barely conscious. You can well understand what a satisfaction it was to me to know that he had been well cared for and even tenderly nursed by his niece in his last days."[103]

Cassatt never wavered in her admiration for Degas's art, which she ranked above that of the great masters. Generously, she never ceased to promote his work to Americans. Her devotion is most clear in a comment she made to Havemeyer about his oil painting *The Dance Class* of 1874: it "is more beautiful than any Ver Meer [Vermeer] I ever saw."[104] She proposed that it be exhibited and added: "If you could get someone to lend a Vermeer for the Old Masters, it would show Degas's superiority."[105]

Cassatt, *Mother and Child* (or *The Oval Mirror*), c. 1899. Oil on canvas, 32⅛ × 25⅞" (81.6 × 65.7 cm). The Metropolitan Museum of Art, New York; Bequest of Mrs. H. O. Havemeyer, 1929. The H. O. Havemeyer Collection.

Photograph of Morisot at the age of fifty-three, 1894. Private collection.

Photograph of Renoir on the footsteps of his house in Montmartre around the age of forty-nine, c. 1890. Private collection.

Morisot & Renoir

MUTUAL ADMIRATION characterized the close friendship between Morisot and Renoir that began in 1885, when both artists were forty-four years old, and continued until Morisot's death a decade later. They had certainly known each other casually for at least ten years,[1] but in 1885 Morisot began to ask Renoir to her weekly dinner parties, and early in 1886 he invited her to visit his studio. For ten years they were each other's closest artist friends, and Morisot "adopted" Renoir as a member of her family. During this period both looked back to traditional art for inspiration, and their work became more conservative. Morisot followed Renoir's lead in emphasizing solid form and the outline around figures.

Renoir made two tender, respectful portraits of Morisot, one in oil and one in a related etching. At her various country houses, they worked together but only once painted the same model side by side. She made two copies of one of his paintings, one in pastel and one in drypoint. Throughout these years Renoir enjoyed as close a personal relationship with Morisot, Eugène Manet, and their daughter, Julie, as he had with the Monets twenty years earlier. He became a member of the family and would arrive, unannounced, suitcase in hand, for a visit of "several weeks."[2] He was always welcome.[3]

The relationship was decidedly platonic. Renoir's depiction of Morisot has none of the sensuality with which he usually endowed women. Furthermore, the friendship was not exclusive; it included Eugène and Julie as well as the poet Mallarmé.

The appearance of the two artists in their middle years was described by another poet, Henri de Regnier:

It was in the house of Stéphane Mallarmé that I encountered Renoir for the first time. He was seated on a small cane sofa on which Whistler and [Odilon] Redon had often sat.... Renoir was neither silent like Redon nor a conversationalist like Whistler. His features and body were thin and he appeared extremely nervous, his face twitching and intelligent, refined and with watchful eyes. . . . I met him again at Berthe Morisot's . . . in a strange milieu of rare distinction . . . Eugène Manet, nervous and attentive, Berthe Morisot of a lofty and cool courteousness, of a distant elegance beneath her white hair, her glance sharp and sad, and little Julie, a silent but wild child. . . . Friends of the house sometimes met for

dinner. Degas gave the cue to Mallarmé. . . . Renoir partook of his meal with both working-class and rustic gestures, his hands already deformed.[4]

Upon seeing Renoir and Mallarmé together after her mother's death, Julie recalled their friendship: "[It was lovely to see] the spirited painter and the charming poet chatting together as they have so often done at our house on those Thursday evenings in the high-ceilinged pink salon, where the hosts [Julie's parents], in their own surroundings, were among those they loved, among precious friends."[5] She also wrote: "M. Mallarmé and M. Renoir were the most intimate friends, the constant visitors on Thursday evenings."[6] Morisot appointed Mallarmé as Julie's primary guardian and Renoir as backup guardian in case of her own death.[7] And after her husband's death she designated Renoir "family adviser."[8]

Both Morisot and Renoir had grave physical ailments in their middle age. Morisot suffered from "a rheumatic heart,"[9] which she said made her feel, at age forty-nine, that "I am approaching the end of my life, and yet I am still a mere beginner. I feel myself to be of little account, and this is not an encouraging thought."[10] From age forty-seven onward, Renoir had rheumatoid arthritis and suffered stiffness and pains that often made it difficult for him to move his limbs and fingers. He wrote to his dealer: "Four days ago I turned fifty, and if at that age one is still searching, indeed, it's a little old. I do what I can, that's all I can say."[11]

Yet, despite their afflictions, both artists sought to record the beauty and joy of life. Even after their spouses died, and when they were in pain, they continued painting the same light-filled, lovely images with no evidence of their personal difficulties. Both recognized the life-sustaining force of work and turned to their art to uplift themselves.

Their class difference made them an unlikely pair: she was a cultured upper-class lady and he an artisan-class plebeian. Yet their friendship transcended both social distinctions and gender. It is as if her position balanced out his general disregard for female artists. Despite this wide difference Morisot treated Renoir with great respect and warm camaraderie; and despite his avowed male chauvinism he admired her as a woman and as an artist.

Although Morisot and Renoir were both born in 1841 and spent their early years in Limoges, their family backgrounds could not

Degas (photographer), photograph of Renoir (seated), at age fifty-four and Mallarmé (standing) at age fifty-three, at Morisot's home, 40, rue de Villejust, Paris, 1895. Gelatin-silver print, 15⅜ × 11¼″ (39.1 × 28.4 cm). Photograph formerly in collection of Paul Valéry with inscription by Paul Valéry that says: "This photograph was given me by Degas, whose ghostly reflection and camera appear in the mirror. Mallarmé is standing beside Renoir, who is sitting on the sofa. Degas had required them to hold the pose for fifteen minutes, by the light of nine oil lamps. The location is the fourth floor, no. 40, rue de Villejust. In the mirror can be seen the shadowy figures of Mme. Mallarmé and her daughter. The enlargement is by Tasset." Museum of Modern Art, New York; Gift of Paul F. Walter.

have been more different. She was wealthy and well educated, whereas he was poor and schooled only until he was twelve. Her father had a distinguished civil service career; his was a tailor. From the age of eleven, Morisot lived in Passy, an upper-class neighborhood of Paris. At the time of their friendship, Renoir lived in working-class Montmartre. Although she had exhibited at prestigious art shows for ten years, when she married at age thirty-three she described herself as having "no profession," and her husband listed himself as a "man of property."[12] When Renoir married at age forty-nine, he gave his occupation as "artist painter" and that of his thirty-one-year-old wife as "seamstress." He thought of himself as a working man, although by the time of his friendship with Morisot he lived a middle-class life. However, Julie Manet reported that, in 1898, when discussing whether he was a bourgeois, Renoir said: "No, we are intellectuals!"[13]

Their close friendship is evidence that what mattered to Morisot was Renoir's talent and his human qualities. Despite this he did not feel secure enough during the first six years of their relationship to risk disclosing his private life to her. Fearful that if Morisot knew that he was married to a seamstress from a rural background she might sever the tie, he never mentioned Aline Charigot, whom he had met in 1879 and who had been first his

model, then his mistress, and, in 1885, the mother of his child.

Among his male friends it was common to have a lower-class mistress and an illegitimate child. Cézanne, Monet, and Pissarro had such arrangements; they all eventually married the mothers of their children, and they all knew about Aline and little Pierre. But a peasant common-law wife and a child might have stigmatized Renoir as immoral or bohemian among his friends in the *haute-bourgeoisie*. Hence he kept his family a secret from some of them, including Morisot and Mallarmé, whom he saw weekly beginning in the year of Pierre's birth. When, in 1886, he showed Morisot drawings of Aline nursing the baby, he neglected to mention who the models were. Five years later, on April 14, 1890, he married Aline, but he still kept silent, even though he spent several weeks during the summer of 1890 with Morisot and her family in Mézy.[14] This concealment may be difficult to understand now, but it was less unusual in the late nineteenth century, when discreet people did not so readily discuss their private affairs.

In July 1891, fifteen months after his marriage, Renoir unexpectedly visited Morisot and her husband accompanied by a woman and a six-year-old child, whom he did not introduce. Berthe and Eugène were speechless until they deduced that Aline and Pierre were Renoir's own family. Morisot wrote to Mallarmé,

"I have seen Renoir for a moment with his family. I shall tell you about this later."[15]

Aline, very overweight, may have embarrassed her husband. He was justified in his fears about the reaction of the sophisticated Parisians. In her diary Julie wrote several times about Aline's rotundity. Mme. Renoir had told her that when "she was twenty-two . . . [she] was very slim . . . (which is hard to believe)."[16] In 1895 Julie recorded ten-year-old Pierre's remark, while learning to swim with his parents: "Maman, when you are seen from below, you're even fatter."[17] Two years later Julie reported, "She's getting thinner—or rather, less fat."[18] Morisot had a similar repugnance, as a letter to Mallarmé indicates: "Renoir has spent a few days with us, without his wife this time. I shall never succeed in describing to you my astonishment at the sight of this ungainly [very heavy] woman whom, I don't know why, I had imagined to be like her husband's paintings. I shall introduce her to you this winter."[19]

While Renoir felt inferior to Morisot because of his class, and feared to offend her with knowledge of his personal life, still he felt superior to her because of his gender. Both of them subscribed to the prevailing belief that men were superior to women and thus must be the better artists. Both felt that, although Morisot was an exceptional woman, she still was not the equal of her male colleagues. Neither she nor most others appreciated the revolutionary nature of her style, or valued it as highly as they would

have had she been a man. Certainly her work has rarely been applauded as being in the forefront of the avant-garde and surpassing that of all her fellow artists in fulfilling Impressionist aims. While the others retain a suggestion of physical sensuality, in her pure Impressionist phase Morisot totally dissolved her figures. Thus she brought Impressionist figure painting to its zenith.

MORISOT'S ATTITUDES about women's ability underlay her numerous negative statements about her talent and work. For example, in 1882, she wrote to her husband, "I have begun my lady with the parrots. . . . I thought all the time what Édouard [Manet] would do of her, and as a result I naturally found my own attempt all the less attractive."[20] And a few years later she wrote to her sister Edma about the Impressionist group: "There are clashes of vanity in this little group that make any understanding difficult. It seems to me that I am about the only one without any pettiness of character; this makes up for my inferiority as a painter."[21]

Yet she felt comfortable as the only female artist in the group at the exhibitions of 1874, 1876, and 1877. She saw herself as a qualified member, as did others. In May 1878 Duret published *The Impressionist Painters*, the first authoritative attempt to explain the movement. He included her as one of its leaders, the others being Monet, Pissarro, Renoir, and Sisley. Her place in the nucleus of the Impressionist group was clearly acknowledged.

After the 1876 show she wrote to one of her aunts: "If you read

Photograph of Mme. Renoir and Coco at Le Cannet, 1902. In this photograph Aline is forty-three and Coco is one year old.

any Paris newspapers, among others *Le Figaro,* which is so popular with the respectable public, you must know that I am one of a group of artists who are holding a show of their own, and you must also have seen how little favor this exhibition enjoys in the eyes of the gentlemen of this press. On the other hand we have been praised in the radical papers, but these you do not read. Anyway, we are being discussed, and we are so proud of it that we are all very happy."[22]

As she aged her passion for her work, belief in her own creativity, and professional determination to succeed grew. When forty Morisot wrote: "The love, the habit of any work, does not diminish with the years. It is this that reconciles us to our wrinkles and white hair."[23]

Nonetheless, she maintained the modesty and self-deprecation that were considered characteristics of femininity; in polite society the reverse was found shocking. As her daughter wrote admiringly: "Maman, full of talent and so straightforward, charming and yet not seeming to be aware of the fact."[24] In a diary entry of 1890, Morisot wrote some observations about women's nature and ability: "The truth is that our value lies in feeling, in intention, in our vision that is subtler than that of men, and we can accomplish a great deal provided that affectation, pedantry, and sentimentalism do not come to spoil everything."[25] Yet she also bemoaned the injustice of her situation. At the age of forty-nine, when Eugène was still alive, she wrote: "I want to do my duty [to my art] now until my death; I would like others not to make that too difficult for me. I don't think there has ever been a man who treated a woman as an equal, and that's all I would have asked, for I know I'm worth as much as they."[26] At heart she was a feminist! That same year, after thirty-three years of painting in the living room, she got a studio of her own.

Despite his sexism Renoir had no trouble accepting Morisot as his equal and as one of the key Impressionists. In 1877 he and Caillebotte wrote to her with news of the forthcoming Impressionist exhibition: "We are happy to think that you will want to participate as usual."[27] In response to Durand-Ruel's request to include his work in an 1882 exhibition, Renoir wrote: "With Monet, Sisley, Morisot, Pissarro I would accept, but only with them."[28] Two days later he changed his mind about Pissarro: "Get rid of those people [Pissarro, Gauguin, Guillaumin, and others with revolutionary political affiliations] and exhibit me with artists like Monet, Sisley, Morisot, etc. and I'm your man, for that's no longer politics, it's pure art."[29]

About other female artists, Renoir displayed the typical bigoted attitude of both men and women of his time toward professional women. To the art critic Philippe Burty he wrote:

My dear friend, I consider women writers, lawyers, and politicians, [the two women writers] George Sand,[30] Mme. [Juliette] Adam,[31] and other bores as monsters and nothing but five-legged calves [freaks]. The woman artist is nothing but ridiculous, but I wholeheartedly approve of the female singer and dancer. In antiquity and among primitive peoples, the woman sings and dances and is no less feminine [because

of that]. Gracefulness is her domain and even a duty. I am well aware that today the situation is debased, but what can be done? In ancient times, women sang and danced for nothing, for the pleasure of being pleasant and graceful. Today one has to pay too much [money for it], and that takes away the charm.[32]

Renoir's ideal women were mothers, homemakers, and those who were sources of sexual pleasure for men. He also felt that in women resided the highest beauty, which it was the artists' duty to capture.[33]

But Morisot was an exception. He encouraged her work, urging her to finish paintings and to exhibit. Besides her charm the fact that she was the sister-in-law of the revered Manet no doubt affected his feelings about her. Morisot enjoyed her special status, which her daughter also applauded. After her mother's death, Julie reminisced in her diary:

> On the subject of painting, M. Renoir repeated that one must work for short periods and rest a good deal. "Madame Manet knew how to work admirably," he said. Jean Baudot [a young student of Renoir] says that he constantly speaks of Maman with admiration and that he finds very special words for her. Sometimes I think again of the phrase with which M. Renoir replied to M. Mallarmé when one Thursday evening, leaving the house, he was speaking of all Maman's qualities: ". . . and with all that, any other woman would find a way of being quite unbearable."[34]

Julie reported: "M. Renoir's comment . . . touched Maman deeply when it was repeated to her."[35]

The friendship between Morisot and Renoir was a balancing of attitudes. While she did not esteem him to the same extent as she had Manet, she respected Renoir as an authority figure, and he looked up to her as an exceptional woman, whose elegance and charm fascinated him. They admired each other's art. A couple of years before their close friendship began, Morisot had called him a man of "immense talent."[36] She owned at least one of his paintings, an oil sketch of a girl seated in the grass that he made when visiting her at Mézy in 1890 and insisted that she keep.[37] Renoir owned several works by Morisot: an unidentified drawing,[38] an oil, *Basket of Flowers on a Table of 1890*,[39] and a lost oil, *Apples* of 1887, bequeathed to him in her will.[40]

Morisot, *The Black Bodice*, 1876. Oil on canvas, 28¾ × 23½" (73 × 59.8 cm). The National Gallery of Ireland, Dublin.

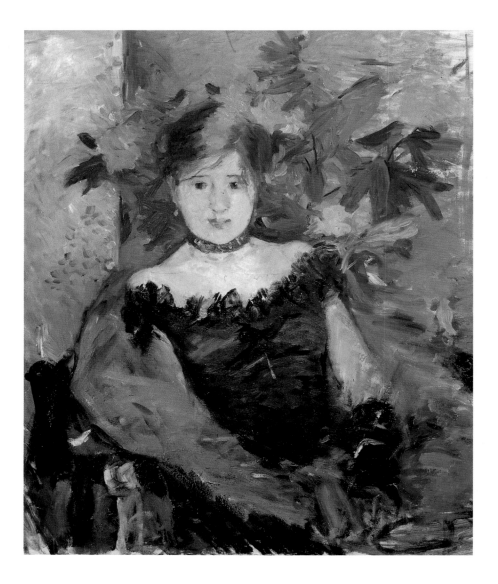

In 1876, when Morisot painted *The Black Bodice* and Renoir *Mme. Henriot*, they were both in their most pure Impressionist phases. She wanted to seize the effervescent, dissolving sensations of the moment; he was a sensualist who portrayed people's beauty. In *The Black Bodice* Morisot seems to have captured the feeling of being a demure woman; she also gave a measure of dignity, sensitivity, and soul to the figure. In his portrait Renoir saw a woman from the outside, as "the other," and depicted her appeal to men.

Although Morisot and Renoir were both Impressionists, there were important differences between them. Renoir was a much more productive artist, even taking into account the fact that Morisot died at age fifty-four and he at seventy-eight. She produced a total of about 425 oil paintings in thirty-five years, whereas he painted a total of about 5,450 canvases in almost sixty years.[41] Furthermore, he had a wider range of themes and many more distinct styles. Nonetheless, Morisot took Impressionism further than Renoir did in the way that, with great daring, she allowed the light to dissolve her figures.

Their subjects and styles are different. Renoir often showed romancing couples and the world of the boulevard and café. Morisot presented the sedate, sheltered world of an *haute-bourgeoise*. Her primary interest was in light, his in figures. Morisot also was a genius with watercolor, a medium that Renoir used only on occasion. Her messy, straight, and short brushstrokes move in all directions with freedom and imagination, whereas his are smaller and more delicate.

Morisot surpassed all her peers in her fidelity to the original aesthetic of Impressionism. Reviewers asserted, often as a criticism, that she was the quintessential Impressionist. Most perceptive were Paul Mantz's comments during the 1877 exhibit: "The truth is that there is only one Impressionist in the group at Rue le Peletier: it is Berthe Morisot. She has already been acclaimed and should continue to be so. She will never finish a painting, a pastel, a watercolor; she produces prefaces for books that she will never write, but when she plays with a range of light tones, she finds grays of an extreme finesse and pinks of the most delicate pallor."[42] And Charles Bigot wrote, more negatively, "You could say that she particularly is the victim of the system of painting that she has adopted."[43] Arthur Baignières stated:

She carries the [Impressionist] system to an extreme, and we are all the sorrier as she has rare qualities as a colorist. . . .

Renoir, *Mme. Henriot*, 1876.
Oil on canvas, 26 × 19⅝″ (66
× 50 cm). National Gallery of
Art, Washington; Gift of the
Adele R. Levy Fund.

You should not, for example, come closer [to the paintings] nor look at details; [do so and] the illusion disappears and you find yourself in the presence of monstrous beings, incoherent dabs and crazy perspectives. Mlle. Morisot is such a dedicated Impressionist that she wishes to paint even the motion of inanimate things.[44]

While none of Morisot's contemporaries believed she had the genius that they saw in the work of Cézanne, Degas, Manet, Monet, Pissarro, and Renoir, all agreed on her central position within the avant-garde, perhaps on the level of those considered lesser Impressionists, such as Bazille, Caillebotte, Cassatt, and Sisley. One wonders what would have happened if Morisot had been a man. Her radical treatment of form would have been appreciated more by others and by herself. She would have applied her vaporous technique to a wider range of themes, such as the boulevards and the cafés. She would also have had the time and energy to paint more works. Perhaps she would have continued exploring the way bright light appears to dissolve form, instead of following Renoir's more traditional path in the mid-1880s.

As early as 1869, when Monet and Renoir were working out-doors at La Grenouillère, she was concerned with the same issues as they. In her diary she observed, "You can do *plein air* painting indoors, by painting white in the morning, lilac during the day and orange-toned in the evening."[45] That same year she wrote to her sister Edma of her Impressionist aims: "The tall Bazille has painted something that I find very good. It is a little girl in a light dress seated in the shade of a tree, with a glimpse of a village in the background. There is much light and sun in it. He has tried to do what we have so often attempted—a figure in the outdoor light—and this time he seems to have been successful."[46]

Later in her life, despite the fact that her form had become less Impressionist, she wrote of her aims:

It's been a long time since I hoped for anything, even of others, since the desire for glorification after death seems to me an unreasonable ambition. Mine is limited to wanting to *capture something that passes;* oh, just something! the least of things. And yet that ambition is still unreasonable! A distinctive pose of Julie, a smile, a flower, a fruit, the branch of a tree, and every once in a while a more vivid reminder of my family, just one of these would suffice.[47]

Morisot, *Nursing* (Nurse and Julie), 1879. Oil on canvas, 20 × 24″ (50.8 × 61 cm). Private collection.

MORISOT'S ONLY CHILD, Julie, was born on November 14, 1878. Morisot, with her rheumatic heart, had a difficult delivery and recovery. Continuing health problems prevented her from exhibiting five months later in the 1879 group show.

While the two nursing paintings feature the same motif—each artist's firstborn infant being nursed outdoors—Morisot's canvas of 1879 and Renoir's of 1886 are radically different. Morisot, like most upper-class women, did not nurse her own child.[48] Her painting is so discreet that one has difficulty making out the nurse's breast. Renoir, by contrast, focused on Aline's exposed breast and Pierre's genitals. Even in its vaporous state, Morisot's work suggests the emotional relationship of nursing, whereas Renoir concentrated on the physical.

Morisot painted *Nursing* at the height of her Impressionist period. When it was exhibited two years later, Geffroy wrote: "The forms are always vague in Berthe Morisot's paintings, but a strange life animates them. The artist has found the means to fix the play of colors, the quivering between things and the air that envelops them. . . . Pink, pale green, faintly gilded light sings with an inexpressible harmony. No one represents Impressionism with more refined talent or with more authority than Morisot."[49] And Mantz pointed out that she had gone as far as possible in suggestiveness: "Mme. Morisot has come—and this is something of a surprise—to exaggerate her manner and to blur the already im-

precise forms. She has made no more than beginnings of beginnings: the result is curious, but more and more metaphysical. Evidently a colorist's talents are needed in order to draw up such delicacy out of nothingness."[50]

Renoir's *Nursing* of seven years later represents his least Impressionist manner. Here (and in *The Bathers* of 1887; see p. 227) his style was extremely conservative, as he sought to portray clearly defined sculptural form and to emphasize basic geometric shapes. It is one stage in his evolving treatment of form, which moved from Impressionism (1869–1877) to realism (1878–1883) to classicism (1884–1889) and then to his pearly sculptural style (1890–1899). Renoir's timelessness and permanence, his simplification and generalization of form, are the opposite of an Impressionist conception. But the work remains Impressionist in the light, colorful palette and visible brushstrokes.

Morisot painted *Nursing* directly from what she saw in her garden. She captured the spontaneity of her vision. Valéry wrote that she "would take up the brush, leave it aside, take it up again, in the same way as a thought will come to us, vanish, and return. It is this which gives her works the very particular charm of a close and almost indissoluble relationship between the artist's ideals and the intimate details of her life."[51]

Conversely, Renoir's canvas was the end result of a laborious process. Soon after Pierre's birth in March 1885, he began work-

Renoir, *Nursing*
(Aline and Pierre),
second version, 1886.
Oil on canvas, 31½ ×
25½″ (80 × 64.8 cm).
Private collection.

ing on the theme of nursing, for which he made numerous preparatory pencil and pen drawings, two sanguine drawings, and three finished oil versions. Whereas Morisot's *Nursing* is certainly the most Impressionist nursing scene ever made, a tour de force capturing a momentary vision, Renoir's is a portrait of secularized Madonna and Child.[52]

Renoir's anti-Impressionist treatment of form pleased Morisot when she first saw it early in 1886; thereafter she followed his lead, although she never became as crisply linear and detailed as was he in *Nursing* (1886), *The Bathers* (1887), and *Julie Manet with Cat* (1887; see p. 238). She moved away from Impressionist formlessness to achieve masterful but more traditional works such as *The Piano* (1888; see p. 244) and *The Cherry Tree* (1891–92; see p. 248).

By the mid-1880s, only Monet continued the Impressionist search to capture the momentary glimpse. The others were becoming more conservative. Cassatt was concentrating on her mother and child scenes in her formal manner; Cézanne, on making Impressionism more like the art of the museums; Degas, who was having problems with his vision, on broad pastels of dancers and nudes; and Pissarro, on Seurat's pointillism in an effort to achieve greater structure and order; later, Pissarro returned to Impressionism.

In the mid-1880s, Renoir and Morisot stopped recording sensations directly and adopted a more controlled procedure, making numerous studies *en plein air* and completing their work in the studio, often with a professional model. They even made tracings from drawings onto their canvases, as had fresco painters in the early Renaissance. Their Impressionist work had concerned itself with daily life, but beginning in 1886 Morisot followed Renoir in occasionally depicting the nude. Like him she rejected Impressionist formlessness and depicted forms with defined edges, weight, volume, and relief. Her compositions became more structured.

Renoir, *Two Studies of a Child Sleeping and Two Studies of a Child Awake for Nursing Painting*, 1885–86. Pencil on paper, 8⅔ × 13⅛″ (22 × 33.5 cm). Present collection unknown.

Renoir, *Three Studies of a Child Sleeping, One of a Child Nursing, and Three of Its Arm for Nursing Painting*, 1885–86. Pencil, pen, and ink on paper, 9 × 12⅛″ (23 × 31 cm). Present collection unknown.

Renoir, *Two Studies of Child Nursing and Two of Drapery Folds for Nursing Painting*, 1885–86. Pencil on paper, 8⅔ × 13⅛″ (22 × 33.5 cm). Present collection unknown.

OPPOSITE: Renoir, *Drawing for Nursing Painting*, 1885–86. Pencil on paper, 19⅓ × 14½″ (49 × 37 cm). Present collection unknown.

Morisot, *Portrait of Julie Manet*, 1886. Bronze, 10½″ (26.7 cm). Private collection.

OPPOSITE: Renoir, *Nursing Composition with Two Infant Heads for Nursing Painting*, 1885–86. Red chalk heightened with white chalk on beige prepared canvas, 36¼ × 28¾″ (92 × 73 cm). Musée de Strasbourg.

MORISOT'S ABANDONMENT of Impressionist form was encouraged by her admiration for what Renoir was doing in 1886. Even earlier, however, she had experienced a desire for the traditional and in 1885 had set out to study the great art of the past throughout Europe, planning to end her tour in Italy. She got only as far as Belgium and Holland, where she particularly admired Peter Paul Rubens. Also in 1885 she complained to her sister Edma about her dissatisfaction with her art and expressed an eagerness to find a new style in time for the forthcoming eighth Impressionist show in 1886: "I am working with some prospect of having an exhibition this year: everything I have done for a long time seems to me so horribly bad that I should like to have new, and above all better, things to show to the public."[53]

Her style had already begun to change. For one painting of a goose, she made twelve preparatory drawings in watercolor and pastel; her procedure was no longer spontaneous. By 1885 she seems to have felt that the atmospheric, vaporous character of her work was not expressing what she wanted to convey. Renoir had already felt this about his own work beginning in 1878, although he had the additional motivation of finding a style that would enable him to earn a living. One wonders whether the mostly negative reaction of the critics, public, and more traditional artists

from 1870 through the mid-1880s might have discouraged both and led them to turn away from an avant-garde treatment of form.

Morisot's nascent traditionalism was soon reinforced by her admiration for Renoir's new work. On January 11, 1886, she visited his studio for the first time and saw the preparatory drawings for *Nursing* (see pp. 222–3). In a little notebook she wrote: "Visit to Renoir. On a stand, a red pencil and chalk drawing of a young mother nursing her child, charming in subtlety and gracefulness. As I admired it, he showed me a whole series done from the same model and with about the same movement. He is a draftsman of the first order; it would be interesting to show all these preparatory studies for a painting, to the public, which generally imagines that the Impressionists work in a very casual way."[54] No doubt inspired by Renoir, Morisot now made red chalk drawings as preparatory studies for oil figure paintings and reinforced the edges of some of her figures. That year she also made a sculpture of her daughter in plaster which was cast in bronze, for which she consulted Auguste Rodin.[55] (Twenty-two years later Renoir tried soft-wax sculpture in a bust and a profile medallion of his youngest son, Coco.)[56]

ON THAT FIRST TRIP to Renoir's studio, Morisot also saw several drawings of nudes, preparatory studies for a large oil painting, *The Bathers,* which he completed in 1887. The precise drawings impressed her; she wrote in her diary: "I do not think it possible to go further in the rendering of form; two drawings of women going into the water I find as charming as the drawings of Ingres. He said that nudes seemed to him to be one of the essential forms of art."[57]

Renoir, *Study of Three Right Nudes with Part of Foot of Reclining Left Nude for The Bathers,* c. 1885. Red and black chalk heightened with white on yellowish paper, 34½ × 20½″ (87.6 × 52 cm). Present collection unknown.

Renoir, *The Bathers*, d. 1887. Oil on canvas, 46⅜ × 67¼"
(117.8 × 170.8 cm). The Philadelphia Museum of Art;
Mr. and Mrs. Carroll S. Tyson Collection.

Renoir, *Study of Splashing Nude for The Bathers*, c. 1885. Pencil, black,
red, and white chalk touched with wash on brown cardboard, 38¾ ×
25¼″ (98.5 × 64 cm). The Art Institute of Chicago; Bequest of Walter
and Kate S. Brewster.

WHEREAS THE NUDE is the major theme in Renoir's art
beginning in 1885, it is a minor theme in Morisot's. Her in-
terest in the subject was inspired both by her visit to his studio and
by her renewed interest in earlier artists such as Rubens, François
Girardon, and François Boucher. In 1886 and 1887 she hired two
professional models (Isabelle Lambert and Carmen Gaudin) who

posed either nude or covered by white sheets for works that she did
in various media (oil, pastel, charcoal, watercolor, and pencil).

One of these works, the pastel *Young Woman Drying Herself*,
presents an intimate view of a woman naked to the waist. It fol-
lows Renoir in the flowing outline and graceful arabesque of the
silhouette as well as in the firm sense of modeling. The body has

Morisot, *Young Woman Drying Herself*, 1886–87. Pastel on paper, 16⅝ × 16⅛″ (42 × 41 cm). Private collection, New York.

weight and mass. Yet Morisot's nude is relaxed and natural, whereas the figures in Renoir's drawings as well as in *The Bathers* (see p. 227) appear contrived and posed, like pinups. Renoir saw the bather as a sex object for male viewers.

Because of its linearity and traditionalism, *The Bathers* did not appeal to many of Renoir's friends and former patrons,[58] yet Morisot and her husband admired his new style. Shortly after seeing *The Bathers* exhibited at Georges Petit's gallery, where Morisot's work was also represented, they commissioned a portrait of their daughter, which Renoir executed in the same linear style.

François Girardon, *Nymphs Bathing*, 1668–1670. 88½ × 242⅛″ (225 × 615 cm).
Iron bas-relief. Fountain of Diana, Allée des Marmousets, Versailles.

Renoir, *Study of Nine Nude and Clothed Bathers*, for *The Bathers*,
c. 1885. Pastel, 8¼ × 10⅝″ (21 × 27 cm). Private collection.

ON HER FIRST VISIT to Renoir's studio, Morisot saw that at least one of his drawings for *The Bathers* (see p. 227) was inspired by an iron bas-relief of nudes that decorated one of the pools at Versailles, Girardon's *Nymphs Bathing* of 1668–1670.

Study of Nine Nude and Clothed Bathers has affinities with the Girardon in some of the figures' postures and gestures. Following Renoir's example, Morisot went to Versailles and made pencil copies in a small sketchbook of some of the nudes' poses.

Morisot, *Sketchbook Copies of Girardon's Nymphs Bathing*, c. 1886. Two
pages from a Sketchbook, pencil on paper, 7⅞ × 6¼″ (20 × 16 cm).
Archives Wildenstein.

François Boucher, *Venus at Vulcan's Forge*, 1757. Oil on canvas, 126 × 126″ (320 × 320 cm). Musée du Louvre, Paris.

In the mid-1880s Morisot copied a detail of two nudes from a large painting by Boucher at the Louvre. The copy was unusually big for her—almost four feet by over four feet. She made this as a decoration for the area above a mirror in her living room on the Rue de Villejust in Paris. This copy is in soft, decorative colors, and the edges of the bodies are reinforced with precise colored lines. As in so many of her own nudes, one figure is seen from the back and the other's body is modestly covered. Nonetheless, Morisot's copy captures Boucher's titillation and charm.

A few years earlier Philippe Burty had noted the way Morisot followed the rococo spirit: "[She] handles the palette and brush with a truly astonishing delicacy. Since the eighteenth century, since [Jean-Honoré] Fragonard, no one at all has used lighter tones with such intelligent assurance."[59] Much later Paul Valéry wrote that those who appreciate her work "know that the true begetters of her taste and vision were the luminous painters who expired before David."[60]

Renoir shared Morisot's appreciation for the creator of *Venus at Vulcan's Forge*. In his youth he had decorated porcelain with paintings, some after Boucher.[61]

Morisot, *Copy of Detail from Boucher's Venus at Vulcan's Forge,*
c. 1884–1886. Oil on canvas, 44⅞ × 54⅜″ (114 × 138 cm).
Private collection, Paris.

In *A Girl Arranging Her Hair* of 1885–86, Morisot seems to have been following Renoir's renderings of this theme. As in the Renoir, there is stress on the edge of the form and interest in volumes, and the details of the model's face are sketchily depicted. Yet the light, color, and strokes remain Impressionist. However, the similarity ends here. Morisot's girl seems much more spontaneous and sincere than Renoir's women, who seem coyly posed to call attention to their bodies. Renoir's women are a spectacle for men to enjoy, but Morisot captured what it feels like to be a woman and fix one's hair unselfconsciously.

Renoir, *Bather Arranging Her Hair*, d. 1885. Oil on canvas, 36⅛ × 28¾″ (92 × 73 cm). Sterling and Francine Clark Art Institute, Williamstown, Mass.

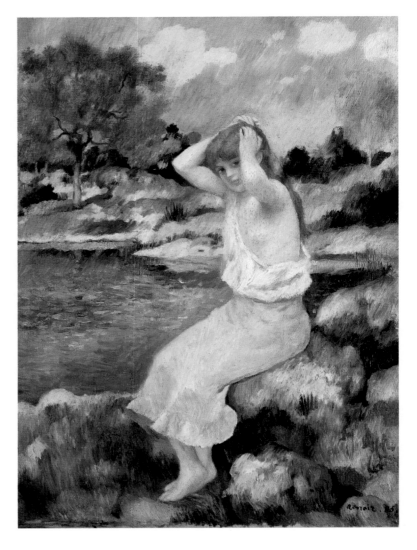

Renoir, *Girl Fixing Her Hair*, d. 1885. Oil on canvas, 20¼ × 14½″ (51.4 × 36.2 cm). Private collection.

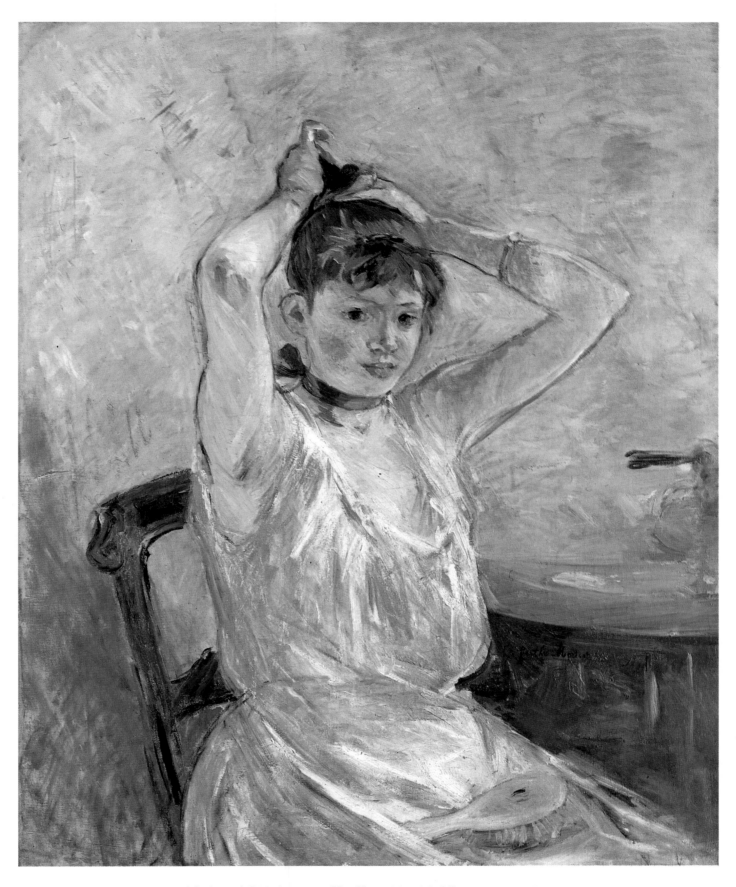

Morisot, *A Girl Arranging Her Hair*, 1885–86. Oil on canvas, 35⅞ × 28⅜″ (91.1 × 72.3 cm). Sterling and Francine Clark Art Institute, Williamstown, Mass.

Renoir, *Julie Full Face*, 1887. Charcoal and pencil on paper, 23 × 17″ (58.4 × 43.2 cm). Private collection.

IN THE SPRING or summer of 1887, Morisot and her husband commissioned Renoir to paint Julie's portrait. At the time he had few portrait commissions, because his patrons resisted his new, severe style. He gave Morisot the complete set of preparatory drawings, so we can reconstruct the transformations of the eight-year-old girl's appearance. He began by recording his direct observation; the rounded shapes are presented straightforwardly and simply. By the last drawing he had arrived at the formalized abstraction that appears in the painting. He purposely modulated the size, shape, and direction of every line so that there are rich variations from the heart-shaped face to the angular area between the two points of her collar, to the tapered shape of her neck.

Renoir, *Julie Three-quarters with Cat*, 1887. Charcoal and pencil on paper, 24 × 19″ (61 × 48.2 cm). Private collection.

In 1963 the eighty-four-year-old Julie Manet Rouart recalled the steps in the painting of her portrait. First Renoir primed the canvas with a white lead ground. Once the ground was dry, he took the tracing and applied sanguine on the reverse side of the traced outlines. Next he placed the tracing in its correct position on the dry canvas, sanguine side down. He then followed the outline of his drawing with a hard pencil. In this manner he was able to transfer the exact silhouette of the face and collar from the last preparatory drawing onto the primed canvas. Renoir's working method followed age-old techniques but did not allow for spontaneity, because the artist retained in the painting the exact linear relationships that he had first worked out in the drawings.[62]

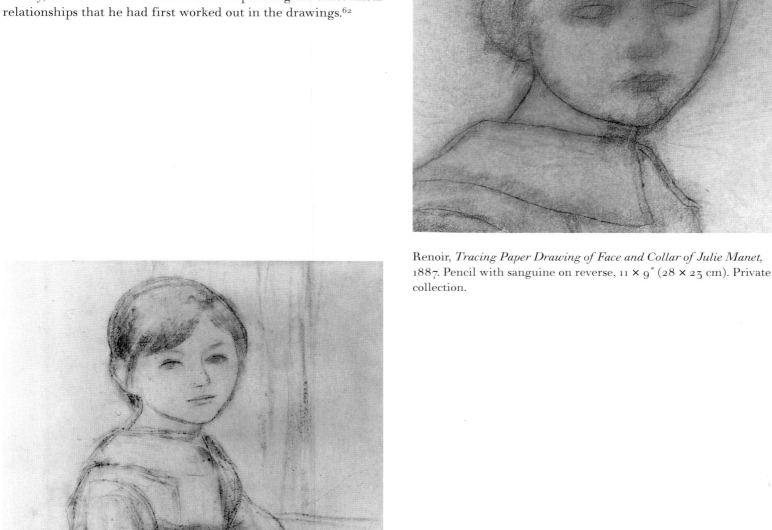

Renoir, *Tracing Paper Drawing of Face and Collar of Julie Manet,* 1887. Pencil with sanguine on reverse, 11 × 9″ (28 × 23 cm). Private collection.

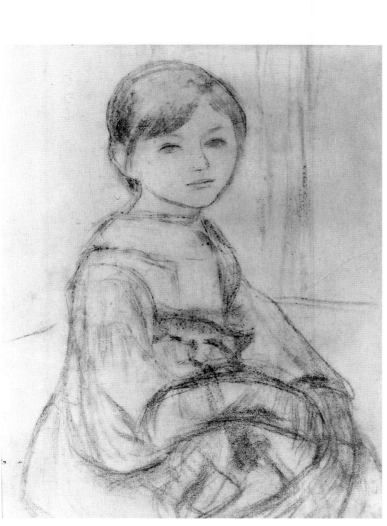

Renoir, *Julie, Cat and Background,* 1887. Charcoal and pencil on paper, 24 × 18¼″ (61 × 46.3 cm). Private collection.

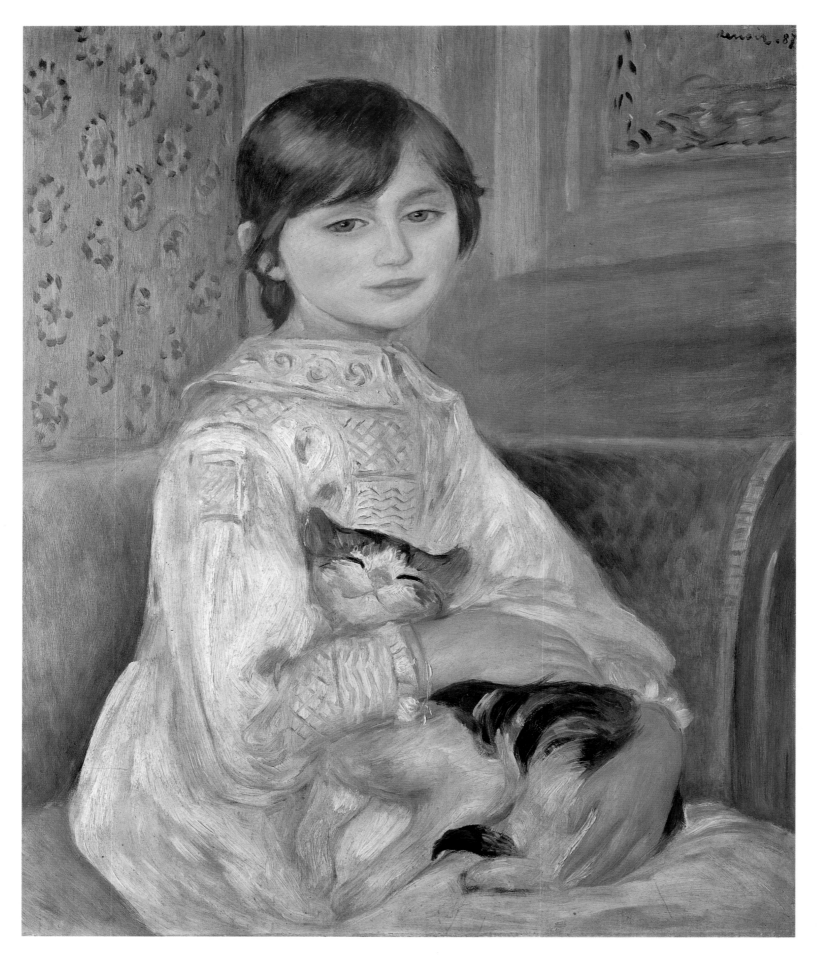

OPPOSITE: Renoir, *Julie Manet with Cat*, d. 1887. Oil on canvas, 25 × 21″ (63.5 × 53.3 cm). Private collection.

BELOW: Morisot, *Little Girl with Cat* (copy of Renoir's portrait of Julie Manet), c. 1888. Pastel, 23⅔ × 18″ (60 × 46 cm). Private collection.

RIGHT: Morisot, *Julie Manet with Cat* (copy of Renoir's portrait), from "Collection of Eight Dry-Points," c. 1888. Drypoint, 6 × 5″ (15.2 × 12.7 cm). National Gallery of Art, Washington; Rosenwald Collection, 1953.

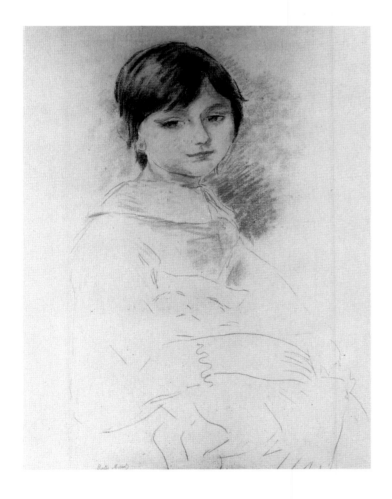

MME. ROUART recalled that Renoir painted her portrait with oils "bit by bit, one day my head and a little of the background, another day my dress and the cat." This controlled procedure resulted in the separation of areas of color. She recalled that to retard drying during the various stages, he used to leave the canvas in their damp cellar overnight. Renoir's method achieved the transparent and muted effect he sought.[63]

The following year Morisot copied the portrait in a pastel of a similar size, which details Julie's head and faintly indicates her body and the cat. She also made a small drypoint, which appears reversed because of the printing process. The next year, when she was working on *The Piano* (see p. 244), she followed Renoir's technique of making multiple preparatory drawings and tracing one of them onto a canvas.

In December 1887 Morisot and Renoir embarked on a new collaborative venture. Mallarmé asked them as well as Degas, Monet, and John-Lewis Brown (an artist of sporting pictures) to illustrate an anthology of his prose poems to be called *The Lacquer Drawer*.[64]

Neither Morisot nor Renoir had done graphics before; moreover, they were confused by the subtlety of Mallarmé's poems. Morisot wrote to him, "It would be kind of you to come to dinner Thursday. Renoir and I are quite bewildered; we need explanations for the illustrations."[65]

Morisot agreed to illustrate "The White Water-Lily":

I had rowed for a long time, with a clean, sweeping, drowsy motion. . . . To see clearly into my adventure, I had to call to mind my early departure, on this flaming July day, through the lively opening, banked by dormant foliage, of an always narrow and meandering stream, in search of water flowers. . . . I had just run aground in a clump of reeds, the mysterious end of my voyage, in the middle of the river where, suddenly widened to a fluvial grove, it displays the indifference of a pool rippling with the hesitation of a well spring about to depart.[66]

She did a preparatory drawing. As Mallarmé later reported, "Monet was charmed by the white waterlily done with three pencils."[67] Unfortunately this drawing is not known. Among the nine drypoints that Morisot made in 1888 and 1889, none is of water lilies. However, it is possible that her landscape *Edge of the Lake* was her intended illustration. The same size as Renoir's etching for the volume (see p. 243), it is a waterscape that corresponds to some passages in the poem.

Morisot, *Edge of the Lake*, 1888. Drypoint, 6¼ × 4¾″ (15.5 × 11.5 cm).
Bibliothèque Nationale, Paris.

Renoir, *Three Drawings for Venus* (or *"The Phenomenon of the Future"*), 1888. Left drawing: pencil on paper, 6⅛ × 3½" (15.5 × 9 cm). Middle drawing: pencil and India ink on paper, 6 × 5¼" (15.2 × 13.5 cm). Right drawing: pen on paper, 6⅛ × 3½" (15.5 × 9.5 cm). Musée du Petit Palais, Paris.

R ENOIR ILLUSTRATED the poem "A Phenomenon of the Future," with an image entitled *Venus*. For this early in 1888 he executed four pencil, pen, and India ink drawings of a female nude, a figure corresponding to these lines: "in lieu of vain apparel, she has a body; and her eyes, though they resemble precious stones, are not equal to the expression that springs from her happy flesh: from breasts raised as if they were full of eternal milk, tipped toward the sky, to glistening legs that retain the salt of the primeval sea."[68] No doubt the sensualism of the poem appealed to Renoir.

From these drawings, Renoir made his first etching. It prefigures the classical nude that he would develop in his painting, graphics, and sculpture for the following thirty years. This relaxed, voluptuous woman is small breasted and large hipped. She has a defined silhouette and seems massive. She exemplifies the artist's ideal woman, the epitome of beauty, the source of sexual pleasure, and the origin of life. In 1890, when Durand-Ruel asked Renoir for a work to be included in a show of painters who were also engravers, the artist suggested this etching[69] and then wrote to Mallarmé: "Dear Poet, May I exhibit the only etching that I've done and which you own? I am having an exhibition in which an etching is obligatory; it is not to be sold, only exhibited. Would you be kind enough to tell me simply yes or no. . . . I have only that unique copy of it. R."[70]

Morisot and Renoir responded to Mallarmé's request, but the project was only partially realized.[71] Three years later a collection of his poems, *Pages*, was published with *Venus* as the frontispiece.[72] In Renoir's copy of this volume, Mallarmé inscribed: "Given so that his [Renoir's] friendly vision may wander over the many pages of the book illustrated by Renoir."[73]

Renoir, *Venus* (or *"The Phenomenon of the Future"*), c. 1888–89.
Etching, only state 7¾ × 4¼" (19.8 × 10.7 cm). Bibliothèque
Nationale, Paris.

Morisot, *The Piano* (Jeannie Gobillard playing the piano and Julie
Manet listening), 1888. Pastel, 24¾ × 31″ (63 × 79 cm).
Private collection.

OVER A PERIOD of more than a year, Morisot made nu-
merous preparatory studies for *The Piano*. As Renoir had, she
did a charcoal transfer drawing for this pastel. Beginning in 1889
Renoir often painted two young girls together, which probably re-
flects the influence of Morisot's frequent portrayals, as here, of
Julie with her one-year-older cousin Jeannie Gobillard.[74] *The
Piano* also appears to influence *Girls at the Piano* in the posture of
the girl leaning forward on the piano with her other arm resting
on the chair. In both canvases the artists aimed for a flowing sil-
houette around the forms.

In 1888, when Morisot was working on *The Piano*, Renoir en-
couraged her to exhibit her works. He wrote: "Dear Madam, since
I shall not have the pleasure of seeing you tomorrow—I am in the
country trying to paint a landscape or two—I must inform you

that Durand-Ruel is preparing an exhibition for May 18; the only
expense will be that of sending one's pictures."[75] Morisot (as well
as Renoir) did participate in the exhibition, which took place from
May 25 to June 25.

In December of that year, Renoir was stricken with his first se-
rious attack of rheumatoid arthritis. The disease began with facial
paralysis, and problems with his eyes, teeth, and ears—a mani-
festation known as Sjögren's syndrome. He described his condition
in a letter to Eugène Manet:

I am trapped: I have caught cold in the country, and I have a
facial, local, rheumatic etc. paralysis.... In short, I can no
longer move a whole side of my face, and for diversion I have
two months of electrical treatments. I am forbidden to go out

Renoir, *Girls at the Piano*, 1892.
Oil on canvas, 45⅝ × 35½"
(116 × 90 cm). Musée d'Orsay,
Galerie du Jeu de Paume, Paris.

for fear of catching another cold. It is not serious, I think, but up until now nothing has improved. I need not tell you that I am bored with being kept here in this dark and foggy weather; I shall let you know when I am better, this will be my solace. Otherwise I am alright; I have no pain. I have waited a little to tell you this news, as I hoped to find a medical man who would cure me. My hopes were frustrated, and so I am forced to tell you about my illness; this is the least I can do.

I hope that unlike me all of you are well and that I shall find you glowing with magnificent health. My regards.[76]

In a subsequent letter he wrote, "My eyes hurt, just to imitate Degas."[77]

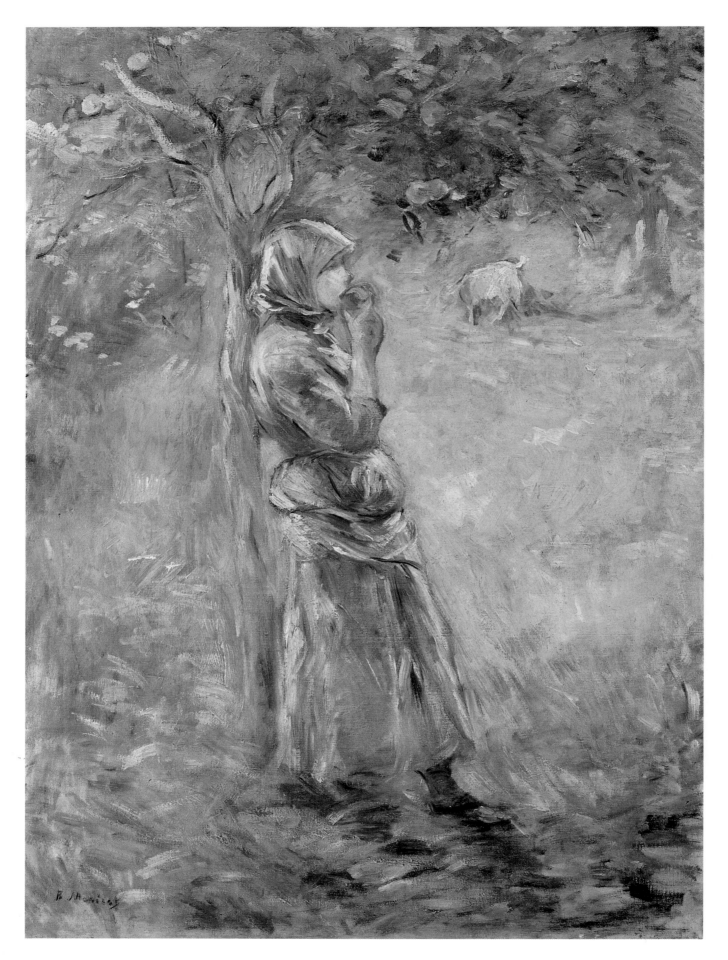

Renoir, *Young Peasant Girl Eating an Apple*, c. 1890. Oil on canvas, 25 × 15¼″ (63.5 × 38 cm). Private collection.

IN THE EARLY 1890s Renoir was a frequent houseguest of Morisot and her family at their summer home at Mézy. Around 1890, Renoir and Morisot painted side by side. A model, Julie Dufour, posed, and both artists painted her from different sides on canvases that are called *Young Peasant Girl Eating an Apple*. Morisot's version is more finished, with a goat in the background,[78] whereas Renoir's slightly smaller canvas is unfinished in the background and in the figure's legs.

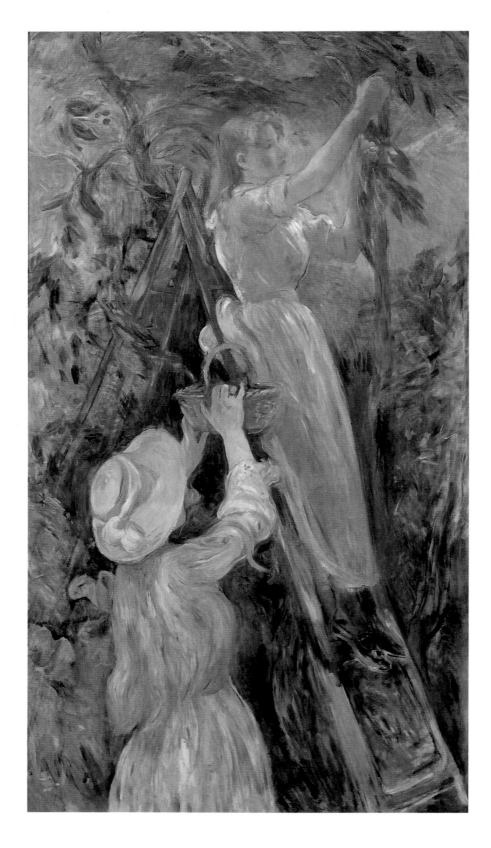

Morisot, *The Cherry Tree*, 1891–92. Oil on canvas, 60⅔ × 33½″ (154 × 85 cm). Private collection.

OPPOSITE: Renoir, *Girls Picking Flowers in a Meadow*, c. 1891. Oil on canvas, 25⅝ × 31⅞″ (65 × 81 cm). Museum of Fine Arts, Boston; Juliana Cheney Edwards Collection.

IN 1891 at Mézy, both artists painted girls picking fruit or flowers from trees; they first made studies outdoors and then completed their work in the studio. The paintings resemble each other in the emphasis on the graceful arabesque that silhouettes the substantial forms and in the balanced symmetrical composi-tions. Both artists were interested in form and line; both drew carefully interlocked poses, applied more ordered strokes than be-fore, and used more decorative, rather than naturalistic color.

The Cherry Tree took Morisot two years to complete. At first Julie posed on a ladder and Jeannie held a basket. Early in the fall

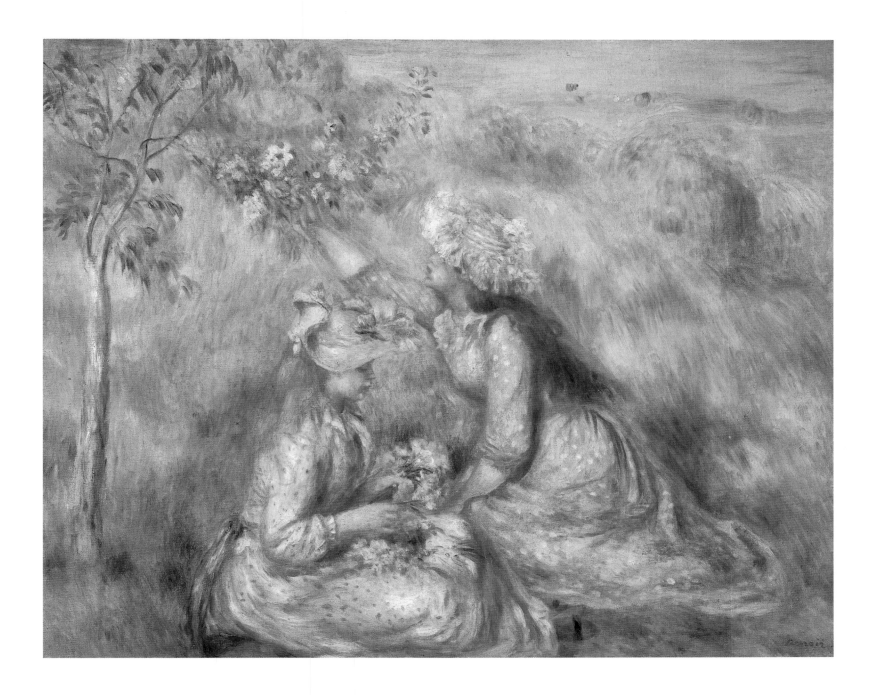

Renoir encouraged Morisot: "Be sure to finish your painting with the cherry trees. I shall send something to the [exhibition at the] Champ de Mars, so try and do the same. We must show our work. I send you all my wishes for success."[79]

Morisot continued working on the canvas in her Paris studio during the winter of 1891–92. On April 13, 1892, several months after her husband died, she and Julie moved to a smaller apartment on the Rue Weber, where she resumed work on this project with a professional model replacing Julie and Jeannie.[80] In the course of two years, Morisot completed three oil paintings of the motif, for which the preparatory work included at least eighteen studies in oil, pastel, watercolor, colored pencils, chalks, and graphite. As part of her procedure she made transfer tracings from drawings to the canvas. Renoir was also employing a similar non-Impressionist method at that time. He wrote her, "I am going to paint outdoor pictures in the studio."[81]

Several months before Eugène's death, Morisot had planned her first one-woman show, including forty oils plus watercolors, at the Boussod & Valadon Gallery in Paris.[82] When the show opened on May 25, 1892, she was in mourning and had already left the capital. Renoir reported her success: "Your colleague is happy to tell you that your dread of a fiasco is itself a fiasco. It has gone very well; they have already sold the ducks, the large painting which I think is entitled *The Veranda* and some water-colours. In short, everybody is satisfied, and I compliment you."[83]

MORISOT AND RENOIR painted striking portraits of Julie at the age of sixteen, in 1894. Morisot's is extremely graceful in the supple rhythm of the edge of the form. Renoir's, showing Julie at ease and pensive, forms a striking contrast with her portrait at eight with her cat, when he had depicted her as stiff and self-conscious.

That year, when Morisot was fifty-three, her rheumatic heart gave her problems, including difficulty in walking. Renoir mentioned this in an invitation to her: "Next Wednesday Mallarmé will give me the pleasure of coming to dinner at Montmartre. If the climb in the evening is not too arduous for you, I thought that he would like to meet you there. Durand-Ruel will come, and I am going to write to the above-mentioned poet to invite [Henri de] Régnier for me. P.S. I am not mentioning sweet and lovable Julie: that is of course taken for granted, and I think that Mallarmé will bring his daughter. I wanted to invite Degas; I confess that I don't dare."[84]

Also that year Morisot invited Renoir to visit, and he reluctantly declined. He wrote to her: "It is my fate that each time you have everything to make me welcome and delight me, circum-

Renoir, *Mlle. Julie Manet*, 1894.
Oil on canvas, 22 × 18⅛″ (56 ×
46 cm). Archives Wildenstein.

OPPOSITE: Morisot, *Julie
Daydreaming*, 1894. Oil on
canvas, 27½ × 23⅝″ (70 ×
60 cm). Private collection.

stances prevent me from taking advantage of it. . . . I am truly dis-
tressed at not being able to accept your invitation. I might have
worked, perhaps, but I have wasted my summer; let's say no more
about it."[85] Morisot relayed her disappointment to Mallarmé:
"Renoir could not join me, to my great regret, and his too, I think,
at least so he says. He is consoling himself at Deauville with
[Paul] Gallimard."[86]

Renoir had told Morisot that Aline was expecting their second
child. Morisot had predicted a girl. After the birth Renoir wrote
her: "I have a perfectly ridiculous piece of news for you, but com-
pletely contradicting the letter that you sent me and that I re-
ceived today: namely, the arrival of a second son, who is called
Jean. Mother and baby are in excellent health. Regards to sweet
and charming Julie, and to the no less charming mother."[87]
Morisot replied that he would think for another ten years and then
have a girl.[88] His third was a boy, Claude (Coco), born nine years
later.

Chère Madame

L'exposition de Manet dure 10 jours de plus.

Je voudrais si ce n'était pas trop désagréable au lieu de faire Julie seule la faire avec vous. mais voilà le côté ennuyeux, c'est que si je vais chez vous j'aurai tout le temps quelque chose qui m'en empêchera mais si vous vouliez me donner 2 heures c'est à dire 2 matinées ou après midi par semaine. Je pense pouvoir faire les portraits en 6 séances au plus. Dites moi oui ou non.

amitiés
Renoir

7 rue Tourlaque porte à = à gauche.

Letter from Renoir to Morisot about his portrait of Morisot and Julie, 1894

Letter from Renoir to Morisot about his portrait of Morisot and
Julie, 1894

IN APRIL 1894, when Renoir wanted to paint a third por-
trait of Julie, he wrote to Morisot: "If you do not mind I should
like, instead of painting Julie alone, to paint her with you. But this
is what bothers me: if I were to plan to work at your house, some-
thing will always turn up to keep me from coming. On the other
hand, if you are willing to give me two hours, that is, two morn-
ings or afternoons a week, I think I can do the portraits in six ses-
sions at the most. Tell me, is it yes or no? In friendship, Renoir. 7
rue Tourlaque, 4th floor to the left."[89]

Morisot agreed to the portrait. Renoir's next letter confirms the
arrangements: "Dear Madame, Tuesday morning we begin. But I
will come to see you Sunday or Monday for the dresses, even
though I prefer certainly the white and country style hat for the
young lady. In friendship, Renoir."[90]

Morisot, *Self Portrait with Julie*, 1885. Oil on canvas, 28⅜ × 35⅞″
(72 × 91 cm). Private collection.

Mother and daughter posed first for a pastel study and later for an oil (see p. 257), both of which Renoir presented as gifts to them. The sittings in the studio of the Rue Tourlaque took place in the morning, and sometimes Morisot and Julie went to lunch at the Renoirs', where Mme. Renoir prepared an excellent meal for them.[91] In his painting nearly a decade later, Renoir seems to have followed Morisot's earlier self-portrait with Julie, in which she combined full-face and profile views.

Renoir's canvas is unique in his oeuvre for sensitively portraying the devastation that both Julie and Berthe still felt two years after Eugène's death. Here Morisot plays a secondary role, and

Julie is in the spotlight. The high-strung sixteen-year-old looks trustingly at the artist. Renoir captured a similar intense expression that Julie shows in a contemporary photograph, but he smoothed her high cheekbones to emphasize her round face, as he had in the portrait of her at eight.

In his depiction of Morisot, Renoir captured the aloofness that Valéry described: "distinction was of her essence."[92] He concentrated on her somber feelings rather than her outward beauty, maintaining an appropriate solemn distance from the mourning widow and capturing what Mallarmé wrote of her: "Her hair whitened by the abstract purification of the beautiful rather than

aged, with a length of veil, a serene discernment, whose judgment, under the circumstances, had no need of death's perspective."[93]

Morisot's posture indicates a sad detachment. She appears world-weary and looks away from the painter. Through the profile view, crossed arms, and lack of eye contact, Renoir conveyed that she had bottled up her emotion and was absorbed in her own thoughts. This was what the fifty-one-year-old widow had communicated in a letter to a friend six months after Eugène's death:

I do not write because my heart is filled with sorrow. . . . The affectionate memory that you have kept of Eugène touches me deeply: not everyone realized how kind and intelligent he was.

In brief, my dear friend, I am ending my life in the widowhood that you experienced as a young woman; I do not say in loneliness, since I have Julie, but it is a kind of solitude none the less, for instead of opening my heart I must control myself and spare her tender years the sight of my grief. . . . I also hope that we shall meet again here. We now constitute a circle of old ladies of bygone days. Is not life strange? To think that we have already reached this point.[94]

ABOVE: Photograph of Julie Manet at the age of sixteen, 1894.

RIGHT: Renoir, *Berthe Morisot and Her Daughter Julie*, 1894. Pastel and charcoal on paper glued to cardboard, 23¼ × 17½″ (58.4 × 43.2 cm). Musée du Petit Palais, Paris.

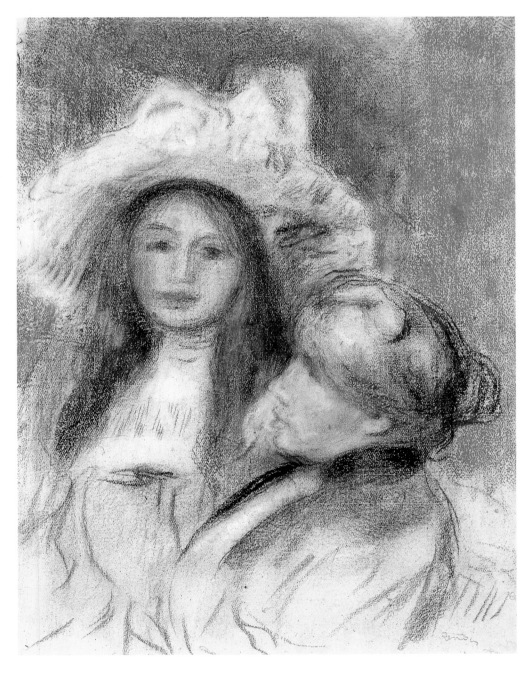

Early in 1895 Julie fell ill with influenza. While caring for her Morisot contracted the disease, which became pneumonia. On March 2 she died at age fifty-four. As she was dying she wrote:

> My little Julie, I love you as I die; I shall still love you even when I am dead; I beg you not to cry, this parting was inevitable. I hoped to live until you were married.... Work and be good as you have always been; you have not caused me one sorrow in your little life. You have beauty, money; make good use of them. I think it would be best for you to live with your cousins, Rue de Villejust, but I do not wish to force you to do anything. Please give a remembrance from me to your aunt Edma and to your cousins; and to your cousin Gabriel give Monet's *Repairing the Boats*. Tell M. Degas that if he founds a museum he should select a Manet. A souvenir to Monet, to Renoir, and one of my drawings to [Paul Albert] Bartholomé. Give something to the two concierges. Do not cry; I love you more than I can tell you. Jeannie, take care of Julie.[95]

Renoir was devastated when he learned of Morisot's death. When Julie was eighty-two years old, Jean Renoir visited her, and she wrote in an addendum to her diary: "Jean told me that his father was painting alongside Cézanne [at the Jas de Bouffan] in March [1895] when Renoir heard the news of Maman's death. He closed his paint box and took the next train back to Paris—I have never forgotten the way he arrived in my room in the Rue Weber and held me close to him; I can still see his white Lavallière cravat with its little red dots."[96]

Renoir expressed the depth of his feelings when he wrote: "My dear Pissarro, I have the deep pain to announce to you the death of our good friend Berthe Manet. We will bring her to her last resting place Tuesday at 10:00 a.m."[97]

After Morisot's death Renoir was extremely solicitous to Julie, then sixteen, and to her orphaned cousins Jeannie, seventeen, and Paule, twenty-six.[98] Five months later he invited the three young women to spend two months with his family (Aline, Pierre, Jean, and his model, Gabrielle) in Brittany, Pont Aven, and Douarnenez. During their visit he gave them painting lessons, and when they departed in early October, Julie wrote in her diary: "M. Renoir has been so kind and so charming all summer; the more one sees of him, the more one realizes he is a true artist, first class and extraordinarily intelligent, but also with a genuine simple heartedness."[99]

In March 1896 Julie organized a 300-work retrospective exhibition of her mother's art at Durand-Ruel's Paris gallery. Renoir gave detailed advice and helped in the hanging of the show. His etched portrait of Morisot served as the frontispiece for the catalog. In her diary Julie wrote of his admiration for Morisot's art: "Monsieur Renoir is quite touching in the way he looks after us and the way he talks to us about Maman's exhibition for instance. He looked at a portfolio of water-colors which he thought were delightful and he explained what needed to be done to frame these gems, the majority of them almost unknown."[100]

Julie recorded numerous other instances of kindness from the man "who gives me the impression of being our protector."[101] She considered him "charming, affectionate, and likable as a woman never would be."[102] He continued to give her painting lessons,[103] and she again spent the summer in his company in 1897, when she and her two cousins traveled with him to Dieppe, Essoyes, Valvins, and Troyes.

Three years after her mother's death, when she was twenty, Mallarmé died, so Renoir became her primary guardian. His abiding kindness and affection to her is a tribute to the depth of his feeling for Morisot and to their remarkable relationship and mutual admiration. Furthermore, he seems to have loved Julie as the daughter he never had, to judge from the letter that he wrote to her on her engagement to Ernest Rouart in 1900:[104]

> A thousand Bravos!!!! My dear Julie, this is a piece of good news that fills my wife and me with joy. Now I can tell you that he was the fiancé of our dreams. My wife had spoken of it to Degas while coming back together from a dinner at your house. Our wish has been fulfilled, again Bravo!! And to dispel the only cloud that darkens your happiness, as the old man of the mountain, I send you this old saying: When happiness comes into the house, you must count to three. We kiss you all, my wife and I, and I am ordering a new suit.[105]

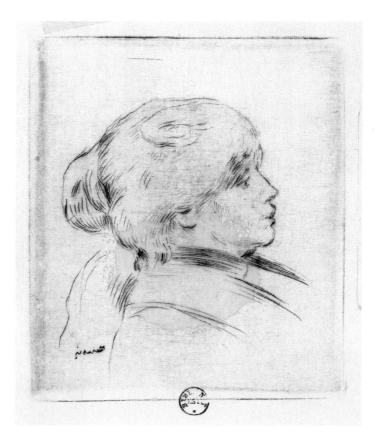

Renoir, *Berthe Morisot*, c. 1894–1896. Etching, only state, 4⅜ × 3½" (11 × 9 cm). Bibliothèque Nationale, Paris.

OPPOSITE: Renoir, *Berthe Morisot and Julie*, 1894. Oil on canvas, 32 × 26" (81.2 × 66 cm). Private collection.

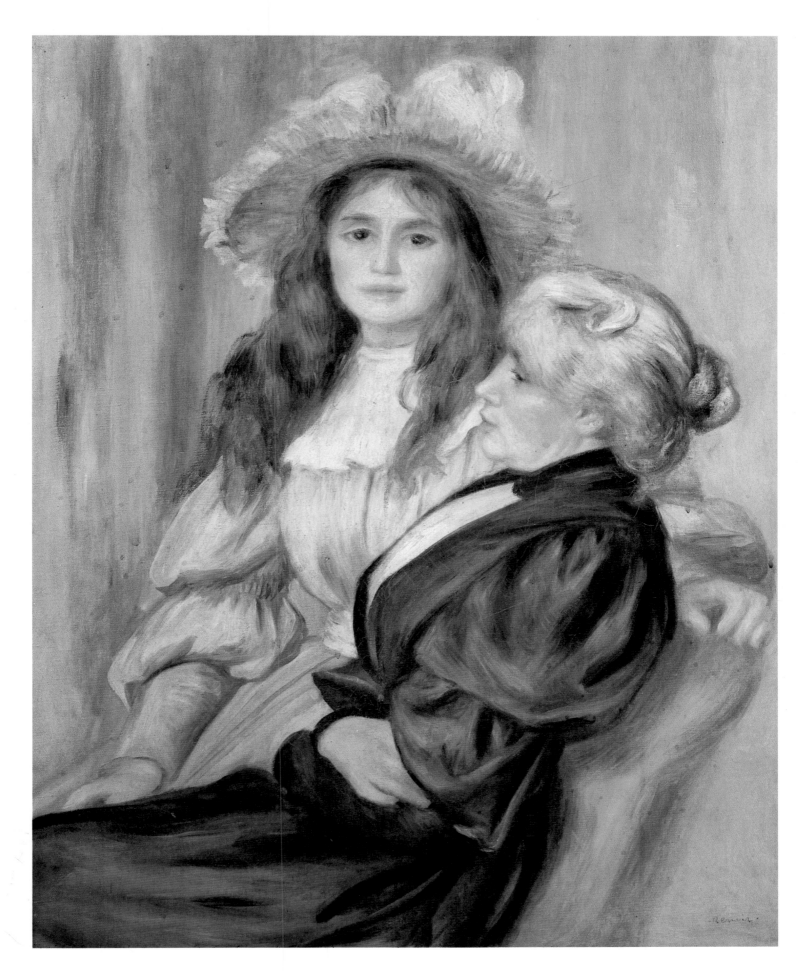

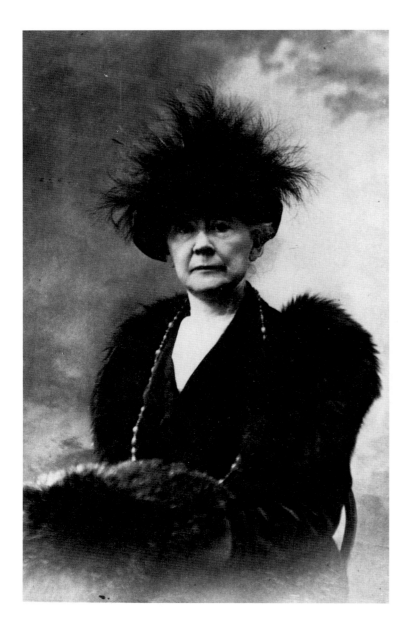

Photograph of Cassatt around the age of sixty-six, c. 1910, at the Villa Angeletto, Grasse. Courtesy Archives of American Art, Smithsonian Institution, Washington; Frederick Sweet Papers (copy obtained from the Art Institute of Chicago by Frederick Sweet).

Photograph of Morisot around the age of fifty-four, c. 1895. Private collection.

Cassatt & Morisot

CASSATT AND MORISOT, despite the fact that they were both upper-class women who were allied with important male artists, did not sustain the intimate friendship one might expect. They exhibited together at the group shows of 1880, 1881, and 1886,[1] saw each other at dinner parties with other members of their circle, and were cordial colleagues until Morisot's death in 1895; but the artistic exchange between them was minimal. They never did portraits of each other and never painted in tandem. On one occasion in 1890, they each made two drawings of a nude side by side, and around the same time they may have exchanged ideas about printmaking. They rarely mentioned each other in diaries or letters.

There are many reasons why they never became truly intimate friends or drew on each other's art for inspiration. One is that neither wanted her art to look like the other's because they were constantly being compared by artists and critics. For example, after seeing the Impressionist exhibition in 1880,[2] Paul Gauguin declared, "Miss Cassatt has as much charm, but she has more power [than Morisot],"[3] and J. K. Huysmans wrote that Cassatt's painting was "more poised, more calm, more able than that of Mme. Morizot [sic]."[4] In 1886 Octave Maus asserted: "With more femininity, but perhaps a less accurate sense of color, Berthe Morisot has taken her place beside the American artist [Cassatt]."[5]

As noted, the women lived different lifestyles, one more tied to her family and one more emancipated. These differences may explain why their friendship didn't develop further. Morisot lived a more sheltered life than did Cassatt. She always resided with her family in the elegant western area of the city. Cassatt had lived in Europe for many years while her family was in America; they finally joined her in Paris when she was thirty-three. Morisot painted in the living room of her home until age forty-nine, when she finally obtained her own studio. Cassatt, by contrast, had a studio outside the family home. Both her home and studio were in the artists' quarter in the heart of Paris. Every day Cassatt walked by the Café de La Nouvelle Athènes (see p. 24) on her way to her studio at 2, Rue Deperré. As an upper-class woman, she would not go inside the café, which was frequented by male artists, critics, and writers of her circle. Nonetheless, they were aware of her presence. As one wrote: "She did not come to the Nouvelle Athènes it is true, but . . . we used to see her everyday."[6]

Another possible inhibition to their friendship is that such an alliance might have been threatening to their male mentors as well as to the other men in the group. By the time Cassatt met Degas, he had managed to alienate both Manet and Renoir, so if she became close to Morisot, Degas might have been even more belligerent toward her or, even worse, might have severed the relationship. And perhaps as women Cassatt and Morisot were uncomfortable when in direct competition, whereas the men were less troubled by rivalry.

Both women lived in the shadows of their mentors. When they were in their late thirties, a reviewer identified Cassatt as "pupil of Degas" and Morisot as "pupil of Manet,"[7] even though neither woman was a student of her eminent male friend. The attitudes of Degas and Manet were patronizing, and the women deferred because they felt the men's art to be superior to their own. Cassatt was more self-confident, but she still rated the quality of her art below Degas's. Morisot had a sexist attitude herself and felt she had less talent than her male colleagues. However, her relationship with Renoir, which occurred when both were middle-aged, was more equal.

Compared with the diverse and varied milieu of the male artists, the setting in which Cassatt and Morisot lived was uniform and narrow. One could argue that their talents, individuality, and creativity were comparable to the men's; nonetheless, the limitations in their lives ultimately made the women's art less rich than their mentors'. Each experienced her own unique artistic development and made boldly original contributions to Impressionism. But without the stimulation and support of Degas, Manet, and Renoir, it is unlikely that either Cassatt or Morisot would have produced so much and such great work.

Cassatt, *Woman with a Pearl Necklace in a Loge,* 1879. Oil on canvas, 31⅝ × 23″ (80.3 × 58.4 cm). Philadelphia Museum of Art; Bequest of Charlotte Dorrance Wright.

CASSATT WAS three years younger than Morisot, but she outlived her by thirty-one years. Cassatt made a total of 614 oils and pastels, and Morisot, despite her relatively short life, made a comparable number, 608. Their choice of other media identifies their styles. Cassatt, who preferred a more defined form, made 220 prints and 74 watercolors. Morisot, whose form is more diffuse, made 238 watercolors, 8 drypoints, and a colored lithograph. In addition, Morisot painted landscapes, which Cassatt rarely did.

A comparison of Cassatt's *Woman with a Pearl Necklace in a Loge* of 1879 and Morisot's *Young Woman Dressed for a Ball* of the same year shows the key differences in their styles.[8] As in her prints Cassatt's people are created with a precise edge around separate volumes. She excelled in the sureness of drawing and clarity of the design of solid, stable figures. Her restrained painting feels timeless. She combined the vision of a realist with Impressionist high-key color and luminosity.

By contrast, Morisot's oils of 1870–1885 have the feeling of watercolors. She excelled in her goal of capturing something transient and effervescent. No matter how far back you stand, you cannot focus her figures' features, which share a blurry quality with the surroundings. However, sometimes (as here), she does reinforce the edges with a light colored edge. Her fluttering, spontaneous brushstrokes give an effect of vaporousness. These airy, floating, diffuse images suggest an effortless execution of quicksilver, nervous energy. Morisot pushed Impressionism to its limits with more daring than any other member of the group.

The relationship between Cassatt and Morisot began warmly and cooled over time. We know nothing of their early interactions, but they could have met anytime after 1877, when Cassatt and Degas met. At an auction in June 1878, Cassatt purchased a painting by Morisot.[9] The earliest recorded connection between them occurred in March 1879, when Degas sent Cassatt to visit Morisot to learn whether she planned to exhibit in April. "Mlle Cassatt is seeing Mlle Morisot tomorrow and will know her decision," he wrote.[10] Four months after the birth of her daughter, Morisot still was not feeling well. Hence for Degas to send Cassatt on such a delicate mission implies that she and Morisot must already have been acquainted. Morisot declined to exhibit at the show.

About six months later the women were corresponding. In response to an unknown letter from Morisot,[11] Cassatt wrote back (in French): "I am so happy that you have done so much work, you will reclaim your place at the [next] exposition with *éclat,* I am very envious of your talent I assure you." Because Morisot was away from Paris, she concluded her letter: "Bring back many

Morisot, *Young Woman Dressed for a Ball*, 1879. Oil on canvas, 28 × 21¼″ (71 × 54 cm). Musée d'Orsay, Paris.

pretty things, and much health and courage, I am eager to see what you have done. . . . Many kisses to Miss Julie and a thousand best wishes to her mother from their affectionate friend Mary Cassatt."[12] And, in the spring of 1880, when Morisot was planning to exhibit again, Cassatt wrote to her: "I am very happy about your return . . . the exhibition promises to be good . . . with you returning."[13]

During the summer of 1880, Morisot made several visits to Cassatt and her family at their Marly-le-Roi villa. Years later Louisine Havemeyer wrote:

I recall that when I was a very young girl I went to see Miss Cassatt at Marly-le-Roi. Her villa joined [Édouard] Manet's home and his fatal malady made him very ill at that time. After luncheon we walked over to his villa to ask after him. Mme. Morisot met us at the gate and at Miss Cassatt's inquiry sadly shook her head, saying that he was very ill and that she feared the worst. Mme. Morisot walked back to our villa with us and I recall that she was a charming, intelligent woman, and that she and Miss Cassatt were very friendly and talked of art matters.[14]

When they exhibited together at the 1881 show, they were aligned with opposing factions within the Impressionist group.[15] In 1882 Degas defected from the group show and Cassatt withdrew to support him.[16] Eugène wrote to his wife: "Yesterday I met Miss Cassatt at the exhibition. She seems to wish to be more intimate with us. She asks to do portraits of Bibi [Julie] and of you. I said, yes, gladly, on condition of reciprocity."[17] As Eugène sensed, this proposal was Cassatt's way of trying to become closer to his wife. Yet Morisot does not seem to have encouraged their friendship; nor did they do the proposed portraits. It appears that the friendship had somewhat cooled, perhaps on Morisot's account.

A year later, writing to her brother of his plans for an exhibition in America, Morisot said: "If you talk with Mlle Cassatt, she might be helpful to you; her address is 13 Avenue Trudaine; she is intelligent."[18]

In the mid-1880s Cassatt and Morisot continued seeing each other at soirees at each other's homes as well as at the homes of mutual friends, such as Degas and Mallarmé.[19] For the last group show in 1886,[20] Cassatt's father explained, "The parties who put up the money for the rent & are responsible for all deficiencies in expenses. . . . The getters up of the affair. . . . [are] Degas and his friend [Alfred] Lenoir, Mme. Manet [Morisot] & Mame [Cassatt]."[21]

Cassatt was inspired to include a color print of a half-nude woman, *The Coiffure* (see p. 264), in her 1891 series of ten color prints by seeing this theme at the 1890 Japanese print show. She may also have owed something to Morisot, who (under Renoir's influence) had depicted the half-nude since 1886. Cassatt had only once before depicted a nude, in an art class in 1875, and after the 1891 print and its related drawings she made only one other nude, a pastel of 1913. Clearly it was not a theme that interested her.

This period around 1890 marked the closest artistic interaction between the two women. At this time both were interested in adding color to their prints. Morisot first tried printmaking in 1888, when she experimented with etching as well as color lithography.[22] Because Cassatt had been printmaking extensively since 1879, it is possible that she helped Morisot learn certain techniques.[23]

The exhibition of 725 Japanese colored woodcuts of the eighteenth and nineteenth centuries opened at the École des Beaux-Arts in mid-April 1890. At that time Cassatt wrote in response to Morisot's luncheon invitation:

> I think that for the time being I am not able to go and have lunch at Mézy, but if you would like, you could come and dine here with us and afterwards we could go to see the Japanese prints at the Beaux-Arts. Seriously, *you must not* miss that. You who want to make color prints, you couldn't dream of anything more beautiful. I dream of it and don't think of anything else but color on copper. Fantin [Latour] was there the first day I went and was in ecstasy. I saw [James] Tissot there who also is occupied with the problem of making color prints.[24] Couldn't you come the day of the wedding, Monday, and then afterwards we could go to the Beaux-Arts? If not that day then another and just drop me a line beforehand. My mother sends her compliments and I send a kiss to Julie and my best regards to Monsieur Manet.... P.S. You *must* see the Japanese—*come as soon as you can.*[25]

Morisot was also enthusiastic about attending this show and wrote to Mallarmé: "Wednesday I shall go to Miss Cassatt to see with her those marvelous Japanese prints at the Beaux-Arts."[26]

Morisot again tried color lithography after seeing the print show. Late in 1890 she wrote to her sister Edma: "You ask me what I am doing: not much; my attempts at color prints are disappointing, and that was all that interested me. I worked all summer with a view to publishing a series of drawings of Julie."[27] Unlike Cassatt, who exhibited ten color prints in 1891, Morisot never exhibited her single color lithograph; she did not think it worthy.

The Japanese show included several prints depicting half-nude women fixing their hair, and there may well have been one similar to the drawing by Hokusai. After seeing the exhibition together, Cassatt and Morisot worked side by side on two drawings of a nude.[28] It is likely that they executed their drawings at Morisot's studio, using one of her models. Morisot, who had done half-nude figures in painting, etching, and drawings previously, employed various models, including Carmen Gaudin, who posed

Katsushika Hokusai, *Woman Adjusting Her Hair*, c. 1800. Ink on paper, 15½ × 10½″ (39.4 × 26.7 cm). The Metropolitan Museum of Art, New York; In memory of Charles Stewart Smith, 1914.

OPPOSITE TOP LEFT: Cassatt, *Study for The Coiffure* (no. 2), 1890. Pencil on paper, 8½ × 5½″ (21.7 × 14 cm). Present location unknown.

OPPOSITE TOP RIGHT: Cassatt, *Study for The Coiffure*, 1890. Pencil on white paper, 5¾ × 4½″ (14.6 × 11.2 cm). The Metropolitan Museum of Art, New York; Rogers Fund, 1920.

OPPOSITE BOTTOM LEFT: Morisot, *Untitled Drawing*, 1890. Pencil on paper, dimensions unknown. Present location unknown.

OPPOSITE BOTTOM RIGHT: Morisot, *Half-Nude Woman, Seen from the Back, Doing Her Hair with a Mirror Reflecting Her Body*, 1890. Graphite on tracing paper, 14⅛ × 9⅛″ (36 × 23.2 cm). Musée du Louvre, Département des Arts Graphiques, fonds du Musée d'Orsay, Paris.

nude to the waist for *Young Woman Drying Herself* (1886–87; see p. 229).

The four drawings are of an identical pose, a half-length woman, nude to the waist, who arranges her hair and looks at her reflection in a mirror. In the second drawings, more precision is given to rendering the reflection in the mirror.

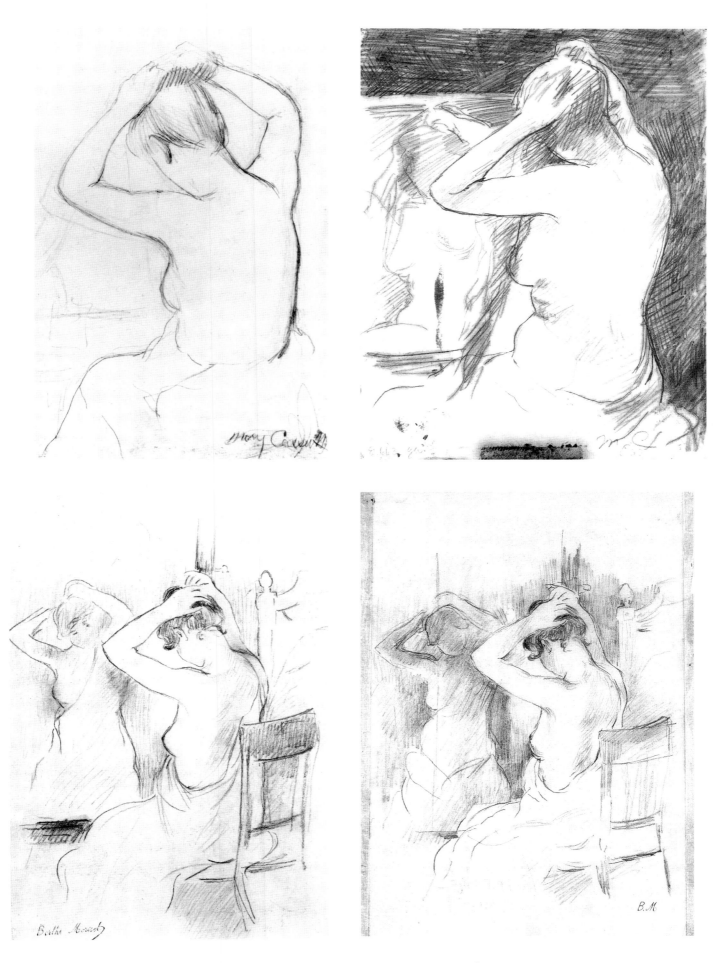

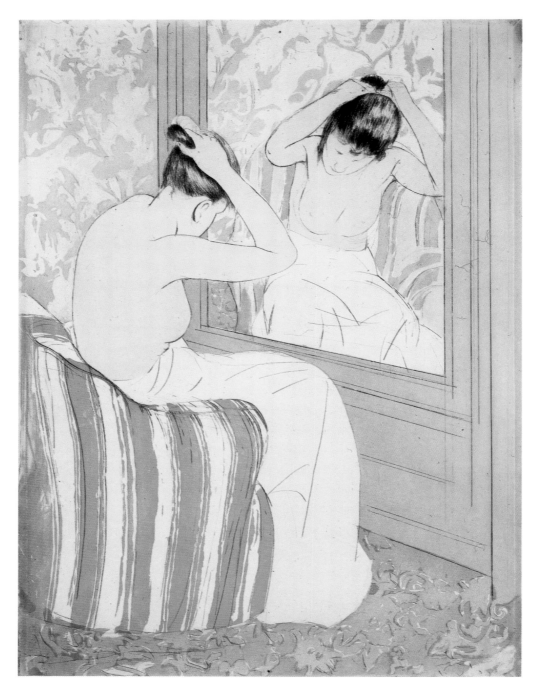

Cassatt, *The Coiffure*, 1891. Color print with drypoint, soft-ground, and aquatint, 14½ × 10½″ (36.7 × 26.7 cm). Worcester Art Museum, Worcester, Mass.

Each artist used the drawings as preparatory studies for an important project of 1891: Cassatt's color print *The Coiffure* and Morisot's oil *At the Mirror*.[29] Their depictions of nudity are objective, without any of the sensual connotations of most male scenes of the nude.

Some time after they worked side by side, Cassatt and Morisot seem to have had a rift in their friendship. One reason was Cassatt's growing ambitiousness, so different from Morisot's reserve. As Cassatt's mother reported to her brother on July 23, 1891: "Mary is at work again, intent on fame & money she says, & counts on her fellow country men now that she has made a reputation here—."[30] Morisot was never so overtly ambitious. As previously noted, her daughter specifically praised aspects of her mother that were opposite Cassatt: "Maman, full of talent and so straightforward, charming and yet not seeming to be aware of the fact."[31] Morisot may have been offended by Cassatt's assertiveness.

Another cause of friction between the women concerned one-person shows.[32] Cassatt had a show at Durand-Ruel's in April 1891 where she exhibited her ten color prints (including *The Coif-*

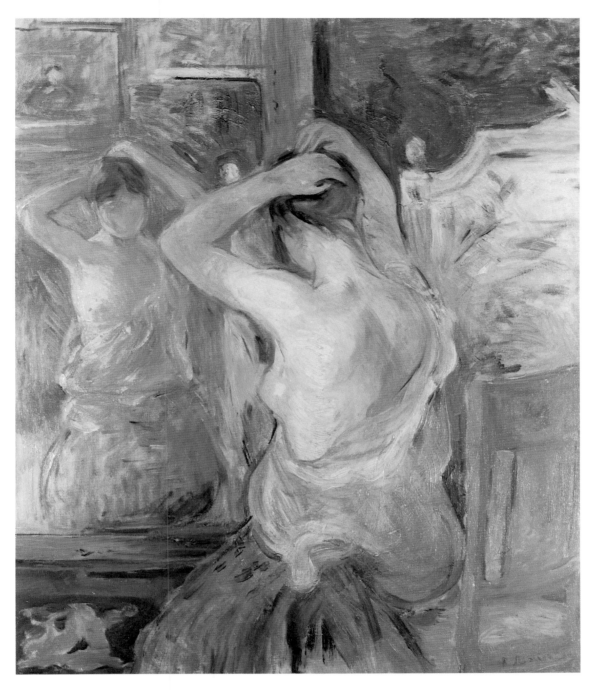

Morisot, *At the Mirror*, 1890. Oil on canvas, 21¾ × 18″ (55 × 46 cm).
Private collection.

fure), two oils, and two pastels. Morisot, doubtless upset that Durand-Ruel did not invite her to do the same,[33] sought another gallery (Boussod and Valadon) for a solo show, which took place May 25–June 18, 1892. Afterwards, assuming Cassatt's envy, Morisot wrote ironically to a friend, "As you can imagine, Miss Cassatt is not one to write me about an exhibition of mine."[34] Yet, unbeknownst to her, Cassatt had written a guardedly complimentary letter to Pissarro, praising Morisot's exhibition as a "very interesting and well-chosen collection."[35]

The following year Durand-Ruel gave Cassatt a second exhibition, in which she showed *Young Women Picking Fruit* (1891; see p. 209). Of this painting Cassatt later wrote that Degas had spoken to Morisot and she "did not like it. I can understand that."[36]

From that point until Morisot's death, the relationship weakened. One fancies that the two women, each in her way so independent, stood aloof from each other. Their association had never been as intense or as productive as their friendships with Degas, Manet, and Renoir. The relationship between them was not typical of the close artistic friendships, rivalries, and exchanges which characterized the six other relationships explored in this book.

Chronology

1830 Pissarro born
1832 Manet born
1834 Degas born
1839 Cézanne born
1840 Monet born
1841 Morisot and Renoir born
1844 Cassatt born
1859 Pissarro's first acceptance at Salon
1861 Cézanne and Pissarro meet in Paris.
 Manet's first acceptance at Salon
 Degas and Manet meet.
 Degas first paints horse races; Manet begins this theme three years later.
Early 1860s Manet and his friends socialize at the Café de Bade.
1862 Manet first paints casual portraits of friends in *Concert in the Tuileries Gardens.*
 Bazille, Monet, Renoir, and Sisley meet at Gleyre's classes at the École des Beaux-Arts, Paris.
1864 Morisot's and Renoir's first acceptance at Salon
 Degas does his first portrait of Manet around 1864 and continues to portray him through around 1868.
1865 Degas's and Monet's first acceptance at Salon
1866–1873 Manet and his friends socialize at the Café Guerbois, Paris.
1866 Renoir first paints Monet's portrait and continues to do so through the next nine years.
 Zola begins to write favorably about Manet.
1867 Manet exhibits fifty works outside the Paris World's Fair.
 Fantin-Latour introduces Morisot to Manet.
1868 Manet makes first of fourteen portraits of Morisot.
1869 Side by side, Monet and Renoir paint pairs of canvases at La Grenouillère that are now considered the first Impressionist paintings; over the next six years, they make many works in tandem.
1870 Manet "corrects" a Morisot painting destined for Salon.
1870–71 Franco-Prussian War: Degas, Manet, and Renoir serve.
 Cézanne avoids draft and stays in southern France near Aix.
 Monet and Pissarro go to London to avoid the draft.
 Morisot and her parents stay in Paris until the Commune.
 Cassatt is in Italy and Pennsylvania.
1871 Monet and Pissarro meet the dealer Paul Durand-Ruel in London.
1872 Durand-Ruel begins selling works by Degas, Renoir, Manet, and Morisot (though buys little from Morisot).
 Cassatt's first acceptance at Salon
 Cézanne comes to Pontoise to work with Pissarro.
 Cézanne copies a painting by Pissarro.
1873 Cézanne and Pissarro paint side by side throughout the next decade.
1874 First Impressionist group exhibition includes works by Cézanne, Degas, Monet, Morisot, Pissarro, and Renoir.

 Cézanne and Pissarro make portraits of each other.
 Manet, Monet, and Renoir paint together at Argenteuil.
 Morisot marries Manet's brother Eugène.
Mid-1870s Manet and his friends socialize at the Café de la Nouvelle-Athènes, Paris.
1875 First Impressionist auction
1876 Second Impressionist group exhibition includes works by Degas, Monet, Morisot, Pissarro, and Renoir.
1877 Third Impressionist group exhibition includes works by Cézanne, Degas, Monet, Morisot, Pissarro, and Renoir.
 Cassatt and Degas meet.
 Degas invites Cassatt to exhibit at the next Impressionist exhibition, which takes place in 1879.
 Cassatt persuades her friend Louisine Elder, the future Mrs. Henry O. Havemeyer, to purchase a Degas pastel over monotype; she becomes Degas's first American patron.
1878 Degas "corrects" a Cassatt painting that she sends to the Exposition Universelle that year.
 Morisot gives birth to daughter, Julie Manet.
1879 Fourth Impressionist group exhibition includes works by Cassatt, Degas, Monet, and Pissarro.
 Cassatt begins to model for the first of eight Degas images made in the course of the next six years.
 Cassatt and Degas begin to collaborate on an etching project.
1880 Fifth Impressionist group exhibition includes works by Cassatt, Degas, Morisot, and Pissarro.
1881 Sixth Impressionist group exhibition includes works by Cassatt, Degas, Morisot, and Pissarro.
 Durand-Ruel begins to represent Cassatt.
1882 Seventh Impressionist group exhibition includes works by Monet, Morisot, Pissarro, and Renoir.
 Cézanne's painting is accepted at Salon.
1883 Manet dies.
 Degas and Renoir invited by Durand-Ruel to mount one-man shows
1885 Morisot begins to invite Renoir to weekly dinner parties at her home.
 The Impressionists institute monthly dinners at Café Riche.
1886 Morisot first visits Renoir's studio.
 Eighth and final Impressionist group exhibition includes works by Cassatt, Degas, Morisot, and Pissarro.
1887 Morisot and Renoir collaborate on etching project to illustrate poems by Mallarmé.
1890 Cassatt and Morisot visit the Paris Japanese woodcut exhibit together.
 Cassatt and Morisot side by side make drawings of a nude.
 Morisot and Renoir paint side by side.
1891 Durand-Ruel gives Cassatt a one-woman show.
 Renoir introduces Morisot to his wife and six-year-old son.

1892 Morisot has first one-woman show at Boussod & Valadon Gallery.

1894 Renoir does a painted and an etched portrait of Morisot.

1895 Morisot dies.
Cézanne has first one-man show at Ambroise Vollard's gallery.

1903 Pissarro dies.

1906 Cézanne dies.
Renoir draws a portrait of Monet for Vollard that later became the basis for a bronze medallion.

1917 Degas dies.

1919 Renoir dies.

1926 Cassatt and Monet die.

Appendix

OTHER IMPRESSIONIST PAIRS WHO PAINTED THE SAME MOTIF
SIDE BY SIDE OR MADE PORTRAITS OF EACH OTHER

Renoir & His Friends

1. RENOIR AND BAZILLE

Portraits

Bazille, *Portrait of Auguste Renoir*, 1867. Oil on canvas, 24½ × 20″ (62.2 × 50.8 cm). Musée d'Orsay, Paris, on loan from Musée National des Beaux Arts, Algiers.

Renoir, *Portrait of Frédéric Bazille at His Easel*, d. 1867. Oil on canvas, 41⅞ × 29¼″ (106 × 74 cm). Musée d'Orsay, Paris.

2. RENOIR AND CAILLEBOTTE

Portraits

Renoir, *Oarsmen at Chatou* (Caillebotte is standing), d. 1879. Oil on canvas, 32 × 39⅔″ (89 × 100 cm). National Gallery of Art, Washington.

Renoir, *Luncheon of the Boating Party* (Caillebotte is seated in right foreground), d. 1881. Oil on canvas, 51¼ × 68″ (130 × 173 cm). The Phillips Collection, Washington.

Side by Side

Caillebotte, *Melon and Dish of Figs*, 1882. Oil on canvas, 21¼ × 25½″ (54 × 65 cm). Private collection.

Renoir, *Still Life with Melon*, 1882. Oil on canvas, 21½ × 25½″ (54.5 × 65.0 cm). Private collection.

3. RENOIR AND CÉZANNE

Side by Side

Cézanne, *Ravine near L'Estaque*, c. 1882. Oil on canvas, 28¾ × 21¼″ (73 × 54 cm). Museum of Fine Arts, Houston; John and Audrey Jones Beck Collection.

Renoir, *Rocky Crags at L'Estaque*, d. 1882. Oil on canvas, 26⅛ × 31⅞″ (66.34 × 80.80 cm). Museum of Fine Arts, Boston.

Cézanne, *Pigeon Tower of Bellevue* (estate of Montbriant), c. 1889–90. Oil on canvas, 25½ × 31½″ (65 × 81 cm). Cleveland Museum of Art.

Renoir, *Pigeon Tower of Bellevue* (estate of Montbriant), 1889. Oil on canvas, 18 × 21″ (46 × 55 cm). The Barnes Foundation, Merion Station, Pa.

Renoir, *Pigeon Tower of Bellevue* (estate of Montbriant), 1889. Oil on canvas, 21¼ × 25⅝″ (54 × 65 cm). Location unknown.

Renoir, *Study for Pigeon Tower of Bellevue* (estate of Montbriant), 1889. Oil on canvas, 18⅛ × 21″ (46 × 55 cm). Location unknown.

Cézanne, *Mont Ste.-Victoire*, c. 1890. Oil on canvas. 25½ × 36¼″ (65 × 92 cm). Musée d'Orsay, Paris.

Renoir, *Mont Ste.-Victoire*, c. 1888–89. Oil on canvas, 21 × 25″ (53 × 64 cm). Yale University Art Gallery, New Haven; The Katharine Ordway Collection.

Renoir, *Mont Ste.-Victoire*, d. 1889. Oil on canvas, 21½ × 25¾″ (54.6 × 62.2 cm). The Barnes Foundation, Merion Station, Pa.

Portraits

Renoir, *Cézanne*, d. 1880. Pastel on paper, 21¾ × 17¼″ (55.2 × 43.8 cm). Private collection.

Cézanne, *Copy of Renoir's Pastel Portrait of Cézanne*, c. 1880. Oil on wood, 22½ × 18½″ (57 × 47 cm). Whereabouts unknown.

Renoir used his 1880 portrait in two later versions: Renoir, *Paul Cézanne*, c. 1902. Lithograph, 10 × 9″ (25.4 × 22.9 cm). Bibliothèque Nationale, Paris.

Renoir, *Sculpted Medallion of Cézanne*, 1916–17. Bronze, diameter 30″ (76.2 cm). Chrysler Art Museum, Norfolk, Va.

4. RENOIR AND MANET

Side by Side

Manet, *Camille and Jean in the Garden*, 1874. Oil on canvas, 24 × 39¼″ (61.0 × 99.7 cm). The Metropolitan Museum of Art, New York; Bequest of Joan Whitney Payson.

Renoir, *Portrait of Camille and Jean in the Garden at Argenteuil*, 1874. Oil on canvas, 19⅜ × 26¾″ (49.2 × 68.0 cm). National Gallery of Art, Washington; Ailsa Mellon Bruce Collection.

5. RENOIR AND PISSARRO

Portraits

Renoir, *The Artist's Studio, Rue St. Georges* (left rear to right foreground: painter Pierre Franc-Lamy, art critic and Renoir biographer Georges Rivière, Camille Pissarro, painter Frédéric Samuel Cordey, and Gustave Caillebotte), 1876–77. Oil on canvas, 17¾ × 14½″ (45.0 × 36.8 cm). The Norton Simon Foundation, Los Angeles.

Renoir, *Portrait of Pissarro* (copy of Pissarro's etching below), c. 1898–1903. Charcoal, 12¼ × 9¼″ (31.1 × 23.5 cm). Dallas Art Museum.

Pissarro, *Self Portrait*, 1890–91. Etching, 7¼ × 7″ (18.5 × 17.7 cm). Art Institute of Chicago.

Possible Side by Side

Renoir, *Road in Louveciennes*, c. 1869–70. Oil on canvas, 15 × 18¼″ (38.1 × 46.4 cm). The Metropolitan Museum of Art, New York.

Pissarro, *Road in Louveciennes* (or *Spring in Louveciennes*), c. 1869–70. Oil on canvas, 20⅝ × 32⅜″ (52.5 × 82.0 cm). National Gallery, London.

6. RENOIR AND SISLEY

Portraits

Renoir, *Portrait of Sisley*, 1868. Oil on canvas, 32 × 25½″ (81.2 × 64.8 cm). E. G. Bührle Collection, Zurich.

Renoir, *Alfred Sisley and His Wife*, d. 1868. Oil on canvas, 42¼ × 30″ (107.3 × 76.2 cm). Wallraf-Richartz-Museum, Cologne.

Renoir, *Portrait of Sisley*, 1874. Oil on canvas, 25⅝ × 21¼″ (65.1 × 54.0 cm). Art Institute of Chicago; Mrs. L. L. Coburn Collection.

Side by Side
Renoir, *Country Road, Springtime*, 1873. Oil on canvas, 18 × 24¼″ (45.7 × 62.0 cm). Private collection.

Sisley, *Country Road, Springtime*, d. 1873. Oil on canvas, 20⅞ × 28¾″ (53 × 73 cm). Private collection.

Monet & His Friends

7. MONET AND BAZILLE

Apparent Side by Side—Bazille's Is Copy of Monet's Sketch
Bazille, *Beach at Sainte Adresse*, d. 1865. Oil on canvas, 23⅝ × 55⅛″ (58 × 140 cm). High Museum of Art, Atlanta.

Monet, *Study—Seaside at Sainte Adresse*, 1864. Oil on canvas, 15 × 28″ (40 × 73 cm). The Minneapolis Institute of Arts; Gift of Mr. and Mrs. Theodore Bennett.

Portraits
Bazille, *The Improvised Ambulance* (Monet after his accident at the inn at Chailly), 1865. Oil on canvas, 18½ × 24½″ (47 × 62 cm). Musée d'Orsay, Paris.

Monet, *Bazille and Camille, Study for Luncheon on the Grass*, c. 1865. Oil on canvas, 36⅝ × 27⅛″ (93 × 69 cm). National Gallery, Washington; Ailsa Mellon Bruce Collection.

Monet, *Luncheon on the Grass* (study includes portrait of Bazille), d. 1866. Oil on canvas, 51¼ × 71¼″ (130 × 180 cm). Pushkin State Museum of Fine Arts, Moscow.

Monet, Fragment: left part of *Luncheon on the Grass* (includes portrait of Bazille), 1865–66. Oil on canvas, 164½ × 59″ (418 × 150 cm). Musée d'Orsay, Paris.

Monet, Fragment: central part of *Luncheon on the Grass* (includes portraits of Bazille, Courbet, and Camille), 1865–66. Oil on canvas, 97⅝ × 85⅜″ (248 × 217 cm). Musée d'Orsay, Paris.

8. MONET AND MANET

Portraits
Monet, *Manet Painting in the Garden at Argenteuil*, 1874. Oil on canvas, unknown size. Painting stolen from New York collection in 1935.

Manet, *Portrait of Monet*, c. 1874. Brush and ink, 5½ × 4⅞″ (14.0 × 12.5 cm). Private collection.

Manet, *Portrait of Monet*, 1874. India ink wash, 6¾ × 5¼″ (17.1 × 14.0 cm). Musée Marmottan, Paris.

Manet, *Monet in His Floating Studio*, 1874. Oil on canvas, 42 × 53″ (106.7 × 134.6 cm). Staatsgalerie, Stuttgart.

Manet, *Portrait of Monet in His Studio Boat*, 1874. Oil on canvas, 29½ × 39″ (75 × 99 cm). Neue Pinakothek, Munich.

9. MONET AND PISSARRO

Side by Side
Monet, *The Seine at Bougival*, 1870. Oil on canvas, 15¾ × 28¾″ (40 × 73 cm). Private collection.

Pissarro, *Bank of the Seine at Bougival*, 1870. Oil on canvas, 10⅝ × 15¾″ (27 × 40 cm). Musée de Strasbourg.

Monet, *The Seine near Bougival*, 1871–72. Oil on canvas, 18⁹⁄₁₀ × 37⅖″ (48 × 95 cm). Private collection.

Pissarro, *The Seine near Bougival* (or *Riversides*), d. 1871. Oil on canvas, 10⅝ × 15¾″ (27 × 40 cm). Private collection.

10. MONET AND SISLEY

Side by Side
Monet, *The Seine at Argenteuil*, 1872–73. Oil on canvas, 19⅝ × 24″ (50 × 61 cm). Musée d'Orsay, Paris.

Sisley, *The Seine at Argenteuil*, 1872. Oil on canvas, 18⅛ × 25⅜″ (46 × 65 cm). Private collection.

Monet, *Old Rue de la Chaussée at Argenteuil*, 1872. Oil on canvas, 21⅝ × 28¾″ (55 × 73 cm). Private collection.

Sisley, *Square at Argenteuil* (or *Old Rue de la Chaussée at Argenteuil*), d. 1872. Oil on canvas, 18⅛ × 25⅜″ (46 × 65 cm). Musée d'Orsay, Paris.

Monet, *Boulevard Héloïse at Argenteuil*, 1872. Oil on canvas, 13¾ × 23¼″ (35.0 × 59.1 cm). Yale University Art Gallery, New Haven.

Sisley, *Boulevard Héloïse at Argenteuil*, d. 1872. Oil on canvas, 15½ × 23½″ (39.4 × 59.7 cm). National Gallery of Art, Washington; Ailsa Mellon Bruce Collection.

Monet, *The Grande Rue at Argenteuil*, d. 1874. Oil on canvas, 27½ × 18⅛″ (70 × 46 cm). Private collection.

Sisley, *The Grande Rue at Argenteuil*, c. 1874. Oil on canvas, 25⅝ × 18⅛″ (65 × 46 cm). Norwich Castle Museum.

Monet, *Snow at Argenteuil*, 1874. Oil on canvas, 22½ × 29⅛″ (57 × 74 cm). Museum of Fine Arts, Boston.

Sisley, *Snow at Argenteuil*, d. 1874. Oil on canvas, 21¼ × 25⅜″ (54 × 65 cm). Private collection.

Sisley & His Friends

11. SISLEY AND BAZILLE

Portrait
Bazille, *Portrait of Sisley*, 1867–68. Oil on canvas, 11 × 12½″ (28 × 32 cm). Formerly Wildenstein Galleries, Paris; destroyed during World War II.

Side by Side
Bazille, *Still Life with Heron*, d. 1867. Oil on canvas, 39⅜ × 27⅛″ (100 × 70 cm). Musée Fabre, Montpellier.

Sisley, *Still Life with Heron*, 1867. Oil on canvas, 31⅞ × 38⅛″ (79 × 97 cm). Musée d'Orsay, Paris, on loan to Musée Fabre, Montpellier.

12. SISLEY AND CAILLEBOTTE

Side by Side
Caillebotte, *The Machine of Marly*, c. 1876. Oil on canvas, 10⅜ × 13⅜″ (27 × 34 cm). Private collection.

Sisley, *The Dam and the Machine of Marly*, 1876. Oil on canvas, 15 × 24″ (38 × 61 cm). Private collection.

Manet & His Friend

13. MANET AND BAZILLE

Portraits
Bazille, *Portrait of Manet at His Easel*, 1869. Charcoal, 11⅝ × 8½″ (29.5 × 21.6 cm). The Metropolitan Museum of Art, New York; Collection of Robert Lehman, 1975.

Bazille, *The Artist's Studio, Rue de la Condamine* (left to right: Monet, Sisley, Renoir, Manet, Bazille, Maître), d. 1870. Oil on canvas, 38⅞ × 47″ (98.5 × 119.4 cm). Musée d'Orsay, Paris.

Notes

I have made my own translations from the French, except where otherwise credited. Many of the previously published letters and reviews cited have been newly translated from the original French sources, which are listed in the Notes and Bibliography. Mistakes in spelling and punctuation have generally been corrected. All dates and locations in the text and notes are as the writer gave them. Bracketed dates or locations are inferred from a letter's content or are deduced from the similarity of the letter to other correspondence. Shortened forms are used in most references; complete information about each source is given in the Bibliography. If a review appears only once, it is cited in full in the Notes and is not in the Bibliography.

ABBREVIATIONS

n. = note
c. = circa
n.p. = no page
n.d. = no date
n.l. = no location
no. = number or lot number
cat. = catalog

Introduction

1. In the later nineteenth century and into the twentieth century, this legacy of mature painters working and learning together continued, including the Post-Impressionists Van Gogh and Gauguin; the Fauves Matisse, Derain, and Vlaminck; the Cubists Braque and Picasso; and others.
2. John Rewald, "The Impressionist Brush" [1973–74]; in Rewald, *Studies in Impressionism*, p. 190.
3. Albert Wolff, *Le Figaro*, Mar. 2, 1881; in Rewald, *Impressionism*, p. 450.
4. Letter, Pissarro to son Lucien, Paris, Nov. 22, 1895; in *Pissarro: Letters*, p. 352.
5. Letter, Pissarro to son Lucien, Paris, [May 14, 1887]; in ibid., p. 119.
6. Letter, Monet to E. Charteris, Giverny, June 21, 1926; in Wildenstein, *Monet*, vol. 4, p. 421.
7. Letter, Monet to Gustave Geffroy, [Giverny], Oct. 7, 1890; in ibid., vol. 3, p. 258.
8. Letter, Pissarro to Eugène Murer, [Paris ?, early Apr. 1876]; in *Correspondance de Pissarro*, vol. 2, p. 383.
9. These were Renoir, Monet, Sisley, Pissarro, Cézanne, and Morisot. See White, *Renoir* (New York and Paris), pp. 24, 26.
10. C. L. de Moncade, "Le Peintre Renoir et le Salon d'Automne" (interview), *La Liberté*, Oct. 15, 1904.
11. The first to use the term was Louis Leroy, "Exhibition of the Impressionists," *Charivari*, Apr. 24, 1874; in Rewald, *Impressionism*, pp. 318–24.
12. Jules Catagnary, "Exposition du boulevard des Capucines—Les Impressionnistes," *Le Siècle*, Apr. 29, 1874.
13. Letter, Cézanne to Zola, [Paris], Aug. 24, 1877; in *Cézanne Correspondance*, p. 158.

14. Letter, Pissarro to Eugène Murer, Paris, Friday, [1878]; in *Correspondance de Pissarro*, vol. 1, p. 116.
15. Letter, Pissarro to son Lucien, Eragny, [Aug. 28, 1887]; in *Pissarro: Letters*, p. 133.
16. Because Pissarro's canvases of 1869 were destroyed during the Franco-Prussian War, it is impossible to determine whether he, too, was painting in an Impressionist style that year.
17. Maurice Denis, "Cézanne," *L'Occident*, Sept. 1907; in Doran, *Conversations avec Cézanne*, p. 170.
18. Meyer Schapiro, "Nature of Abstract Art," in Schapiro, *Modern Art*, pp. 190–91.

Degas & Manet

1. Letter, Mme. Morisot to daughter Berthe, [Paris, 1872]; in *Morisot: Correspondence*, p. 84.
2. Rewald, "Future Impressionists at the Café Guerbois," p. 22.
3. Reff, *Notebooks of Degas*, notebook 6, 1856, vol. 1, p. 49.
4. Goncourt, *Journal*, Feb. 12, 1874, vol. 2, pp. 967–68; translation in McMullen, *Degas*, pp. 241–42.
5. Letter, Degas to James Tissot, n.l., [Mar. 1874]; in Rouart-Valéry et al., *Degas inédit*, p. 365.
6. Letter, Morisot to sister Edma, [Paris, Mar. 1869]; in *Morisot: Correspondence*, p. 32.
7. Letter, Morisot to unknown, Paris [1869]; in ibid., p. 40.
8. Other letters from Manet to Degas c. 1868–69 are an undated invitation to dine with the Stevensons and Puvis de Chavannes; Manet's expression of regret at having missed Degas at a social evening and inquiry whether Degas's father would be receiving visitors the next day; and a note in which Manet asks Degas to return the two volumes of Baudelaire that he has borrowed. See Boggs, *Degas*, New York, p. 140, and Reff, *Degas: The Artist's Mind*, p. 150.
9. Letter, Manet to Degas, Boulogne-sur-Mer, July 29, [1868]; in Wilson-Bareau, *Manet by Himself*, p. 47.
10. Letter, Manet to Fantin-Latour, [Boulogne-sur-Mer], Aug. 26, 1868; in Courthion and Cailler, *Manet, Raconté*, vol. 1, pp. 48, 50.
11. Letter, Degas to Henri Rouart, New Orleans, Dec. 5, 1872; in *Degas Letters*, p. 25.
12. Letter, Manet to Zola, n.l., May 7, [1866]; in Wilson-Bareau, *Manet by Himself*, p. 38.
13. George Moore, *Confessions of a Young Man* (London: Swan, Sonnenschein & Lowry, 1888), p. 102; in Denvir, *Impressionists at First Hand*, p. 78.
14. Moore, "Degas: The Painter of Modern Life," p. 422.
15. Letter, Mme. Morisot to daughter Berthe, [Paris], July 14, 1871; in *Morisot: Correspondence*, p. 81.
16. Letter, Mme. Morisot to unknown, [Paris], Oct. 18, 1870; in ibid., p. 56.
17. Paris, Sept. 15, [1870]; in Wilson-Bareau, *Manet by Himself*, p. 57.

18. Paris, Nov. 19, [1870]; in ibid., p. 60.

19. Letter, Degas to Tissot, n.l., [Mar. 1874]; in Rouart-Valéry et al., *Degas in-édit*, pp. 364–65.

20. Letter, Eugène Manet to Morisot, [Paris], Mar. 1, 1882; in *Morisot: Corre-spondence*, p. 119.

21. Recorded by Proust, [1879]; in Wilson-Bareau, *Manet by Himself*, p. 185.

22. Letter, Degas to Tissot, Paris, Sept. 30, 1871; in Kendall, *Degas by Himself*, p. 100.

23. Letter, Degas to Henri Rouart, n.l., May 2, [1882]; in *Lettres de Degas*, p. 63.

24. Baudelaire, *Baudelaire: Oeuvres Complètes*, vol. 2, 1976, pp. 495–96; trans-lation in Cachin and Moffett, *Manet*, p. 124.

25. Baudelaire, "Le Peintre de la vie moderne," [1859–60]; in *Baudelaire: Oeu-vres complètes*, vol. 2, 1976, pp. 691–92.

26. Unpublished letter, Manet to Degas, Boulogne-sur-Mer, July 1869; private collection; in Boggs, *Degas*, New York, p. 57.

27. Antonin Proust, "Édouard Manet: Souvenirs," *La Revue blanche*, Feb.–May 1897, p. 125; in Cachin and Moffett, *Manet*, p. 124.

28. Reff, *Notebooks of Degas*, notebook 23, 1868–1872, vol. 1, pp. 117–18.

29. Jacques-Émile Blanche, *Manet* (Paris: Rieder & Cie., 1924), pp. 55–56.

30. Reff, *Notebooks of Degas*, notebook 30, 1877–1883, vol. 1, p. 134.

31. Letter, Pissarro to son Lucien, Osny, June 13, 1883; in *Correspondance de Pissarro*, vol. 1, p. 218.

32. Moore, "Degas: The Painter of Modern Life," p. 423.

33. Berthe Morisot's recollections of Degas's table talk (at her home as recorded in her notebook and communicated by Julie Manet Rouart); cited in Valéry, *Oeuvres*, p. 1225.

34. Émile Zola, "My Portrait by Édouard Manet," *L'Événement illustré*, May 10, 1868; in Gronberg, *Manet: A Retrospective*, p. 100.

35. Ibid.

36. Georges Jeanniot, "En Souvenir de Manet," *La Grande Revue*, 46 (Aug. 10, 1907), p. 854; in Cachin and Moffett, *Manet*, p. 19.

37. Valéry, *Degas, Manet, Morisot*, p. 83.

38. Émile Zola, "Édouard Manet [Jan. 1, 1867]," *Mes Haines* (Paris, 1880), pp. 357 ff.; in *Zola Salons*, p. 98.

39. Goncourt, *Journal*, Feb. 12, 1874, vol. 2, pp. 967–68; translation in Mc-Mullen, *Degas*, pp. 241–42; cited in Boggs, *Degas* (New York), p. 212.

40. In 1857 Degas made an etched copy of a Rembrandt; in 1860–61 he copied an Ingres. In 1860 Manet made etched copies of a Velázquez and a Fra An-gelico.

41. See Reed and Shapiro, *Degas as Printmaker*, p. 43.

42. Letter, Manet to Astruc, Fontainebleau, [Aug. 23?, 1865]; in Wilson-Bareau, *Manet by Himself*, p. 34.

43. Letter, Manet to Fantin-Latour, Madrid, summer 1865; in Rewald, *Impres-sionism*, p. 125, n. 53.

44. However, already in 1857 Degas had made an etched portrait of an artist friend, Joseph Tourney, at work.

45. Degas's portraits of friends: Léon Bonnat, 1863; Édouard Manet, c. 1864–c. 1868; Evariste de Bernardi de Valernes, 1865; Tissot, 1866; Mlle. Victoria Dubourg, 1866; Vicomte Ludovic Napoléon Lepic, 1876; Carlo Pellegrini, 1876; Henri Rouart, 1877; Cassatt, 1879–1884; Zacharian, c. 1885; see Boggs, *Portraits by Degas*.

46. Émile Zola, "Édouard Manet [Jan. 1, 1867]," *Revue du XIXe siècle*; in Cachin and Moffett, *Manet* (New York), p. 13.

47. See Reed and Shapiro, *Degas as Printmaker*, p. 57, n.1. Degas made four dif-ferent states of this bust-length image, and six or seven impressions were pulled.

48. Reff, *Notebooks of Degas*, notebook 23, 1868–1872, vol. 1, p. 118.

49. Ibid., notebook 22, 1867–1874, vol. 1, p. 111. This is a quotation from Barbey d'Aurevilly.

50. Armand Silvestre, *Au Pays du souvenir: Mes Maîtres et mes maîtresses* (Paris: Librairie illustrée, 1892), p. 161, see also p. 153.

51. Of the etching with hat in hands, two states were made, with three im-pressions of the first and six of the second; of the etching with clasped hands, four states were made, and seventeen or more impressions were pulled. See Reed and Shapiro, *Degas as Printmaker*, pp. 46, 50. Other sources

say that forty impressions were made of the clasped hands etching; see Boggs, *Degas* (New York), p. 128.

52. Monneret, *L'Impressionisme*, vol. 1, p. 304.

53. Letter, Baudelaire to Étienne Carjat, n.l., Oct. 6, 1863; in *Baudelaire: Lettres*, p. 353.

54. The returned Manet painting probably was *Walnuts in a Salad Bowl* (1866).

55. Morisot, *The Mother and Sister of the Artist*, 1870, and Bazille, *Studio of the Artist*, 1870.

56. Julie Manet, *Growing up with the Impressionists*, entry of Nov. 20 [1895], pp. 73–74: "Arrived quite late at M. Degas's house. . . . I admired the portrait of my Uncle Édouard by him, which I hadn't seen before. This portrait was the cause of an argument. M. Degas had painted Aunt Suzanne at the piano and Uncle Édouard lying on a sofa listening; the latter, finding that his wife looked too ugly, cut her off. Monsieur Degas quite reasonably became angry with this conduct and took back the canvas, which he now has in his draw-ing-room. He has also Aunt Suzanne on a sofa in pastel and Uncle Édouard's *Ham*."

57. Manet did make portraits of five other artist friends: Morisot, 1868–1874; Gonzalès, 1870; Émile Bellot, 1873; Desboutin, 1875; and Carolus-Duran, 1876.

58. Gonzalès posed more than twenty-five times. See Letter, Morisot to sister Edma, n.l., Aug. 13, 1869; in *Morisot: Correspondence*, p. 44.

59. This drawing is related to Degas's *Woman with Binoculars*, c. 1875–76, shown in the Cassatt-Degas chapter.

60. Harris, "Manet's Racetrack Paintings," pp. 78–82.

61. Manet mentioned a visit from Mme. Loubens in a letter to Isabelle Lemon-nier, Bellevue, [July 11 or 18, 1880]; in Wilson-Bareau, *Manet by Himself*, p. 251.

62. May 2, 1869; in *Morisot: Correspondence*, p. 36.

63. May 8, 1869; in ibid., p. 38.

64. June 22, 1871; in ibid., p. 76.

65. Both of the images here predate photographs of running horses, which were first published in California by the English photographer Eadweard Muybridge in 1872–73; his book was published in France in 1878–1881. See Reff, *Manet and Modern Paris*, p. 131.

66. Reff, *Notebooks of Degas*, notebook 30, 1877–1883, vol. 1, p. 134.

67. Ibid., notebook 23, 1868–1872, vol. 1, p. 117.

68. Moore, *Confessions of a Young Man*; in Tinterow and Loyrette, *Origins of Impressionism*, p. 281.

69. Illus. Tinterow and Loyrette, *Origins of Impressionism*, p. 283.

70. Illus. Boggs, *Degas* (New York), p. 101.

71. Watercolor, 8⅞ × 22¼″, Fogg Art Museum, Cambridge, Mass.

72. Letter, Degas to Henri Rouart, Paris, 1886; in *Degas Letters*, p. 117.

73. Desboutin made portraits of both Degas and Manet. Cassatt made a portrait of Desboutin in c. 1879; illus. Breeskin, *Cassatt: Catalogue Raisonné of the Oils . . .*, p. 52, no. 67.

74. Stéphane Mallarmé, "The Impressionists and Edouard Manet," *Art Monthly Review*, Sept. 1876; in Denvir, *Impressionists at First Hand*, p. 108.

75. Letter, Desboutin to Joseph de Nittis, Dijon, July 18, 1876; in Howard, *Im-pressionnistes par eux-mêmes*, p. 215.

76. Reff, *Notebooks of Degas*, notebook 30, 1877–1883, vol. 1, p. 134.

77. F.F., "Des Peintres et leur modèle," *Bulletin de la vie artistique*, 2d year, 9 (May 1, 1921), p. 263; in Boggs, *Degas* (Paris), p. 288.

78. F.F., "Des Peintres et leur modèle," in Boggs, *Degas* (New York), p. 285.

79. Georges Rivière, "L'Exposition des impressionnistes," *L'Impressionniste, journal d'art*, no. 1 (Apr. 6, 1877); in Muehsam, *French Painters and Paint-ings*, p. 450.

80. Reff, *Notebooks of Degas*, notebook 30, 1877–1883, vol. 1, p. 134; translation in Nochlin, *Impressionism and Post-Impressionism*, pp. 62–63.

81. Letter, Degas to Evariste de Valerne, Paris, [December? 6?], 1891; in *Lettres de Degas*, p. 184.

82. She also modeled for Renoir, *End of Luncheon* (1879) and *Luncheon of the Boating Party* (1881); for Desboutin; and for the academic painters Henri Gervex, Alfred Stevens, and Florent Willems. Also, Degas may have hired Manet's model Victorine Meurent, because her address appears in his note-

book and one drawing could be of her. See Boggs, *Portraits by Degas*, pl. 48, p. 124.

83. The drypoint is related to *Project for Portraits in a Frieze;* see Reed and Shapiro, *Degas as Printmaker*, p. 120.

84. She may also have modeled for Manet's painting *The Plum* (1877–78). See Reff, *Manet and Modern Paris*, no. 18, p. 76; cf. Cachin and Moffett, *Manet* (New York), p. 409.

85. Boggs, *Degas* (New York and Paris), p. 285, n. 7.

86. Manet had a slow, painful demise from a disease that many think was syphilis of the spinal cord. See Rewald, *Impressionism*, p. 476.

87. Letter, Degas to Bartholomé, n.l., Spring 1883; in *Degas Letters*, p. 73.

88. Blanche, *Manet*, p. 57; in Rouart-Valéry et al., *Degas inédit*, p. 89.

89. See Boggs, *Degas*, p. 379, fig. 184.

90. [Paris, 1884]; in *Morisot: Correspondence*, p. 138. Berthe Morisot and Eugène Manet purchased the painting for 620 francs at the Manet auction Feb. 4–5, 1884, in order to sell it to Edma Morisot and her husband, Commander Adolphe Pontillon. Because Pontillon disliked the painting, they gave it to Degas.

91. Degas paid 147 francs for these three works.

92. Manet, who did not have an extensive art collection, does not seem to have owned any paintings by Degas.

Monet & Renoir

1. Louveciennes, Aug. 20, 1900; in Baudot, *Renoir*, p. 49.

2. Unpublished letter, Monet to Renoir, Giverny, Feb. 16, 1914; in private collection.

3. François Thiébault-Sisson, "Claude Monet," *Le Temps*, Nov. 27, 1900.

4. Letter, Duret to Caillebotte, [Paris, c. 1889]; in Berhaut, *Caillebotte*, p. 247.

5. Rewald, "The Impressionist Brush," [1973–74]; in Rewald, *Studies in Impressionism*, p. 190. Yet Monet was also generous with his time and money to Pissarro, to Manet's widow, and to Sisley's children.

6. Ibid.

7. Rivière, *Renoir et ses amis*, p. 16.

8. Unpublished letter, Renoir to Caillebotte, n.l., n.d.; in private collection.

9. André, *Renoir*, p. 50.

10. Monet also worked side by side on the same motif twice with Pissarro in 1870–71, and five times with Sisley in 1872–74. Renoir painted side by side once with Sisley in 1873, once with Manet in 1874, once with Caillebotte in 1882, three times with Cézanne in 1882–1889 and once with Morisot in 1894. (See Appendix: Other Impressionist Pairs Who Painted the Same Motif Side by Side or Made Portraits of Each Other.)

11. Arsène Houssaye, *L'Artiste*, June 1, 1870; in Venturi, *Archives*, vol. 2, p. 283.

12. Duret, intro. to Renoir 1883 exhibition catalog, at Durand-Ruel, Paris; in House and Distel, *Renoir* (London), p. 301.

13. Letter, Renoir to Durand-Ruel, Tamaris-sur-Mer, Mar. 25, 1891; in Venturi, *Archives*, vol. 1, p. 145.

14. Letter, Monet to Bazille, n.l., Oct. 14, 1863; in ibid., p. 21.

15. Such as *The River* of 1868.

16. Several of Renoir's still lifes and landscapes foreshadow Impressionism (such as *Spring Bouquet*, 1866; *The Champs Elysées during the Paris Fair of 1867*, 1867; and *Skaters in the Bois de Boulogne*, 1868).

17. T. Taboureux, from "Claude Monet" [interview], *La Vie moderne* (June 12, 1880); in Venturi, *Archives*, vol. 2, p. 340.

18. Letter, Monet to Gustave Geffroy, [Giverny], Oct. 7, 1890; in Wildenstein, *Monet*, vol. 3, p. 258.

19. Octave Mirbeau, *Renoir* (Paris: Bernheim-Jeune, 1913), pp. ix, xi.

20. Georges Rivière, "L'Exposition des Impressionnistes," *L'Impressionniste, journal d'art*, no. 1 (Apr. 6, 1877); in Venturi, *Archives*, vol. 2, p. 311.

21. Letter, Monet to Bazille, [Paris, May 20, 1867]; in Wildenstein, *Monet*, vol. 1, p. 423.

22. [Paris, Fall 1867]; in Poulain, *Bazille*, p. 101.

23. N.l., [1867]; in Daulte, *Bazille*, p. 203.

24. Letter, Monet to Geffroy, Giverny, Dec. 4, 1920; in Wildenstein, *Monet*, vol. 4, p. 408. Camille and two-year-old Jean were at St. Michel-Bougival, and Renoir was with his parents at Voisins-Louveciennes.

25. Saint-Michel; in ibid., vol. 1, p. 426.

26. [Late Aug. 1869]; in Poulain, *Bazille*, pp. 153–54.

27. N.l. [Sept. 1869]; in ibid., pp. 155–56.

28. Henri Rouart, an industrialist, amateur artist, and collector, bought Monet's still life in Dec. 1878.

29. [Saint-Michel], Sept. 25, 1869; in Wildenstein, *Monet*, vol. 1, p. 427.

30. Theodore Robinson [the American Impressionist painter], "Claude Monet," *Century Magazine*, no. 44 (Sept. 1892): 696; in Broude, *Impressionism: A Feminist Reading*, p. 76.

31. Monet's three Grenouillère paintings were sold or given as gifts and then exhibited. The National Gallery version was sold to M. Charles Ephrussi in 1881, and Monet exhibited the work at Georges Petit's gallery in 1889. The second Monet version, now in the Metropolitan Museum, was either sold or given to Manet and appears in his death inventory in 1883. The third, lost version was believed to have been rejected at the Salon of 1870, bought by Durand-Ruel for the high sum of 2,000 francs in 1873, then exhibited at the 1876 Impressionist exhibition. Renoir sold the Winterthur painting to Durand-Ruel and gave the version now in Stockholm to his brother Edmond.

32. [Étretat, Dec. 1868]; in Wildenstein, *Monet*, vol. 1, pp. 425–26.

33. Monet's *Duck Pond* was bought by Durand-Ruel in 1873 and exhibited in 1886. The private-collection Renoir was bought by Durand-Ruel in 1891; the Dallas Museum Renoir was also bought by Durand-Ruel (at an unknown date, but before 1913).

34. The puzzle was solved when Monet's canvas turned out to be signed. Thereafter Renoir signed the work in question which seems to have been the Dallas Museum Renoir. Léon Werth cited his conversation with Monet in 1913; in Rewald, *Impressionism*, p. 307, n. 13; cited from Léon Werth, *Bonnard le peintre* (Paris: Galerie Charpentier, 1945).

35. Argenteuil, Sept. 12, 1873; in Wildenstein, *Monet*, vol. 1, p. 429.

36. Ibid., p. 66.

37. Monet's painting was purchased by Mary Cassatt's brother Alexander in 1893 and exhibited that year; a similar Monet painting is at the Musée d'Orsay in Paris. Illus. ibid., no. 339, p. 260.

38. The Renoir painting was bought by Durand-Ruel in 1889 and exhibited in 1908.

39. Letter, Zola to Antoine Guillemet, July 23, 1874; in *Zola Salons*, pp. 25–26.

40. Marc Elder interview of Monet, quoted in Marc Elder, *Chez Claude Monet à Giverny* (Paris: 1924), p. 70; reprinted in House and Distel, *Renoir* (London), p. 205.

41. Tabarant, *Manet et ses oeuvres*, p. 175.

42. *Camille* and *Road in Fontainebleau Forest*.

43. Courbet's open letter to his students in the *Courrier du dimanche* (Paris), Dec. 25, 1861, cited in Linda Nochlin, *Realism and Tradition in Art, 1848–1900* (Englewood Cliffs, N.J.: Prentice-Hall, 1966), p. 35.

44. See Betty Al-Hamdani, "Color and Luminosity."

45. The Monet painting was bought by Durand-Ruel in 1873 and exhibited in 1899. The Renoir painting also became the property of Durand-Ruel in 1896 and was exhibited in 1905.

46. Jacques [pseud.], *L'Homme libre*, Apr. 11, 1877.

47. *La Petit Presse*, Apr. 9, 1877; in Moffett, *New Painting*, p. 228.

48. Louis Leroy, *Le Charivari*, Apr. 11, 1877; in Moffett, *New Painting*, p. 228.

49. Camille Doncieux was born in Lyon in 1847 and died at age thirty-two in Vetheuil in 1879. She first posed for Monet in 1865 and gave birth to two of his sons—Jean in 1867 and Michel in 1878. Both families opposed her marriage to Monet, which took place on June 28, 1870. At the end of her life, she and her children were cared for by Alice Hoschedé, who later became Monet's second wife.

50. Letter, Gabrielle Renard to Maurice Gangnat, Wessling, summer 1910; in White, *Renoir* (New York), p. 245.

51. This painting was exhibited at the seventh Impressionist show of 1882 and was sold to Durand-Ruel in 1891 for 1,500 francs.

52. Monet sold this painting to Durand-Ruel in either 1872 or '73; it appeared

at the Impressionist auction of 1875 and at the second Impressionist exhibition of 1876.

53. Monet's *Mme. Monet with a Japanese Fan* was exhibited in 1871 at an international exhibition at South Kensington as *Repose*, and it was noted that it belonged to the artist. A year later it was shown in Rouen at the Musée des Beaux Arts. In 1873 Durand-Ruel bought this painting from Monet for 500 francs; later the dealer sold it to Victor Chocquet.

54. This painting was bought by Durand-Ruel in 1891 for 1,500 francs.

55. Unpublished letter, Renoir to Burty, [Paris, 1874]; in Bibliothèque Centrale du Louvre, Paris.

56. In about six works from 1871 to 1886, Renoir painted Japanese fans, and in *The Portrait of Mme. Charpentier and Her Children* (1878) he painted a Japanese salon.

57. Wildenstein, *Monet*, vol. 4, p. 12. Monet purchased this work in 1900 from Durand-Ruel but complained that the 10,000-franc price was a bit too high.

58. About the last-mentioned canvas, see letter, Monet to Durand-Ruel, Giverny, June 19, 1892; in Venturi, *Archives*, I, p. 345.

59. René Gimpel, *Diary of an Art Dealer*, p. 128.

60. Ibid.

61. Pissarro also painted this view many times in 1901. For example, see Pissarro, *Le Pont Neuf*, 1901. Oil on canvas, 18 × 15″ (45.7 × 38.1 cm). Allen Memorial Art Museum, Oberlin College, Oberlin, Ohio.

62. It was bought for 300 francs by his dealer, Durand-Ruel, who sold it at the 1919 Hazard sale for a record price of over 100,000 francs.

63. Rewald, "Auguste Renoir and His Brother" (Mar. 1945); in Rewald, *Studies in Impressionism*, p. 13.

64. Chocquet did not purchase Renoir's landscape.

65. Argenteuil; in Joëts, "Les Impressionnistes et Chocquet," *L'Amour de l'art*, no. 16 (Apr. 1935), p. 122.

66. Émile Zola, "Le Naturalisme au Salon," *Le Voltaire*, June 18–22, 1880; cited in *Zola Salons*, pp. 242–43.

67. Albert Wolff, "Quelques Expositions," *Le Figaro*, Mar. 2, 1882, p. 1.

68. Aix, Feb. 23, 1884; in *Cézanne Letters*, p. 213.

69. [Gênes ?, Dec. 1883]; in Venturi, *Archives*, vol. 1, p. 126.

70. Ibid., pp. 267–68.

71. Ibid., p. 271.

72. [Cap d'Antibes, Jan. 21, 1888]; in Wildenstein, *Monet*, vol. 3, p. 225.

73. Giverny, Nov. 11, [1884]; in ibid., vol. 2, p. 256.

74. N.l., June 18, 1886; excerpt in Drouot sale cat., June 19, 1970, no. 138.

75. Giverny, July 6, 1912; in Wildenstein, *Monet*, vol. 4, p. 385.

76. [20, Rue des Capucines, Paris, c. 1889]; in Berhaut, *Caillebotte*, p. 247.

77. Letter, Monet to Pissarro, Giverny, July 22, 1891; in Wildenstein, *Monet*, vol. 3, p. 262.

78. At the 1907 Viau sale, Monet's paintings ranged from 7,000–17,000 francs each and Renoir's brought 25,000–26,000 francs each.

79. Louveciennes, Aug. 20, 1900; in Baudot, *Renoir*, p. 49.

80. N.l., Aug. 23, 1900; in ibid., p. 50.

81. N.l., n.d.; in ibid.

82. Giverny, Aug. 23, 1900; in Wildenstein, *Monet*, vol. 4, p. 348.

83. Unpublished letter, Monet to friend [M. de Conchy?], Giverny, June 16, 1901; in Getty Center for the History of Art and the Humanities, Los Angeles, Calif.

84. Letter, Renoir to Paule Gobillard, Cagnes, 1908; in White, *Renoir* (New York), p. 241.

85. Giverny, Oct. 23, 1912; in Wildenstein, *Monet*, vol. 4, p. 386. On Oct. 20, 1912, Renoir became an officer of the Legion of Honor; on Feb. 19, 1919, he was promoted to commander.

86. Unpublished letter, Alice Monet to her daughter Germaine Salerou, Giverny, Oct. 23, 1906; in private collection.

87. Ibid., Oct. 24, 1906.

88. Ibid., Oct. 25, 1906.

89. Ibid., Oct. 26, 1906.

90. Because this drawing appears in Vollard's book, it was in either Renoir's or Vollard's collection in 1918. See Ambroise Vollard, *Renoir*, vol. 2, no. 309.

91. Letter, Monet to Georges Durand-Ruel, Giverny, Dec. 13, 1916; in Wildenstein, *Monet*, vol. 4, p. 395.

92. Giverny, Dec. 8, 1919; in ibid., p. 403. Also see letter to Félix Fénéon, mid-Dec. 1919; in ibid., p. 403; letter to Joseph Durand-Ruel, Giverny, Jan. 17, 1920; in ibid., p. 404; and letter to Jeannie Gobillard (cousin of Julie Manet Rouart), in Jacqueline and Maurice Guillaud, *Claude Monet at the Time of Giverny* (Paris: Centre Culturel du Marais, 1983), p. 244.

Cézanne & Pissarro

1. Francisco Oller Cestero, 1833–1917, was a Puerto Rican painter.

2. Paris, Dec. 4, 1895; in *Correspondance de Pissarro*, vol. 4, p. 128. Here Pissarro referred to the free studio of Charles Suisse on Quai des Orfèvres, Paris.

3. Eragny-sur-Epte, [early July 1885]; in White, *Renoir*, p. 155.

4. See Reff, "Pissarro's Portrait of Cézanne," p. 630.

5. John Rewald, "Cézanne and His Father" (1971–72); in Rewald, *Studies in Impressionism*, p. 72.

6. Letter, Cézanne to Chocquet, Gardanne, May 11, 1886; in *Cézanne Letters*, p. 224.

7. Pontoise, May 20, 1881; in ibid., p. 198.

8. Letter, Cézanne to Egisto Paolo Fabbri, Paris, May 31, 1899; in *Cézanne, Correspondance*, p. 270.

9. Letter, Cassatt to Mrs. James Stillman, n.l., [c. 1894]; in Howard, *Impressionists by Themselves*, p. 104.

10. Letter, Pissarro to son Lucien, Rouen, Jan. 20, 1896; in *Pissarro: Letters*, p. 358.

11. Letter, Cézanne to Joachim Gasquet, Aix, July 8, 1902; in *Cézanne Letters*, p. 284.

12. Rouen, Feb. 6, 1896; in *Pissarro: Letters*, p. 361.

13. Pontoise, Dec. 8, 1873; in Howard, *Impressionists by Themselves*, p. 103.

14. Osny, May 15, 1883; in *Correspondance de Pissarro*, vol. 1, p. 208.

15. Rouen, Feb. 6, 1896; in ibid., vol. 4, p. 159.

16. Cézanne owned some early works by Pissarro that he wanted to sell in 1874. See ibid., vol. 1, p. 94, n. 2.

17. Pissarro had friendships and artistic exchanges with Cézanne, Gauguin, Guillaumin, Monet, and Seurat.

18. Tabarant, *Pissarro* (New York and London), pp. 60–61.

19. Ambroise Vollard, *Souvenirs d'un marchand de tableaux* (Paris: Albin Michel, 1937), p. 169.

20. Natanson, *Peints à leur tour*, p. 59.

21. Émile Zola, "Mon Salon," *L'Événement illustré*, May 19, 1868; in *Zola Salons*, p. 127.

22. [Paris], Sept. 26, 1874; *Cézanne, Correspondance*, p. 148.

23. Rewald, *Cézanne*, p. 216.

24. Letter, Cézanne to Émile Bernard, [Aix, 1905]; in *Cézanne Letters*, p. 311.

25. Jules Borély, [1902], "Cézanne à Aix," *L'Art vivant*, no. 2 (1926), pp. 491–93; in Doran, *Conversations avec Cézanne*, p. 21.

26. Émile Bernard, [1904], "Paul Cézanne," *L'Occident* (Feb.–Mar. 1904); in Doran, *Conversations avec Cézanne*, p. 37.

27. Karl Ernst Osthaus, [1906], "Une Visite à Paul Cézanne," *Das Feuer* (1920–21); in Doran, *Conversations avec Cézanne*, p. 98.

28. Conversation with Joachim Gasquet (1896–1904), in Doran, *Conversations avec Cézanne*, p. 121.

29. Paris, Mar. 15, 1865; in *Cézanne Letters*, p. 107.

30. Joachim Gasquet, *Cézanne*, 1921; in Doran, *Conversations avec Cézanne*, p. 121.

31. Émile Zola, "Mon Salon," *L'Événement*, May 20, 1866; in *Zola Salons*, p. 78.

32. Those Zola owned included *Study of Woman*, 1864; *Estaque Village*, 1870; *Stove in Studio*, 1865–1868; *Black Clock*, 1869–1871; *Portrait of Cézanne*, 1865–66; *Rape*, 1867; *Zola and Alexis*, 1869–70; and *Alexis Reading to Zola*, 1869–70.

33. *Zola Correspondance*, p. 218; in *Zola Salons*, p. 12.

34. *Zola Correspondance*, pp. 357–58; in ibid.

35. Zola, "Peinture," *Le Figaro*, May 2, 1896; in ibid., p. 266.

36. Letter, Cézanne to Roger Marx, [Aix], Jan. 23, 1905; in *Cézanne Letters*, p. 309.

37. Letter, Cézanne to Émile Bernard, Aix, May 12, 1904; in *Cézanne, Correspondance*, p. 302.

38. Letter, Cézanne to son Paul, Aix, Sept. 26, 1906; in *Cézanne Letters*, p. 325.

39. [Aix, around Oct. 19, 1866]; in ibid., pp. 116–18.

40. [Aix, Oct. 23, 1866]; in ibid., pp. 118–19.

41. Émile Zola, "Mon Salon," *L'Événement illustré*, June 1, 1868; in *Zola Salons*, 135.

42. [Aix], June 24, 1874; in *Cézanne Letters*, p. 147.

43. Paris, Apr. 8, 1895; in *Pissarro: Letters*, p. 337.

44. Letter, Cézanne to Émile Bernard, Aix, May 12, 1904; in *Cézanne, Correspondance*, p. 301.

45. Aix, Oct. 15, 1906; in ibid., p. 332.

46. Letter, Lucien Pissarro to brother Paul-Émile, n.l., [1912]; in Meadmore, *Lucien Pissarro*, pp. 26–27.

47. Letter, Lucien Pissarro to Paul Gachet, Jr., London, Nov. 4, 1927; in Gachet, *Lettres Impressionnistes*, p. 54.

48. Letter, Pissarro to Guillemet, Paris, Sept. 3, 1872; in *Correspondance de Pissarro*, vol. 1, p. 77.

49. Joachim Gasquet, *Cézanne* (1921); in Doran, *Conversations avec Cézanne*, p. 121. Also see Maurice Denis, "Cézanne," *L'Occident*, Sept. 1907; in ibid., p. 170.

50. Letter, Cézanne to Émile Bernard, Aix, Apr. 15, 1904; in *Cézanne Letters*, p. 296.

51. [Paris], Nov. 22, 1895; in *Pissarro: Letters*, p. 352.

52. Letter, Pissarro to son Lucien, Paris, Nov. 21, 1895; in *Correspondance de Pissarro*, vol. 4, p. 119.

53. In statement by Renoir during interview, Walter Pach, "Pierre Auguste Renoir," *Scribner's Magazine*, May 1912, pp. 612–14; in White, *Renoir* (New York), p. 251.

54. This stylistic analysis is derived from Schapiro, *Cézanne*.

55. Jack Lindsay, *Cézanne, His Life and Art* (Greenwich, Conn.: New York Graphic, 1969), p. 153; in Shikes and Harper, *Pissarro* (New York), p. 128.

56. See List of Thirteen Other Impressionist Pairs Who Made Side-by-Side Paintings or Portraits Together.

57. In 1876–1878 Cézanne copied Guillaumin's *The Seine at Bercy* (1873–1875). He also painted landscapes side by side with Guillaumin in 1876, c. 1877, and c. 1879; see John Rewald, "Cézanne and Guillaumin" (1975); in Rewald, *Studies in Impressionism*, pp. 102–19.

58. See List of Thirteen Other Impressionist Pairs Who Made Side-by-Side Paintings and Portraits Together.

59. That these paintings form a pair was first noted by Reff, in "Cézanne's Constructive Stroke," p. 221.

60. Paris, Dec. 6, 1873; in Pissarro and Venturi, *Camille Pissarro*, vol. 1, p. 26.

61. Will of Pissarro, Montfoucault, Jan. 3, 1875; in *Correspondance de Pissarro*, vol. 1, p. 97. Ludovic Piette and Armand Guillaumin were fellow artists.

62. Reff, "Cézanne's Constructive Stroke," p. 226; n. 29; and Brettell, *Pissarro*, p. 106.

63. July 2, 1876; in *Cézanne Correspondance*, p. 152.

64. A good example is Pissarro's *The Avenue, Sydenham*, 1871, National Gallery, London; see X-ray photograph illus. in Bomford, *Art in the Making: Impressionism*, fig. 68, p. 138.

65. The actor Jean-Baptiste Faure purchased Pissarro's *The Hermitage at Pontoise* (c. 1867–68), Solomon R. Guggenheim Museum, New York (Justin K. Thannhauser Collection), which is 59⅛ × 78¾" (151 × 200 cm). See Letter, Cézanne to Pissarro, L'Estaque, July 2, 1876, in Rewald, ed. *Cézanne Letters*, p. 154.

66. Sept. 10, 1876; in ibid., p. 156.

67. This comparison was first noted by Reff, "Cézanne's Constructive Stroke," p. 221, yet Reff says he doubts that Cézanne came to Pontoise and Auvers that year.

68. Letter, Pissarro to son Lucien's wife Esther, Paris, Nov. 13, 1895; in *Pissarro: Letters*, p. 346.

69. Brettell, " 'First' Exhibition of Impressionist Painters"; in Moffett, *New Painting*, p. 196.

70. Jacques [pseud.], *L'Homme libre*, Apr. 12, 1877; in ibid., p. 213.

71. Émile Zola, "Une Exposition: Les peintres impressionnistes," *Le Sémaphore de Marseille*, Apr. 19, 1877; in Bonafoux, *Les Impressionnistes: Portraits and Confidences* (Geneva: Skira, 1986), p. 95.

72. Pissarro's remark to Walter Sickert, in Sickert, "French Painters at Knoedler's Gallery," *Burlington Magazine*, 43, no. 244 (July 1923), pp. 39–40; in Bomford, *Art in the Making: Impressionism*, p. 161.

73. Letter, Pissarro to Duret, Pontoise, Mar. 12, 1882; in *Correspondance de Pissarro*, vol. 1, p. 158.

74. Kunstler, *Pissarro: Villes et Campagnes*, p. 18; in Shikes and Harper, *Pissarro* (Paris), p. 190.

75. Pissarro made a drawing of the *Young Woman Sewing* that was published in *The Portfolio* of 1891 [illus. in *Pissarro: Letters*, p. 182], but Cézanne's drawing resembles Pissarro's painting more than it does his drawing.

76. Letter, Cézanne to Zola, Pontoise, May 20, 1881; in *Cézanne Letters*, p. 198.

77. Theodore Reff first noticed this side-by-side in Reff, "Cézanne's Constructive Stroke," p. 221; also see pp. 214–27.

78. Ibid.

79. In Pissarro's collection was his own *Portrait of Cézanne* (full-face) and his oil of Cézanne as well as Cézanne's profile head of him; *Pissarro in Pontoise Going Out to Paint with a Walking Stick and Knapsack*; and *Pissarro, Seen from the Back*. In Cézanne's collection was his own *Portrait of Pissarro and Sketches*.

80. This analysis is based on Reff's article "Pissarro's Portrait of Cézanne," pp. 627–32.

81. Courbet's image was taken from a caricature by Léonce Petit published in *Le Hanneton* at the time of the painter's one-man show outside the grounds of the 1867 Universal Exposition in Paris. Courbet is here identified as the antiauthoritarian artist, with large, colorful palette, proletarian clay pipe, and glass of beer. By 1874 Courbet was living in exile in Switzerland to avoid paying an enormous fine levied on him because of his role in the destruction of the Vendôme Column after the Franco-Prussian War.

82. See letter, Lucien Pissarro to his brother Paul-Émile, n.l., [1912]; in Meadmore, *Lucien Pissarro*, pp. 25–27. This political cartoon by André Gill was pinned to the wall of Pissarro's studio. It had appeared two years earlier in the newspaper *L'Éclipse* and was entitled "La Délivrance," which means both delivery (of a baby) and salvation. It depicts France as a woman in bed who has just given birth. Standing next to her is Adolphe Thiers, the conservative acting president of the French provisional government, as a triumphant doctor who has just delivered the "baby." This "baby" is the 41 billion francs that the French people pledged within twenty-four hours as a loan to help their government pay off the German indemnity after France's defeat in the Franco-Prussian War. By 1874 Thiers was no longer in power, having resigned on May 24, 1873. Neither Cézanne nor Pissarro liked his conservative politics, and hence Cézanne turns his back on Thiers.

83. Letter, Lucien Pissarro to his brother Paul-Émile, n.l., [1912]; in Thorold, *Pissarro and His Friends*, p. 8.

84. Paris, Mar. 7, 1898; in *Correspondance de Pissarro*, vol. 4, p. 458.

85. Reff, "Pissarro's Portrait of Cézanne," p. 628.

86. Dr. Paul Gachet, a neighbor and friend in Auvers, was a homeopathic physician, art collector, and artist.

87. Letter, Pissarro to son Lucien, Paris, May 7, 1891; in *Pissarro: Letters*, p. 210.

88. Letter, Pissarro to son Lucien, [Paris], Nov. 22, 1895; in *Correspondance de Pissarro*, vol. 4, p. 121.

89. Ambroise Vollard, *Renoir*, ch. 8 (Paris, 1918); in Rewald, "Chocquet and Cézanne" (1969); in Rewald, *Studies in Impressionism*, p. 126.

90. Émile Zola, "Le Naturalisme au Salon," *Le Voltaire*, June 19, 1880; in *Cézanne Letters*, p. 194, n. 5.

91. He eventually owned about thirty-seven works by Cézanne.

92. Gardanne, May 11, 1886; in *Cézanne Letters*, p. 224.

93. Reff, "Reproductions and Books in Cézanne's Studio," p. 306.

94. Letter, Cézanne to Émile Bernard, Aix, May 12, 1904; in *Cézanne Letters*, p. 297.

95. Anderson, "Cézanne, Tanguy, Chocquet," pp. 135–39.

96. Maurice Denis, "Extrait du Journal [1906]"; in Doran, *Conversations avec Cézanne*, p. 94.

97. Letter, Pissarro to son Lucien, Oct. 31, 1896; in *Correspondance de Pissarro*, vol. 4, p. 291.

98. Letter, Pissarro to Clément-Janin, Paris, Feb. 19, 1892; in ibid., vol. 5, p. 417.

99. Paris, Apr. 8, 1895; in *Pissarro: Letters*, p. 338.

100. Letter, Pissarro to a young painter, Louis Le Bail, n.l., [1896–97]; in Rewald, *Histoire de l'Impressionnisme* (Paris, 1955), pp. 279–80.

101. Letter, Cézanne to son Paul, Aix, Sept. 8, 1906; in *Cézanne Correspondance*, p. 324.

Manet & Morisot

1. See the eight paintings (1866–1880) of his wife, in Rouart and Wildenstein, *Manet catalogue raisonné*, vol. 1, nos. 116, 117, 131, 136, 202, 290, 337, 345.

2. Mallarmé, "Berthe Morisot," *Divagations*, 1896; in *Mallarmé: Oeuvres complètes*, p. 533.

3. Valéry, "Tante Berthe"; in *Degas, Manet, Morisot*, p. 123.

4. Boulogne-sur-Mer, Aug. 26, [1868]; in Wilson-Bareau, *Manet by Himself*, p. 49.

5. [Paris], May 2, 1869; in *Correspondance de Morisot*, p. 26.

6. Letter, Edma to sister Berthe, Pau, Mar. 21, 1869; in *Morisot: Correspondence*, p. 33. Edma had married on Mar. 8, 1869.

7. Manet's mother had paid for the construction of the pavilion near the Pont de l'Alma to house fifty of his paintings. His exhibition ran concurrently with the Universal Exposition, and he advertised it in the fair's catalog.

8. In 1866 Morisot was accepted, but Manet was rejected. After their meeting they continued to exhibit at the Salon together in 1870, 1872, and 1873; in 1874 Morisot was rejected and Manet accepted.

9. Illus. in Stuckey and Scott, *Morisot* (New York), p. 26.

10. [Paris], May 2, 1869; in *Morisot: Correspondence*, p. 36.

11. Letter, Morisot to sister Edma, Paris, Summer [1872]; in *Morisot: Correspondence*, p. 89.

12. Eva Gonzalès (1849–1883) was Manet's student and also posed for him. Her paintings included scenes from modern life, portraits, still lifes, and outdoor scenes. She exhibited at the Salon from 1870 to 1883.

13. Letter, Morisot to sister Edma [Paris, May 1883]; in *Morisot: Correspondence*, p. 131.

14. Letter, Morisot to sister Edma, Paris, early 1884; in *Correspondance de Morisot*, p. 118.

15. After 1877 Mary Cassatt sometimes attended the soirees of Morisot and Degas.

16. N.l., [May 11, 1869]; in *Correspondance de Morisot*, p. 29.

17. Statement by Morisot's brother Tiburce, who quoted statement by Joseph Guichard, a teacher of the Morisot sisters, in late 1850s; in *Morisot: Correspondence*, p. 19.

18. Letter, Morisot to sister Edma, Paris, c. Aug. 1871; in *Correspondance de Morisot*, p. 67.

19. N.l., Mar. 15, 1869; in *Morisot: Correspondence*, p. 32.

20. Letter, Edma to sister Berthe, [Lorient, 1869]; in *Correspondance de Morisot*, p. 31.

21. [Paris], Mar. 19, 1869; in ibid., p. 24.

22. Letter, Morisot to sister Edma, n.l., Apr. 23, 1869; in *Morisot: Correspondence*, p. 34.

23. Letter, Morisot to sister Edma, Saint-Germain, [c. Apr. 1871]; in ibid., p. 66.

24. [Paris], Mar. 22, 1870; in ibid., pp. 49, 51.

25. [Paris], Aug. 13 [1870]; in ibid., p. 44.

26. N.l., [1870]; in ibid.

27. [Paris, 1871]; in ibid., p. 83.

28. Letter, Édouard Manet to Morisot, [Paris], Dec. 28, [1880]; in ibid., p. 116.

29. Letter, Édouard Manet to Morisot, n.l., Dec. 29, 1881; in ibid., p. 117.

30. *Julie Manet at Fifteen Months*, 14¼ × 13″ (36 × 33 cm), 1879; illus. Rouart and Wildenstein, *Manet catalogue raisonné*, vol. 1, p. 235, no. 298. And *Julie*

Manet on the Watering Can, 39⅓ × 31¾″ (100 × 81 cm), 1882; illus. ibid., p. 293, no. 399.

31. Letter, Morisot to sister Yves, n.l., [1879]; in *Morisot: Correspondence*, p. 115.

32. Valéry, "Berthe Morisot," *Catalogue of Berthe Morisot Exhibition* (Paris: Musée de l'Orangerie, 1941), pp. v–vi.

33. Mallarmé, "Berthe Morisot," *Divagations*, 1896; in *Mallarmé: Oeuvres complètes*, p. 537.

34. Morisot's notebooks; in Howard, *Impressionists by Themselves*, p. 190.

35. Gustave Geoffroy, *La Justice*, Apr. 19, 1881; in Moffett, *New Painting*, p. 366.

36. [Paris, Sept. 1869]; in *Morisot: Correspondence*, pp. 45–46.

37. Letter, Morisot to sister Edma, [Paris, Mar. 1870]; in ibid., p. 46.

38. Letter, Morisot to sister Edma, [Paris, 1870]; in ibid., pp. 48–49.

39. [Paris], Mar. 22, 1870; in ibid., p. 49.

40. N.l., May 8, [1870]; in ibid., pp. 51–52.

41. [Paris, May 1870]; in ibid., p. 52.

42. Letter, Morisot to sister Edma, Passy, [1871]; in ibid., p. 82.

43. [Paris], May 5, 1869; in ibid., p. 37.

44. Baudelaire, "Le Peintre de la vie moderne," 1859 ff.; in *Baudelaire: Oeuvres complètes*, 1954, p. 920.

45. Letter, Morisot to sister Edma, [Paris, 1870]; in *Morisot: Correspondence*, p. 45.

46. Letter, Mme. Morisot to daughter Edma, n.l., Aug. 14, [1869]; in *Correspondance de Morisot*, p. 33.

47. The photographer Nadar (Gaspard-Félix Tournachon), who took photographs of contemporary life, including aerial views of Paris, influenced the Impressionists' visual imagination.

48. See Reff, *Manet and Modern Paris*, pp. 36–39.

49. N.l. [late 1869]; in *Morisot: Correspondence*, pp. 45–46.

50. [Paris], Sept. 28, 1869; in ibid., p. 46.

51. Letter, Mme. Morisot to unknown, n.l., [1871–72]; in ibid., p. 84.

52. Letter, Mme. Morisot to daughter Edma, [Paris, Mar. 1869]; in ibid., p. 34.

53. Letter, Morisot to sister Edma, [Paris], May 2, 1869; in *Correspondance de Morisot*, p. 26.

54. Letter, Morisot to sister Edma, [Paris], May 2, 1869; in *Morisot: Correspondence*, p. 36.

55. Letter, Mme. Morisot to [Edma], [Paris], May 23, 1869; in ibid., p. 40.

56. Letter, Morisot to [sister Edma], [Paris, 1869]; in ibid., p. 40.

57. Both works were still in Manet's studio at the time of his death.

58. Letter, Mme. Morisot to daughter Berthe, [Paris, 1869]; in *Morisot: Correspondence*, p. 43.

59. [Paris], Aug. 13 [1870]; in ibid., p. 44.

60. [Paris, 1870]; in ibid., p. 45.

61. Letter, Morisot to sister Edma, [Paris, winter 1870]; in ibid., p. 49.

62. Letter, Morisot to sister Edma, [Paris, 1870]; in ibid., p. 52.

63. N.l., Jan. 24, 1875; in ibid., p. 96.

64. Théophile Silvestre, *Le Pays*, July 13, 1870; in Tabarant, *Manet et ses oeuvres*, p. 211; in Cachin and Moffett, *Manet Catalogue*, p. 317.

65. Théodore de Banville, *Le National*, May 15, 1870; in Tabarant, *Manet et ses oeuvres*, p. 206.

66. Letter, Manet to Mme. Morisot, Arachon, Mar. 1871; in Bernice F. Davidson, "*Le Repos*: A Portrait of Berthe Morisot by Manet," *Bulletin of Rhode Island School of Design*, Dec. 1959, p. 6.

67. Cachin and Moffett, *Manet* cat. (New York), p. 318. In Jan. 1872 *Repose* was acquired by Manet's dealer, Paul Durand-Ruel, along with twenty-three other canvases. Durand-Ruel lent it back to Manet to exhibit at the Salon of 1873.

68. Letter, Mme. Morisot to unknown, [Paris], Dec. 15, 1870; in *Morisot: Correspondence*, p. 57.

69. Letter, Manet to Gonzalès, Paris, Sept. 10, 1870; in Wilson-Bareau, *Manet by Himself*, p. 55.

70. Letter, Manet to wife Suzanne, Paris, [Sept. 11, 1870]; in ibid.

71. Letter, Manet to wife Suzanne, Paris, Sept. 30, [1870]; in ibid., p. 58.

72. Letter, Manet to wife Suzanne, Paris, Jan. 4, 1871; in ibid., p. 63.

73. Paris, June 10, [1871]; in *Morisot: Correspondence*, p. 74.

74. Letter, Mme. Morisot to daughter Berthe, [Paris], July 14, [1871]; in ibid., p. 81.

75. Passy, [1871]; in ibid., p. 82.

76. Letter, Mme. Morisot to daughter Berthe, [1871]; in Higonnet, *Morisot* (New York), p. 84.

77. Diary entry of Dec. 3, 1895; in Julie Manet, *Journal 1893–1899*, pp. 74–75.

78. Diary entry of Dec. 3, 1895; in ibid., p. 74.

79. Valéry, "Triumph of Manet," *Manet Exhibition Catalogue* (Paris: Musée de l'Orangerie, June 1932; in Valéry, *Oeuvres*, vol. 2, p. 1,333.

80. There is also a black lead drawing 6⅞ × 5½" (17.5 × 14.0 cm) related to the first state of the lithograph; see Rouart and Wildenstein, *Manet catalogue raisonné*, vol. 2, p. 146, no. 389.

81. Mallarmé, "Berthe Morisot," *Divagations* (1896); in *Mallarmé Oeuvres Complètes*, p. 533.

82. The portrait with the fan (see p. 174) was sold or given to one of Manet's physicians, Dr. De Bellio. The other portraits remained in his studio.

83. [Paris, 1874]; in *Correspondance de Morisot*, p. 77.

84. Letter, Morisot to brother Tiburce, n.l., Jan. 24, 1875; in ibid., p. 80.

85. The painting remained in Manet's studio until his death, when it was given to Dr. De Bellio. Eventually Degas acquired it.

86. Letter, Eugène Manet to Morisot, Paris, Summer [1874]; in *Morisot: Correspondence*, p. 93.

87. Letter, Eugène Manet to Morisot, [1874]; in ibid., pp. 94–95.

88. Letter, Morisot to her brother Tiburce, n.l., Jan. 1875; in *Correspondance de Morisot*, p. 80.

89. N.l., [1883]; in *Morisot Correspondence*, p. 132.

90. Ernest Ange Duez (1843–1896) was a painter.

91. Paris, early 1884; in *Correspondance de Morisot*, p. 118.

Cassatt & Degas

1. Letter, Cassatt to George Biddle, Paris, Sept. 29, [1917]; in *Cassatt: Selected Letters*, p. 328.

2. Havemeyer, "Cassatt Exhibition," pp. 377–78.

3. Havemeyer, *Sixteen to Sixty*, p. 244.

4. Ibid.

5. Letter, Robert Cassatt to his son Alexander, Paris, Aug. 20, 1883; in Sweet, *Cassatt*, p. 81.

6. Segard, *Cassatt*, p. 5, n. 3.

7. *Cassatt: Selected Letters*, p. 11.

8. Havemeyer, *Sixteen to Sixty*, p. 243. Cassatt told this to Havemeyer.

9. Lydia had Bright's disease, a degenerative disease of the kidneys. She died on Nov. 7, 1882.

10. Letter, Mrs. Cassatt to son Alexander, Bachivilliers, July 23, 1891; in *Cassatt: Selected Letters*, p. 222.

11. Letter, Cassatt to brother Alexander, [Paris], Nov. 18, [1880]; in ibid., p. 152.

12. Degas came frequently to Cassatt's house and met, among others, Georges Clemenceau and Jacques-Émile Blanche. Cassatt went with the Havemeyers to Degas's studio. Cassatt painted the child of a friend of Degas in *Little Girl in a Blue Armchair*, 1878, and the two daughters of his sister Marguerite Fèvre: Odile Fèvre in *Woman and Child Driving*, 1881, and the pastel *Portrait of Little Madeleine [Fèvre]*, 1880 (illus. Breeskin, *Cassatt: Catalogue Raisonné of Oils...*, p. 64, no. 99). Degas drew Lydia along with Cassatt at the Louvre.

13. Letter, Cassatt to Colonel Paine, Villa Angeletto, Feb. 28, [1915]; in *Cassatt: Selected Letters*, p. 321.

14. Letter, Cassatt to Louisine Havemeyer, n.l., 1915; in ibid., p. 33.

15. Havemeyer, *Sixteen to Sixty*, p. 245.

16. Cassatt had known Tourney since the summer of 1873, when they met (along with his wife) in Antwerp. Tourney was a portraitist and watercolor specialist who was connected to the Gobelins tapestry factory.

17. *Ida*, 1874. Oil on canvas, 23 × 18" (58.4 × 45.7 cm). Collection of Joseph and Carol Anton; illus. Mathews, *Cassatt: A Life*, p. 91.

18. Segard, *Cassatt*, p. 35.

19. Ibid., pp. 7–8.

20. Letter, Cassatt to Harrison Morris, [Paris], Mar. 15, 1904; in *Cassatt: Selected Letters*, p. 291.

21. Letter, Robert Cassatt to son Alexander, Paris, May 21, 1879; in ibid., p. 144.

22. Letter, Pissarro to son Lucien, Paris, [Mar. 5, 1886]; in *Pissarro: Letters*, p. 74.

23. Boggs, *Degas* (New York), pp. 258–59. See also Mathews, *Cassatt and the "Modern Madonna,"* pp. 43, 209, n. 112.

24. *The Ballet Rehearsal (A Ballet)*, 1876–77. Gouache and pastel over monotype, 21¾ × 26¾" (55.2 × 67.9 cm). The Nelson-Atkins Museum of Art, Kansas City; illus. Weitzenhoffer, *Havemeyers*, p. 32, pl. 1.

25. Between 1878 and 1884, Parisian shop clerks' wages averaged 100 francs per month; dinner at a modest restaurant cost about 14 francs.

26. In Feb. 1878 Louisine lent *The Ballet Rehearsal* to the eleventh annual exhibition of the American Watercolor Society, which was held at the National Academy of Design in New York. See Weitzenhoffer, *Havemeyers*, p. 23.

27. Havemeyer, *Sixteen to Sixty*, p. 250.

28. Adriani, *Degas Pastels, Oil Sketches, Drawings*, p. 368.

29. Letter, Cassatt to Rose Lamb, Bachivillers, Nov. 30, [1892]; in *Cassatt: Selected Letters*, p. 240.

30. Letter, Cassatt to Samuel P. Avery, Sienna, Italy, Mar. 2, [1893]; in ibid., p. 246.

31. Havemeyer, *Sixteen to Sixty*, pp. 252–53.

32. Letter, Cassatt to Morisot, [Paris, 1879]; in *Cassatt: Selected Letters*, p. 149.

33. In Alexander's collection was the pastel *Le Jockey*, c. 1889; illus. Lemoisne, *Degas*, vol. 3, p. 583, no. 1001.

34. *The Ballet Class* is illus. in ibid., vol. 2, p. 265, no. 479; the nude *Woman in the Tub* is illus. in ibid., vol. 3, p. 467, no. 816. See letter, Cassatt to Havemeyer, Villa Angeletto, Dec. 28, 1917, in *Cassatt: Selected Letters*, pp. 330–31. Earlier she had owned the oil *Estelle Musson Balfour*, 1863–65, which left her collection in 1903; illus. Brame and Reff, *Degas et son oeuvre*, p. 43, no. 40.

35. Sale Degas Collection, nos. 8, pp. 102–4, nos. 16–58; in *Catalogues des tableaux, pastels et dessins par Edgar Degas et provenant de son atelier dont les ventes aura lieu à Paris, Galeries Georges Petit*, May 6–8, 1918; Dec. 11–13, 1918; Apr. 7–9, 1919; and July 2–4, 1919.

36. Letter, Degas to Henri Rouart, Paris, Oct. 26, [1881]; in *Degas Letters*, p. 63.

37. "Poor Mlle Cassatt had a fall from her horse, broke the tibia of her right leg and dislocated her left shoulder.... She is doing well, and here she is for a long time to come, first of all immobilised for many long summer weeks, and then deprived of her active life and perhaps also of her horsewoman's passion." Letter, Degas to Henri Rouart, n.l., [1889]; in *Degas Letters*, pp. 125–26.

38. See discussions of *Little Girl in Blue Armchair*, 1878, and *Seated Woman with Dog on Knees* [Mary Cassatt], c. 1878–1880.

39. Degas's sonnet, which was written in the winter of 1888–89, inspired Cassatt to make a drypoint of her maid and parrot in *The Parrot*, 1889–1891; illus. Breeskin, *Cassatt: Catalogue Raisonné of the Graphic Work*, p. 136, no. 138.

Parrot
To Miss Cassatt regarding her cherished Coco

When that voice cried, almost human, over there
At the long beginning of this one day
Or while he read from his faded Bible,
What must that weary Robinson have felt?

That voice of the beast, to him so familiar,
Did it make him laugh? At least, he does not say
If he cried over it, the poor dear. Piercing and guttural,
The parrot's voice would call Robinson in his enclosed island.

It is you who pity the parrot, it does not pity you;
Yours.... But be aware, like a tiny, little saint,
That a Coco collects himself and gives away in his flight

What your heart has said, to the receptive confidant,
Then, with the tip of the wing, immediately takes off
A bit of tongue, then he is mute . . . and green.

Degas, *Huit Sonnets d'Edgar Degas*, pp. 27–28.

40. Havemeyer, *Sixteen to Sixty*, p. 247.
41. Ibid., p. 244.
42. Ibid., p. 243.
43. Ibid.
44. Recollection to Breeskin of Cassatt's anonymous personal friend; in Breeskin, *Cassatt: Catalogue Raisonné of the Graphic Work*, p. 15, n. 12.
45. Letter, Cassatt to Rose Lamb, Bachivillers, Nov. 30, 1892; in *Cassatt: Selected Letters*, p. 240.
46. Letter, Cassatt to Mrs. Palmer, Bachivillers, Dec. 1, [1892]; in Sweet, *Cassatt*, p. 132.
47. Letter, Morisot to sister Edma, [Paris, 1885]; in *Correspondance de Morisot*, p. 126.
48. Letter, Caillebotte to Pissarro, Jan. 24, 1881; in Berhaut, *Caillebotte*, pp. 245–46, n. 22.
49. Havemeyer, *Sixteen to Sixty*, p. 244.
50. Georges Rivière, *M. Degas, Bourgeois de Paris* (Paris, 1935), p. 18; in Broude, "Degas's 'Misogyny,' " in Broude and Garrard, *Feminism and Art History*, p. 250.
51. Letter, Degas to Evariste Bernard de Valernes, Paris, Oct. 26, [1890]; in *Degas Letters*, pp. 171–72.
52. Letter, Degas to Henri Rouart, Cauterets, Sept. 11, [1890]; in ibid., p. 152.
53. Havemeyer, *Sixteen to Sixty*, p. 247.
54. Sweet, *Cassatt*, p. 182.
55. Letter, Cassatt to Havemeyer, Villa Angeletto, Mar. 12, [1915]; in *Cassatt: Selected Letters*, p. 322.
56. Letter, Henry O. Havemeyer to Paul Durand-Ruel, n.l., Jan. 24, [1899]; in Weitzenhoffer, *Havemeyers*, p. 134.
57. Mesnil-Beaufresne, [1903]; in *Cassatt: Selected Letters*, pp. 281–82. Original in French.
58. Letter, Degas to M. le Comte Ludovic-Napoléon Lepic, n.l. [c. 1878 or later]; in *Lettres de Degas*, pp. 149–51. Count Lepic was a great dog breeder, painter, and engraver. He posed for Degas several times, once with Marcellin Desboutin (illus. in Degas-Manet chapter).
59. Letter, Degas to Henri Rouart, Paris, Oct. 26, [1878?]; in *Degas Letters*, p. 63.
60. Boggs, *Degas* (New York), pp. 129–30, pp. 262–63.
61. Letter, Degas to Félix Bracquemond, n.l., [1879]; in *Degas Letters*, p. 52.
62. Of Degas's *At the Races in the Countryside*, see Linda Nochlin, "Morisot's *Wet Nurse*," p. 96.
63. Havemeyer, *Sixteen to Sixty*, p. 258.
64. "Miss Mary Cassatt also did the portrait of Degas. One can hardly believe that she has been able to capture intensely all that is bitter and disillusioned in the face of this misanthrope. I was not given the opportunity to see this portrait. It must have been destroyed or stolen from the shed where it was stored." Segard, *Cassatt*, p. 168, n. 1.
65. Letter, Cassatt to Havemeyer, Grasse, Dec. 7, 1918; in Boggs, *Degas*, p. 321.
66. Edmond Duranty, *La Nouvelle Peinture* (1876; Paris: Librairie Floury, 1946), p. 42.
67. Havemeyer, *Sixteen to Sixty*, p. 258.
68. Reff, "*Au Musée du Louvre* by Edgar Degas," p. 90.
69. Reed and Shapiro, *Degas as Printmaker*, p. 169.
70. Diary entry of Ludovic Halévy, May 16, 1879; in "Les Carnets de Ludovic Halévy," *Revue des deux mondes*, Dec. 15, 1937, p. 826; in Reed and Shapiro, *Degas as Printmaker*, p. 168.
71. N.l., [1880]; in *Degas Letters*, p. 56.
72. Letter, Robert Cassatt to son Alexander, n.l., Oct. 15, 1879; in Sweet, *Cassatt*, p. 47.
73. N.l., [1880]; in *Degas Letters*, p. 59.
74. N.l., 1879–80; in *Lettres de Degas*, p. 49.
75. Letter, Mme. Cassatt to son Alexander, [Paris,] Apr. 9, [1880]; in *Cassatt: Selected Letters*, p. 151.

76. Another Cassatt print intended for this issue, *Under the Lamp*, was an indoor evening scene with artificial light; see Breeskin, *Cassatt: Catalogue Raisonné of the Graphic Work*, p. 106, pl. 71.
77. "Serie unique de treize états." Ibid., p. 47. Six known states plus intermediate trial proof states exist.
78. Segard, *Cassatt*, p. 108.
79. Havemeyer, *Sixteen to Sixty*, pp. 257–58.
80. Havemeyer, "Cassatt Exhibition," p. 378.
81. Grasse, [late 1912]; in Venturi, *Archives*, vol. 2, p. 129.
82. Letter, Cassatt to Durand-Ruel, Grasse, Apr. 9, 1913; in ibid., p. 131.
83. Also see Thomson, "Notes on Degas's Sense of Humour," pp. 11–16.
84. N.l., Sept. 11, 1913; in Boggs, *Degas* (New York), p. 497.
85. Letter, Cassatt to Havemeyer, Villa Angeletto, Dec. 4, [1913]; in *Cassatt: Selected Letters*, p. 313.
86. Letter, Mme. Cassatt to son Alexander, Paris, Nov. 30, [1883]; in ibid., p. 174.
87. Segard, *Cassatt*, pp. 184–85.
88. Degas's charcoal and pastel drawing was *Woman Bathing in Shallow Tub*, 1885 (illus. Boggs, *Degas* [New York], p. 444, pl. 269).
89. Cauterets, Aug. 30, 1888; in ibid., p. 389.
90. Letter, Degas to Bartholomé, n.l., Apr. 29, 1890; in *Degas Letters*, p. 146.
91. Letter, Pissarro to his son Lucien, Paris, Apr. 8, 1891; in *Correspondance de Pissarro*, vol. 3, p. 58.
92. See Mathews, *Cassatt: A Life*, p. 275.
93. Letter, Cassatt to Sarah Hallowell, [Paris], 1893; in Howard, *Impressionnistes par eux-mêmes*, p. 274.
94. Letter, Cassatt to Bertha Palmer (Mrs. Potter Palmer), Bachivillers, Oct. 11, [1892]; in *Cassatt: Selected Letters*, pp. 237–38.
95. Bachivillers, June 17, [1892]; in ibid., p. 229.
96. N.l., [1892]; in ibid., n. 2.
97. Letter, Cassatt to Homer Saint-Gaudens (director of the Carnegie [Art] Institute, Pittsburgh), Villa Angeletto, Dec. 28, 1922; in ibid., p. 335.
98. Letter, Cassatt to Durand-Ruel, Grasse, Feb. 12, [1914]; in Venturi, *Archives*, vol. 2, p. 133.
99. Originally it was to have been an exhibition of Degas's pastels and paintings in Durand-Ruel's New York Gallery. Later the idea changed to be a Degas-Cassatt show at that gallery. Still later it became "Masterpieces by Old and Modern Painters" at M. Knoedler & Co. in New York and took place in Apr. 1915 with 23 Degases, 18 Cassatts, and 18 old masters: Bronzino, Van Dyck, Holbein, De Hooch, Rembrandt, Rubens, and Vermeer.
100. Letter, Paul Durand-Ruel to Mr. H. Havemeyer, n.l., July 7, 1899; in Weitzenhoffer, *Havemeyers*, p. 136. Havemeyer bought the work through Durand-Ruel.
101. Havemeyer, *Sixteen to Sixty*, p. 244.
102. Ibid., p. 249.
103. Paris, Oct. 2, [1917]; in *Cassatt: Selected Letters*, p. 328.
104. From Louisine Havemeyer's unpublished chapter on Mary Cassatt, p. 24; in Weitzenhoffer, *Havemeyers*, p. 126.
105. Letter, Cassatt to Mrs. Havemeyer, Grasse, Jan. 20, 1915; in Boggs, *Degas* (New York), p. 236, n.l.

Morisot & Renoir

1. Morisot and Renoir may have met as early as 1867 and known each other in the late 1860s and 1870s. According to Rewald, *Impressionism*, p. 172, they were among those mentioned by Bazille in his letter to his mother, n.l. [1867]; in Marandel and Daulte, *Bazille:* "A dozen talented young people [who have] . . . decided to rent each year a large studio where we will exhibit as many of our works as we like" (p. 180). In the late 1860s Morisot and Renoir were each close to Manet. Because they both exhibited at the government-sponsored Salons of 1864, 1865, 1868, and 1870, they could have been acquainted there. They exhibited together in the Impressionist group

show of 1874, the Impressionist auction of 1875, and the subsequent shows of 1876, 1877, and 1882.

2. Letter, Morisot to Mallarmé, Mézy, Oct. [1890]; in *Morisot: Correspondence*, p. 177.

3. In ibid., p. 176.

4. Henri de Regnier, *Renoir, peintre du nu* (Paris: Bernheim-Jeune, 1923), pp. 7, 9. Thursday-night regulars included Degas, Mallarmé, Monet, and Renoir. Others who occasionally attended included the artists Cassatt, Fantin-Latour, John-Lewis Brown, Chavannes, Odilon Redon, Auguste Rodin, Henri Rouart, and James Abbott McNeill Whistler. Also invited were the writers Astruc, Édouard Dujardin, Mirbeau, Oscar Wilde, and Teodor de Wyzewa.

5. Journal entry of Dec. 31, 1896; in Julie Manet, *Growing Up with the Impressionists*, p. 104.

6. Journal entry of Sept. 14, 1898; in ibid., p. 145.

7. Letter, Morisot to sister Edma, n.l., end of 1890; in *Morisot: Correspondence*, p. 179.

8. Letter, Renoir to Morisot, Saint-Chamas, [1892]; in ibid., p. 199.

9. Letter, Morisot to sister Edma, n.l., end of 1890; in ibid., p. 179.

10. Letter, Morisot to sister Edma, n.l., end of 1890; in ibid., p. 179.

11. Letter, Renoir to Durand-Ruel, Tamaris-sur-Mer, Mar. 5, 1891; in Venturi, *Archives*, vol. 1, p. 144.

12. Higonnet, *Morisot* (New York), p. 119.

13. Entry of Jan. 30, 1898; in Julie Manet, *Growing Up with the Impressionists*, p. 127.

14. See letter, Morisot to Mallarmé, [Mézy, early Oct. 1890]; in *Morisot: Correspondence*, p. 177.

15. [Mézy], July 14, [1891]; in ibid., p. 182.

16. Entry of Sept. 19, 1895; in Julie Manet, *Growing Up with the Impressionists*, p. 67.

17. Entry of 1895; in ibid., p. 81.

18. Entry of Dec. 23, 1897, in ibid., p. 121.

19. Mézy, [1891]; in *Morisot Correspondence*, p. 185.

20. In ibid., p. 126.

21. [Paris, 1885]; in ibid., p. 143.

22. [Paris, 1876]; in ibid., p. 111.

23. Letter, Morisot to a friend, summer 1881; in ibid., p. 117.

24. Entry of Oct. 28, 1897; in Julie Manet, *Growing Up with the Impressionists*, p. 116. Also see Higonnet, *Morisot* (New York), pp. 30, 78–79, 203.

25. In *Morisot: Correspondence*, p. 177.

26. Diary entry c. 1890; in Higonnet, *Morisot* (New York), p. 203.

27. Letter, Caillebotte and Renoir to Morisot, [Paris, spring 1877]; in *Correspondance de Morisot*, p. 98.

28. L'Éstaque, Feb. 24, 1882; in Venturi, *Archives*, vol. 1, p. 120.

29. Letter, Renoir to Durand-Ruel, [L'Éstaque, draft of letter of Feb. 26, 1882]; in ibid., p. 122.

30. Pseudonym of Amandine Lucie Aurore Dupin, Baroness Dudevant (1804–1876); French novelist.

31. Juliette Adam [1836–1936] was a prominent political journalist who began as a feminist in 1858 but became committed to Republicanism and patriotism after the Franco-Prussian War.

32. Cagnes, Apr. 8, 1888; in Daulte, *Renoir*, vol. 1, p. 53; [Letter in the archives of Durand-Ruel, Paris].

33. Entry in Morisot's diary, 1892; in *Morisot: Correspondence*, p. 189.

34. Entry Paris, Jan. 31, 1899; in Julie Manet, *Growing Up with the Impressionists*, p. 159.

35. Entry of Dec. 31, 1896; in ibid., pp. 104–5.

36. Letter, Morisot to brother Tiburce, [Bougival], Aug. 20, [1883]; in *Morisot: Correspondence*, p. 133.

37. See Rouart, *Homage à Morisot et à Renoir*, p. 37, n. 47, no. 29.

38. Mentioned in Cagnes inventory of Renoir's dining room after his death, Mar. 13, 1920, p. 77. Private collection.

39. Bataille and Wildenstein, *Morisot: Catalogue*, p. 40, no. 253.

40. Ibid., p. 37, no. 214.

41. The number of Morisot oils comes from the Bataille and Wildenstein

Morisot catalog; the number of Renoir oils comes from a conversation between the author and M. François Daulte who for many years has been compiling a Renoir catalog.

42. Paul Mantz, *Le Temps*, Apr. 22, 1877; cited in Stuckey and Scott, *Morisot* (New York), p. 70.

43. Charles Bigot, *La Revue politique et littéraire*, Apr. 8, 1876; in Moffett, *New Painting*, p. 182.

44. Arthur Baignières, "Exposition de peinture par un groupe d'artistes," *L'Echo universel*, Apr. 13, 1876; in Stuckey and Scott, *Morisot* (New York), p. 70.

45. Recorded by Morisot [1868–78]; in Wilson-Bareau, *Manet by Himself*, p. 303.

46. [Paris], May 5, 1869; in *Morisot: Correspondence*, p. 37.

47. Diary entry around 1890; in Higonnet, *Morisot* (New York), pp. 203–4.

48. Also see Nochlin, "Morisot's *Wet Nurse*," pp. 91–102.

49. Gustave Geffroy, *La Justice*, Apr. 19, 1881; in Moffett, *New Painting*, p. 366.

50. Paul Mantz, "Exposition des oeuvres des artistes indépendants," *Le Temps*, Apr. 23, 1881; cited in Stuckey and Scott, *Morisot* (Paris), p. 88.

51. Valéry, "Berthe Morisot," *Catalogue of Berthe Morisot Exhibition* (Paris: Musée de la Orangerie, 1941); in Valéry, *Degas, Manet, Morisot*, p. 119.

52. Four years later, when Cassatt did her first nursing painting, she was closer to Renoir's concrete treatment of form.

53. Letter, Morisot to sister Edma, [Paris, 1885]; in *Morisot: Correspondence*, p. 143.

54. Entry in Morisot's diary, Jan. 11, 1886; in *Morisot: Correspondence*, p. 145.

55. Julie Manet Rouart recalled: "Mother did this bust of me when I was seven. She asked Rodin to advise her about it. One day he walked into my room, felt the shape of my head and said, 'It is absolutely the little model'"; cited in *Life*, May 10, 1963, p. 51.

56. Illus., White, *Renoir* (New York and Paris), p. 235.

57. [Visit to Renoir's studio, Paris], Jan. 11, 1886; in *Morisot: Correspondence*, p. 145.

58. See White, *Renoir* (New York and Paris), p. 174.

59. Philippe Burty, "Exposition des oeuvres des artistes indépendants," *La République Française*, Apr. 10, 1880.

60. Valéry, "Tante Berthe"; *La Renaissance* (1926), p. 317. In 1892 she again copied Boucher.

61. Edmond Renoir, "Cinquième Exposition de 'La Vie Moderne,'" *La Vie moderne*, June 19, 1879; in Venturi, *Archives*, vol. 2, p. 335.

62. Interview by Barbara Ehrlich White with Mme. Ernest Rouart (Julie Manet Rouart), Paris, summer 1963. Mme. Rouart died in 1966.

63. Ibid.

64. See *Morisot: Correspondence*, p. 151.

65. [Paris], Dec. [1887]; in ibid., p. 151.

66. Mallarmé, "The White Water-Lily," in Mallarmé, *Collected Poems*, p. 110. Also see Bailly-Herzberg, "Les Estampes de Berthe Morisot," pp. 215–227.

67. Letter, Mallarmé to Morisot, n.l., Feb. 17, 1889; in *Correspondance de Morisot*, p. 145.

68. Excerpt from "Le Phénomène futur" by Mallarmé, in *Collected Poems*, p. 87.

69. Letter, Renoir to Durand-Ruel, n.l., Feb. 1890; in Venturi, *Archives*, vol. 1, p. 141.

70. N.l., [1890]; in White, *Renoir* (New York), p. 178.

71. See also letter, Mallarmé to Emile Verhaeren, n.l., Jan. 15, 1888; in *Mallarmé: Correspondance*, vol. 3, pp. 161, 162, n. 3, 163. And see Bailly-Herzberg, "Les Estampes de Berthe Morisot," p. 226, n. 24.

72. Ibid.

73. *Mallarmé: Correspondance*, vol. 5, p. 76, n.l.

74. *Girls at the Piano* was the first Renoir work bought by the French government, which acquired it in 1892; two years later the state bought its first Morisot, *Young Woman at a Ball* (1879).

75. N.l., [1888]; in *Morisot: Correspondence*, p. 153.

76. N.l., [1888]; in ibid., p. 163.

77. Letter, Renoir to the Eugène Manets, n.l., [1888]; in *Correspondance de Morisot*, p. 143.

78. Morisot made a related, small, red chalk drawing 19 × 11½″ (48 × 29 cm).

79. Letter, Renoir to Morisot, [Paris], Aug. 17, [1891]; in *Correspondance de Morisot*, p. 161.

80. Jeanne Fourmanoir was the professional model. See Alain Clairet, " 'Le Cerisier' de Mézy," pp. 48–51.

81. [Paris, 1891]; in *Morisot: Correspondence*, p. 183.

82. Renoir had his first one-man show of seventy works at Durand-Ruel in Apr. 1883.

83. Letter, Renoir to Morisot, [Paris], May 25, [1892]; in *Morisot: Correspondence*, p. 192.

84. [Paris], Mar. 31, [1894]; in ibid., p. 205.

85. [Paris, Aug. 1894]; in *Correspondance de Morisot*, pp. 180–81.

86. [Brittany], Sept. 1, 1894; in *Morisot: Correspondence*, p. 207.

87. N.l., mid-Sept. [1894]; in ibid., p. 208.

88. See ibid., p. 209.

89. [Paris, Apr. 1894]; in ibid., p. 205. Also see illus.

90. [Paris, Apr. 1894], see illustration.

91. In *Morisot: Correspondence*, p. 205.

92. Valéry, "Tante Berthe"; in Valéry, *Degas, Manet, Morisot*, p. 123.

93. *Mallarmé: Oeuvres complètes*, p. 536; translation in Higonnet, *Morisot* (New York), p. 218.

94. Letter, Morisot to friend Sophie Canat, Oct. 7, 1892; in *Morisot: Correspondence*, p. 197.

95. Letter, Morisot to daughter Julie, [Paris], Mar. 1, [1895]; in ibid., p. 212.

96. Notes by Mme. Ernest Rouart (Julie Manet) following a visit from Jean Renoir to Le Mesnil in Aug. 1961; in Julie Manet, *Growing Up with the Impressionists*, p. 81.

97. [Paris], Mar. 3, 1895; excerpt in Charavay sale cat. 786, Mar. 1986, no. 41187.

98. These were daughters of Berthe's older sister, Yves Morisot Gobillard.

99. Entry of Oct. 4, 1895; in Julie Manet, *Growing Up with the Impressionists*, p. 69.

100. Entry of late Oct./early Nov. 1895; in ibid., p. 71.

101. Entry of Nov. 29, 1895; in ibid., p. 76.

102. Entry of Feb. 1, 1897; in ibid., p. 108.

103. Entry of Sept. 16, 1897; in ibid., p. 111. See also entries of Oct. 14, 1897, Nov. 16, 1897, Dec. 3, 1897, and Oct. 2, 1898.

104. Ernest, an amateur painter, was the son of Henri Rouart. He was a friend and former pupil of Degas.

105. Grasse, Jan. 17, 1900; White, *Renoir* (New York), p. 217.

Cassatt & Morisot

1. Morisot had exhibited alone at the Impressionist exhibitions of 1874, 1876, and 1877. A third woman, Marie Bracquemond (wife of Félix, who stood in the way of her artistic ambitions), was a much less prominent figure. She exhibited less often and showed fewer works than either Cassatt or Morisot (two in 1879, three in 1880, and six in 1886).

2. Cassatt exhibited eight paintings and eight prints; Morisot exhibited ten paintings, four watercolors, and one fan.

3. Segard, *Cassatt*, p. 63.

4. J. K. Huysmans, "L'Exposition des indépendants en [Apr.] 1880," reprinted in Huysmans, *L'Art moderne* (Paris: G. Charpentier, 1883), p. 110.

5. Octave Maus, *L'Art moderne*, [Brussels], June 27, 1886; in Moffett, *New Painting*, p. 460.

6. George Moore, *Reminiscences of the Impressionist Painters* (Dublin: Maunsel, 1906), p. 35; quoted in Mathews, *Cassatt: A Life*, p. 123.

7. Huysmans, "L'Exposition des Indépendants en 1880," p. 110.

8. Cassatt exhibited her painting at the first Impressionist show to which she was invited, in 1879. Subsequently it was sold to a private collector. Morisot's painting, exhibited at the Impressionist show of 1880, was purchased by a collector that same year. In 1894 it was repurchased by the French government for the Louvre.

9. Morisot, *Woman at Her Toilette*, 1877. Oil on canvas, 18⅛ × 15″ (46 × 38 cm). Location unknown, illus. Stuckey and Scott, *Morisot* (New York), p. 70, fig. 44. The auction was the Hoschedé sale, and the purchase price was 95 francs. The painting had been exhibited at the second Impressionist show of 1876. Cassatt also encouraged her brother Alexander to buy Morisot's *River Scene*; see Sweet, *Cassatt*, p. 84. Morisot did not own any Cassatt oils, pastels, or drawings; it is not known if she owned any prints.

10. Letter, Degas to Caillebotte [Paris], c. Mar. 1879; in Higonnet, *Morisot* (New York), p. 154.

11. There are no known letters from Morisot to Cassatt, but five sympathetic and supportive letters from Cassatt to Morisot. Cassatt wrote to Morisot in French. They are addressed: "Dear Madame Manet" or "Dear Madame" or, once, "My dear Friend." They are signed "My best to you," "Affectionate friend," "Affectionately yours," or "Yours affectionately."

12. [Paris, fall 1879]; in *Cassatt: Selected Letters*, p. 149. Original in French.

13. [Paris, spring 1880]; in ibid., p. 150. Original in French.

14. Havemeyer, *Sixteen to Sixty*, p. 217.

15. Cassatt exhibited four oils and seven pastels; Morisot exhibited five oils, two pastels, and three uncataloged works. Morisot was affiliated with Pissarro, Guillaumin, Gauguin, and Paul Vignon. Others who sided with this faction but who had withdrawn to exhibit at the Salon were Renoir, Monet, Sisley, and Cézanne. Cassatt was aligned with Degas, Jean-Louis Forain, Jean-François Raffaëlli, Henri Rouart, Charles Tillot, Eugène Vidal, and Federico Zandomeneghi.

16. Monet and Renoir did exhibit because of the insistence of Durand-Ruel. Because Degas declined from exhibiting, no one enforced his rule that one could not exhibit both at the Salon and with the Impressionists.

17. [Paris, 1882]; in *Morisot: Correspondence*, p. 127.

18. [Bougival], Aug. 20, [1883]; in ibid., p. 133.

19. Ibid., p. 144.

20. Cassatt exhibited six oils and one pastel; Morisot exhibited eleven oils, a series of drawings, a series of watercolors, and fans.

21. Letter, Robert Cassatt to son Alexander, Paris, May 5, 1886; in *Cassatt: Selected Letters*, p. 198.

22. Bailly-Herzberg, "Les Estampes de Berthe Morisot."

23. Ibid., pp. 218, 220. Morisot never exhibited her prints. On the possible assistance by Cassatt, see Higonnet, *Morisot* (New York), p. 186, and Stuckey and Scott, *Morisot*, New York, p. 128.

24. James Joseph Jacques Tissot (1836–1902) was a painter and etcher, a friend of Degas who worked primarily in London.

25. [Paris, Apr. 1890]; in *Cassatt: Selected Letters*, p. 214. Original in French.

26. Mézy, Spring [1890]; in *Morisot: Correspondence*, p. 174.

27. N.l., late 1890; in *Correspondance de Morisot*, p. 157.

28. See Mathews and Schapiro, *Cassatt: Color Prints*, pp. 38–39, and Higonnet, *Morisot's Images of Women*, pp. 182 ff., esp. pp. 189–91.

29. Cassatt also made five other related drawings. Morisot made four other related drawings.

30. Letter, Katherine Cassatt to Alexander Cassatt, n.l., July 23, 1891, cited in Mathews, *Cassatt: A Life*, p. 346, n. 5.

31. Entry of Oct. 28, 1897; in Julie Manet, *Growing Up with the Impressionists*, p. 116.

32. Cassatt and Morisot had their first one-person shows much later than the men. Manet mounted his first large one-man show in 1867. Both Degas and Renoir were invited by Durand-Ruel to have one-man shows in 1883; Degas refused, and Renoir accepted.

33. Durand-Ruel had bought almost nothing from Morisot after 1873.

34. Letter, Morisot to Louise Riesener, n.l., [1892]; in *Morisot: Correspondence*, p. 194.

35. Bachivillers, June 17, [1892]; in *Correspondance de Pissarro*, vol. 3, p. 245, n.l.

36. Letter, Cassatt to Homer Saint-Gaudens, Villa Angeletto, Dec. 28, 1922; in *Cassatt: Selected Letters*, p. 335.

Selected Bibliography

Listed here are the writings that have been of use in the preparation of this book, but this is by no means a complete record of all the works and sources that have been consulted. The bibliography provides full documentation for previously published works; unpublished sources are given in full in the Notes. Any book, article, or review not listed here is cited in full in the Notes.

General

Al-Hamdani, Betty. "Color and Luminosity in the Impressionism of Monet-Renoir-Pissarro-Cézanne." Master's thesis, Columbia University, 1956.

Baudelaire, Charles. *Baudelaire: Lettres, 1841–1866.* Paris: Société du Mercure de France, 1907.

———. *Baudelaire: Oeuvres complètes.* Paris: Gallimard, 1954; and Claude Pichois, editor, new ed., 2 vols. Paris: Gallimard, 1976.

Bellony-Rewald, Alice. *The Lost World of the Impressionists.* Boston: New York Graphic Society, 1976.

Berhaut, Marie. *Caillebotte sa vie et son oeuvre, catalogue raisonné des peintures et pastels.* Paris: Bibliothèque des Arts, 1978.

Bomford, David, et al. *Art in the Making: Impressionism.* London: National Gallery, 1991. Exhibition catalog.

Bonafoux, Pascal. *The Impressionists: Portraits and Confidences.* New York: Skira-Rizzoli, 1986. *Les Impressionnistes: Portraits et confidences.* Geneva: Skira, 1986.

Brettell, Richard, et al. *A Day in the Country: Impressionism and the French Landscape.* Los Angeles: Los Angeles County Museum of Art, 1984; Chicago: Art Institute, 1984; Paris: Grand Palais, 1985. Exhibition catalog.

Broude, Norma. *Impressionism: A Feminist Reading, the Gendering of Art, Science, and Nature in the Nineteenth Century.* New York: Rizzoli, 1991.

Broude, Norma, and Mary Garrard. *Feminism and Art History.* New York: Harper and Row, 1982.

Champa, Kermit. *Studies in Early Impressionism.* New Haven: Yale University Press, 1973.

Claparède, J., and G. Sarraute. *Bazille.* Introduction by Daniel Wildenstein. Paris: Wildenstein, 1950. Exhibition catalog.

Daulte, François. *Frédéric Bazille et son temps.* Geneva: Cailler, 1952.

Dayez, Anne, et al. *Impressionism: A Centenary Exhibition.* New York: Metropolitan Museum of Art, 1974. Exhibition catalog.

Delteil, Loys. *Le Peintre-graveur illustré.* Vol. 17, *Pissarro/Sisley/Renoir.* New York: Dacapo, 1969.

Denvir, Bernard. *The Impressionists at First Hand.* London: Thames and Hudson, 1987.

Distel, Anne. *Impressionism: The First Collectors.* New York: Abrams, 1989. *Collectionneurs des impressionnistes, amateurs et marchandes.* Düdingen: La Bibliothèque des Arts, 1989.

Gachet, Paul. *Lettres Impressionnistes.* Paris: Grasset, 1957.

Gimpel, René. *Journal d'un collectionneur, marchand de tableaux.* Paris: Calmann-Lévy, 1963. *Diary of an Art Dealer.* New York: Farrar, Straus, and Giroux, 1966.

Goncourt, Edmond de, and Jules de Goncourt. *Journal: Mémoires de la vie littéraires.* Edited by Robert Ricatte. 4 vols. Paris: Fasquelle, Flammarion, 1956.

Hamilton, George H. "The Philosophical Implications of Impressionist Landscape Painting." *Houston Museum of Fine Arts Bulletin* 6 (Spring 1975): 2–17.

Herbert, Robert. *Impressionism: Art, Leisure, and Parisian Society.* New Haven: Yale University Press, 1988.

Howard, Michael, ed. *The Impressionists by Themselves.* London: Conran Octopus, 1991. *Les Impressionnistes par eux-mêmes.* Paris: Éditions Atlas, 1991.

Isaacson, Joel. *The Crisis of Impressionism, 1878–1882.* Ann Arbor: University of Michigan Museum of Art, 1980.

Mallarmé, Stéphane. *Collected Poems.* Translated and with a commentary by Henry Weinfield. Berkeley and Los Angeles: University of California Press, 1994.

———. *Mallarmé: Correspondance.* Edited by Henri Mondor and Lloyd James Austin. 7 vols. Paris: Gallimard, 1959–1982.

———. *Mallarmé: Oeuvres complètes.* Paris: Gallimard, 1945.

———. *Mallarmé: Selected Prose Poems, Essays, and Letters.* Translated by Bradford Cook. Baltimore: John Hopkins University Press, 1956.

Marandel, J. Patrice, and François Daulte. *Frédéric Bazille and Early Impressionism.* Catalog entries by J. Patrice Marandel; letters translated by Paula Prokopoff-Giannini. Chicago: Art Institute of Chicago, Mar. 4–Apr. 3, 1978. Exhibition catalog.

Moffett, Charles S., et al. *The New Painting: Impressionism, 1874–1886.* Washington: National Gallery, 1986; San Francisco: Fine Arts Museums, 1986. Exhibition catalog.

Monneret, Sophie. *L'Impressionnisme et son epoque.* 4 vols. Paris: Denoël, 1978–1981.

Muehsam, Gerd. *French Painters and Paintings from the Fourteenth Century to Post-Impressionism.* New York: Ungar, 1970.

Natanson, Thadée. *Peints à leur tour.* Paris: Albin Michel, 1948.

Nochlin, Linda. *Impressionism and Post-Impressionism, 1874–1904.* Englewood Cliffs, N.J.: Prentice-Hall, 1966.

Poulain, Gaston. *Bazille et ses amis.* Paris: Renaissance du Livre, 1932.

Rewald, John. "The Future Impressionists at the Café Guerbois." *Art News* 45 (Apr. 1946): 22–65.

———. *History of Impressionism.* New York: Museum of Modern Art, 1973. *Histoire de l'Impressionnisme.* Paris: Albin Michel, 1955, 1986.

———. *Studies in Impressionism.* Edited by Irene Gordon and Frances Weitzenhoffer. New York: Abrams, 1985.

Schapiro, Meyer. "The Nature of Abstract Art," *Marxist Quarterly* 1, no. 1 (Jan.–Mar. 1937); reprinted in Schapiro, Meyer. *Modern Art, Nineteenth and Twentieth Centuries: Selected Papers.* New York: Braziller, 1978, pp. 185–211.

Tinterow, Gary, and Henri Loyrette. *Origins of Impressionism.* New York: Metropolitan Museum of Art, 1994. *Impressionnisme, Les Origines, 1859–1869.* Paris: Réunions des Musées Nationaux, 1994. Exhibition catalog.

Valéry, Paul. *Oeuvres.* Vol. 2. Paris: Gallimard, 1960.

Venturi, Lionello. *Les Archives de l'Impressionnisme.* 2 vols. Paris and New York: Durand-Ruel, 1939. Reprint. New York: Burt Franklin, 1968.

White, Barbara Ehrlich, ed. *Impressionism in Perspective.* Englewood Cliffs, N.J.: Prentice-Hall, 1978.

White, Harrison C., and Cynthia A. White. *Canvases and Careers: Institutional Change in the French Painting World.* New York: Wiley, 1965.

Zola, Émile. *Émile Zola Salons.* Edited by F. W. J. Hemmings and Robert J. Niess. Geneva: Droz, 1959.

Cassatt

Breeskin, Adelyn Dohme. *Mary Cassatt: A Catalogue Raisonné of the Graphic Work.* Washington, D.C.: Smithsonian Insitution Press, 1979.

———. *Mary Cassatt: A Catalogue Raisonné of the Oils, Pastels, Watercolors, and Drawings.* Washington, D.C.: Smithsonian Institution Press, 1970.

Giese, Lucretia H. "A Visit to the Museum." *Boston Museum of Fine Arts Bulletin* 76 (1978): 42–53.

Havemeyer, Louisine W. "The Cassatt Exhibition." *Pennsylvania Museum Bulletin,* May 1927, 373–82.

———. *Sixteen to Sixty: Memoirs of a Collector.* New York: Metropolitan Museum of Art, 1961.

Hyslop, Francis E. Jr. "Berthe Morisot and Mary Cassatt." *College Art Journal* 13, no. 3 (Spring 1954): 179–84.

Mathews, Nancy Mowll. *Cassatt and Her Circle: Selected Letters.* New York: Abbeville, 1984.

———. *Mary Cassatt.* New York: Abrams, 1987.

———. *Mary Cassatt: A Life.* New York: Villard, 1994.

———. *Mary Cassatt and Edgar Degas.* San Jose, N.M.: San José Museum of Art, Oct. 15–Dec. 15, 1981. Exhibition catalog.

———. *Mary Cassatt and the "Modern Madonna" of the Nineteenth Century* [Ph.D. diss., New York University, 1980]. Ann Arbor, Mich.: University Microfilms, 1980.

Mathews, Nancy Mowll, and Barbara Stern Shapiro. *Mary Cassatt: The Color Prints.* New York: Abrams, 1989. Exhibition catalog.

Segard, Achille. *Mary Cassatt, un Peintre des enfants et des mères.* Paris: Ollendorff, 1913.

Sweet, Frederick A. *Miss Mary Cassatt: Impressionist from Pennsylvania.* Norman: University of Oklahoma Press, 1966.

Watson, Forbes. *Mary Cassatt.* New York: Whitney Museum of American Art, 1932.

Weitzenhoffer, Frances. *The Havemeyers: Impressionism Comes to America.* New York: Abrams, 1986.

Cézanne

Anderson, Wayne. *Cézanne's Portrait Drawings.* Cambridge, Mass.: MIT Press, 1970.

———. "Cézanne, Tanguy, Chocquet." *Art Bulletin* 49 (June 1967): 135–39.

Cézanne, Paul. *Paul Cézanne Letters.* Edited by John Rewald. Translated by Seymour Hacker. New York: Hacker, 1984; *Paul Cézanne correspondance.* Edited by John Rewald. Paris: Grasset, 1978.

Chappuis, Adrien. *The Drawings of Paul Cézanne: A Catalogue Raisonné.* 2 vols. Greenwich, Conn.: New York Graphic Society, 1973.

Doran, P. M., ed. *Conversations avec Cézanne.* Paris: Macula, 1978.

Gasquet, Joachim. *Joachim Gasquet's Cézanne: A Memoir with Conversations.* London: Thames and Hudson, 1991.

Gowing, Lawrence. *Cézanne: The Early Years, 1859–1872.* London: Royal Academy, 1988; Paris: Musée d'Orsay, 1988; Washington, D.C.: National Gallery, 1989. Exhibition catalog.

Kendall, Richard, ed. *Cézanne by Himself.* Boston: Little, Brown, 1988.

Larguier, Leo. *Le Dimanche avec Paul Cézanne (Souvenirs).* Paris: L'Édition, 1925.

Lloyd, Christopher. "Paul Cézanne, Pupil of Pissarro: An Artistic Friendship." *Apollo* 136 (Nov. 1992): 284–90.

Reff, Theodore. "Cézanne's Constructive Stroke." *Art Quarterly* 25, no. 3 (Autumn 1962): 214–27.

———. "Reproductions and Books in Cézanne's Studio." *Gazette des Beaux-Arts,* 6th ser., 56 (Nov. 1960): 303–9.

Rewald, John. *Cézanne.* New York: Abrams, 1986.

———. "Chocquet and Cézanne." *Gazette des Beaux-Arts,* 6th ser., 74 (July–Aug. 1969): 33–96.

Schapiro, Meyer. *Paul Cézanne.* New York: Abrams, 1952.

Shiff, Richard. *Cézanne and the End of Impressionism.* Chicago: University of Chicago Press, 1984.

Venturi, Lionello. *Cézanne—Son Art, son oeuvre.* 2 vols. Paris: 1936. Reprint. San Francisco: Wofsy, 1989.

Wechsler, Judith, ed. *Cézanne in Perspective.* Englewood Cliffs, N.J.: Prentice-Hall, 1975.

Degas

Adhémar, Jean, and Françoise Cachin. *Degas: The Complete Etchings, Lithographs and Monotypes.* New York: Viking, 1975.

Adriani, Götz. *Degas Pastels, Oil Sketches, Drawings.* New York: Abbeville, 1985.

Boggs, Jean Sutherland, et al. *Degas.* New York: Metropolitan Museum of Art, 1988–89; Paris: Grand Palais, 1988; Ottawa: National Gallery, 1988. Exhibition catalog.

———. *Drawings by Degas.* St. Louis: City Art Museum, 1966.

———. *Portraits by Degas.* Berkeley and Los Angeles: University of California Press, 1962.

Brame, Philippe, and Theodore Reff, comp. *Degas et son oeuvre: A Supplement.* New York and London: Garland, 1984.

Brettell, Richard R., and Suzanne Folds McCullagh. *Degas in the Art Institute of Chicago.* New York: Art Institute of Chicago and Abrams, 1984.

Broude, Norma. "Degas's 'Misogyny.'" *Art Bulletin* 59 (Mar. 1977): 95–107. Reprinted in Broude and Garrard. *Feminism and Art History.* New York: Harper and Row, 1982 pp. 247–70.

Degas, Edgar. *Degas Letters.* Edited by Marcel Guérin. Translated by Marguerite Kay. Oxford: Cassirer, 1947. *Lettres de Degas.* Edited by Marcel Guérin. Paris: Grasset, 1945.

Degas, Jean Neveu. *Huit sonnets d'Edgar Degas.* New York: Wittenborn, 1946.

Guillaud, Maurice, et al. *Degas: Form and Space.* Paris: Centre Culturel du Marais, Guillaud, 1984.

Kendall, Richard, ed. *Degas by Himself: Drawings, Prints, Paintings, Writings.* Boston: New York Graphic Society, 1987. *Degas par lui-même.* Paris: Éditions Atlas, 1987.

Lemoisne, Paul André. *Degas et son oeuvre.* Paris: Brame et De Hauke, 1946–1949. 4 vols. [Plus supplement, see Brame and Reff.]

Loyrette, Henri. *Degas.* Paris: Fayard, 1991.

McMullen, Roy. *Degas: His Life, Times, and Work.* Boston: Houghton Mifflin, 1984.

Moore, George. "Degas: The Painter of Modern Life." *Magazine of Art* 13 (1890): 416–25.

Reed, Sue Welsh, and Barbara Stern Shapiro. *Edgar Degas: The Painter as Printmaker.* Boston: Little, Brown, 1984.

Reff, Theodore. "*Au Musée du Louvre* by Edgar Degas." In *Art at Auction: The Year at Sotheby's, 1983–84.* New York: Sotheby's, 1984. pp. 90–95.

———. *Degas: The Artist's Mind.* Cambridge, Mass.: Belknap Press, Harvard University Press, 1987.

———. *The Notebooks of Edgar Degas: A Catalogue of the Thirty-eight Notebooks in the Bibliothèque Nationale and Other Collections.* 2 vols. Oxford: Clarendon, 1976.

Rouart-Valéry, Agathe, et al. *Degas Inédit.* Actes du colloque Degas Musée d'Orsay, Apr. 18–21, 1988, École du Louvre, Musée d'Orsay. Paris: Documentation Française, 1989.

Sheehan, Lorraine Gayle. "Degas' Influence on Mary Cassatt." Master's thesis, Tufts University, 1971.

Thomson, Richard. "Notes on Degas's Sense of Humour." In *Degas, 1834–1984.* Edited by Richard Kendall. Manchester: Department of History of Art and Design, Manchester Polytechnic, 1985. pp. 11–16.

Valéry, Paul. *Degas, danse, dessin.* Paris: Gallimard, 1965.

———. *Degas, Manet, Morisot.* Translated by David Paul. Bollingen Series 45. Princeton: Princeton University Press, 1989.

Manet

Cachin, Françoise, Charles S. Moffett, et al. *Manet, 1832–1883.* New York: Metropolitan Museum of Art, 1983; Paris: Grand Palais, 1983. Exhibition catalog.

Clark, Timothy J. *The Painting of Modern Life: Paris in the Art of Manet and His Followers.* New York: Knopf, 1985.

Courthion, Pierre, and Pierre Cailler, eds. *Manet raconté par lui-même et par ses amis.* 2 vols. Geneva: Cailler, 1953. *Portrait of Manet by Himself and His Contemporaries.* Translated by Michael Ross. New York and London: Roy, 1960.

Gronberg, T. A. *Manet: A Retrospective.* New York: Hugh Lauter Levin, 1988.

Guérin, Marcel. *L'Oeuvre gravé de Manet.* Paris: Floury, 1944.

Hamilton, George Heard. *Manet and His Critics.* New Haven: Yale University Press, 1986.

Hanson, Anne Coffin. *Manet and the Modern Tradition.* New Haven: Yale University Press, 1977.

Harris, Jean C. *Édouard Manet: The Graphic Work, A Catalogue Raisonné.* San Francisco: Wofsy, 1990.

———. "Manet's Race Track Paintings." *Art Bulletin* 71 (1989): 78–82.

Moreau-Nélaton, Étienne. *Manet raconté par lui-même.* 2 vols. Paris: Laurens, 1926.

Reff, Theodore. *Manet and Modern Paris.* Washington, D.C.: National Gallery of Art, 1982.

Rouart, Denis, and Daniel Wildenstein. *Édouard Manet catalogue raisonné.* 2 vols. Lausanne and Paris: Bibliothèque des Arts, 1975.

Tabarant, Adolphe. *Manet: Historique catalographique.* Paris: Aubier, 1931.

———. *Manet et ses oeuvres.* Paris: Gallimard, 1947.

Wilson-Bareau, Juliet. *Manet by Himself.* Boston: Little, Brown, 1991. *Manet par lui-même.* Paris: Éditions Atlas, 1991.

Monet

Bakker, Boudewijn, et al. *Monet in Holland.* Amsterdam: Rijksmuseum Vincent Van Gogh, 1986.

Geffroy, Gustave. *Claude Monet: Sa Vie, son oeuvre.* 2 vols. Paris: Crès, 1924.

Gordon, Robert, and Andrew Forge. *Monet.* New York: Abrams, 1983.

Herbert, Robert. "Method and Meaning in Monet." *Art in America* 67, no. 5 (Sept. 1979): 90–108.

House, John. *Claude Monet.* London: Phaidon, 1978.

———. *Monet: Nature into Art.* New Haven: Yale University Press, 1986.

Isaacson, Joel. *Claude Monet: Observation and Reflection.* Oxford: Phaidon, 1978.

———. *Monet: Le Déjeuner sur l'herbe.* New York: Viking, 1972.

Kendall, Richard, ed. *Monet by Himself.* Boston: Little, Brown, 1989.

Pickvance, Ronald. "Monet and Renoir in the Mid-1870s." In *Japonism in Art: An International Symposium.* Edited by the Society for the Study of Japonism. Tokyo: Committee for the Year 2001, 1980.

Rewald, John, and Frances Weitzenhoffer, eds. *Aspects of Monet: A Symposium on the Artist's Life and Times.* New York: Abrams, 1984.

Skeggs, Douglas. *River of Light: Monet's Impressions of the Seine.* New York: Knopf, 1987.

Spate, Virginia. *Claude Monet: Life and Work.* New York, London: Thames and Hudson, 1992.

Stuckey, Charles, ed. *Monet: A Retrospective.* New York: Hugh Lauter Levin, 1985.

Thiébault-Sisson, François. "Claude Monet" [interview]. *Le Temps,* Nov. 27, 1900.

Tucker, Paul. *Monet at Argenteuil.* New Haven: Yale University Press, 1982.

———. *Monet in the 90s: The Series Paintings.* New Haven: Yale University Press, 1990.

Wildenstein, Daniel. *Claude Monet: Biographie et catalogue raisonné.* Vols. 1–5. Lausanne: Bibliothèque des Arts, 1974–1991.

Wilson, Michael, Martin Wyld, and Roy Ashok. "Monet's 'Bathers at La Grenouillère.'" *National Gallery Technical Bulletin* 5 (1981): 14–25.

Morisot

Adler, Kathleen, and Tamar Garb. *Berthe Morisot.* Ithaca, N.Y.: Cornell University Press, 1987.

Bailly-Herzberg, Janine. "Les Estampes de Berthe Morisot." *Gazette des Beaux-Arts,* 6th ser., 93 (May–June 1979): 215–27.

Bataille, M.-L., and G. Wildenstein. *Berthe Morisot: Catalogue des peintures, pastels et acquarelles.* Paris: Beaux-Arts, 1961.

Clairet, Alain. "'Le Cerisier' de Mézy." *L'Oeil* 358 (May 1985): 48–51.

Edelstein, T. J. *Perspectives on Morisot.* New York: Hudson Hills, 1990.

Gauthier, Serge, and Denis Rouart. *Homage à Berthe Morisot et à Pierre-Auguste Renoir.* Limoges: Musée Municipal, 1952. Exhibition catalog.

Grayson, Marion L. "Berthe Morisot: 'A Woman Among the Lunatics.'" *Museum of Fine Arts, St. Petersburg Bulletin:* Vol. 18, no. 1 (1981): 4–13.

Higonnet, Anne. *Berthe Morisot.* New York: HarperCollins, 1991.

———. *Berthe Morisot, une biographie.* Paris: Biro, 1989.

———. *Berthe Morisot's Images of Women.* Cambridge, Mass.: Harvard University Press, 1992.

Manet, Julie [Rouart]. *Growing Up with the Impressionists: The Diary of Julie Manet.* Translated, edited, and introduced by Rosalind de Boland Roberts and Jane Roberts. London: Sotheby's, 1987. *Journal (1893–1899): Sa Jeunesse parmi les peintres impressionnistes et les hommes de lettres.* Paris: Klincksieck, 1979.

Mongan, Elizabeth, introduction. *Berthe Morisot, Drawings/ Pastels/ Watercolors/ Paintings.* New York: Shorewood, 1960.

Montalant, Delphine. "Une Longue Amitié: Berthe Morisot et Pierre-Auguste Renoir." *L'Oeil* 358 (May 1985): 42–47.

Morisot, Berthe. *Berthe Morisot: The Correspondence with Her Family and Her Friends.* Compiled and edited by Denis Rouart. Translated by Betty W. Hubbard. Introduction and notes by Kathleen Adler and Tamar Garb. London: Moyer Bell, 1987. *Correspondence de Berthe Morisot avec sa famille et ses amis.* Compiled and edited by Denis Rouart. Paris: Quatre Chemins-Éditart, 1950.

Nochlin, Linda. "Morisot's *Wet Nurse:* The Construction of Work and Leisure in Impressionist Painting." In Edelstein, T. J., ed. *Perspectives on Morisot.* New York: Hudson Hills, 1990, pp. 91–102.

Rey, Jean Dominique. *Berthe Morisot.* Naefels, Switzerland: Bonfini Press, 1982.

Stuckey, Charles F., and William P. Scott. *Berthe Morisot.* Paris: Herscher, 1987. *Berthe Morisot, Impressionist.* New York: Hudson Hills, 1987.

Valéry, Paul. "Tante Berthe." *La Renaissance,* June 1926.

Pissarro

Brettell, Richard R. *Pissarro and Pontoise: The Painter in a Landscape.* New Haven: Yale University Press, 1990.

Brettell, Richard R., Françoise Cachin et al. *Pissarro.* Boston: Museum of Fine Arts, 1981. Paris: Grand Palais, 1981. Exhibition catalog.

Lloyd, Christopher. *Camille Pissarro.* New York: Skira-Rizzoli, 1981.

———. *Studies on Camille Pissarro.* London and New York: Routledge and Kegan Paul, 1986.

Meadmore, W. S. *Lucien Pissarro, Un Coeur simple.* London: Constable, 1962.

Pissarro, Camille. *Camille Pissarro: Letters to His Son Lucien.* Edited with the assistance of Lucien Pissarro by John Rewald. Santa Barbara and Salt Lake City: Peregrine Smith, 1981.

—————. *Correspondance de Camille Pissarro.* Edited by Janine Bailly-Herzberg. Vol. 1. Paris: Presses Universitaires de France, 1980; Vol. 2–5. Paris: Valhermeil, 1986–1991.

Pissarro, Joachim. *Camille Pissarro.* New York: Abrams, 1993.

Pissarro, Ludovic Rodo, and Lionello Venturi. *Camille Pissarro: Son Art, son oeuvre.* 2 vols. Paris, 1939. Reprint. San Francisco: Wofsy, 1989.

Reff, Theodore. "Pissarro's Portrait of Cézanne." *Burlington Magazine* 109 (Nov. 1967): 627–33.

Rewald, John. *Camille Pissarro.* New York: Abrams, 1963.

Shikes, Ralph E., and Paula Harper. *Pissarro: His Life and Work.* New York: Horizon, 1980. *Pissarro.* Paris: Flammarion, 1981.

Tabarant, Adolphe. *Pissarro.* Paris: Rieder, 1924; New York and London: Dodd, Mead, 1925.

Thomson, Richard. *Camille Pissarro: Impressionism, Landscape and Rural Labour.* New Amsterdam and New York: Herbert, 1990.

Thorold, Anne. *Artists, Writers, Politics: Camille Pissarro and His Friends.* Oxford: Ashmolean Museum, 1980.

Renoir

André, Albert. *Renoir.* Paris: Crès, 1923.

Baudot, Jeanne. *Renoir: Ses Amis, ses modèles.* Paris: Éditions Litteraires de France, 1949.

Daulte, François. *Auguste Renoir: Catalogue raisonné de l'oeuvre peint.* Vol. 1, *Figures, 1860–1890.* Lausanne: Durand-Ruel, 1971.

Haesaerts, Paul. *Renoir: Sculptor.* New York: Reynal & Hitchcock, 1947.

House, John, Anne Distel et al. *Renoir.* London: Hayward Gallery, 1985; Boston: Museum of Fine Arts, 1985–86. Exhibition catalog. *Renoir.* Paris: Grand Palais, 1985; Éditions de la Réunion des musées nationaux, 1985. Exhibition catalog.

Joëts, Jules. "Les Impressionnistes et Chocquet." *L'Amour de l'art,* no. 16 (Apr. 1935): 120–25.

Pach, Walter. "Pierre Auguste Renoir." *Scribner's Magazine* 51 (Jan.–June 1912): 606–15.

—————. *Queer Thing Painting.* New York: Harper & Brothers, 1938.

—————. *Renoir.* New York: Abrams, 1950.

Renoir, Jean. *Renoir My Father.* Boston: Little, Brown, 1962. *Renoir.* Paris: Hachette, 1962.

Rewald, John, ed. *Renoir Drawings.* New York: Bittner-Thomas Yoseloff, 1946.

Rivière, Georges. *Renoir et ses amis.* Paris: Floury, 1921.

Stella, Joseph G. *The Graphic Work of Renoir.* London: Lund Humphries, [1971–1975].

Vollard, Ambroise. *Pierre-Auguste Renoir: Paintings, Pastels and Drawings.* Paris, 1918. Reprint. San Francisco: Wofsy, 1989.

Wadley, Nicholas, ed. *Renoir: A Retrospective.* New York: Hugh Levin, 1987.

White, Barbara Ehrlich. *Renoir: His Life, Art, and Letters.* New York: Abrams, 1984. *Renoir.* Paris: Flammarion, 1985.

Index

PERMISSIONS ACKNOWLEDGMENTS

Grateful acknowledgment is made to the following for permission to reprint previously published material:

Abbeville Press, Inc.: Excerpts from various letters from *Cassatt and Her Circle: Selected Letters*, edited by Nancy Mowll Mathews (New York: Abbeville Press, Inc., 1984). Reprinted by permission of Abbeville Press, Inc.

Editions Bernard Grasset: Excerpts (translated by Barbara Ehrlich White) from *Paul Cézanne Correspondance*, edited by John Rewald (Paris: Grasset, 1978); excerpts translated by Barbara Ehrlich White from *Lettres de Degas*, edited by Marcel Guerin (Paris: Grasset, 1945). Reprinted by permission of Editions Bernard Grasset.

Editions du Valhermeil: Excerpts (translated by Barbara Ehrlich White) from *Correspondance de Camille Pissarro, Vols. 3, 4, 5*, edited by Janine Bailly-Herzberg (Editions du Valhermeil, 1986–1991), copyright © by Editions du Valhermeil. Reprinted by permission of Editions du Valhermeil.

Lund Humphries Publishers Ltd.: Excerpts from *Berthe Morisot: The Correspondence with Her Family and Her Friends*, edited by Denis Rouart, English translation by Betty W. Hubbard. Reprinted by permission of Lund Humphries Publishers Ltd., London.

The Metropolitan Museum of Art: Excerpts from *Sixteen to Sixty: Memoirs of a Collector* by Louisine W. Havemeyer, copyright © 1961, 1993 by The Metropolitan Museum of Art. Reprinted by permission of The Metropolitan Museum of Art.

Presses Universitaires de France: Excerpts (translated by Barbara Ehrlich White) from *Correspondance de Camille Pissarro, Vol. I*, edited by Janine Bailly-Herzberg (Paris: Presses Universitaires de France, 1980). Reprinted by permission of Presses Universitaires de France.

Sabine Rewald: Excerpts from *Camille Pissarro: Letters to His Son Lucien*, edited by John Rewald with Lucien Pissarro (Layton, Utah: Peregrine Smith Books, 1981), copyright by Sabine Rewald; excerpts from *Paul Cézanne Letters*, edited by John Rewald, translated by Seymour Hacker (New York: Hacker, 1984), copyright by Sabine Rewald. Reprinted by permission of Sabine Rewald.

University of Oklahoma Press: Excerpts from *Miss Mary Cassatt, Impressionist from Pennsylvania* by Frederick A. Sweet, copyright © 1966 by the University of Oklahoma Press. Reprinted by permission of the University of Oklahoma Press.

Wildenstein Institute: Excerpts (translated by Barbara Ehrlich White) from *Claude Monet: Biographie et Catalogue Raisonné*, vols. 1–5, by Daniel Wildenstein (Lausanne: Bibliothèque des Arts, 1974–1991). Reprinted by permission of Wildenstein Institute, Paris.

Philip Wilson Publishers Limited: Excerpts from *Growing Up with the Impressionists: The Diary of Julie Manet*, edited and translated by Rosalind de Boland Roberts and Jane Roberts (London: first published for Sotheby's Publications by Philip Wilson Publishers, 1987), copyright © 1987 by Rosalind de Boland Roberts and Jane Roberts. Reprinted by permission of Philip Wilson Publishers Limited, 28 Litchfield Street, London WC2H 9NJ.

PHOTOGRAPHIC CREDITS

© Arch. Phot. Paris/SPADEM: 33 (left); Art Resource, New York: 5, 205; Courtesy William Beadleston, Inc.: 101; Courtesy British Museum, Department of Prints and Drawings: 146; Courtesy Bulloz, Paris: 230 (bottom); Courtesy Document Archives Durand-Ruel, Paris—rights reserved: 12, 21, 105; Courtesy Document Archives Durand-Ruel, Paris: 222 (all); 223, 226, 239 (bottom); Courtesy Document Archives Durand-Ruel, Paris, Photo Routhier: 20, 70; Courtesy Document Archives Durand-Ruel, Paris, Photo Albert André, Collection Jacqueline Besson-André: 215; Courtesy Christie's, Inc.: 98, 207 (right), 246, 247; Photo: Fine Art Studio, Paris: 244; Getty Foundation: 138; Giraudon, Paris: 173, 238; Courtesy Robert Gordon: 64 (bottom); Courtesy Mrs. U. Held, 177, 180; Courtesy Galerie Hopkins-Thomas, Paris: 14, 31, 148, 162, 181, 212, 255, 258; Photo: Luis Hossaka: 49; Photo: J. Lathion: 158; Courtesy The Lefevre Gallery, London (Photo: Ali Elai, Camerarts, Inc.): 89 (bottom), 234 (below); Photo: Scott Mc-

Claine: 159; Öffentliche Kunstsammlung, Basel (Photo: Martin Buhler): 127, 143 (top); Photo: Edward Owen: 82 (top); Courtesy Photothèque des Musées de la Ville de Paris; © SPADEM: 255 (right); Courtesy Marc Restellini: 221; © RMN, France: ii, 7, 16, 19, 28 (left), 34 (top) (Photo: M. Bellot), 34 (bottom), 44, 50 (Photo: M. De Lorenzo), 51 (right), 75, 82 (bottom), 83 (top), 88 (top), 100 (bottom), 131, 140 (right), 141 (right), 144 (bottom) (Photo: H. Lewandowski), 145 (left), 147, 152, 163, 174, 188 (Photo: H. Lewandowski), 203 (left), 232, 245, 261, 263 (bottom, right); Courtesy Schmit Gallery, Paris: 13, 55; © Collection Sirot-Angel: 17, 22, 216; Courtesy Sotheby's, Inc.: 68, 85 (top), 100 (top), 113, 119, 123, 135, 137; Photo: Jim Strong, Inc.: 36; Photo: Michael Tropea: 120; Courtesy Valley Gallery, Dallas: 67 (bottom); Photo: Reinaldo Viegas: 89 (top); Courtesy Jayne Warman: vi, 6, 106, 108, 141 (bottom), 142 (right); Courtesy Wildenstein Gallery, Paris: 66, 231, 251

A NOTE ABOUT THE AUTHOR

Barbara Ehrlich White, author of *Renoir: His Life, Art, and Letters* (1984),
is also the editor of the anthology *Impressionists in Perspective* (1978), writer of an
Emmy-winning PBS film on Renoir (1973), and a well-known lecturer.
She and her husband live near Boston, where she is an adjunct
professor of art history at Tufts University.

A NOTE ON THE TYPE

The text of this book was set in Walbaum, a typeface designed by Justus
Erich Walbaum in 1810. Walbaum was active as a typefounder in Goslar and Weimar
from 1799 to 1836. Though the letter forms of this face are patterned closely
on the "modern" cuts then being made by Giambattista Bodoni and the
Didot family, they are of a far less rigid cut. Indeed, it is the slight
but pleasing irregularities in the cut that give this typeface
its humane quality and account for its wide appeal. In
its very appearance Walbaum jumps boundaries,
having a look more French than German.

Printed and bound by
Amilcare Pizzi, Milan, Italy
Designed by Peter A. Andersen